CROSSING *the* CANAL

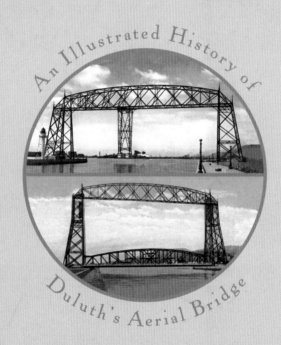

An Illustrated History of
Duluth's Aerial Bridge

TONY DIERCKINS

X-comm

DULUTH, MINNESOTA

X-communication

Duluth, Minnesota

218-310-6541

www.x-communication.org

Crossing the canal: an illustrated history of Duluth's aerial bridge

Text, research, maps, cover design, interior design, and layout by Tony Dierckins

Further research by Maryanne Norton, Carly Moritz, and Jerry Sandvick

Index and reference entries compiled by Jennifer Todd Derrick

Copyediting and editorial guidance by Scott Pearson

Proofreading by Suzanne Rauvola and Kerry Wick

Indexing by Christopher Godsey

A complete list of image credits appears on page 195

First Edition, 2008

08 09 10 11 12 • 5 4 3 2 1

Library of Congress Control Number: 2008929957

ISBNs: 1-887317-33-3; 978-1-887317-33-7

Printed in Singapore by Tien Wah Press

For the late-nineteenth-century residents of Park Point, whose resistance to dissolve as an independent

township and join the City of Duluth forced the Zenith City to promise to build a bridge;

those Park Pointers and other Duluthians who argued for its 1929 – 1930 conversion;

and those who designed, financed, built, maintained, transformed, repaired,

painted, reconditioned, and operated Duluth's iconic landmark.

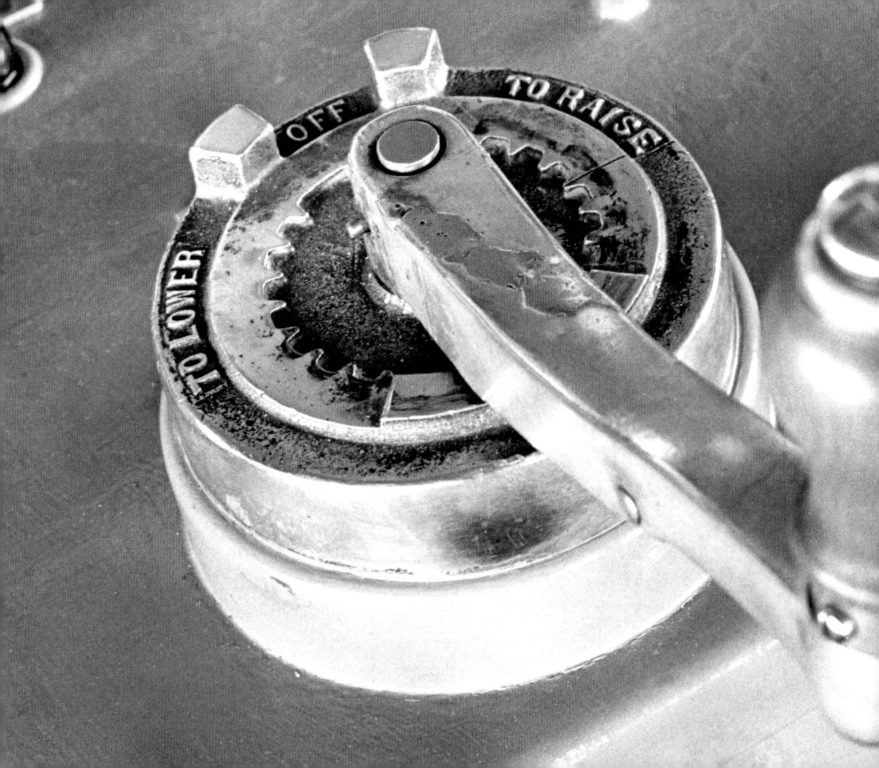

Contents

Facing page: From 1930 to 1985, lift bridge operators turned this handle to lower and raise the bridge's lift span.

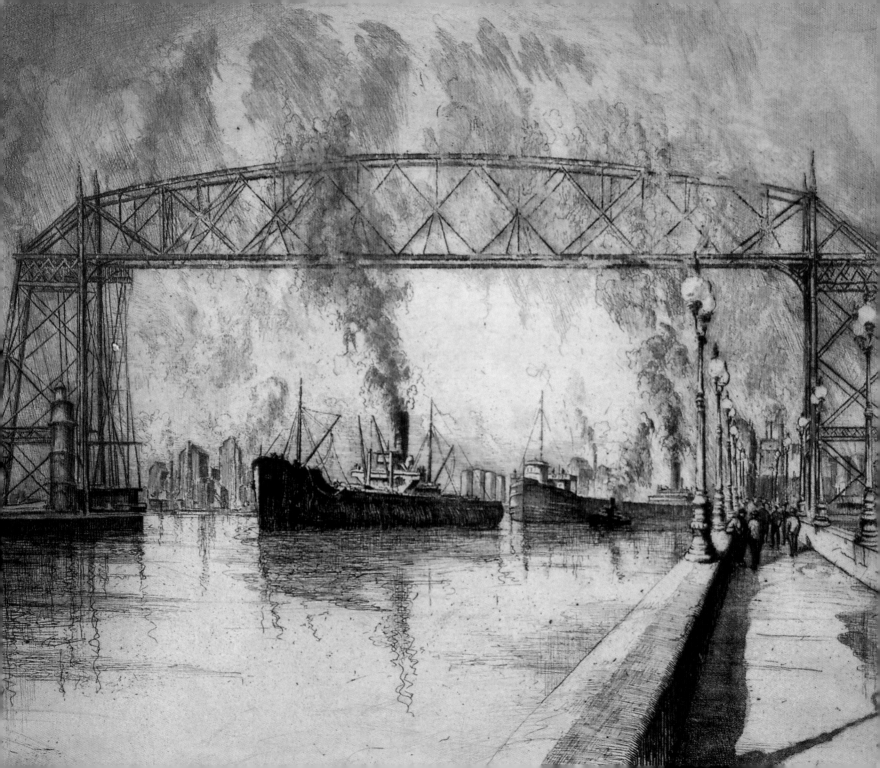

PREFACE

I never planned to write this book. I wanted to publish something similar in 2005, the centennial of the aerial bridge. I had heard, however, that another Twin Ports publisher was already hard at work on just such a book, so I abandoned the idea. Besides, I didn't even have an author at the time. The bridge's anniversary came and went, and, for whatever reason, that book never went to press. In February 2007, I met retired historian and Park Point resident Jerry Sandvick. Jerry had written two impressive articles on the bridge's construction history in 2005 for the *Nor'Easter*, the journal of the Lake Superior Marine Museum Association. We struck on the idea to expand those works into an illustrated history of the bridge; Jerry would write the central narrative, and I would gather images and write vignettes on the history of the lighthouses on the canal's piers, the old foghorn, legends and tall tales, and other bridge-related items. But retirement turned out to have far fewer hours for research and writing than Jerry had anticipated. Sorry to step back from the book, but happy to focus on the needs of his family, Jerry graciously turned his research over to me to keep the project moving forward.

So I started to write. Jerry's extensive files—which included primary source material such as minutes of city council meetings and correspondence from bridge engineers to city offi-cials—gave me a solid foundation. His efforts were bolstered by the materials research assistant Carly Moritz and I had already gathered. When I found I needed more information, I turned as always to Maryanne Norton, volunteer research historian at the Duluth Public Library. Answers Maryanne and I (or Kris Aho and the wonderful reference staff at the DPL) couldn't hunt down were provided by folks like Lake Superior Marine Museum curator Thom Holden, former lift bridge supervisor Steve Douville, current lift bridge supervisor Ryan Beamer, and Larry Lyons, son of late lift bridge supervisor Richard Lyons. Steve and Ryan also helped ensure the accuracy of diagrams and descriptions of the bridge and how it works. And when I completed the manuscript, Scott Pearson, Suzanne Rauvola, and Kerry Wick copyedited and proofread the text—once again making one of my books better than I ever could have without their skills.

Throughout this I encountered a great deal of conflicting information and even more just plain misinformation. History is enhanced by myths and legends, often considered more interesting than the truth, and I found nearly a dozen completely fabricated accounts of the digging of the ship canal (even a version I had published in a previous book had fallen prey to

THE ETCHING ON THE FACING PAGE WAS CREATED IN 1920 BY LOUIS ORR, CONSIDERED ONE OF THE TWENTIETH CENTURY'S OUTSTANDING PAINTER-ETCHERS. ORR'S WORK PLACED HIM IN THE RANKS OF THE FRENCH LEGION OF HONOR, AND TODAY HIS PIECES HANG IN THE LOUVRE, THE METROPOLITAN MUSEUM OF ART, AND THE SMITHSONIAN MUSEUM. AN AFFINITY FOR BRIDGES MAY HAVE DRAWN ORR TO DULUTH'S ICON; AS A BOY HE WAS ONE OF THE FIRST PEOPLE TO WALK ACROSS THE BROOKLYN BRIDGE.

these unreliable sources). For the definitive facts of the canal dig, I relied primarily on the 1898 work of Judge J. D. Ensign; Ensign served as one of Duluth's city attorneys during the years of litigation surrounding the canal dig, and his work is supported by the legal documents pertinent to that issue. Newspaper accounts from the *Minnesotian* and the *Duluth Morning Call* validated that work as well. I haven't left out the myths and legends, but I've done my best to keep them separate from what actually occurred.

This is an illustrated history, and the images are just as important as the words. All sorts of people and organizations helped me acquire the historic images found in this book: Mary-anne Norton; Ryan Beamer; Larry Lyons; Karen Storms; Laura Jacobs of the Lake Superior Maritime Collection; Pat Maus of the Northeast Minnesota Historical Center; The Minnesota Historical Society; the Duluth Public Library; Eileen McCormic and the James J. Hill Library; Amy Rupert and the Rensselaer Polytechnic Institute; Christophe Gouzy and the Maritime, Fluvial and Harbour Museum of Rouen; Amy Heidrich and the Museum of Flight; Marylee Hardenbergh and Global Site Performance; Gina Sacchetti and the Richard I. Bong WWII Heritage Center; Bob Forbort, Marilyn Magnuson, and the City of Duluth's Engineers Office; Jeff Pappas, Steve Forslund, and the City of Duluth's Information Management Office; Michelle Des Rosier of the St. Louis County Law Library; Walter N. Trennery; Pamela Buckner of HNTB Corporation; Ken Newhams of the *Duluth Shipping News*; and Gary Lundstrom of Great Lake Design, who generously donated images of many of the bridge supervisors as well as some modern shots he has been making and gathering for his own projects. Others helped as well, and they are all listed on the "Image Credits" on page 195.

The book's centerpiece consists of two collections of marvelous images by Dennis O'Hara of Duluth's Northern Images and Duluth artist Janet Karon. Their work celebrates the bridge, as I believe this book does—so I've placed their images at the middle, because it seems like an appropriate place for the book's heart.

I could not have completed this book as it is without the efforts of those mentioned above and others I likely failed to mention who helped in large and small ways; I am deeply grateful for their efforts.

The lift bridge is easily Duluth's most recognizable icon. It means many different things to people, especially Duluthians. As a whole we seem to genuinely love the bridge, even though most of us in the Zenith City have probably cursed it when it has caused us delay. Many people have called the bridge the "gateway" to the St. Lawrence Seaway, even the "gateway to the world." I like the phrase; it's poetic. But I'm not convinced of its appropriateness. It's by way of the canal—not the bridge—that freighters and ore boats arrive at and depart from the docks and elevators along the harbor waterfront and Rice's Point, making Duluth the largest inland port in the world. The bridge simply allows people and automobiles to cross the canal; in fact, one might argue that the "proper" position of the bridge's lift span is up, allowing marine traffic. By the time the city built a permanent bridge over it, the canal had already been boosting Duluth's economy for thirty-five years. Duluth's aerial bridge is a gateway only by default (but that image was reinforced when the conversion from the transfer bridge to the lift bridge actually created a gate—the lift span—to open and close). But while its purpose is technically nothing more than to provide a means of crossing the canal, in doing so it reconnects Duluth with Minnesota Point (the city's historic birthplace) and the community of Park Point, making Duluth whole. Without the aerial bridge, the city would be incomplete. It's as simple as that.

But, as I've discovered (and trust you will too), the story of the bridge is not nearly that simple.

— Tony Dierckins, May 2008

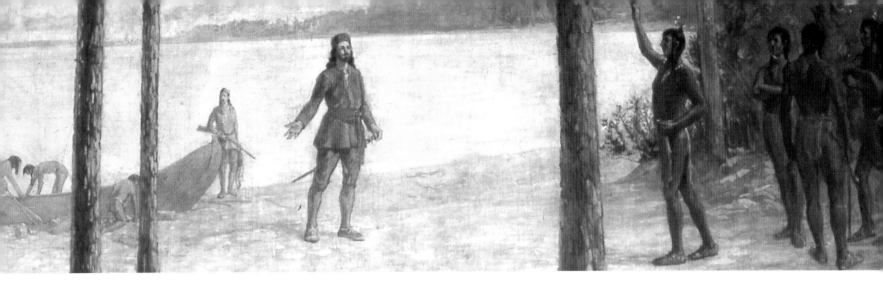

INTRODUCTION:

BEFORE THE CANAL

As the St. Louis and Nemadji rivers emptied themselves into Lake Superior over the last several thousand years, their waters carried silt that deposited where the rivers met the western tip of the lake; at the same time, the big lake itself carried sand westward along its southern shore to the same spot. In this way, the waters eventually formed the largest natural sand bar in the world. This ten-mile isthmus is a natural barrier that created a safe harbor accessible through the Superior Entry, where a stretch of the sand bar is submerged, dividing the bar into two sections. The southern three miles are known as Wisconsin Point; Minnesota Point makes up the northern seven miles. Behind Minnesota Point, Superior Bay formed naturally from the mouth of the St. Louis River (behind Wisconsin Point lies Allouez Bay). By AD 1600 the sand bar had become a popular place to meet and trade among modern peoples such as the Dakota. The Ojibwe, arriving after their long migration from the east before 1700, found the Dakota already established in the region. When the French showed up to expand fur trading, the Dakota and Ojibwe were at war. Acting on his own with a few guides, French soldier and explorer Daniel Greysolon Sieur du Lhut set out from Montreal in 1678 in part to bring peace to the warring native peoples (he would successfully negotiate a treaty between the Dakota and Ojibwe). When he reached the sand bar—where a city would be established in his name—du Lhut and his party did not pass through the natural entry but took a shortcut over a spot the Ojibwe called *Onigamiinsing* or "Little Portage." About 190 years later, local citizens cut a canal through that very spot, turning Minnesota Point into an island. That action would bring the entire community both prosperity and problems. One of those problems, seemingly simple, would prove surprisingly difficult to solve. Without interrupting marine traffic, the people of Duluth needed a quick and convenient way of safely crossing the canal.

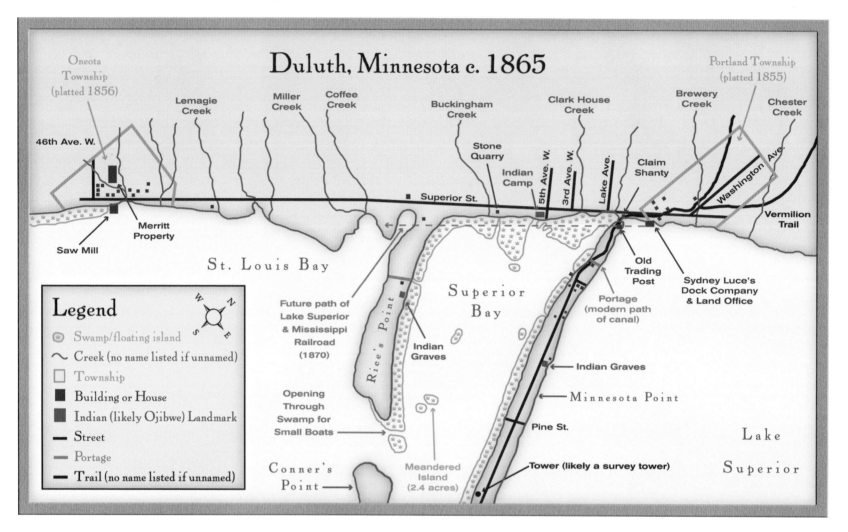

Duluth, Minnesota c. 1865

Oneota Township (platted 1856)

Portland Township (platted 1855)

Lemagie Creek

Miller Creek

Coffee Creek

Buckingham Creek

Clark House Creek

Brewery Creek

Chester Creek

46th Ave. W.

Stone Quarry

Indian Camp

5th Ave. W.

3rd Ave. W.

Lake Ave.

Claim Shanty

Washington Ave.

Superior St.

Vermilion Trail

Merritt Property

Saw Mill

St. Louis Bay

Old Trading Post

Sydney Luce's Dock Company & Land Office

Legend

⊙ Swamp/floating island

∿ Creek (no name listed if unnamed)

☐ Township

■ Building or House

■ Indian (likely Ojibwe) Landmark

— Street

— Portage

— Trail (no name listed if unnamed)

Future path of Lake Superior & Mississippi Railroad (1870)

Rice's Point

Indian Graves

Superior Bay

Portage (modern path of canal)

Indian Graves

Minnesota Point

Opening Through Swamp for Small Boats

Conner's Point

Meandered Island (2.4 acres)

Pine St.

Tower (likely a survey tower)

Lake Superior

THIS MAP IS BASED ON A HAND-DRAWN MAP MADE IN 1865 BY AN UNKNOWN ARTIST (LIKELY COMMISSIONED BY THE CITY OF DULUTH).

THE BIRTH OF DULUTH

The peace du Lhut had established between the Ojibwe and the Dakota would not last. Further conflicts began in 1736 and lasted beyond the French and Indian War, which officially ended in 1763. By 1770 the Ojibwe had taken over northern Minnesota and the French and English continued to clash, a battle now fought over beaver pelts between the French-controlled North West Company and the British-run Hudson's Bay Company. Not long after the Ojibwe took control of the region, colonists back east sent the British packing and formed the United States of America. In 1809 John Jacob Astor, a German-born American citizen, created the American Fur Company and set up a post at Fond du Lac, about twenty miles up the St. Louis River from Minnesota Point. But the Ojibwe still preferred to

trade with the French and British. The War of 1812 put an end to all that, as the post-war American Congress barred foreigners from trading in American territory. And so in 1816 Astor took over the North West Company's interests and built a new fort at Fond du Lac, which operated until 1847, when the fur trade had all but died as hats made of beaver underfur went out of fashion with the introduction of those made of silk.

Despite the death of the fur trade, commerce at the head of the lakes looked promising in the early 1850s. Many speculated that copper mining would create new industry, and construction had begun on locks and channels at Sault Ste. Marie to allow larger sailing craft to navigate into Lake Superior. All this led many fortune-seekers to flock to the obvious place of destiny, a marshy area at the head of the lakes where the St. Louis River fed into Lake Superior: the future home of Superior, Wisconsin, called Superior City in its early years.

New landowners who established Superior in 1854 thought it would eclipse Chicago in importance as a trading center. Indeed, when Congress decided to build a military road between St. Paul and the head of the lakes, Wisconsin lobbyists successfully fought to have the road terminate in Superior rather than Fond du Lac, restricting the Minnesota side of the line to native inhabitants only. But that changed after

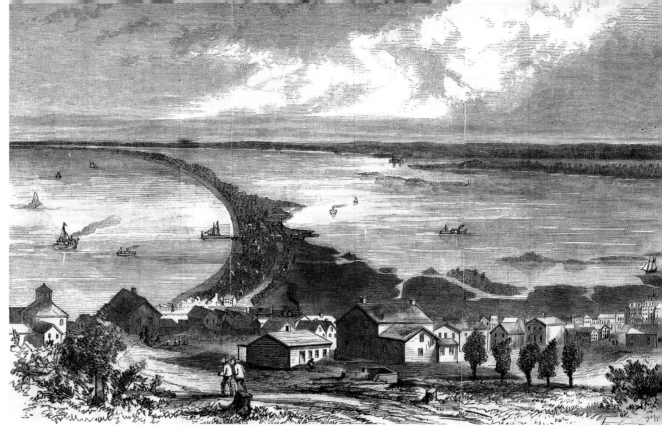

the signing of an 1854 treaty with the Ojibwe that gave native lands north and west of Lake Superior to the United States. Minnesota's Arrowhead region had become U.S. territory and therefore open to settlement and exploitation.

By then surveyor and Superior pioneer George Stuntz had settled on Minnesota Point, becoming the Point's unofficial first resident of European descent. He wasn't alone for long. Speculators hoping to make it rich mining copper swarmed to the Minnesota side of the Superior Entry, and in 1856 began platting townships, including Duluth, a community that encompassed what is today the western portion of downtown (from Lake Avenue to to about Mesaba Avenue). Other townships included North Duluth at roughly the base of Minnesota Point and part

THIS COLOR WOODCUT, PUBLISHED IN *HARPER'S WEEKLY* ON APRIL 29, 1871, SHOWS DULUTH IN 1870 JUST BEFORE WORK ON THE SHIP CANAL WAS BEGUN. (THAT IS NOT A CANAL PIER JUTTING OUT OF THE LAKE SIDE OF MINNESOTA POINT; IT IS THE CITIZEN'S DOCK, BUILT BY THE CITY IN 1869.)

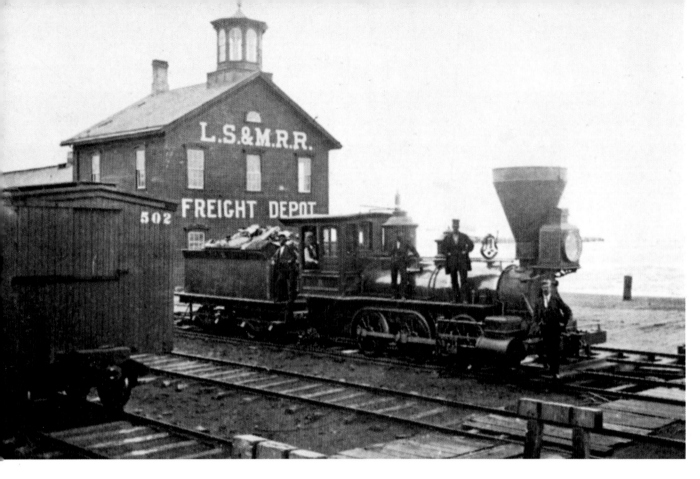

of Minnesota Point. (The Point had been used long enough by the Ojibwe to establish several cemeteries, including one near the Superior entry; a huge storm in 1876 destroyed it, exposing bones and scattering artifacts.)

The local population grew to about 1,500. As in Superior, many speculated that Duluth would surpass Chicago as a center of trade and a destination for immigrants. In 1857, when the township of Duluth was just a year old, the Minnesota Legislature incorporated the Duluth Ship Canal Company with Duluth pioneers George Nettleton, James Ray, and Edmund Ely as directors. The state authorized them to cut a canal three hundred feet wide through Minnesota Point, but the financial Panic of 1857 put an end to the idea. By 1860 just 353 persons populated all of Fond du Lac, Oneota, and Duluth. Duluth even lost its charter.

In 1866 engineer Henry Bacon, working for harbor engineer J. B. Wheeler, suggested a canal be dug through Minnesota Point one and one-half miles north of the Superior Entry, about five and a half miles south of where Minnesota Point sprouts from the lakeshore. But, again, work on the canal never began, due to what was then considered a lack of necessity. Another engineer

of the eastern portion of today's downtown; Cowell's Addition, the northern half of today's Canal Park portion of Minnesota Point; and Middleton, located on Minnesota Point from Oatka north to Portage Street, which ran along the same path as the long established "little portage" that du Lhut had crossed 177 years before (Thomas Taylor of Superior first mapped the town site in 1856, shortly after it was surveyed; Robert Reed and T. A. Markland were its first proprietors). Duluth pioneer George Nettleton owned the land between Middleton and Cowell's Addition. Outside of George Stuntz's trading post and the lighthouse near the Superior Entry, a small community of Ojibwe populated the rest

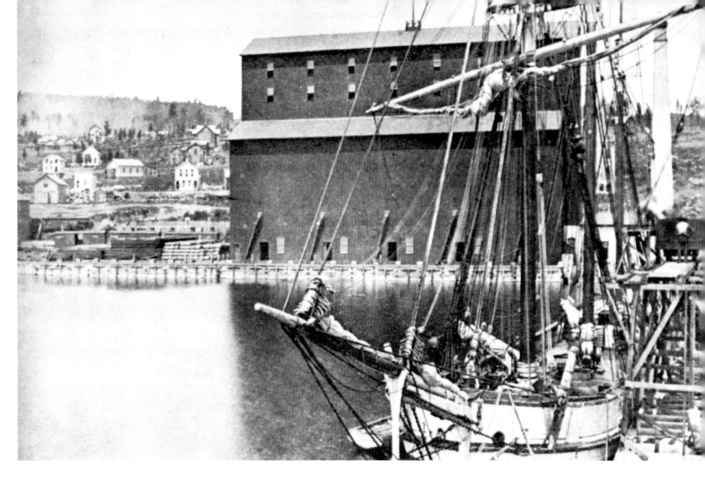

would later write of Bacon's plan, "There does not seem to have been any demand for a harbor on the part of Duluth, there being no place of that name in existence."

But that same year, financier Jay Cooke arrived, announcing he would bring his Lake Superior & Mississippi Railroad from St. Paul to Duluth. Loggers felled virgin timber throughout the region, and lumber mills sprang up on Rice's Point and along Lake Avenue to produce the wood for the railroad's construction.

Work on the LS&M continued over the next few years. In 1869 LS&M built DeCosta's Dock on the west side of Rice's Point for loading and unloading ships arriving in Duluth through the Superior Entry. The dock, named for LS&M's chief engineer, connected by rail to the main LS&M line running along the shoreline. That same year the LS&M began building a breakwater at Fourth Avenue East running parallel to Minnesota Point, which reached into the lake to protect ships anchored at Duluth outside the bay. Cooke's railroad was now within a year of completion, and in anticipation of the commerce that would come with it, Captain James W. Cuyler surveyed the lake and harbor to develop a plan for improvements; he came up with three.

The first involved extending the breakwater to over 2,600 feet long; the second was to dig a canal through the Point, bolstered by piers extending into the lake; the third was to simply keep using Superior Entry, but to also dredge the harbor and open a larger basin closer to Duluth. Cuyler recommended the second plan, but yet again the canal was nixed.

Harbor engineer Wheeler didn't like the idea of the canal because he thought it would result in serious injury to "the natural entrance." This notion, that cutting a canal would change the flow of the St. Louis River and reduce the natural scouring that kept the Superior Entry open,

would be cited time and again by those in Wisconsin opposed to a canal. So in 1870, with almost no commercial activity in Duluth and without certain knowledge of how Cooke's railroad would change that, Cuyler's third plan would be put in motion and work would begin on improvements to the Superior Entry.

But Duluth and Cooke ran out of patience before that work began. Conditions had proved too difficult for ships on their way to DeCosta's Dock from the Superior Entry: the passage was too shallow, and many ships ran aground or had to lighten loads to pass. In order to make a more accessible harbor, work on extending the breakwater had begun in the fall of 1869, almost as soon as its first segment was complete (it was planned to eventually reach 2,200 feet into the lake, but never stretched more than 950 feet over the water). That fall, construction of Cooke's adjacent Elevator A, a towering grain terminal along the outer shore at Fourth Avenue East, also began. Cooke's company then built docks to reach Elevator A, connecting the waterfront to the railway. Cooke's rail line and rumors of gold at Lake Vermilion north of Duluth spawned another land rush in 1869, and the population soared. In January 1869 just fourteen families lived at the base of Minnesota Point; by the middle of 1870, the population of Duluth would

grow to 3,130 people. The gold rush proved a bust, but it did turn up a sample of something much more valuable: iron ore, evidence of a vast deposit that would later change the face of northeastern Minnesota. The shipbuilding industry blossomed, and commercial fishing thrived. When the first telegraph line reached the region in November 1869, it connected St. Paul to Duluth, not Superior. Cooke, continuing to invest in the region, convinced the Northern Pacific Railroad—financed by Cooke's bank—to begin a line from Carlton, Minnesota, about twenty miles west of Duluth, to Moorhead, Minnesota, on the Red River bordering the Dakota Territory. Groundbreaking took place on February 15, 1870.

On March 6, 1870, the township of Duluth—joined by Rice's Point (including land extending to about Fortieth Avenue West that would become known as the West End, today's Lincoln Park neighborhood), North Duluth, Cowell's Addition, Middleton, Portland (roughly today's East Hillside neighborhood west of Chester Creek), and Endion (roughly east of Chester Creek to Twenty-first Avenue East)—became the city of Duluth. The city's charter, written in April 1870, granted the City Council power to "construct or authorize any individual or corporation to construct canals connecting Lake Superior with Superior Bay."

PART I:
BEFORE THE BRIDGE
(1870 – 1902)

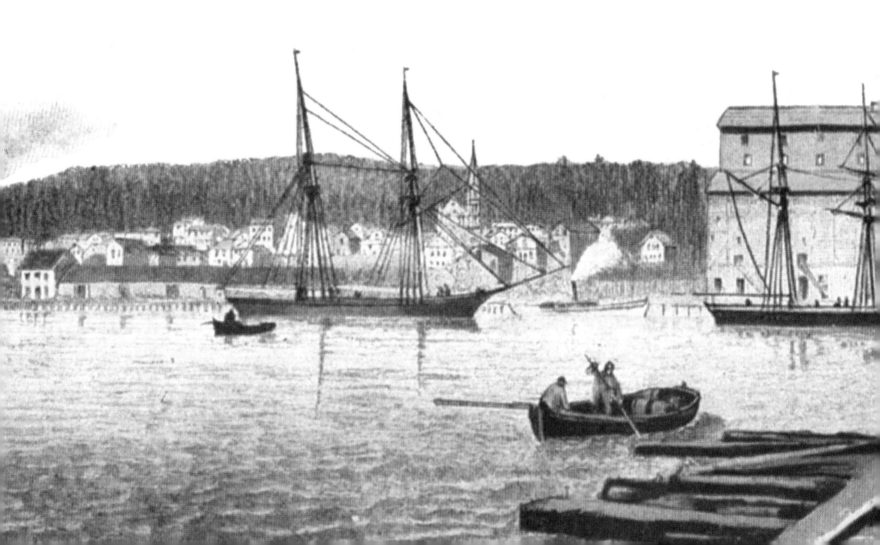

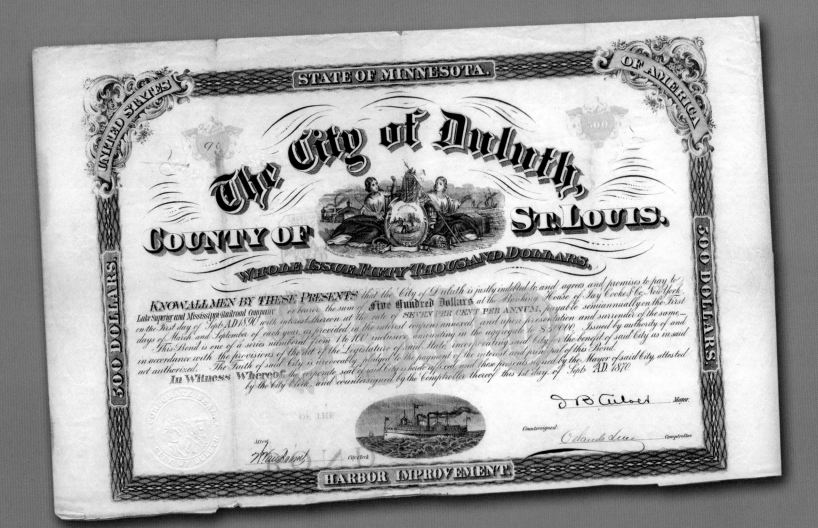

NUMBER 90 OF 100 $500 BONDS ISSUED TO REPAY A $50,000 LOAN TO THE CITY OF DULUTH FROM JAY COOKE'S LAKE SUPERIOR & MISSISSIPPI RAILROAD FOR "HARBOR IMPROVEMENTS," WHICH INCLUDED DIGGING A SHIP CANAL THROUGH MINNESOTA POINT.

The image shows a bird's-eye view of Duluth with labels: SUPERIOR ST., LAKE AV., CITIZENS DOCK, SHIP CANAL, BREAKWATER, and LAKE SUPERIOR.

DULUTH BEGINS TO TAKE SHAPE

In the spring of 1870, fearing the railroad's docks on Rice's Point and at Fourth Avenue East would not be adequate to handle future commerce, Duluth built the Citizen's Dock, which reached six hundred feet from Minnesota Point into the lake just north of Morse Street in what is today considered Canal Park. J. B. Culver, Duluth's first mayor, paid for the dock's construction. Elevator A and about four hundred feet of the breakwater were completed over the summer, and the first trains of the LS&M rolled into Duluth on August 1 that same year.

While Duluth had floundered to find its feet, life in the late 1850s and throughout the 1860s had been more stable across the bay in Superior, Wisconsin, which was considered the only town of note in the entire region. But the LS&M's terminus in Duluth threatened Superior's position as the region's premier city. Superiorites had campaigned aggressively to get the railroad to come to their city—even suggesting that Cooke drop the word "Lake" from the railroad's name—and felt Cooke had snubbed them.

So Cooke's railroad and his other projects brought prosperity to Duluth rather than to Superior. But slighted Superior still had one great advantage over Duluth: the Superior Entry kept the majority of fledgling industry on the Wisconsin side of the bay. A canal in Duluth would change all of that. And Superior would do all it could to stop any digging.

While Cooke's company pushed to expand the breakwater, Duluthians were convinced it would never hold up, and that the only safe harbor must be located in the natural bay. In the fall of 1870, the Duluth City Council exercised the power of its charter and decided the canal should finally be dug. Its members determined the canal would be 150 feet wide and 16 feet deep and protected by piers on each side stretching 18 feet into the lake. To finance this and other harbor improvements, the city accepted a $50,000 loan from Cooke's LS&M in the form of one hundred $500 bonds bearing 7 percent interest, final payment due on September 1, 1890.

THIS DETAIL FROM ARTIST E. CHRISMAN'S VIEW OF DULUTH IN 1871 SHOWS THE LS&M RAIL LINE, ELEVATOR A, THE OUTER BREAKWATER, CITIZEN'S DOCK, AND THE BRAND-NEW SHIP CANAL. THE IMAGE IS RATHER IDEALIZED: DULUTH'S HILLSIDE HAD MORE STUMPS AND MUD THAN TREES AND GRASS, AND NO PERMANENT ROADWAY BRIDGED THE SHIP CANAL.

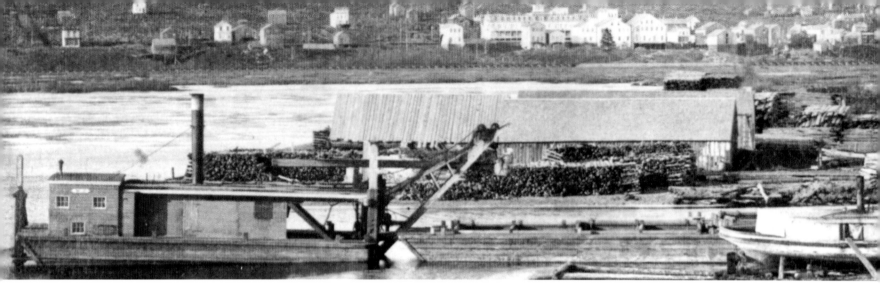

CUTTING THE CANAL

THE W. W. WILLIAMS &
COMPANY'S DREDGING
VESSEL *ISHPEMING*,
PILOTED BY MAJOR JOHN
UPHAM, AND A SCOW
BARGE AT THE SITE OF
THE DULUTH SHIP
CANAL IN 1871. THE
LARGE WHITE BUILDING
IN THE BACKGROUND
IS THE CLARK HOUSE
HOTEL, BUILT IN 1869 AT
SUPERIOR STREET AND
FIRST AVENUE WEST.

On September 5, 1870, the steam-powered dredging tug *Ishpeming* took its first bite out of Minnesota Point at what was plotted as Portage Street—the path that for hundreds of years had been the Ojibwe and French fur traders' *Onigamiinsing* or "Little Portage" that provided passage over Minnesota Point without having to paddle through what had become the Superior Entry. When winter froze the gravel, Major John Upham of W. W. Williams & Co.—the dredge's owner—stopped digging for the season.

The *Ishpeming* went back to work on April 24, 1871, and dug continuously during daylight hours until Saturday, April 29. She had cut a swath thirty feet wide and eight feet deep to within a few feet of the lake-side beach when, according to the *Minnesotian*, Duluth's first newspaper, she struck a vein of gravel frozen so hard it stopped her. Immediately a group of men went to work with "shovels and picks and drills and powder (two kegs)." They scooped, smashed, bored, and blasted through the rocklike frozen chunk of sand bar, allowing the *Ishpeming* to go on dredging. At I P.M. that day the waters of Lake Superior joined with those of Superior Bay or, as Dr. Thomas Foster wrote in the *Minnesotian*, "the union of the waters became forthwith an accomplished fact." Duluth's first publisher, Foster often came across as part poet and part contract attorney, and he fancied himself a grand orator. At a speech given during an Independence Day picnic on the Point in 1856, he coined Duluth's first nickname: "The Zenith City of the Unsalted Seas."

Foster's paper reported that the waters of the Bay, a few inches higher and a few degrees warmer than the lake's waters, cut and thawed through the dredged channel. The next morning, Sunday, April 30, a channel five feet deep and twenty wide flowed with a six mile an hour current into the lake. That afternoon the small steamer ferry-tug *Frank C. Fero*, piloted by Captain George W. Sherwood, navigated the canal. The *Ishpeming* returned to work the next day, and kept cutting throughout the summer, making the canal deeper and wider.

Foster didn't get the news out until May 6. Seth Wilbur Payne's *Morning Call* scooped him as the first newspaper to report the completion of the canal, at the same time bemoaning the lack of pomp and circumstance surrounding the event:

The Legend(s) of the Duluth Ship Canal Dig

The legend of digging the Duluth Ship Canal keeps growing taller with time. Most versions start with the facts: When the *Ishpeming* first began dredging in the fall of 1870, Superiorites filed suit to stop the dredging. Work stopped for the winter, and began again with the spring thaw.

That's when the facts get lost in the drama.

In most versions of the myth, the courts sided with Superior the week before the *Ishpeming* started digging in April 1871. An injunction ordered Duluth to "absolutely desist and abstain from digging, excavating and constructing…said canal." It was dispatched to Duluth via a courier: a soldier from Kansas, some say; others claim it was none other than pioneer George Stuntz. In 1922 memoirist Jerome Cooley claimed a telegram arrived on Friday, April 28, telling Duluthians the injunction would arrive by Monday. So the *Ishpeming*'s crew went to work at dawn Saturday and "didn't stop until Monday noon." The canal was open before the injunction arrived.

Author Dora May McDonald, writing in 1949, tells that same portion of the story with more flair. In her account, after the *Ishpeming* struck frozen gravel that Saturday morning, word came that Stuntz had left St. Paul bound for Duluth with injunction in hand, destined to arrive Monday. Duluth city fathers called for every able-bodied man, woman, and child in Duluth "who could handle a spade or shovel, or beg, borrow, or steal a bucket or a bushel basket." Citizens rushed to the work site and "dug, scratched, and burrowed till it was finished." On Sunday rowboats filled with angry Superiorites arrived to watch and heckle the Duluthians' efforts. At the break of dawn on Monday morning, the Duluthians had cleared a canal. When Stuntz arrived, the tug *Frank C. Fero* was making her very first pass through the canal; the canal was a navigable waterway, rendering the injunction moot.

Perhaps the most astonishingly inaccurate depiction of the canal's birth appeared in the *Duluth Evening Herald* on July 1, 1929:

> Leading Duluthians of the time…led by W. C. Sargent…formed the "Dynamite Club." Under the cover of darkness they went to Minnesota Point at the site of the present ship canal. Bankers, clerks, professional men and laborers worked frantically with pick and shovel during the night to dig a ditch so the waters of Lake Superior and St. Louis Bay could join. As daylight approached and they realized they would not finish the task, leaders called for dynamite.
> The blast that followed cracked every window within a radius of several miles, pioneers recall, but when the debris settled the dynamiters were rewarded by the water rushing through the ditch thus created. The canal was dug shortly afterward by the government.

An article in the June 3, 1945, *Minneapolis Sunday Tribune* did little to dispel the myth, and came complete with a cartoon-like depiction of the fabled event (pictured, above right).

Actually, an injunction to halt the canal was not served until months after the *Ishpeming* had finished its initial cut. The legend of Duluthians hand-digging the canal does include a kernel of

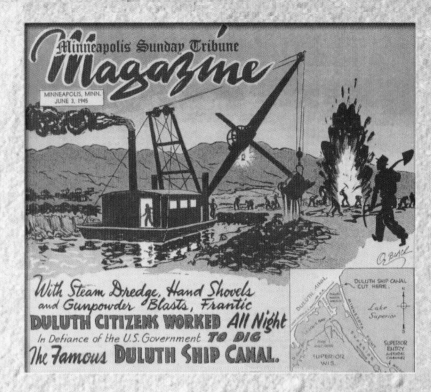

truth: hand work and blasting was needed to get through a particularly tough patch of frozen gravel, but once this was breeched, the *Ishpeming* returned to work. The legend likely got its start by elaborating on that event. Indeed, Duluth pioneer R. S. Munger would later tell historians the following tale:

> I was engaged by the citizens of Duluth to dig the channel. We began work on a Saturday and by night Superior knew what we were about. At once the people over there began to scurry around to get a federal injunction restraining us. I hired a gang of several hundred men…and we worked all that day and far into the night…When the Superior people came over Monday morning there was the channel open and they couldn't do anything.

If Munger's tale has any truth to it, the government courts once worked quickly—and on weekends. Other versions further embellish the drama. At least one historian wrote that a Superior firm advertised a sale of surplus muskets leftover from the Civil War to arm Superiorites against those "cliff dwellers" across the bay.

The truth (explained in much more detail in this book's main text) involved more lawyers than shovels. There were no heroic feats by man nor machine, and Wisconsin's seven-year effort to close the canal never once stopped dredging and improvements.

But the legends make much more fun stories, and they also display another aspect of the city's lore: the work ethic and determined self-sufficiency of Duluth's pioneers.

An event occurred yesterday of greater importance than would have been the commencement of the [Northern Pacific] docks. We refer to the opening of the canal across Minnesota Point. Why did not our capitalists and real estate criers not show their love for Duluth by some appropriate public demonstration?"

LET THE LITIGATION BEGIN

Almost immediately after Duluth began work cutting the canal in the fall of 1870, Superiorites—and indeed all of Wisconsin—went to work to end it. In September of that year Wisconsin congressman Cadwallader C. Washburn alerted General A. A. Humphreys, the Chief of U.S. Engineers, about the dredging and requested that the federal government take action to halt the work.

The U.S. Attorney General must have anticipated Duluth's determination to dig the canal, because the very day the *Ishpeming* had resumed dredging, April 24, 1871, St. Paul's Cushman Davis, acting on behalf of the U.S. Attorney General, filed for

an injunction against the city of the Duluth and W. W. Williams & Co. The suit claimed that unless the dredging ended or a dike was built between Minnesota Point and Rice's Point, the current of the St. Louis River would be diverted; the silt carried by the river would deposit at Superior Entry rather than further out into the lake as it normally did, rendering navigation through the entry impossible. The suit asked that the defendant "be enjoined and restrained from constructing said canal."

The suit was served on May 4, 1871—five days after the canal had become a navigable waterway. The Minnesota circuit court judge, R. R. Nelson, had many business interests in Superior and so recused himself. Because of this the case was heard in Topeka, Kansas, by Supreme Court Justice Samuel Freeman Miller, who was "riding circuit" at the time (from 1793 until 1890, U.S. Supreme Court justices were obliged to travel to and preside over hearings in circuit courts throughout the country). In Topeka the attorneys general of Wisconsin and Minnesota squared off on behalf of their respective cities at the head of the lakes—that location was destined to become a major port, and both states wanted to reap the benefits.

Relying on the reports of the U.S. Engineers, Judge Miller sided with Superior. Sort of. While Miller's decision agreed with Superior, it did not require Duluth to stop dredging, but allowed the canal construction to continue on the condition that Duluth also must build the dike referred to in the complaint. Miller went as far as to state that if Duluth built the dike to the government's specification, the injunction "may be modified or dissolved." In other words, *build the dike and the injunction goes away.*

The injunction was served on June 13, 1871. By then the canal stretched fifty feet wide and was eight feet deep. Workers began forming timber cribs to support the newly created shoreline on the north side of the canal. Money soon became a problem. Duluth had already spent $50,000 on the canal and hadn't even begun to build the dike. Attorney (and later judge) James J. Egan, acting as Duluth's city attorney, wrote to General Humphreys, explaining the fledgling city's plight and requesting that the federal government dissolve the injunction and issue a $100,000 bond to Duluth to complete the work—all on the condition that the canal would be completed by December 1, 1871. With Humphreys' recommendation, the U.S. District At-

torney dissolved the injunction in June that year. Not once did any of the legal action taken on behalf of the City of Superior stop the dredging and construction of the canal.

Just over a year old, Duluth was the terminus of a great railroad, with a breakwater and docks forming an outer harbor and a ship canal to allow ships the safer harbor of the docks along the shore of Rice's Point on Superior Bay. Jay Cooke, whose vast wealth financed the Union during the Civil War, was the town's best friend. The future looked very bright for Duluth. But across the bay in Superior the grumbling continued; its leaders believed that if they didn't act to close the canal, their city's future would be forever shrouded in the shadow cast by its neighbor on the hill.

THE DIKE DEBACLE

While the *Ishpeming* dredged the canal and lawyers battled the injunction, Duluthians had continued work on the outer breakwater begun by Cooke's outfit, extending it to 950 feet by June of 1871; its older portion was repaired and bolstered with riprap, heavy rocks placed within the timber cribs.

NOTE THE DREDGING VESSEL *ISHPEMING* AT THE WEST END OF THE CANAL. THE WHITE-AND-BLACK LIGHTHOUSE AT THE END OF THE CANAL'S WOODEN PIERS AND WHAT APPEARS TO BE THE DIKE BETWEEN RICE'S POINT AND MINNESOTA POINT ARE SPECULATIVE: NEITHER THE PIER, LIGHTHOUSE, NOR DIKE HAD BEEN BUILT WHEN MUNGER MADE HIS PAINTING.

Free Floating Fremont

Prior to the canal's digging, the northern portion of the bay between Minnesota Point and Rice's Point—location of today's Duluth Entertainment and Convention Center and Bayfront Park—was a marsh that included floating islands experts speculate were "caused by driftwood and accumulating vegetable matter." Settlers C. P. Heustis and Charles A. Post platted Fremont Township on one of the larger islands, a chunk of land 1,200 feet long and 400 feet wide.

When the canal was cut, more than boats passed through. New currents created by the canal broke up the smaller chunks of land and swept many of the floating islands against the Point's bay-side shore or through the canal and out to the big lake. When Fremont Island itself broke free and passed through the canal in May 1873, Duluth City Clerk Walter Van Brunt, Customs House employee Charles F. Johnson, and two others chased down the island in a rowboat. When they caught up with the renegade chunk of land, one of them tied an American flag and a banner bearing the statement "First Clearance from Duluth, May 10, 1873" to the top of its tallest tree. They needn't have bothered: that night lake currents drove the island against the Point, where it broke up.

Material dredged from the canal and harbor to aid navigation was used to fill in this area in order to develop it commercially. In this same way Rice's Point and Minnesota Point were also made more substantial—neither sand bar was as wide then as it is today.

Besides his work at the Customs House, Johnson also did some drawing, including an 1872 sketch of the early temporary bridge that spanned the ship canal during the winters of the 1870s (see page 24) and a depiction of the events described above, which he sketched in May of 1875 (it was later published in the *Duluth News-Tribune* in 1895). Johnson is likely also the person who sketched an 1865 map of Duluth that was the basis for the map on page 2.

The Northern Pacific Railroad took a deeper interest in the city on the hill that year, arranging to use the Lake Superior & Mississippi's line to connect it to Duluth from its eastern terminus in Carlton. By winter Northern Pacific was building docks on Rice's Point and along the shoreline inside the bay. Northern Pacific also arranged with the city to help pay to complete the canal and widen it to 250 feet. Its trains would also help construct the dike to satisfy the injunction's dissolution.

The dike proved a problem from the start, for both Duluth and Superior. Superior's Major D. C. Houston, the engineer in charge of harbor improvements who believed the dike a necessity, said that "It will be impossible to locate this dike anywhere so that someone will not object to it." Indeed, the structure—designed to be continuous from shore to shore with no gates—would prevent any vessel entering the Duluth Ship Canal from reaching Superior and the St. Louis River; conversely, vessels entering through the Superior Entry would be cut off from the Duluth side of the bay. Houston recommended holding off the construction until after the spring of 1872.

General Humphreys disagreed with Houston, so the dike work commenced. Duluth City Engineer C. G. Franklin drew up specifications for the dike's construction: a single row of pilings sixteen inches thick driven at eighteen foot intervals with four-inch wood panels driven and bolted between them. The dike would commence on Rice's Point at Spruce Avenue and terminate on Minnesota Point at Chamber's Street. But it didn't have to be completed in December as stated in the injunction, as the City had received an extension to complete the dike by March 15, 1872.

Feeling the dike would be temporary, Duluth did not follow its own plans, driving the piles thirty feet apart instead of eighteen. When Major Houston inspected the work, he found piles poorly driven and improperly aligned—and the planks did little

to hold back the flow of the St. Louis. Indeed, much of the dike had already broken up and floated away. Houston reported it was "of no value whatever" and that even if Duluth had followed the plans, "it would have been little better."

Humphreys then warned Duluth that it must build the dike or else fill in the canal, so the city contracted with Roger Munger and R. A. Gray to build a new dike, this one made of cribbing and filled with riprap. But even before work on the more substantial dike commenced, Wisconsin governor Lucius Fairchild wanted it gone, arguing as early as June 1871 that it "cut off the people of Wisconsin from the free, unobstructed navigation of the public waters of Superior bay." It would also cut Superior off from the railroads that terminated in Duluth. In December, as the first dike already lay in ruins, nearly one hundred Superiorites signed a letter urging the federal government to take action. At the end of January 1872, newly elected Wisconsin governor Cadwallader C. Washburn—who as a congressman initiated the first injunction—called upon the federal government to take action in any one of three ways: closing the canal, replacing the dike with another located closer to the canal that would provide greater access to the bay, or rebuilding the damaged dike to include gates.

Meanwhile Munger and Gray had put their men to work in January 1872. By March 25, Houston reported that a 10 foot wide dike of timber and rock stretched 4,490 feet from Rice's Point toward Minnesota Point. Except for a single section

100 feet long, the final 800 feet connecting to Minnesota Point would be made of logs; that final section of cribbing was designed to be removed in the future. The dike was designed well enough, in Houston's opinion, to satisfy the requirements of the injunction. A rail line sat atop the dike, not for passage between the points, but to carry riprap material to fill the crib work and secure the dike.

The work was dangerous. On April 20, 1872, the *Minnesotian* reported that a "Frenchman" working on the dike had been severely injured when another worker accidentally struck him with an axe, and that a "Swede from St. Paul named Hendrickson," who had been riding on one of the gravel train's dump cars, died when the car "accidentally and suddenly tilted on one side—throwing him down on the track—where eleven cars passed over him, killing him instantly." The paper blamed Hendrickson's death on "the men or jealous rivals who made that unnecessary Dyke [*sic*] a necessity." Despite incidents such as these, work continued until June of that year, but it was never completed, at least not to the recommended standards.

THE DIKE DULUTH WAS FORCED TO BUILD TO PREVENT AN INJUNCTION BY THE STATE OF WISCONSIN TO HALT WORK ON THE DULUTH SHIP CANAL. SUPERIORITES THOUGHT THAT THE CANAL WOULD DIVERT THE ST. LOUIS RIVER, LEAVING THE SUPERIOR ENTRY TO FILL IN WITH SILT—AND THAT A DIKE WOULD PREVENT THIS FROM OCCURRING. IT WAS A MISGUIDED SOLUTION THAT LITERALLY DIDN'T HOLD WATER.

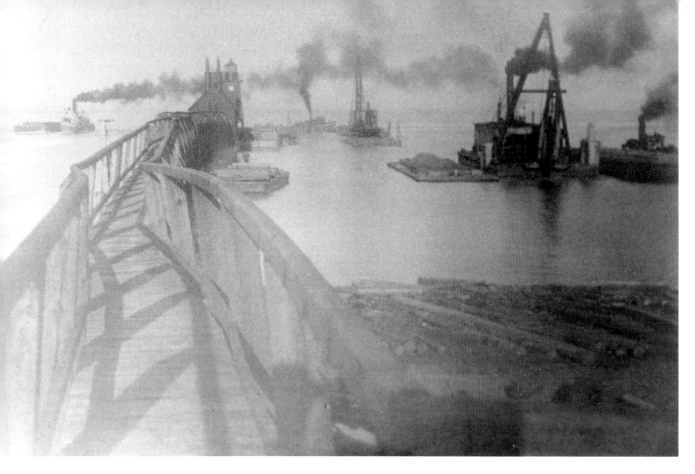

That same month Superior once again asked for an injunction, this time to stop construction of the dike; it was quickly dismissed. Justice Miller determined that the circuit court in which the bill was filed did not have the jurisdiction to hear the case. The next day Miller visited Duluth and, while being treated to a tour of the harbor and dike, wondered aloud why Superior had waited until the dike had been constructed before asking for an injunction to restrain Duluth from building it.

While the new dike looked solid, problems lay beneath the surface. The bay's depth varied greatly, and the dike began settling in deeper

WHILE LAWYERS ARGUED OVER ITS RIGHT TO EXIST, THE SHIP CANAL CONTINUED TO BE DREDGED WIDER AND DEEPER, AND WOODEN PIERS WERE INSTALLED TO SUPPORT IT—ALTHOUGH THE PIERS WERE HARDLY ENGINEERING MARVELS, NOT EVEN MAINTAINING A STRAIGHT LINE.

Not only was the work left incomplete, but saboteurs tried their best to stop it. On May 4, 1872, the *Minnesotian* reported an attempt had been made by "sacrilegious scamps" to blow a hole in the dike using gunpowder; the attempt had been unsuccessful because the bombers had placed the charge on top of the dike, not below the water line. The newspaper reported that repairs had already neared completion, then taunted and berated the attackers: "Children! Babes! When you come again with your powder in tin tubes, with your water-proof fuse inserted at the middle, bury it deep in the centre [*sic*] of the Dyke [*sic*] and then stand on top and touch it off. . . ."

waters. After a July storm the receding waters created a current the dike couldn't handle, and it broke near Minnesota Point. Knowing that their Wisconsin neighbors would take their failed injunction to a higher court, Duluth decided to invest no more time or labor—or money—into the dike.

The suit was indeed rejoined in the United States Supreme Court on November 1, 1872. The state of Wisconsin made the complaint; the defendants were listed as Duluth, Sidney Luce (Duluth's mayor at the time), and the Northern Pacific Railroad, who had become a party when it took over construction of the canal and allowed its trains to be used to fill in the dike

cribbing. The railroad had never wanted to be involved with the dike, and it certainly didn't enjoy being party to the lawsuit.

So Northern Pacific wrote to Governor Washburn in Wisconsin and requested he meet with the railroad's president, G. W. Cass, to discuss removing the dike and making navigational improvements to the bay that would benefit all parties. Washburn then wrote Luce and invited a delegation from Duluth to join him to meet with the president of the Northern Pacific Railroad, at its headquarters in New York. J. B. Culver and B. S. Russell joined Luce as representatives of Duluth. The meeting couldn't have gone better.

If Wisconsin would abandon its efforts to force Duluth to build a dike, Northern Pacific offered to extend its rail line from Rice's Point to Connor's Point in Superior and run it along the shoreline to the mouth of the Nemadji River and to connect the railroad to future wharves and docks. Northern Pacific would even build a bridge between the points and a grain elevator in Superior. The railroad's intention, it declared, was to "place Duluth and Superior on equal footing as to leave the commercial world to elect for itself where to do business without any discrimination in favor of either place, delivering passengers and freight both at Superior and Duluth."

Armed with this agreement, the delegations from Duluth and Wisconsin together headed for Washington, D.C. The group approached senators and congressmen from their respective states and worked together to appropriate funds for harbor improvements. They succeeded: Congress would give them

$10,000 in March of 1873. The controversy was settled and the Supreme Court suit dismissed. It looked like the towns had found a way to come together. The St. Louis River had already demonstrated that it was folly to try to keep them apart.

The dike was partially dismantled in July 1873; years of neglect finished the job, but not thoroughly. In 1956 the *Duluth News-Tribune* wrote that "spooners"—unmarried couples seeking privacy—who went boating in the harbor often used the ruins as an excuse, claiming "our boat got stuck on the dike" years before spooning motorists came up with "the car ran out of gas."

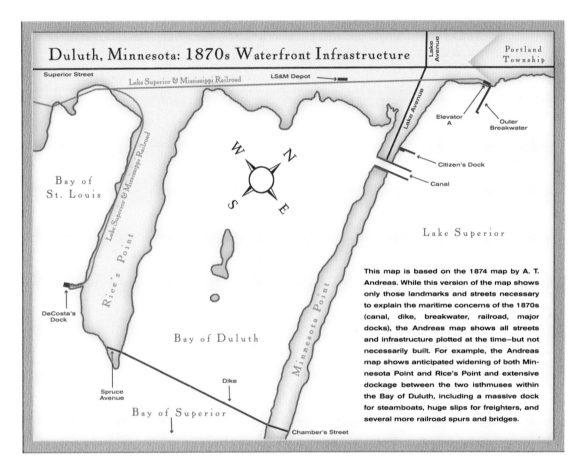

Duluth, Minnesota: 1870s Waterfront Infrastructure

Superior Street

Lake Superior & Mississippi Railroad

LS&M Depot

Lake Avenue

Portland Township

Bay of St. Louis

Rice's Point

Lake Superior & Mississippi Railroad

Elevator A

Outer Breakwater

Citizen's Dock

Canal

Lake Superior

DeCosta's Dock

Bay of Duluth

Minnesota Point

Dike

Spruce Avenue

Bay of Superior

Chamber's Street

This map is based on the 1874 map by A. T. Andreas. While this version of the map shows only those landmarks and streets necessary to explain the maritime concerns of the 1870s (canal, dike, breakwater, railroad, major docks), the Andreas map shows all streets and infrastructure plotted at the time—but not necessarily built. For example, the Andreas map shows anticipated widening of both Minnesota Point and Rice's Point and extensive dockage between the two isthmuses within the Bay of Duluth, including a massive dock for steamboats, huge slips for freighters, and several more railroad spurs and bridges.

THE DIKE COMPLICATED MARINE TRAFFIC, ESSENTIALLY CLOSING OFF THE BAY OF DULUTH FROM THE MOUTH OF THE ST. LOUIS RIVER, INCLUDING THE BAYS OF ST. LOUIS AND SUPERIOR.

BREAKWATER AND BUILDER BOTH BREAK

Back in June 1871, the outer breakwater had been extended to 950 feet and stood six feet above the waterline. A "great storm" on November 16, 1872, caused severe damage to the structure, leaving Elevator A, ware-houses, and docks vulnerable. Work-ers had made repairs and added heavy stones to the breakwa-ter's exterior in an effort to fortify the structure. But after that, Duluth spent no more time or money attempting to keep it in place. The canal was in full operation, and with access to the safety of the bay, the breakwater was becom-ing more a burden than an asset. Besides that, at the time Duluth had a dike to build and further lawsuits to discourage if it wanted to keep its operational canal. By the time Northern Pacific helped settle the dike issue by the summer of 1873, traffic on the canal was in full swing and nearly all shipping commerce in Duluth had moved to the bay inside of Minnesota Point, ren-dering repair to the breakwater much less important. A gap of between seventy-five and one hundred feet had been made in the dike in July, opening traffic once again to both sides of the bay. More importantly, with the canal in operation Duluth's future success looked more and more assured.

But then September 18 rolled around. The bottom had ripped open on Philadelphia financier Jay Cooke's wallet; Jay Cooke & Co. announced its failure. Cooke had arrived on the shores of Duluth in 1866 tossing gold pieces to the Ojibwe and sporting a silk top hat. It was an unintended metaphor: the use of silk had ended the demand for bea-ver pelts used to make hats in Europe. The Ojibwe had benefited from this fur trade for almost two hundred years and lost a large income stream when the trappers left. Then Cooke, dressed as a thoroughly modern man, had arrived to finance Duluth's future, behaving as if all he had to do was reach into his waistcoat and toss out his extra cash. But now those pockets had finally emptied. Cooke and his bank had vastly overextended loans to railroads—especially Northern Pacific—and the "Great White Father," as the local Ojibwe had dubbed him, went bankrupt and closed his banks. The whole nation felt the loss—his-torians refer to it as the "Panic of '73."

While the entire nation suffered from its trickling effects, Cooke's failure would hit Duluth particularly hard. Within two months nearly half of Duluth businesses disappeared; many of Duluth's commercial ventures had begun with financing from Cooke's bank. Not the least among their ranks was the North-ern Pacific Railroad. At the time only 424 miles of operational

track stretched west from Duluth, far from the railroad's goal to reach the Pacific Northwest as the country's first northern transcontinental railway; without Cooke's money it couldn't keep laying track, and it certainly wasn't going to invest in Duluth's battered breakwater. Built to secure the city's future by protecting the docks serving Cooke's grain elevator, each day the breakwater fell ever closer to ruin; the symbolism must have been painful for the people of Duluth.

Cooke's failure also threatened the canal: Northern Pacific wouldn't be able to build Superior's bridge, rail line, and grain elevator, called for in the agreement that ended litigation over the canal and dike. Failing to get the infrastructure promised, Superior would be within its rights to seek some reparation. Perhaps even another injunction.

Superior had good reason to feel that the lack of rail cost them commerce: In 1874 Major F. U. Farquhar, who had replaced

The South Breakwater Light

Once dug, the canal needed a light to help mariners locate it. In 1872, the Corps of Engineers advertised for proposals to build a beacon on the outer end of the south pier. That year a small dwelling for the light's keeper went up on shore, but a storm ripped apart the pier's wooden breakwater, delaying work on the light itself until 1873.

After repairing the breakwater, contractors built a wooden pyramid tower and capped it with an octagonal cast-iron lantern housing a fifth order Fresnel Lens (a lens developed specifically for navigational lights by French physicist Augustin-Jean Fresnel). The light, which cast a red beacon visible 12.5 miles away, was lit for the first time on June 2, 1874. In 1877 the light was upgraded with a fixed red fourth order Fresnel lens. The western tip of Lake Superior had already gained a reputation for extremely thick fog. So in 1880 engineers installed an automated fog bell inside the light's tower, but it proved inadequate. Five years later it was replaced with tin steam-powered fog whistles housed in a small structure near the light. Duluth experienced one of the foggiest

seasons on record in 1895, and the fog-signal whistle screamed for over 1,000 hours, gobbling forty-five tons of coal in the effort. The whistles not only sent a warning to mariners on the lake, they also bounced off Duluth's rocky hillside, creating a cacophony Duluthians couldn't bear. To remedy the problem, the signal's horns were relocated to the roof and covered with a parabolic reflector. The reflector not only directed sound away from the city, it nearly doubled the signal's reach. The signal would be upgraded several times over the years.

Building the new concrete piers at the turn of the twentieth century meant tearing down the shaky old wooden piers—and everything on top of them. In June 1900 contractors began constructing the new lighthouse, a single-story building forty-five feet long and twenty-two feet wide made of Cream City brick. A tower sprouted thirty-five feet from its east end; here workers installed the old tower's lens inside a new circular cast-iron lantern that gave it a range of twelve miles. The fog signal was also installed, along with a new steel parabolic reflector to keep the hillside quiet. On September 1, 1901, the new light guided mariners to the canal for the first time. Many images of the 1901 lighthouse can be found throughout the book.

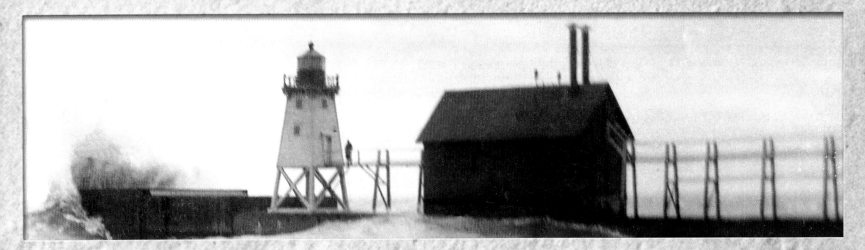

The Rear Range Light

While the South Breakwater Light helped mariners find the canal, another light was needed to provide a focal point by which to guide them through. In 1880 the Lighthouse Board recommended appropriating $2,000 for another light at the south pier's western (or inner) end. The light would stand taller than the South Breakwater Light; when used together, the two lights helped navigators establish range, as lighthouse historian Terry Pepper explains: "By maintaining a line in which these two lights were constantly oriented one above the other, a direct course could be followed to the opening between the two piers."

Construction on the wooden pyramid that would hold the light didn't start until March 1889, but the light was shining by September that same year. Like the South Breakwater Light, the beacon boasted a red fourth order Fresnel lens, but instead of a continuous beam, it flashed a signal every six seconds. It wasn't foolproof: just sixteen days after the light commenced flashing, the steamer *India* collided with the pier at the base of the light itself, damaging the foundation.

As with the old South Breakwater Light, the first Rear Range Light (seen below with a canal ferry scow) came down during the pier's reconstruction. By then, electricity had arrived in Duluth, which brought more lights along the shore; mariners complained they had difficulty differentiating the guiding lights from others. The new light would have to be much different than its predecessor.

And it was. Engineers replaced the wooden pyramid with a seventy-foot-tall steel tower eight feet in diameter. Built in 1902, the tower is supported by four tube-like legs bolstered with struts and tension rods. The gallery at its top holds an octagonal cast-iron lantern that houses the lens. Workers painted the watch room black and the rest of the tower bright white, providing a striking visual contrast that allowed mariners to use it as a navigation device even in daylight. Engineers also relocated the light, placing it roughly in the middle of the pier instead of at the westernmost end.

In 1995 the old Fresnel lens retired to the Lake Superior Maritime Visitor Center; a new acrylic optic light took its place. And the tower has a slightly different look than when first lit: at some point painters reversed the black-and-white scheme. Images of the 1902 light can be found throughout the book.

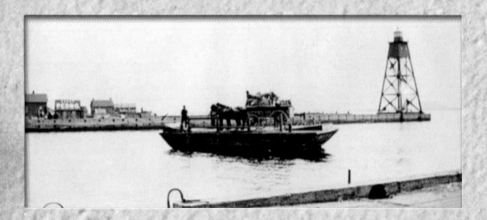

Houston in charge of the Duluth and Superior Harbors, reported that 290 ships had arrived at Duluth, loading over a million and a half bushels of wheat from Elevator A and its new neighbor in the outer harbor, Elevator Q (later called "Elevator D"), as well as tons of lumber milled on Rice's Point, accessed by entering the bay from the ship canal. Duluth was still a long way from the bustling harbor it would become, but a far cry better than Superior: the report indicated that not a single vessel used her port that year.

By December 1874, Superior had had enough, and the state of Wisconsin filed a bill of complaints against the City of Duluth and Northern Pacific Railroad asking that the canal not only be closed, but filled in completely to "restore the current of [the St. Louis] river to its accustomed and natural channel." They used the same old argument, the only one they had, despite the lack of evidence that the canal's affects on the river's current had been detrimental in any way, not to mention that federally funded improvements had kept the Superior side of the dike fully operational.

The Duluth defense pointed out as much, bolstering its argument with the fact that federal funds had been used to improve the canal and build and repair its wooden piers—why would the federal government order the destruction of infrastructure in which it had already invested?

It took some time before that defense would be heard. The case had been delayed when Northern Pacific failed to answer the complaint in time; the company asked for and received an extension, and the defense it finally delivered was nearly identical to Duluth's. The case was further delayed by the time it took to gather and transcribe testimony from engineers who had monitored the bay in previous years.

Twice during the months it took to gather testimony, Congress appropriated funds for improvements in the Duluth harbor, primarily dredging. In August 1876 the second appropriation,

in the amount of $15,000, came with a guarantee: it was for work to improve the outer harbor, but on the condition that it "shall be without prejudice to either party in the suit now pending between the State of Wisconsin, plaintiff, and the City of Duluth and the Northern Pacific Railroad Co., defendants." In other words, even if Wisconsin won the case, that $15,000 would be spent on improvements in Duluth.

When the U.S. Supreme Court finally heard the complaint in October 1877, the case both began and ended with surprises. First, at some point prior to the hearing—perhaps even at the onset of the hearing itself, sources aren't clear—Wisconsin dismissed Northern Pacific as a defendant (accounts are as vague about why this action was taken as they are about when it occurred). Then Associate Justice S. F. Miller—whose 1871 decision over Wisconsin's initial request for an injunction called for the dike's construction—surprised everyone with his decision: He couldn't care less about the St. Louis River's current.

The very points of contention Wisconsin and Duluth had argued over for seven years—whether the mouth of the river emptied into St. Louis Bay or Superior Bay, whether the bays were part of the lake or the river, etc.—he considered "immaterial." And he flat out failed to address whether Wisconsin had any legal right to the waters of the St. Louis River. All that mattered to him was that the U.S. had not only approved of the canal's construction, but by virtue of its financial investments in it had also "taken possession and control of the work" on

it. And this took the decision out of his hands, but not out of his jurisdiction:

"When Congress appropriates $10,000 to improve, protect and secure this canal this court can have no power to require it to be filled up and obstructed. While the engineering officers of the government are under the authority of Congress doing all they can to make this canal useful to commerce and to keep it in good condition this court can owe no duty to a state which requires it to order the City of Duluth to destroy it. These views show conclusively that the state of Wisconsin is not entitled to the relief asked by her bill and that it must therefore be dismissed with costs."

And just like that, it was all over. For good: the state of Wisconsin on behalf of Superior never again filed suit asking for the canal's closure. Were Superiorites bitter? Historian and former Duluth City Attorney J. D. Ensign hints at it: "Our neighbors were not so happy in those days as they are now," he wrote in 1898. As evidence that old wounds had healed he provided a few words he attributed to "an old citizen of Superior":

When Duluth had a railroad and Superior had none, when Duluth had business and commerce and Superior had none, it was hard to keep still and Wisconsin raised questions on the canal, etc., and kept a belligerent attitude now happily ended.

UNITED STATES SUPREME COURT JUSTICE S. F. MILLER, WHO PRESIDED OVER TWO LANDMARK COURT CASES INVOLVING THE DULUTH SHIP CANAL. HIS FIRST DECISION FORCED DULUTH TO BUILD A DIKE; HIS SECOND DEMANDED THE DIKE BE TORN DOWN, AND DETERMINED THAT, BECAUSE THE FEDERAL GOVERNMENT HAD INVESTED IN THE CANAL, SUPERIOR AND THE STATE OF WISCONSIN HAD NO RIGHT TO REQUEST THAT THE CANAL BE FILLED IN. THAT DECISION ENDED ONCE AND FOR ALL THE LEGAL BATTLE OVER THE CANAL.

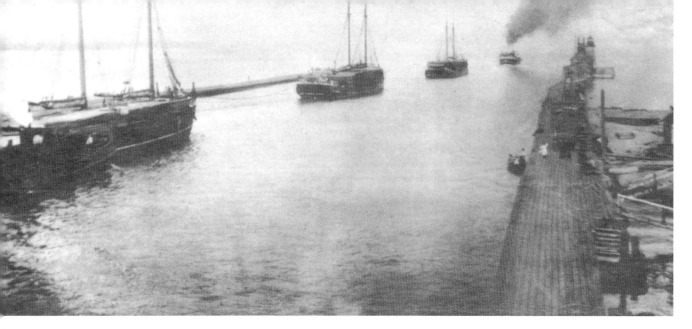

As Duluth prospered from its railroads and ship canal, the canal's piers needed frequent attention. In 1879 ice damage forced engineers to replace 250 feet of cribbing; in 1880, 325 feet of the north pier were completely rebuilt, along with 190 feet of the south pier. In 1882 workers finally placed decking on the piers.

The natural flow of water through the canal also undermined the piers—literally. Originally dredged to a depth of fourteen feet at the time the workers laid the piers' cribbing, by 1882 portions of the canal near the piers had been naturally scoured to a depth of eighteen feet. With its feet washed out from under it, the north pier again listed toward the canal. Workers pulled the pier back and bolstered it again, this time with large iron rods fastened to the face of the cribbing.

Each spring the same problems arose: damage from ice and log rafts had battered the piers. The canal's engineers thought spending money on further repairs was far from practical, so only absolutely necessary work was done on the piers throughout the 1880s. In 1881 Congress had passed the River and Harbor Act, which authorized plans for the Corps of Engineers to improve the Superior Entry and the Canal. Five years later the Corps established a district office in Duluth, and engineers focused on designing a better canal and pier system, one that would stay in place and could handle an increase in ship trafficking and larger, heavier boats that required deeper waters. Work on this "new" canal would not begin until the 1890s.

BOLSTERING THE CANAL

Throughout the years of litigation, efforts to improve the canal had continued. Almost as soon as the *Ishpeming* finished its initial cut, work began on wooden piers that would frame the canal along the dig site and expand its length on the lakeward side. It was in constant need of repair from the start. Some portions of the cribbing sunk to support the piers had gone in crooked and were never properly aligned, causing problems throughout the wooden piers' entire existence. Further, the same November 1872 storm that destroyed the breakwater also severely damaged the piers, requiring $25,000 worth of work in 1873. The federal government helped pay for the repairs, and that same year the piers were completed.

In 1874 the federal government unofficially took control of the canal. When the 1875 shipping season opened a large section of the north pier had tilted and many feared it would fall into the canal. It took over three hundred cords of stone riprap to bolster the pier once it had been put back in place.

SEVERAL FREIGHT VESSELS BEING TOWED THROUGH THE DULUTH SHIP CANAL. IN 1874, 290 VESSELS HAD USED THE DULUTH HARBOR WHILE NONE HAD CALLED ON SUPERIOR ACROSS THE BAY. THE FEDERAL GOVERNMENT TOOK CONTROL OF THE CANAL THAT SAME YEAR.

MEANWHILE, ON MINNESOTA POINT

While engineers were busy keeping the piers in place and dreaming up their replacements, Duluth had been busy digging itself out of the financial hole left by Cooke's absence. The city received a great deal of help from farmers. When Cooke's railroad arrived and his elevator had sprung up back in 1870, long-established trade routes which did not involve Lake Superior carried wheat from the west to the east. Duluth's pioneers found it difficult to divert the wheat through Duluth. Between 1871 and 1874, the only grain that passed through Duluth's elevators was sent by dealers purposefully trying to create another market. That market got a significant boost in 1876, when the farms of the newly settled Red River Valley along the border between western Minnesota and the eastern portion of the Dakota Territory started producing wheat. The eastern section of the Northern Pacific's line had only gotten as far as Bismarck, but that was far enough. All that grain would be heading to Duluth at harvest time. In 1877 the grain trade also helped revive the LS&M, dormant since Cooke's failure, which reorganized as the St. Paul & Duluth Railroad (in 1900 the StP&D would become absorbed by Northern Pacific).

These events couldn't have come at a better time. After Cooke's failure, Duluth's population had quickly sunk to below 1,500, and in 1877 the state allowed its charter to expire: it was a city no more. But thanks to the new grain trade, it wouldn't be gone for long. Grain and lumber would carry the Duluth Harbor into the 1880s; the iron ore industry would help keep it very busy for another hundred years after that.

But while the canal helped create commerce, it also created a problem: it had cut off the residents of Middleton from the rest of the city by literally turning Minnesota Point into an island.

Duluth's history is absolutely reliant on the Point's history. Government surveyor George Stuntz, the Point's first non-native

Minnesota Point Lighthouse

Standing fifty feet tall when built in 1858 and located at the end of Minnesota Point, one of Lake Superior's first lighthouses was intended to help mariners navigate the Superior Entry. R. H. Barrett, its first keeper, lived with his family in a simple cottage built of the same red Ohio brick German stonemason Adam Dopp used to build the tower. Both buildings were later whitewashed in limestone. When the fog became thick, Barrett used his own lungs to blow a warning through a logging camp dinner horn. Local residents called it "Barrett's Cow."

The lighthouse constantly needed repairs; it leaked, and plaster fell off in chunks. The ever-changing sand bar also created a problem: the location of the natural entry shifted; within a year of the tower's construction, it no longer stood close to the water (today it is about a half mile away). By 1885 most ship traffic passed through Duluth's canal, so on August 6 of that year the government discontinued the lighthouse's use.

In 1889 a wooden pierhead beacon was built on the north timber pier under construction in the Superior Entry and it was fitted with the lens from the Minnesota Point light. That light was destroyed in the *Mataafa* Storm of 1905 (see page 68).

While the keeper's house was torn down long ago, the lighthouse—what's left of it—still stands. It's now barely thirty feet high and is protected by a fence. The tower still contains the "zero" marker used for all surveys mapping Lake Superior—work undertaken by pioneer George Stuntz, the first non-native to settle on Minnesota Point.

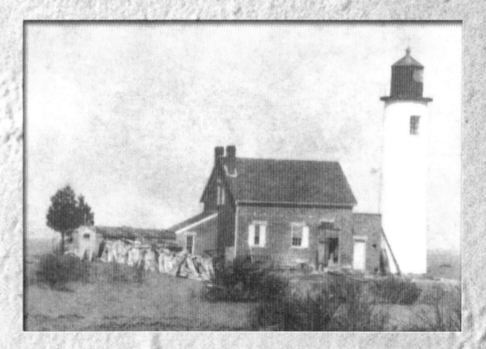

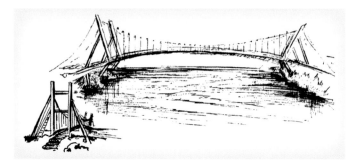

resident, established a trading post near the Superior entry in 1853, just a year after he arrived in Superior and began surveying what would become Duluth. He also established a dock and trading post the same year. When the first Duluth Township was established in 1856, legend has it that local residents gathered at a picnic on Minnesota Point to select a name for the fledgling city, choosing an adaptation of the name of the first European who made a significant mark on the town's site. That same year the township established its first park: Lafayette Square on Minnesota Point. In 1858, to help mariners locate the Su-

perior Entry, U.S. engineers erected the Minnesota Point Lighthouse on the very spot government officials had earlier marked as "zero" for surveys of U. S. territories surrounding the lake (See "Minnesota Point Lighthouse" on page 23).

Cutting off access to the mainland changed everything. Crossing the canal proved to be a major inconvenience: everything Middleton's residents needed to survive—food, clothing, building materials—now had to be delivered by boat. Almost immediately after the *Ishpeming* dug the canal, ferries and a succession of temporary bridges were used to traverse the span. The first mention of a bridge over the canal and a ferry system ap-

peared in the *Minnesotian* on April 18, 1872:

The Bridge over the Ship Canal on Minnesota Point remains undisturbed. The City Fathers have been consulting with Engineer Gaw as to the best and most economical arrangement of crossing it when the time comes to remove the Bridge. It has been nearly concluded to project slips 20 by 60 feet into Lake Avenue on each side of the Canal and run a scow-boat ferry by a copper wire rope to be dropped to the bottom of the Canal whenever vessels need to pass in or out. Two men will work it, and the cost will not be great.

A week later, the *Minnesotian* announced the establishment of a ferry system: "Arrangements have been perfected by the city with S. L. Secrest and Thos. Brunette to maintain a ferry at the canal during the summer. They propose to run small boats for passengers and scows for teams. The former will run from 6 A.M. to 11 P.M. and the latter from 6 A.M. to 8 P.M. The contract price is $14 a day." In 1874 Duluthians spent $962 building a temporary suspension bridge "of rough wooden towers with cables and a

six-foot-wide platform," but workers didn't complete it until February, two months before it had to be removed for the shipping season. When in place, the bridge could barely handle a breeze and often "swayed dangerously" in the wind. It tossed so badly during storms that residents passed back and forth on "hands and knees." Middleton residents grew increasingly impatient with the rest of Duluth; they felt neglected and, understandably, cut off.

When Duluth lost its charter in 1877, Middleton residents—frustrated that little had been done to connect them with the rest of the city—decided to put even more distance between themselves and their neighbors than had the canal. They elected to maintain separate corporation status from Duluth and begin to call their community "Park Point," a term that had been in use informally for some time. (Rice's Point, including the West End, also separated itself from Duluth.) The Park Pointers even considered annexing to Wisconsin where they would be "treated more fairly."

In 1881 the community officially became the Village of Park Point, electing R. H. Palmer as its president. It then set its sights on the canal problem. At some point prior to this, use of the winter suspension bridge ended. After an 1881 application by J. M. Nutt to operate a ferry across the canal was denied, Pointers took matters into their own hands the following year, when "an appropriation of $25 was made for benefit of a bridge across the canal." More cash followed, but hardly enough to build a bridge; the community instead used the money to build "a sort of board walk...laid across the ice." This structure proved particularly difficult to navigate, and accounts of Park Pointers crawling across it were frequent.

In 1883 village trustees appointed Charles Winters "superintendent of repairs on the ship canal bridge" and adopted regulations for a ferry service that called for a tariff on crossings of "five cents for a single trip" and, for families, a flat monthly rate of one dollar; groceries cost between twenty-five and fifty cents a month. Mr. Winters also became the ferry's only licensed operator, expected to be available weekdays from 6 A.M. to 10 P.M. and until 11 P.M. on Saturdays and Sundays.

In 1884 Park Point handed the canal crossing question back to Duluth when it adopted a resolution "permitting the Village of Duluth to build and maintain a combined wagon and railroad draw bridge across the ship canal." Unfortunately for the Pointers, Duluth didn't build the bridge.

THIS DETAIL FROM AN 1883 BIRD'S-EYE ETCHING OF DULUTH BY HENRY WELLGE SHOWS THE DEVELOPMENT IN DULUTH'S WATERFRONT AND HARBOR SINCE THE SHIP CANAL WAS DUG THIRTEEN YEARS EARLIER. BUT THE STRIP OF MINNESOTA POINT SOUTH OF THE CANAL SHOWN HERE IS NOT PART OF DULUTH AT THIS TIME; IT IS THE NORTHERN TIP OF THE VILLAGE OF PARK POINT, AN INDEPENDENT TOWNSHIP.

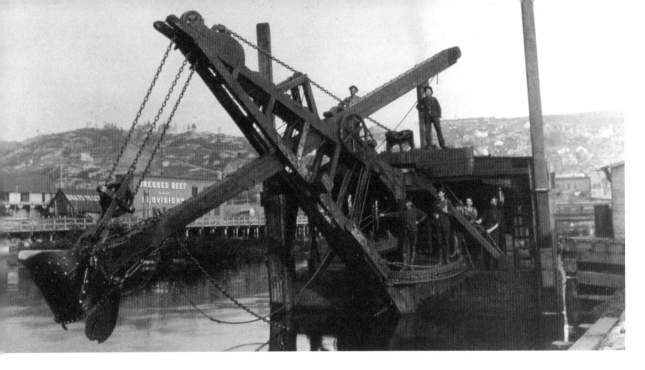

body that would, from that point on, be in charge of the ship canal.

As the Village of Duluth prospered and its population grew, it continued to pay off the debt of the defunct City of Duluth; by 1887 it had cleared the books, and the state legislature sanctioned its incorporation: Duluth—from the canal north up the hillside along Lake Avenue west to roughly Seventh Avenue West—was once again a city. Nearby townships, eager to reap the same benefits Duluth would as a city, folded themselves into Duluth's ranks: by 1888 North Duluth, Portland, and Endion stretched the new City of Duluth's borders east to about Twenty-first Avenue East while Rice's Point, including the West End, extended its western reach once again to Fortieth Avenue West. But one portion of the original Duluth Township refused to join the new city: Middleton, now the Village of Park Point.

The problem, as it had always been, was the bridge over the canal; or rather, the lack thereof. Without a permanent solution for crossing the canal, Park Point would remain an independent township. Duluth's city fathers had long envisioned the bay side of Minnesota Point lined with slips, but it could hardly create that infrastructure on land it didn't own. So Duluth promised Park Point a bridge. Historian Walter Van Brunt suggests Duluth's approach wore down the Pointers rather than wooed them with genuine offers: "Finally, being promised a bridge, rather informally and not truly officially perhaps, [the residents of Park Point] surrendered." In 1890 Park Point technically became one with the City of Duluth, but the canal kept the community separate.

A CITY ONCE AGAIN

With the growing grain and lumber industries keeping its harbor busy with activity and commerce, the Village of Duluth prospered throughout the 1880s. As the harbor became further developed with grain elevators and lumber and flour mills, dredging further improved the canal and bay. By then, two beacon lights and fog a signal had been added to the canal.

The outer harbor had changed as well. The Citizen's Dock, abandoned in 1880, was "destroyed" in 1886 (as with the dike, remnants of it must have remained for some time, as it is included in both the 1888 *Sanborn Insurance Maps* and the 1902 *Frank's Atlas*). That same year fire consumed elevators A and Q. The breakwater that had served the elevator, neglected since Cooke's failure, had all but disintegrated. No matter: with the canal, the inner harbor had rendered the outer infrastructure unnecessary. 1886 also saw the creation of the Duluth District Corps of Engineers, a federal

THE DREDGING VESSEL *WILLIAM SUPHANCO,* WHICH DREDGED THE DULUTH SHIP CANAL DURING THE 1880S, KEEPING IT DEEP ENOUGH FOR INCREASINGLY LARGER FREIGHTERS TO PASS THROUGH WHILE FULLY LOADED.

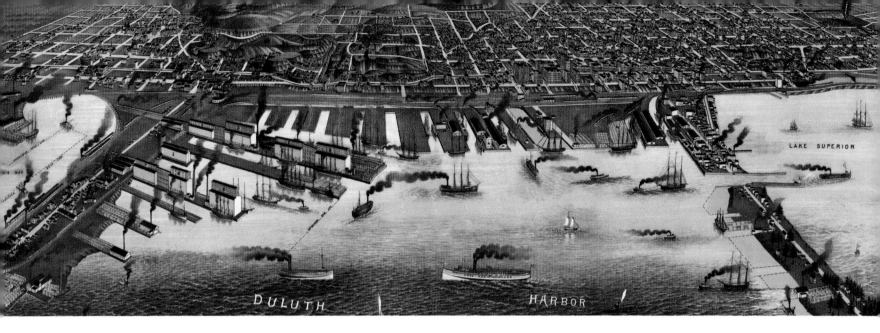

DULUTH HARBOR

LAKE SUPERIOR

THE CROSSING CONUNDRUM

Within three years of Park Point joining its ranks, Duluth continued to grow, swallowing up townships to the north and east of its boundaries: Duluth Heights, Glen Avon, Hunter's Park, Kenwood, Morley Heights, Piedmont Heights, Woodland, Belville, Lakeside Village, New London, and Lester Park. By 1895 West Duluth and Oneota, Bay View Heights, Riverside, Gary, New Duluth, and Fond du Lac stretched Duluth's borders twenty miles up the St. Louis River. Duluth now hugged the shore of Lake Superior and the northern bank of the St. Louis for nearly thirty miles, earning it a new nickname it would have to share with New Orleans: The Crescent City.

Park Point still did not have its bridge, but it wasn't as if the city hadn't been hard at work on the problem. At the behest of the Common Council (Duluth operated under an aldermanic government until 1912, when it switched to a commissioner-driven city council system; the city switched to its present mayor/city council form of government in 1956), the Duluth Board

of Public Works had hired Alfred Pancoast Boller, a nationally recognized consulting engineer, to produce the first plan to span the canal with a professionally designed bridge. One of Boller's biggest challenges would be satisfying federal engineers: as the canal and the land adjacent to it was owned and operated by the federal government, no bridge could be built without the federal government's approval. That acceptance—which proved difficult to gain—as well as the costs of various proposed designs, would delay the reality of a bridge for another fifteen years.

For his 1890 proposal, Boller designed a 475 foot swing bridge mounted on a massive masonry pier rising out of the canal tight against the canal's south pier; nearly half the bridge would actually hang over Minnesota Point when in use. To allow ship traffic to pass, the bridge would pivot on a great turntable at its center—using fifty-eight twenty-inch steel balls as bearings—so that when it was moved to allow a ship to pass, the entire bridge would rest along the south pier wall. The bridge would take fifteen seconds to unlock and another ninety seconds to swing out

Mr. Boeing's Claim on the Canal

Years after the Duluth ship canal was dug, German immigrant and Michigan lumberman Wilhelm Boeing (pictured) claimed ownership to the land the canal passed through. Boeing had apparently bought fourteen lots after the Panic of 1873.

On September 27, 1889, Boeing posted an announcement that beginning on October 15 that same year, he would deny all boat and vessel owners passage through the canal; further, he would stretch a rope across the canal and threatened lawsuits against anyone who would cut it. Boeing then told the *Duluth Evening Herald* that the posting was his attempt to prod the city into purchasing the property, which he claimed the city had already appointed a committee to investigate. They had yet to contact Boeing, and he had become impatient.

Common Council President J. J. Costello hinted at the cause of the delay, telling the *Herald* that Duluth had considered paying a reasonable sum for the property but Boeing's asking price—$100,000—was "preposterous." Besides, Costello argued, since the canal was then eighteen years old, it was likely Mr. Boeing's claim on the land had expired due to some statute of limitations. And since the federal government took over ownership of the canal in 1887, how could Boeing sue Duluth over property it had no jurisdiction over?

A 1953 *Duluth News-Tribune* story reported that Boeing, as promised and with the help of ferryman Charles Winters, tied a piece of rope to pilings on either side of the canal at 12:15 A.M. on October 15, 1889. Police Officer Frank Horgan promptly cut the rope. When Horgan went home after his shift, Boeing put the rope back up. When the steamer *Winslow* was warned of the rope as she passed through the canal later that day, her captain yelled "to hell with you and your old clothesline" and steamed through, the ship itself cutting the rope. Boeing then put the rope up again, only to watch the tug *Spirit* break it a short time later. Boeing then purchased some chain, but by then Police Chief Doran had arrived threatening to arrest anyone attempting to block the canal. By 9 A.M. Boeing had sold his chain and hopped the next train back to Detroit.

Whether those events reported in 1953 ever took place is highly doubtful. There is no evidence Boeing was even in Duluth during 1889; his affairs in town had been handled by Marshall H. Alworth, his business partner in lumber speculation (some reports have Alworth tying a rope across the canal in 1888). And Boeing died from influenza in 1890, just months after the posting.

Even without $100,000 for the land the canal passed through, Boeing had plenty of money. Most of his vast wealth went to his son William, who would eventually move to the Pacific Northwest and start building airplanes. Today, of course, Bill Boeing's company makes most of the commercial airplanes in service.

of the way or back into place. Boller's report took great pains to show that his bridge would not infringe in the slightest on the passage needed for shipping, allowing 200 feet for navigation. He also designed the bridge's deck to carry both railroad and horse and wagon traffic and included sidewalks for pedestrians.

Despite the careful consideration to keep the canal wide open for ship traffic, nothing ever became of Boller's plan. The town simply didn't have the money. Then, as today, the City of Duluth was all too well acquainted with the difficulty of balancing tax revenue against outlay for the public good. Boller's bottom line was $112,000 for substructure and masonry, $114,000 for the superstructure, and $150,000 for construction of the roadway approaches to the bridge. Miscellaneous and contingent costs brought the bill to just shy of $400,000—over $8.5 million in today's dollars—a figure that the city fathers could not seriously contemplate at the time. Cost aside, city leaders dropped Boller's idea due to "difficulties and opposition encountered." Local business owners and captains of industry—including Captain Alexander McDougall, whose whaleboat freighters were revolutionizing Great Lakes shipping—opposed any sort of mechanical bridge: there was too much potential for such a structure to fail and block the canal, preventing ships from accessing Duluth's harbor.

In an attempt to avoid the potential problems a bridge might create, Duluth turned its attention to a new idea: a tunnel. The city hired Chicago consulting engineer William Sooy Smith to come up with a plan, which he delivered on January 27, 1891.

The Sooy Smith tunnel would take St. Croix Avenue, which ran along the eastern shore of Minnesota Point, underground and below the canal, emerging south of the waterway. (St. Croix Avenue was later renamed First Avenue East and is known today as Canal Park Drive.) Sooy Smith actually drew up two plans: one

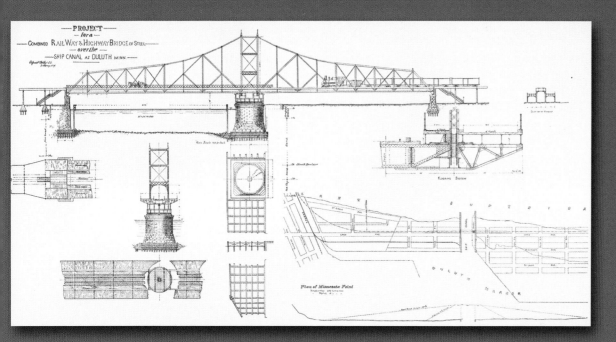

EARLY IDEAS
FOR CROSSING THE CANAL

PLANS FOR
ALFRED PANCOAST BOLLER'S
1890 475-FOOT SWING BRIDGE
DESIGN (LEFT) AND SOOY SMITH'S
1891 ST. CROIX AVENUE TUNNEL
DESIGN (BELOW). BOLLER'S WORK WAS
CONSIDERED TOO LIKELY TO BLOCK
SHIPPING TRAFFIC, AND SMITH'S
TUNNEL WAS SIMPLY
TOO EXPENSIVE.

SMITH'S PLANS
INCLUDED
DRAWINGS FOR
BOTH A THREE-
AND A FOUR-
LANE TUNNEL

Duluth's 1891 Canal Bridge Contest

Entry Submission Plans

Arentz & Sangdahl's bi-level, single sliding draw bridge (upper right) won the contest, but the city asked the United States Corps of Engineers for permission to build John Alexander Low Waddell's aerial lift bridge design (upper left; sketch on facing page), the first bridge of its kind, over the Duluth ship canal. They were told "No"; the risk of the bridge malfunctioning and blocking marine traffic was deemed too great.

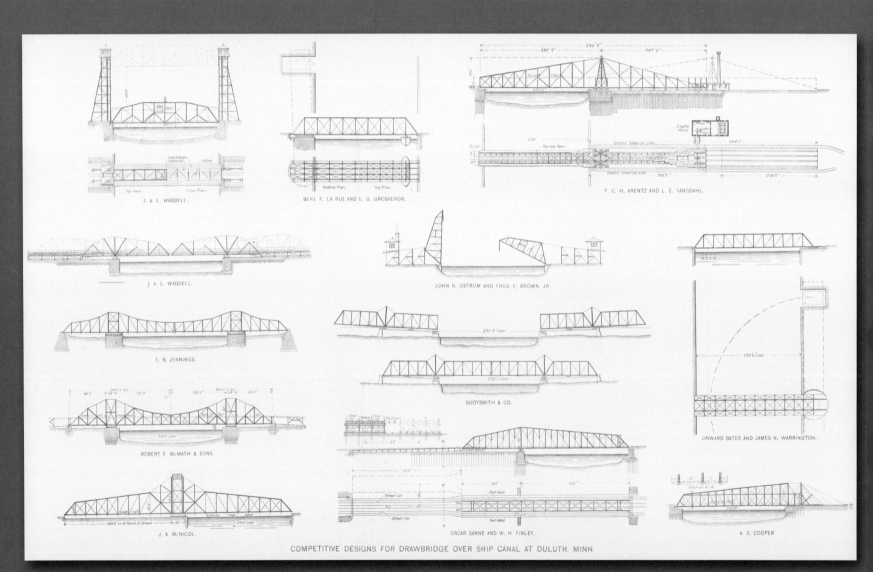

J. A. L. WADDELL.

BENJ. F. LA RUE AND L. D. GROSVENOR.

F. C. H. ARENTZ AND L. E. SANGDAHL.

J. A. L. WADDELL.

JOHN N. OSTROM AND THOS. E. BROWN, JR.

E. B. JENNINGS.

SOOYSMITH & CO.

ROBERT E. McMATH & SONS

ONWARD BATES AND JAMES N. WARRINGTON.

J. A. McNICOL.

OSCAR SANNE AND W. H. FINLEY.

A. S. COOPER

COMPETITIVE DESIGNS FOR DRAWBRIDGE OVER SHIP CANAL AT DULUTH, MINN.

with three separate tunnels (one each for pedestrian, train, and wagon traffic) and another with four tunnels (the additional passage was also to be used for trains). Towers on either side of the canal would take pedestrians down a stairway to the walkway.

Sooy Smith argued that most of the work could be done in the open air while the canal remained in operation. Then, during the winter when the canal was free of all shipping traffic, engineers would sink great caissons holding coffer dams that contained lengths of tunnel; once engineers put the tunnel sections in place, the dams would be removed. And once the tunnel was operational, shipping traffic would never have to be inconvenienced in the slightest for people and goods to cross the canal. The residents of Minnesota Point would never again require the use of a ferry or risk their lives on a dangerous temporary bridge.

But again finances doomed the project: estimates ran as high as $1.4 million, over $30 million in today's dollars. The city, which had already expressed reluctance over spending $400,000 for a bridge, was certainly not going to approve a $1.4 million tunnel plan. Nearly two years after promising Park Pointers a bridge, Duluth didn't even have a viable plan.

So the city held a contest. In October 1891 Duluth's Board of Public Works asked the Common Council for the authority to advertise a competition for plans and specifications of a means to cross the canal. The designs had to carry passage for rail, wagons, and pedestrians (the first automobile wouldn't arrive in Duluth until 1900) and work in a way that did not impede canal traffic. The best plan would receive a $1,000 prize. At the end of December the competition was announced in *Engineering News*. Twenty engineers from across the country heard the call and submitted designs.

Two plans called for a swing arm similar to Boller's earlier design. Several, including a submission by tunnel designer Sooy Smith, were for sliding bridges in which either one entire ex-

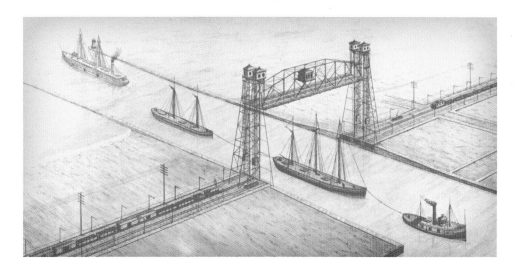

panse or two smaller expanses (one on either side of the canal) would slide back along rails to clear the shipping lane. Two designs involved cantilevering the bridge so it could be tipped up and out of the way

The Milwaukee firm of Arentz & Sangdahl took home the cash for their bi-level, single sliding draw bridge design. The bridge's railway floor would hang above the roadway for wagon and foot traffic; to make way for a passing ship it would slide straight back 316 feet from the canal along rails. A 116-horse-power electric engine would move the bridge with steel ropes. The engineers estimated its cost at $236,000.

But despite winning the contest, Arentz & Sangdahl's design was passed over for a cheaper bridge that would "take care of the business for several years, or until such a time as the city felt it was able to tunnel the canal." The city chose instead a very interesting plan by John Alexander Low Waddell: an aerial bridge whose roadway span could be lifted to allow shipping traffic full use of the canal. The board called the plan "the best adapted to the locality and the most suitable and economic structure as regards both construction and operation."

A SKETCH OF THE AERIAL LIFT BRIDGE PROPOSED IN 1891 BY J. A. L. WADDELL FOR A CONTEST HELD BY THE CITY OF DULUTH. WADDELL'S SUBMISSION LOST THE CONTEST—IT WASN'T FOR A DRAW BRIDGE, AS THE CONTEST GUIDELINES DECREED.

John Alexander Low Waddell: Father of the Modern Lift Bridge

Although his idea for a steam-powered lift bridge failed to get approval in Duluth in 1891, John Alexander Low Waddell did build his bridge two years later: over the Chicago River at Halstead Street. It is known today as the South Halstead Street Bridge. He eventually designed more than one hundred similar lift bridges and other bridges, including the Columbia River Interstate Bridge, the Steel Bridge, and the Hawthorne Bridge in Portland, Oregon; the Marine Parkway-Gil Hodges Bridge and Goethals Bridge in New York City; and the Armour-Swift-Burlington (ASB) Bridge over the Missouri River in Kansas City, Missouri, where Waddell established himself in 1887.

One of the companies Waddell founded, Hardesty & Hanover, still works on moveable bridges today and in 1999 was hired to overhaul Duluth's lift bridge (see pages 162 – 163). In fact, one of Waddell's former colleagues, John Harrington, designed the plans to convert Duluth's transfer bridge to a lift bridge in 1929 (see page 118). The partnership of Waddell & Harrington evolved into HNTB of Kansas City, which still builds bridges today.

But while Waddell's first lift bridge was built in Chicago, his original linen drawing for that bridge currently hangs in a conference room in Duluth's City Hall.

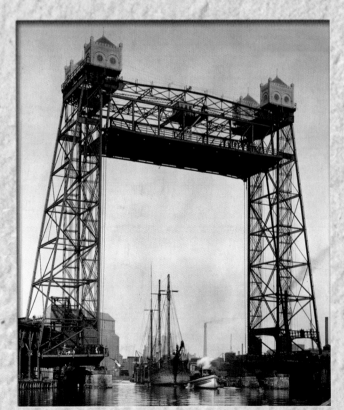

CHICAGO'S
SOUTH HALSTEAD
STREET BRIDGE.

Armed with Waddell's plans, a committee consisting of harbor master J. W. Miller, S. A. Thompson from the Chamber of Commerce, and Henry Truelsen, president of Duluth's Board of Public Works, traveled to Washington to show the plans to S. B. Elkins, the Secretary of War, under whose jurisdiction the canal operated. But as the group completed its presentation, they were informed that a protest had been filed against the construction of any bridge over the canal. A group consisting of the Lake Carrier's Association, the Cleveland Vessel Owner's Association, and others had filed the complaint. Among them was Duluth's Alexander McDougall, a founding member of the Lake Carrier's Association. The groups argued that access to Minnesota Point would have no effect on the local economy: only two hundred people called the land spit home, and its land was not needed for dock space. Further, one of Lake Superior's fierce storms would certainly wash out the bridge. If a bridge were rendered inoperable during a storm, ships would not be able to gain safety by passing through the canal to the inner harbor. They offered three alternatives: continue the ferry service, build a tunnel, or connect Minnesota Point to Rice's Point using a trestle bridge with a center draw.

The War Department formed a board of engineers to hear the complaint in Detroit in March of 1892. Duluth's representatives, including Miller, Thompson, and Truelsen along with city attorney S. L. Smith and Alderman Charles Long, laid out their argument. One of the points they made was that Duluth intended to make the bay side of Minnesota Point a contributing portion of the port. Multiple slips jutting into the bay from the Point could result in "twenty-two miles of dock frontage" and consolidate shipping; without a bridge, railroads could not reach those docks, and Duluth would be denied further economic development. They argued that the bridge would serve the estimated 10,000 people who would one day populate the Point. They denied the bridge would

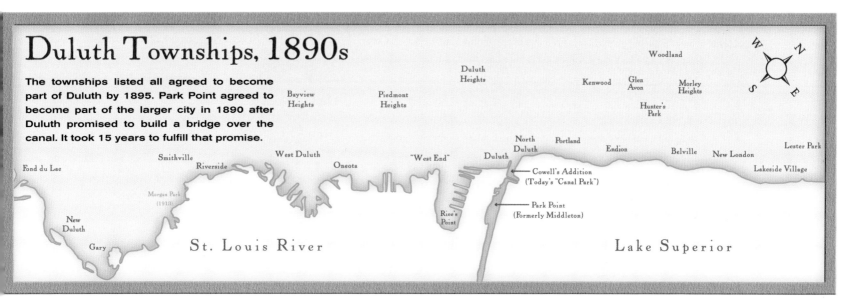

Duluth Townships, 1890s

The townships listed all agreed to become part of Duluth by 1895. Park Point agreed to become part of the larger city in 1890 after Duluth promised to build a bridge over the canal. It took 15 years to fulfill that promise.

Woodland

Duluth Heights

Kenwood Glen Avon Morley Heights

Bayview Heights Piedmont Heights Hunter's Park

North Duluth Portland Endion Belville New London Lester Park

Smithville West Duluth "West End" Duluth

Fond du Lac Riverside Oneota Cowell's Addition (Today's "Canal Park") Lakeside Village

Morgan Park (1913) Rice's Point Park Point (Formerly Middleton)

New Duluth

Gary St. Louis River Lake Superior

obstruct navigation and refuted other claims made by McDougall and his confederates.

But Duluth had to wait until April for the board's response, which was far from what they had hoped. The board praised Waddell's design, yet stated clearly it preferred the idea of a swing bridge such as Boller's idea. And while it sympathized with the people of Duluth over access to the Point, the board decided to base its opinion on "the best interests of all concerned." The board also declared it did not wish to "establish a dangerous precedent" by allowing a bridge to be built over the canal because it is the very point where a mariner "passes the perils of the seas into the shelter of the harbor" and that "such a point cannot be too free from obstruction, or the possibility of it." It opposed "the construction of *any* bridge over the canal at Duluth." Waddell's lift bridge was out—of the Duluth picture, at least. In 1895 the plans would be used to build the Halstead Street Bridge in Chicago, and Waddell would become famous for his design (see page 32).

Duluth was back to one alternative: a tunnel. A very expensive tunnel. The Duluth Board of Public Works' 1892 report on the matter expresses the town's frustration, concluding with the statement, "The day when we will have access to Minnesota Point is probably a long way off." And if the city felt it had been defeated, consider the disappointment Park Point's residents faced: they were still cut off, and the government had cancelled all hope of a bridge in the reasonable future.

The city made one last-ditch effort to connect Park Point to the mainland. They ran another contest, this time for a tunnel design, hoping the government would not object to an idea that eliminated a bridge. C. C. Conkling took home the $1,000 prize, but his tunnel never took another step forward. The Board of Public Works report for 1893 mentioned that "legal complications" had arisen and guessed that the issues would likely be carried to District and Supreme Courts before any work could even be considered. Nothing ever became of Conkling's plans, but it wouldn't be the last time Duluth entertained the idea of a tunnel.

THIS MAP SHOWS THE APPROXIMATE CENTERS OF THE TOWNSHIPS THAT CAME TOGETHER BETWEEN 1888 AND 1895 TO BECOME THE CITY OF DULUTH.

Out with the Wood, In with the Concrete

While Duluth had been stymied in its efforts to bridge the canal and financially prohibited from tunneling beneath it, plans were made for great improvements to the canal and harbor: the old fourteen-foot channel wasn't up to par, not since the locks at Sault Ste. Marie (or "The Soo") on the other end of the lake were enlarged back in 1881. And the iron ore industry had finally arrived in Duluth by way of mines on the Merritt brothers' newly opened Mesaba Iron Range (ore from Charlemagne Towers' Vermilion Range mines was sent to Two Harbors to be loaded and shipped), creating more shipping traffic through Duluth. But the canal's and the harbor's shallow depth prevented bigger ships from carrying larger, more profitable loads.

So in 1893 Captain McDougall set about forming the Duluth-Superior Harbor Improvement Committee, whose first task would be to petition Congress for funds. In 1896 Congress "appropriated $3 million...to make Duluth-Superior harbor the most modern in America." The project called for twenty-foot channels throughout the bay, a connecting channel between the Duluth Bay and the Superior Bay, and an "immense anchorage basin" behind Park Point. Both the Superior Entry and the Duluth Ship Canal would receive new concrete piers. The appropriation also brought Duluth and Superior together: On June 3, 1896, the same act of Congress that appropriated the funds declared that "the harbors of Duluth and Superior [are] unified." The two separate towns—once bitter rivals—had come together to form the Twin Ports.

Plans drawn up in 1896 called for a major renovation of the canal. It would be widened to 300 feet and stretched 400 feet to a total length of 1,600 feet. Substantial concrete structures would replace the rickety, crooked wooden piers that lined the canal. The work would take almost a thousand men and seven years to complete.

The steam dredge *Old Hickory* set to work making the canal deeper and wider: it had to cut another 100 foot swath out of Minnesota Point, dig a trench twenty-four feet deep where cribbing would be set atop wooden pilings to support the new piers, and clear the rest of the canal to a depth of twenty feet. To widen the canal, dredging would take place south of the south pier; the old wooden pier would remain in place until the new one was completed. While engaged in this digging, *Old Hickory* hit a submerged obstacle: the wreck of the two-hundred-foot, three-masted sailing schooner *Guido Pfister*, which had stranded on the point adjacent to the canal some years before, then been abandoned and sunk. Engineers used dynamite to extract the wreckage.

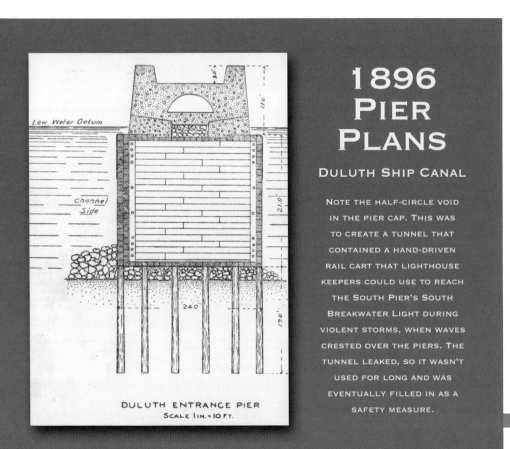

1896 PIER PLANS

DULUTH SHIP CANAL

NOTE THE HALF-CIRCLE VOID IN THE PIER CAP. THIS WAS TO CREATE A TUNNEL THAT CONTAINED A HAND-DRIVEN RAIL CART THAT LIGHTHOUSE KEEPERS COULD USE TO REACH THE SOUTH PIER'S SOUTH BREAKWATER LIGHT DURING VIOLENT STORMS, WHEN WAVES CRESTED OVER THE PIERS. THE TUNNEL LEAKED, SO IT WASN'T USED FOR LONG AND WAS EVENTUALLY FILLED IN AS A SAFETY MEASURE.

Low Water Datum

Channel Side

DULUTH ENTRANCE PIER
SCALE 1 IN. = 10 FT.

As the *Old Hickory* dredged the canal deeper and wider, contractors began driving more than 5,100 wooden pilings, made of fifty-foot Norway pines, into the lake bottom every four feet; these pilings were later cut to a uniform level at twenty-four feet below the waterline.

Workers then set cribbing on top of the pilings. Each crib, assembled at various places around the harbor, measured twenty-four feet wide, one hundred feet long, and twenty-two feet tall. Constructed of twelve-inch square pine beams and reinforced internally by more of the same, each crib featured a one-inch band of iron across the top to prevent ice from damaging the wood. Contractors assembled sixteen such cribs for each of the canal's piers. Each was towed into place, aligned, and sunk onto the pilings with the weight of stones. Once properly aligned, the pier had a solid foundation one foot below the waterline. Engineers then sank nine thousand tons of riprap stone along the base of the new piers to prevent erosion from undermining the structures.

Steam derricks placed concrete footing blocks atop the cribbing. After the footings were aligned, huge monolith blocks—which would form the canal's deck and parapet walls—were set atop them. Unlike the footings, these blocks, which measured ten by eighteen feet and weighed 14,000 pounds each, were molded and cast on site by "large gangs of men working around the clock." These men, mostly Swedish and Finnish immigrants, received $2 a day for their efforts. Thousands of tons of concrete were used to make the 334 monoliths used in the piers, 1,200 barrels of Portland cement for the South Pier alone. A center channel along the bottom of each monolith was left with a half-circle opening. When set in place, this opening formed a tunnel. A pulley-and-cable driven rail system was installed so that lighthouse keepers could reach their posts during treacherous conditions that would make walking atop the piers highly

dangerous. Unfortunately, during storms the tunnel itself became half filled with water; it was little used for decades and later filled in as a safety measure. With the old wooden pier, lighthouse keepers reached the South Pier Light by walking over a trestle walkway, so the keeper could reach the light even when the pier was submerged by large waves.

Work began on the South Pier in 1898 and was completed in 1900. New South Breakwater and Rear Range Lights sat atop the South Pier by September of 1901 (see pages 19 and 20). At the request of Major D. D. Gaillard, chief of the Corps of Engineers in Duluth, engineers included a water-level indicator made from a mosaic of ceramic tiles (and festooned with an

REMNANTS OF
THE WRECK OF THE
TWO-HUNDRED-FOOT,
THREE-MASTED SAILING
SCHOONER *GUIDO
PFISTER*, WHICH HAD
STRANDED ON THE POINT
ADJACENT TO THE CANAL
SOME YEARS BEFORE. IT
WAS BLOWN TO SMALL
PIECES BY DYNAMITE
BEFORE BEING REMOVED
AS THE CANAL WAS
WIDENED IN 1896.

THE DULUTH SHIP CANAL CONCRETE

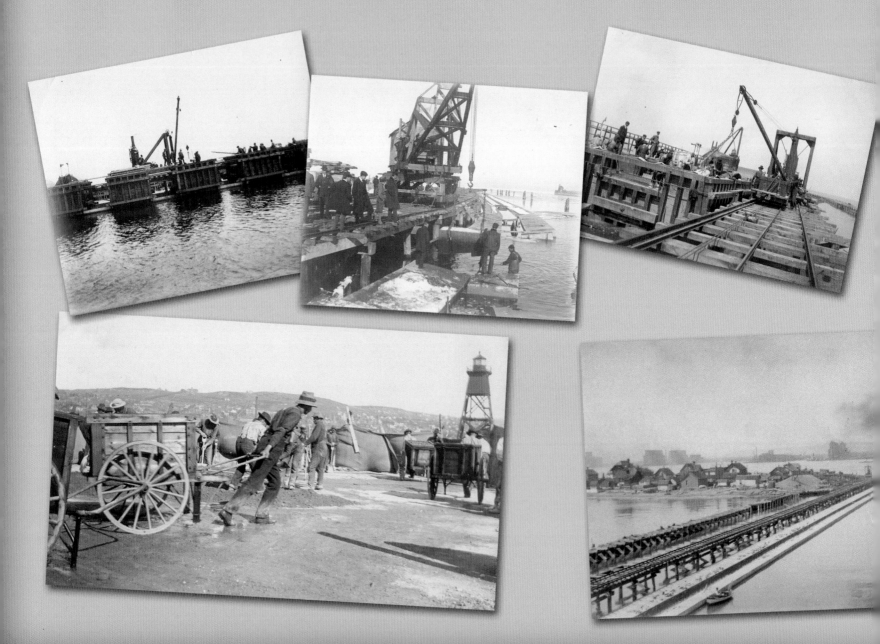

PIER CONSTRUCTION (1896 – 1902)

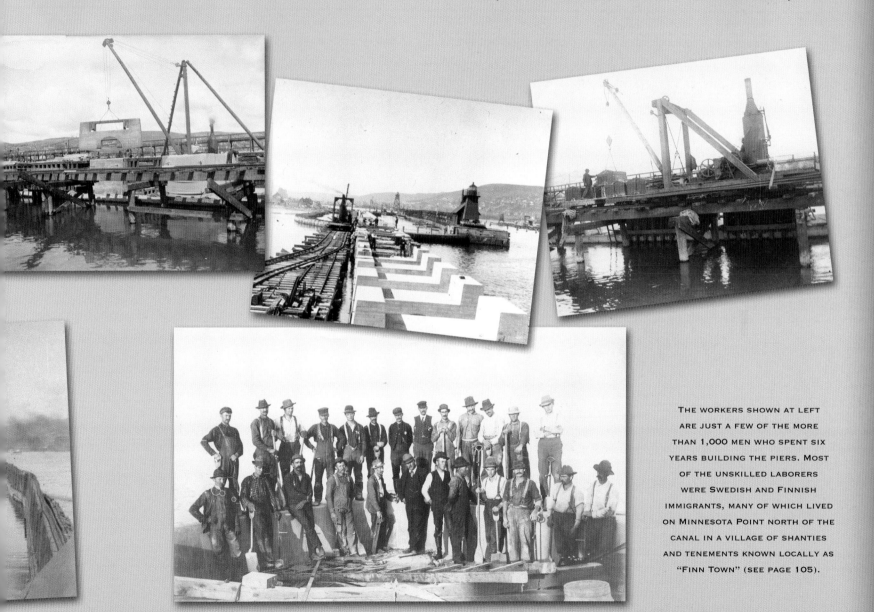

THE WORKERS SHOWN AT LEFT ARE JUST A FEW OF THE MORE THAN 1,000 MEN WHO SPENT SIX YEARS BUILDING THE PIERS. MOST OF THE UNSKILLED LABORERS WERE SWEDISH AND FINNISH IMMIGRANTS, MANY OF WHICH LIVED ON MINNESOTA POINT NORTH OF THE CANAL IN A VILLAGE OF SHANTIES AND TENEMENTS KNOWN LOCALLY AS "FINN TOWN" (SEE PAGE 105).

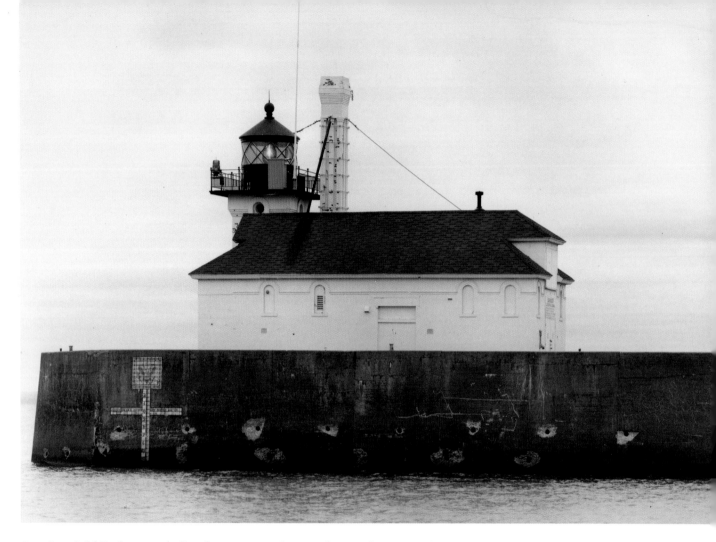

THE SOUTH
BREAKWATER LIGHT
AND FOG STATION,
BUILT IN 1902 TO
REPLACE THE WOODEN
PYRAMID LIGHT THAT
HAD GUIDED MARINERS
FOR YEARS (SEE PAGE
19). THE BUILDING
IS MADE OF CREAM-
COLORED BRICK, BUT
WAS LATER PAINTED
WHITE. NOTE THE TILE
MOSAIC WATER-LEVEL
MARKER INSTALLED
AT THE INSISTENCE OF
MAJOR D. D. GAILLARD,
CHIEF OF THE CORPS OF
ENGINEERS IN DULUTH,
TO AID IN HIS RESEARCH
OF WAVE MOTION.
(THIS PHOTO WAS
TAKEN IN 1986, JUST
BEFORE THE MOSAIC
WAS REMOVED PRIOR
TO RENOVATIONS TO
THE PIER—NOTE THE
POOR CONDITION OF THE
SEA WALLS EIGHTY-
FOUR YEARS AFTER THE
CONCRETE PIER WAS
FIRST BUILT.)

American Bald Eagle to symbolize the government's ownership of the canal) and installed it on the very end of the wall of the South Pier, just below the South Pier Light and its foghorn station, where the pier comes to a point. It wasn't an aid for navigation; Gaillard was researching wave motion, and the work he did at Duluth would later become a book titled simply *Wave Action*. The book is still considered a classic on the subject. (When the pier was renovated in 1986, the tiles were removed and stored by the Corps of Engineers; color images of the tile mosaics appear on page 156.)

In 1902 workers finished the North Pier. Not once did the reconstruction of the canal interrupt shipping. The new century was still young, and Duluth had a brand new canal that would serve it far into the foreseeable future. But on the other side, Park Pointers still had no safe, reliable means of crossing the canal.

PART II:

BUILDING THE BRIDGE
(1897 – 1905)

DULUTH'S NEW CONCRETE SHIP CANAL PIERS AND SOUTH BREAKWATER LIGHT AND FOG STATION DURING A HEAVY STORM IN 1904. THE CANAL WAS NOW STATE OF THE ART, BUT THERE WAS STILL NO SAFE MEANS OF CROSSING IT WITHOUT A FERRY BOAT—AND FERRY BOATS DIDN'T OPERATE WHEN SEAS WERE THIS ROUGH.

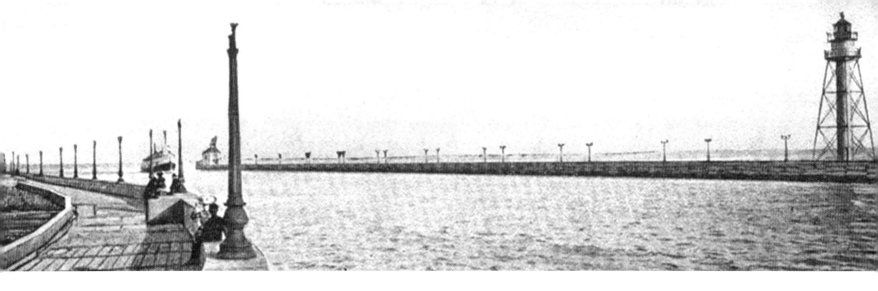

DULUTH AND THE CANAL CONTINUE TO THRIVE

Duluth had prospered during the 1890s, thanks in no small way to the iron mining industry that kept the docks and canal busy shipping out loads from the Mesaba Range. The lumber and grain industries continued to feed the economy as well. With the merger of townships, Duluth's population had grown tenfold, from 3,483 residents in 1880 to 33,115 in 1890. During the 1890s Park Point and the rest of Minnesota Point south of the canal had become a popular summer playground for Duluthians, a place to recreate for an afternoon or camp for an extended period of time; some spent the entire summer on the island. The Point had also, like the North Shore and Isle Royale, become a haven for hay fever sufferers, who summered at these pollen-free locations; antihistamines were a long way off. In fact, in 1900 Duluth would become home to the Hay Fever Club of America. Besides Park Point's citizens, many other Duluthians had started to clamor for a crossing solution more safe and practical than the ferry boat system.

In 1899, as Duluth thrived (its population surging to over 50,000), work on the new canal piers progressed, and Park Pointers continued to call for their promised bridge, Thomas McGilvray, Duluth's City Engineer, had been reading about a new bridge being built over the River Seine at Rouen, France.

Born in Aberdeen, Scotland, in 1863, the son of a Presbyterian minister, McGilvray attended private schools and earned an engineering degree at the University of Edinburgh. After his father died, twenty-one-year-old McGilvray emigrated to North America armed with a letter of recommendation from his maternal grandfather, noted botanist Sir William Hooker. The letter landed him work as a surveyor for the Canadian Pacific Railroad in Calgary in 1884. This led to a job in Minneapolis with the St. Paul, Minneapolis & Sault Ste. Marie (or "Soo Line") Railway.

THIS DETAIL FROM A LITHOGRAPHIC POSTCARD CREATED BEFORE THE BRIDGE WAS BUILT BUT AFTER THE 1904 STORM DEPICTED ON THE FACING PAGE—NOTE THAT THE INSTALLATION OF THE NORTH PIER LAMP POSTS IS COMPLETE IN THE POSTCARD BUT STILL IN PROGRESS IN THE PHOTO.

In 1887 he was briefly employed as county surveyor for Pine County, Minnesota, before going to work for StP&D. Working out of St. Paul, McGilvray began to put his stamp on Duluth on behalf of StP&D as early as 1887. He laid the foundation of the Duluth Union Depot and designed the street layout for Smithville and portions of West Duluth the railroad owned, and oversaw the construction of the Sixth Avenue Viaduct.

City directories first list McGilvray as a Duluth resident in 1891, employed with the firm of Patton & Frank owned by William B. Patton and Charles P. Frank. Patton had been Duluth's City Engineer in 1885 and operated a number of engineering firms in Duluth. When Patton again became Duluth's City Engineer in 1893, McGilvray started his own firm, Rice & McGilvray, with Samuel L. Rice. After Rice moved from Duluth in 1895, McGilvray went into private practice and did some work for the city, designing Lakeside's street layout and Duluth's water works, among other projects. In 1897 he replaced Patton as Duluth's City Engineer for the first time, and the question of crossing the canal had officially fallen to him. He knew well the problems faced by the previous ideas for Boller's swing bridge, Sooy Smith's tunnel, and Waddell's lift bridge. He needed a completely new approach.

In France, the Seine caused a problem similar to the canal: people and goods needed to get across it, but its shipping lanes needed to remain free of obstruction. The Rouen Transporter Bridge, designed by Ferdinand Arnodin, used a suspension bridge frame to carry a ferry car above the water; when not in motion, the ferry rested over land, not over the river, allowing the free flow of marine traffic. (See "Mr. McGilvray's Inspiration" on page 45).

McGilvray at once recognized the potential of a similar bridge over Duluth's Ship Canal. In 1899, the same year the French bridge would be completed, McGilvray sat at his drawing table, adapting Arnodin's plans for the Duluth Ship Canal.

The City loved it. After endless rejection, they had given up on a bridge that would allow railroads access to Minnesota Point and its proposed twenty-two miles of docking space, so any structure for crossing the canal no longer needed railroad tracks or contiguous access. The idea was certainly less expensive than any other previously proposed, and a pittance compared to the tunnel idea: perhaps no more than $100,000. But much had to be done before a single rivet was hammered in place. The city needed to make sure Captain McDougall's Lake Carriers Association would not once again oppose the plan, it needed the permission of Congress and the Secretary of War to build the bridge on and over government property, it needed to find a firm willing to build the bridge, and it had to come up with the funds to pay for the bridge and its operation and maintenance. All that would take time—much more time than anyone ever thought.

In 1900 the city established the Canal Bridge Commission to get the job done: Alderman Thomas F. Trevillion, Common Council President James L. Cromwell, Councilor Marcus B.

THOMAS F. MCGILVRAY, DULUTH'S INTERMITTENT CITY ENGINEER FROM 1897 TO 1912. WHEN THE BRIDGE CROSSING CONUNDRUM BECAME HIS CONCERN, AN AERIAL TRANSPORTER BRIDGE IN ROUEN, FRANCE, CAUGHT HIS ATTENTION. HIS ROUGH SKETCHES WOULD BE DEVELOPED INTO PLANS FOR DULUTH'S AERIAL BRIDGE.

Cullum, Mayor Trevanion W. Hugo, City Attorney Oscar Mitchell, and William B. Patton, who had replaced McGilvray as City Engineer.

The reason Patton replaced McGilvray at this crucial point in the bridge's development remains unclear, but there are clues that suggest it was politics at work. Back in 1897 McGilvray had not stepped into the City Engineer's position easily. Despite being appointed by the Board of Public Works with a 2–1 vote, Public Works President Charles Wilson protested the results, championing a second nominee, E. J. Duffles—and the Council had to confirm the Board's vote to make it official. A vote to confirm McGilvray ended in a 9–6 defeat. The next day the *Duluth News-Tribune*'s headline read, "Down Goes Mr. Mac." Whatever the nine nay-voting aldermen had against McGilvray, it was cleared up by June of that year, when he officially took office as the City Engineer. So in 1900, the year Trevanion W. Hugo replaced Henry Truelsen as Duluth's mayor, Patton replacing McGilvray may have had more to do with who sat in the mayor's office and on the Common Council than either engineer's qualifications for the job.

While Patton had replaced McGilvray just as his aerial bridge idea was moving forward, there is little doubt McGilvray was in constant contact with the project, albeit not at an official level: since Patton was now preoccupied with the matters of the city, McGilvray stepped in to help run Patton's Duluth Engineering Company; essentially, they traded jobs for four years.

1901: Permission Granted

The Commission found success with one issue early the next year. On January 21, 1901, Mayor Hugo reported to the Common Council that the city had received "unofficial assurances from the Lake Carriers Association that their opposition to bridging the ship canal has been removed, and expect official notification any day." He also indicated the Commission was moving quickly to remove its biggest obstacle; a bill was being prepared for Congress, which was empowered to grant permission to build the bridge over federal property. The next step was to find a builder.

Early in February 1901 the Commission placed ads in the *Duluth News-Tribune* and the *Engineering Record* asking for bids regarding two methods of financing. In the first option, the contractor would own, operate, and maintain the bridge and Duluth would pay for the construction, operation, and maintenance in annual installments for twenty years, after which it would take possession of the bridge. The second option also included twenty years of annual payments, but the money would cover the construction cost only; Duluth would take possession as soon as the building was complete, and operation and maintenance from that point on would be the City's responsibility. Bids were due by March 25.

Armed with the Lake Carriers Association's approval, in February City Attorney Mitchell wrote to Secretary of War Elihu Root, enclosing a draft of a bill authorizing the city to construct the bridge over the canal and asking whether Congress

WILLIAM B. PATTON, THOMAS MCGILVRAY'S PAST AND FUTURE EMPLOYER, WOULD TAKE OVER FROM MCGILVRAY AS DULUTH'S CITY ENGINEER DURING THE KEY YEARS OF THE BRIDGE'S CONSTRUCTION, BUT WOULD IN TURN BE REPLACED BY MCGILVRAY AS THE PROJECT NEARED COMPLETION.

> 22 manholes, 8 receiving basins and 1,[...] yds. of rock excavation.
>
> ## BRIDGES.
>
> Duluth, Minn.—Bids are wanted Mar. 25 for the construction, operation and maintenance of a ferry bridge across the ship canal, as advertised in The Engineering Record.
>
> Nashville, Tenn.—The committee appointed to consider the proposition to construct a bridge over Cumberland River at Broad St. has sub- [...] [...] Head estimates showing the

A NOTICE IN THE FEBRUARY 3, 1901, EDITION OF THE *ENGINEERING RECORD* CALLING ATTENTION TO AN AD FOR BIDS TO BUILD AND OPERATE A FERRY BRIDGE. THE DULUTH CANAL BRIDGE COMMISSION PLACED A SIMILAR AD IN THE *DULUTH NEWS-TRIBUNE*. THE CITY WOULD ONLY RECEIVE ONE BID FOR THE PROJECT, FROM THE MINNEAPOLIS BRANCH OF THE AMERICAN BRIDGE COMPANY.

needed to enact special legislation to give Duluth permission to build on and over the canal and, if so, that he introduce the bill in Congress. Root replied that "as the Duluth canal is a waterway wholly within the state of Minnesota, it is believed that the Secretary of War is empowered…to approve plans for a bridge thereover, if the construction of such a bridge is authorized by the laws of the state." So if Minnesota law allowed the bridge, the federal government could then pass legislation allowing for the bridge, and Duluth could build its bridge. In March Duluth put just such a bill before the state legislature.

The Mayor's annual message to the Common Council, also delivered in March, explained the developments and again stressed the need for the bridge while describing its economic advantages: "The necessity [for a bridge] has long been felt, as the inhabitants of that part of the city known as 'Park Point,' have been cut off from direct communication with the business portion of the town ever since the ship canal was cut, their only means of transportation having been by row-boat or steam ferry, and as the City has been obliged to provide for ferry transportation at a cost of from $8,000 to $9,000 per annum." A bridge would improve that communication, and if its cost—

estimated at $100,000—were spread over a number of years, the improvement would create no additional cost; in fact, it may well be cheaper. Another benefit the Mayor mentioned was that "property on Park Point would be greatly enhanced."

The mayor went on to add that the bridge's plans would create a unique structure, "the only one of its kind on this continent." It would be similar to the bridge already standing in Rouen:

> The design consists of an elevated truss, 142 feet above the water level in the canal, supported by steel towers, the span being 401 feet. The truss is provided with a trackway of rails, on which runs a truck, from which is suspended at a height of 8 ft. above the water and level with the roadway of Lake Avenue, a car 25 ft. in width by 40 ft. in length, capable of carrying a double-truck street car, two or more wagons and teams, as well as a full load of foot passengers. The truck and suspended ferry car are to be moved across the canal at a speed of four miles per hour, the motive power being electricity, which will be applied by a motorman on the car, in the same manner in which street cars are operated.

On March 25 Mayor Hugo, reporting on behalf of the Bridge Commission, explained that the City had only received one bid, from the Minneapolis branch of the American Bridge Company, founded a year earlier by J. P. Morgan. In its bid, American Bridge proposed that in exchange for twenty annual payments of $7,000 each, it would build the bridge and operate it for six months to work out any problems or flaws before handing operations over to the city. The price: $140,000, $40,000 more than the City had expected. Still, it was a sum the city's engineers considered reasonable.

Mr. McGilvray's Inspiration

In 1887 France's Ferdinand Arnodin, the son of a bridge inspector, received the first patent for an aerial transfer bridge, often called a "ferry bridge." But he didn't build the first one; he helped his friend Alberto Palacio build one of Palacio's own design: Spain's Vizcaya Bridge, which connects the towns of Portugalete and Las Arenas at the mouth of the Nervion River. Completed in 1893, the 147-foot-high bridge spans 525 feet and was the first of its kind in the world, carrying both traffic and people from a high suspended gondola. Palacio was a disciple of Gustav Eiffel, designer of the famous tower in Paris, so it's not surprising that his bridge is regarded as "one of the outstanding architectural iron constructions of the Industrial Revolution." But it was Arnodin's transfer bridge in Rouen, France, that inspired Thomas McGilvray's idea to span the Duluth Ship Canal.

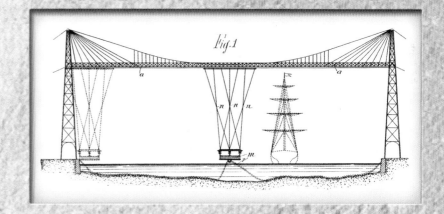

Arnodin's bridge opened on September 16, 1899. Its towers stood 220 feet above the piers along the Seine. It stretched 469 feet across the river, and its span rested 164 feet above the water. Its ferry car, forty-two feet long and thirty-three feet wide, sat twenty-three feet above the water. It had two cabins, one with windows, the other without: first class and second class (first class cost ten centimes and second class five). It crossed the Seine in just fifty-five seconds. In 1940 French Army engineers blew the bridge in a futile attempt to slow the Nazi advance.

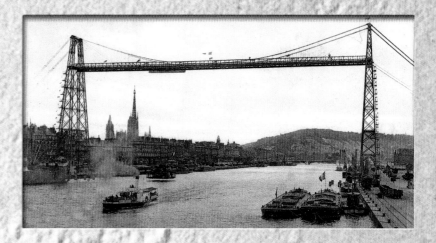

When Duluth's bridge went into service in 1905, transfer bridges were also in use in Newport, England (also an Arnodin design); Bizerte, Tunisia; and Nantes, France, over the River Loire. But Duluth's bridge was the only one of its kind in the western hemisphere. It was also the only stiff-trussed aerial transfer bridge anywhere, and the only ferry bridge operated by an overhead cable system. The others used cables to suspend the ferry car, which was pulled back and forth by a submerged cable or chain which ran through an electrically powered revolving drum on the ferry car. (The cable simply lay along the bottom of the canal when not in use, but while the ferry car was in operation the cable would naturally be pulled out of the water in front of the car and the slack of the cable would sink back down behind the car as it crossed.) McGilvray and C. A. P. Turner (the engineer who actually designed the bridge based on McGilvray's sketch) worried that Duluth's colder climate would cause breakdowns in the winter, and the Duluth canal was only 300 feet wide—there was too great a chance of the cable becoming entangled with a vessel's propellers. This problem spawned the idea of the overhead cable system.

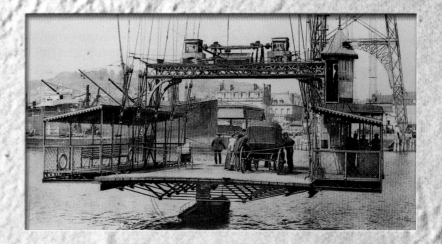

In 1905, the same year the Duluth Aerial Transfer Bridge was finished, two transfer bridges were planned to link the Virginia cities of Norfolk, Berkeley, and Portsmouth by crossing both the north and east branches of the Elizabeth River. The plans were to be nearly identical to those patented by C. A. P. Turner for the Duluth bridge, and McGilvray himself would supervise the construction work done by Modern Steel Structural of Waukesha, Wisconsin, the same firm that built Duluth's aerial bridge. The bridges were never built.

In April 1901 the mayor reported to the Common Council that the Bridge Commission had resolved to enter a contract with the American Bridge Company, contingent on the City Engineer's approval of design and cost and, of course, the federal government's approval. While waiting for that approval, work continued on the plans. At the American Bridge Company, Claude Allen Porter Turner—who had created the company's submitted plans for the bridge based on McGilvray's sketches—was put in charge of the project.

C. A. P. Turner had arrived in Minneapolis just a few years earlier. Born in Rhode Island in 1869, he had earned an Engineering degree at Pennsylvania's Lehigh University before going to work for a number of railroads and bridge-building outfits. He would eventually earn over thirty patents and designed such monumental Midwest bridges as the Arcola High Bridge over the St. Croix River north of Stillwater, Minnesota, and the Mendota Bridge, which links Minneapolis and St. Paul over the confluence of the Mississippi and Minnesota rivers. He also built other famous buildings in St. Paul, including West Publishing, and courthouses in other Midwest cities such as Green Bay, Wisconsin, and Fairmont, Minnesota; he also designed the South Dakota State Capitol building in Pierre. But in the summer of 1901, his focus was on Duluth's transporter bridge.

Throughout the summer Turner corresponded with McGilvray and City Engineer Patton in Duluth to refine the plans. Turn-er also traded letters with Captain D. D. Gaillard, in charge of the Corps of Engineers—and therefore, the canal—in Duluth. Gaillard worked nearly his entire life on canals, and after leaving Duluth in 1903 would rise to the rank of Lieutenant Colonel while working on the construction of the Panama Canal. (Sadly, Gaillard would die before the Canal opened in 1915; President Woodrow Wilson would rename a portion of the canal known as the "Celubra Cut" to the "Gaillard Cut" and raise Gaillard's rank to full colonel posthumously.) Gaillard suggested that the bridge plans be enhanced by the addition of ornamental towers reaching above the bridge's span. They would not make it to the final design. In his letter to Gaillard, Turner stated that he expected the foundations to be complete by November 1, and the support towers would stand by the first day of 1902. The American Bridge Company would complete the entire job by April 15 of that year.

But before that bid could be accepted and a contract signed, Duluth still needed the government's permission to build the bridge. The American Bridge Company wrote the city in June, urging them to push to obtain that permission, suggesting Mayor Hugo travel to Washington, D.C. to lobby in person. Hugo did not go to Washington, but on June 20 City Attorney Mitchell sent Acting Secretary of War William Sanger, Root's temporary replacement, a draft of a bill authorizing the city to construct the bridge over the canal. Sanger, noting that the city was asking to permanently occupy federal property, claimed the War Department had no authority to grant that permission and could

only provide a revocable license. Congress had adjourned for vacation—failing to garner approval would delay the project another year, the newspapers announced.

So Mayor Hugo and Minnesota Congressman Page Morris went to work on the War Department, renewing Duluth's attempt to gain temporary permission to start work immediately, without waiting for Congress to reconvene. Their efforts were better received by Sanger's successor, Acting Secretary of War G. L. Gillespie. Good news arrived in early September, when Gillespie granted a permit—actually a revocable license—to build the bridge and to occupy government property during construction. It stipulated that the bill before Congress to allow the city to permanently occupy the bridge site must pass in the next session or the permit would be revoked. That permission wouldn't officially arrive until February 1902, but no one had any doubts as to its passage and meanwhile the path had been made clear; Duluth could start building its bridge.

Hugo went straight into action, writing to the American Bridge Company asking to begin building straight away. He then convened the Bridge Commission, which immediately started drawing up contracts so that the bridge would be operating as soon as possible. The terms remained the same: American Bridge Company would build the bridge and operate it for its first six months; Duluth would pay $100,000 for the bridge in twenty annual installments of $7,000; the $40,000 in interest was considered "reasonable."

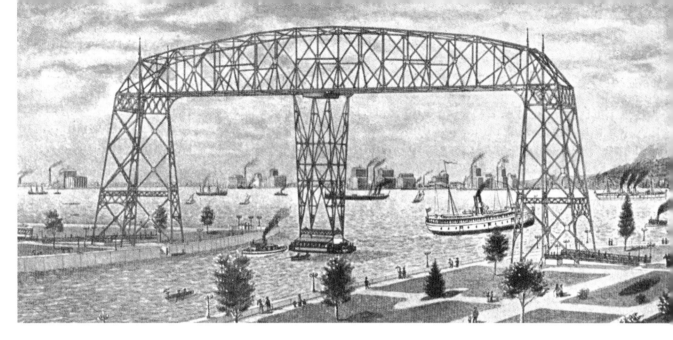

But yet another fly had fallen into the ointment. Earlier in the year, American Bridge, owned by J. P. Morgan, merged with Morgan's newly created U.S. Steel (USS). The parent company's articles of incorporation prevented American Bridge from taking payment "on the installment plan." And so directors of American Bridge—including George F. Edwards, president, and W. H. Osborn, secretary—created the Duluth Canal Bridge Company (DCBC) "for the purpose of taking the contract off the American Bridge Company's hands." The new company, under the direction of General Manager A. Y. Bayne, also allowed the creation of a new contract. American Bridge claimed the ultimate price of $140,000 would violate the legislative act that allowed for the bridge to be built "at a price not to exceed $100,000." So the DCBC would require a new contract, one that paid for construction with a bond. Under USS, American Bridge could not issue bonds. But the DCBC was not a direct subsidiary of USS. It could both enter into the contract and issue bonds.

THE FIRST DRAWING OF DULUTH'S PROPOSED AERIAL TRANSFER BRIDGE, BASED ON PLANS BY C. A. P. TURNER. THIS IMAGE FIRST APPEARED IN THE *DULUTH NEWS-TRIBUNE* IN 1901 AND WAS LATER USED TO ACCOMPANY AN ARTICLE IN *ENGINEERING NEWS*.

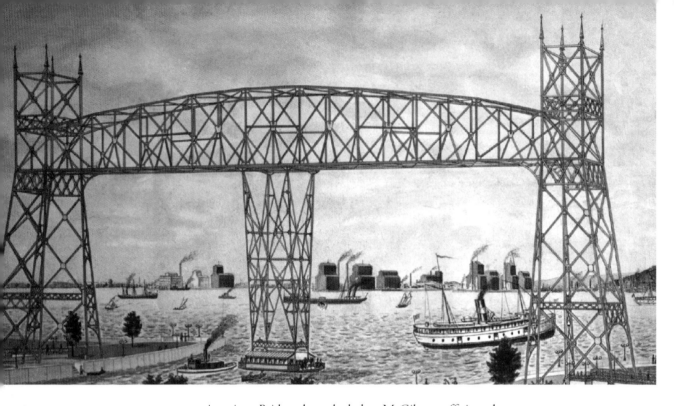

by DCBC at 4 percent interest. The company would give Duluth a $25,000 surety bond, guaranteeing the work would finish on time. The bridge's plans were outlined in the City Engineer's annual report of 1901:

> The plans, as approved, are for a stiff riveted girder of 393 ft. 9 in. span, supported on steel towers resting on pile and concrete foundations, with the bottom chord of the bridge 135 ft. above high water. The ferry car is suspended by stiff, riveted hangers from trucks running on tracks placed within the bottom chords of the trusses. The car is proportioned to carry a loaded streetcar of 21 tons, and the remainder of the floor loaded with 110 pounds per square foot.

The ferry car itself would be fifty feet long and over thirty feet wide, with a seventeen-foot-wide center roadway and seven-foot-wide walkways on either side. The middle thirty feet of each walk would be enclosed to form a cabin. Cables powered by two fifty-horse-power electric streetcar motors installed beneath the ferry (only one would operate at a time, the other reserved as a back up) would drive the ferry car at a rate of four miles an hour. The motors turned a drum on the side of the car; the cables wound around the drum and up to a traveling pulley—a

American Bridge also asked that McGilvray officiate the construction by acting as resident engineer for the DCBC, which would act as the general contractor. So on October 7 the Common Council returned the American Bridge Company's deposit and immediately authorized a proposal for the city to enter a new contract with DCBC. The new company's letterhead featured a drawing of the proposed bridge, complete with Captain Gaillard's ornamental towers.

The new contract called for the bridge to be complete by April 1, 1902, barring any unforeseen delays; if delayed, the DCBC had until May 1, 1903, to finish the job. Plus, the company would run the bridge for at least three months once it was operational, but no more often than once every fifteen minutes from 6 A.M. until midnight and once every half hour from midnight until 6 A.M. The cost would be $100,000, paid for with bonds issued

DULUTH'S AERIAL TRANSFER BRIDGE

PLANS FOR PROPOSED BRIDGE PUBLISHED IN *ENGINEERING RECORD*, MARCH 20, 1902

THESE C. A. P. TURNER DRAWINGS ACCOMPANIED AN ARTICLE ON THE BRIDGE WRITTEN BY WILLIAM B. PATTON, DULUTH'S CITY ENGINEER AT THE TIME.

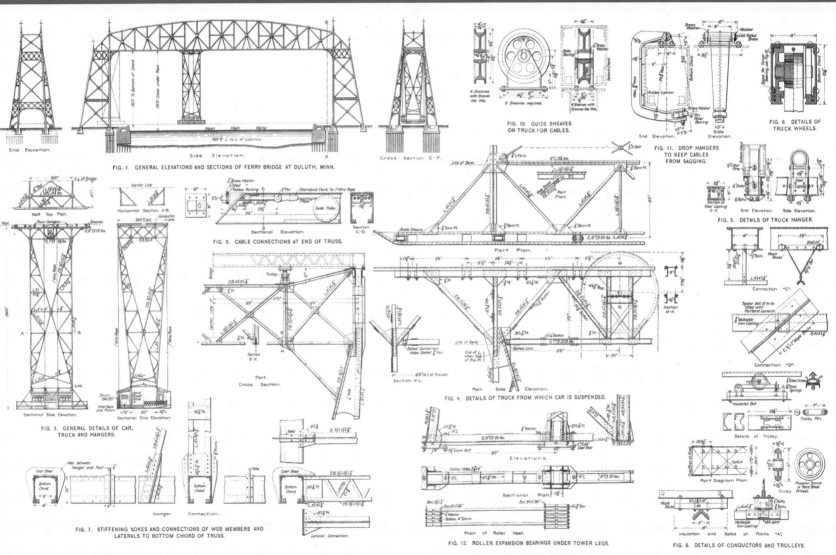

SUSPENDED CAR TRANSFER BRIDGE ACROSS DULUTH SHIP CANAL, DULUTH, MINN.

DULUTH'S AERIAL TRANSFER BRIDGE

PLANS PUBLISHED IN *DULUTH AERIAL FERRY BRIDGE*
(SOUVENIR BOOKLET, 1905)

THESE C. A. P. TURNER DRAWINGS ACCOMPANIED PHOTOGRAPHS OF THE BRIDGE WHILE IT WAS BEING BUILT (SEE PAGES 58 – 63) AND TEXT BY THOMAS MCGILVRAY. THE GLOSSY BOOKLET WAS SOLD AS A SOUVENIR OF THE BRIDGE'S OPENING DAY OF SERVICE.

TURNER'S PLANS CALLED FOR A STIFF RIVETED GIRDER SPAN 393 FEET, 9 INCHES LONG SUPPORTED ON STEEL TOWERS; THE BOTTOM RAIL OF THE BRIDGE SPAN WOULD REST 135 FEET ABOVE HIGH WATER TO ALLOW SAFE PASSAGE OF LARGE VESSELS. THE FERRY CAR WOULD HANG BY STIFF, RIVETED HANGERS (EVERY OTHER FERRY BRIDGE IN THE WORLD USED CABLES) ATTACHED TO TRUCKS RUNNING ON TRACKS PLACED WITHIN THE TRUSSES' BOTTOM RAILS. THE FERRY CAR—50 FEET LONG AND 30 FEET WIDE—WAS DESIGNED TO CARRY A LOADED STREETCAR OF 21 TONS AS WELL AS PASSENGERS AND AUTOMOBILES.

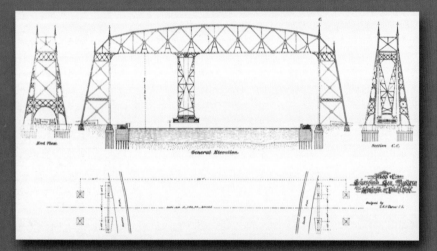

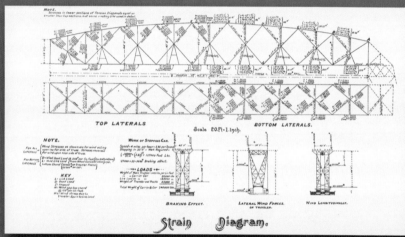

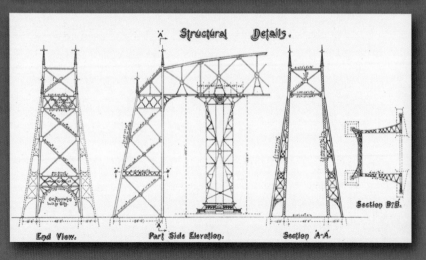

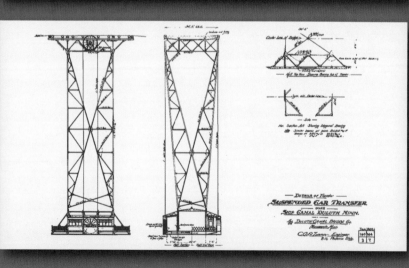

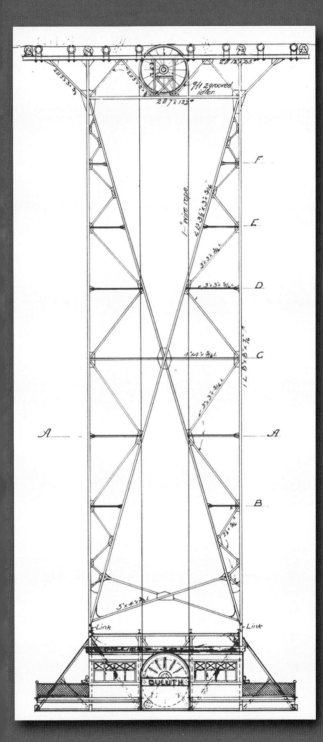

truck holding many sets of wheels, really—that rode along the truss. The revolving drum set the car in motion. If the electric motors failed for any reason, operators could use a hand gear to move the car safely to shore and out of the way of oncoming vessels. When at rest, the ferry car would hang over dry land, allowing ships to pass freely.

A company on paper only, DCBC sublet the structural work back to the American Bridge Company; now relieved of the burden of financing the project, American Bridge could handle the iron work without violating USS's articles of incorporation. The shadow company then hired the Duluth firm of Hugo & Timms to build the bridge's foundations, which was well into its task by the year's end. Around this same time Turner left the American Bridge Company to start his own Minneapolis consulting firm.

1902: A FOUNDATION, BUT NO BRIDGE

With the DCBC in place and the subcontractor hard at work on the foundation, 1902 looked promising for Park Pointers and all who wanted a bridge. On February 7 the revocable license granted in September of 1901 was finally approved by Congress. The March 20 edition of *Engineering News* featured an article on the bridge—the first of its kind in the hemisphere and the only stiff-trussed transporter bridge in the world—written not by Turner or McGilvray but by City Engineer W. B. Patton, complete with plans and an artist's conception of the finished bridge. These plans, however, no longer included the ornamental towers suggested by Captain Gaillard.

But by March plans had hit a snag, a glimpse of the logjam ahead. Although Hugo & Timms had completed the foundations, the DCBC reported that it had become impossible for the company to secure the steel needed to build the bridge; construction would be delayed until at least 1903. The company also continued to struggle in its efforts to raise money for the

project. They eventually acquired a $25,000 surety bond from Duluth's Commercial Investment Company; $75,000 short of what they needed, but enough to allow them to pay for the pier foundations. Meanwhile, Patton got C. A. P. Turner back on the project by hiring his consulting firm to inspect all the material and machinery for the bridge.

In August DCBC showed signs of balking at the project. Citing alterations to the plans by City Engineer Patton that would increase costs, the company requested its contract be modified—Duluth would have to give up its right to have the completed bridge tested before it paid DCBC for the structure. While going over DCBC's plans prior to the ultimate signing of the contract, Patton had noticed that its specifications would have created an unsafe structure, so he sent back alterations that would make the bridge 25 percent stronger. DCBC agreed to make the changes. In an article in the *Duluth News-Tribune* on August 15, Patton suggested that DCBC was using the changes to weasel out of its contract because it was having a difficult time raising the money to pay for it. "I know that a bridge of this kind," Patton said, "which may or may not be accepted and paid for after it is built, is a poor proposition to borrow money on, and it might be a difficult matter to float the bonds with the contract as it is now."

Patton's assessment was spot on: Four days later DCBC wrote to Mayor Hugo withdrawing its modification request, claiming it had made arrangements to secure the bridge's financing, so it would no longer ask the city for any more "favors" such as contract changes. A newspaper report on the matter hinted that in the event DCBC could not uphold its end of the contract, an unnamed firm willing to take over the contract had already contacted the mayor.

Seeing no progress made over the summer, and noting that another outfit was eager to build the bridge, residents of Park Point began getting impatient. In October they sent a petition to the Common Council urging the Council to either hold DCBC to its contract and its deadlines or enter into a contract with a firm that could get the job done by the time shipping resumed the following spring. The petition was nothing new to Park Pointers: they had been on top of the Council to provide a bridge since rejoining Duluth (and, of course, had demanded a bridge since the digging of the canal). Since the government had rejected the Waddell Bridge idea back in 1892, residents had tenaciously taken every opportunity to illustrate the need for a bridge by complaining repeatedly about the inconsistent and unsafe ferry system (see "End of Regular Ferry Service, End of an Era." page 67).

They could complain all they wanted, but DCBC couldn't procure any steel and doubted any one else could. In a letter to Patton in November, DCBC general manager Bayne reported that it would be impossible for his firm to have steel delivered until March 1903, and with the shipping season to open in April, it would be another year of delays for the bridge. Bayne then stated that he doubted the validity of the Park Pointers' petition, claiming that, "if you, or they, know of any one willing to take the contract and erect the work this winter, we will be glad to turn over to them all material, plans, etc. that we have and assist in every way possible in building this bridge." In other words, Bayne implied, if someone thinks they can do this by next April, good luck to them; if not, don't bother us with any more foolish petitions.

The city had grown as impatient as its residents south of the canal. In November the Bridge Commission wanted the city to make a clear statement of its frustration. It advised against litigation at that time, as DCBC did technically have until May 1, 1903, to finish the bridge, a feat quite impossible if steel didn't arrive until March. The company would eventually default on the contract, and the city would be able to act once the deadline passed. In the meantime, the Bridge Commission suggested the city go on record regarding its intent to firmly hold DCBC to its contract. On November 17 the Common Council unanimously passed a resolution insisting on "strict compliance" with the contract and that, should DCBC default on its contract, the city would sue the company for damages and force it to complete the construction. The strategy now was to simply sit tight and wait for DCBC to default.

Within days rumors started flying that DCBC had abandoned the bridge project, which City Attorney Mitchell told the newspaper he did not believe, but admitted the rumor was not entirely unfounded. Mitchell called building the bridge by the deadline "improbable" but suggested DCBC had too much invested to "throw up the contract." He optimistically suggested the project would be finished within the year. On November 22 the newspaper reported on an upcoming meeting between DCBC and the city, saying that the Bridge Commission planned to "give the Canal Bridge company a touch of strenuous life" by insisting the company get to work. The paper suggested this sort of tough-love would not only be good for the DCBC, but serve as an example to other contractors as well: "Let not Duluth get the reputation of being an easy mark for anybody."

At the conference, held on November 22, DCBC said it had done all it could: Despite rumors to the contrary, 90 percent of the structure's steel had been paid for and delivered to American Bridge, but shop work—cutting to length and some riveting—could not be done in time for the bridge to be built over the winter of 1902–1903. The meeting ended with DCBC saying it would make a formal request to extend the deadline so that the bridge could be built the winter of 1903–1904. The City denied the request, sticking to its plan to wait for DCBC to default the following May.

A LETTER FROM C. A. P. TURNER TO MAYOR HUGO IN DECEMBER 1902, POINTING OUT THAT THE DULUTH CANAL BRIDGE COMPANY HAD NOT SECURED SO MUCH AS "AN OUNCE OF METAL" AND WAS NOT IN GOOD STANDING WITH TURNER, WHO OWNED THE PATENT TO THE BRIDGE PLANS.

The Duluth Boat Club

In 1886 eleven local men got together to form the Duluth Boat Club and soon after built a grand clubhouse along the harbor at Seventh Avenue West on the Northern Pacific Slip in St. Louis Bay. A second clubhouse was built at Tenth Street on the bay side of Minnesota Point in 1903. Three years later, the club acquired the former Duluth Yacht Club and moved it to Oatka Beach, three miles down the Point, by dragging it over the ice in the winter.

The club was a Mecca for sports wet and dry: tennis, swimming, rowing, canoeing, sailing, and others. At its peak in 1912 the exclusive club boasted 1,400 members (the largest club of its kind in the nation) and became the hub of social activities for Duluth's elite, hosting lavish parties, banquets, dances, and other events. When the second clubhouse opened in 1903, five hundred people attended the gala affair. Duluth's newspapers' society columns called the dance floor the city's "most exclusive ballroom."

The Boat Club produced twenty national-champion rowing crews led by coach James Ten Eyck Jr., who had been hired by Boat Club benefactor Julius Barnes (pictured). In 1916 the Club played host to the national rowing championships. But by 1926 Ten Eyck had left, and automobiles were all the rage. Starving for funds, the club closed its doors. Barnes, who almost single-handedly financed the club, had made his fortune in the grain trade, replacing Herbert Hoover as Chairman of the Board of Directors of the Food Administration Grain Corporation, and later becoming president of the United States Chamber of Commerce. He and business partner Ward Ames paid for the construction of Duluth's downtown Y.M.C.A. and Y.W.C.A. facilities and the Barnes-Ames building on Second Avenue East. In 1930 Barnes' face graced the cover of *Time* magazine, and his fellow Duluthians named him "First Citizen of Duluth" for his giving ways. At the end of his life he had sold his grand east end home and moved to the Holland Hotel, at the time long past its prime as a luxury hotel and part of Duluth's "Bowery." When Barnes died in 1959, he was nearly penniless.

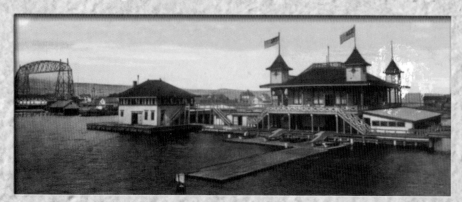

1903: THE DELAYS CONTINUE

The "Ferry Bridge" portion of the City Engineer's annual report for 1903, published in 1904, begins, "This much desired project has passed through another year of vexatious delay." It is an echo of a sentiment shared by Mayor Hugo, whose annual report to the Common Council in March 1903 began, "It is very annoying to have to report little progress on the Duluth Ship Canal Bridge…." No work had been done since the foundations had been completed nearly a year earlier. In his report the Mayor cited an even greater demand for the bridge: "It is not needed for convenience sake alone but for the safety of the hundreds of citizens who now use the ferry, and the crowds who swarm to Park Point during summer months." And the crowds would only grow: that summer the Duluth Boat Club moved its headquarters to a new clubhouse it had built on the bay side of Park Point at Tenth Street; at the time, the Boat Club was the social hub of Duluth's elite (see "The Duluth Boat Club," left). Hugo recommended that when the contract with DCBC inevitably lapsed in May, the City should clear any claims the company has on the foundations and advertise for fresh bids—the process would start all over again.

The deadline lapsed, and on May 18 the Mayor reported to the Common Council that the New York firm of Roebling & Sons stood ready to build a suspension bridge—not a stiff-trussed bridge as planned. That same day C. A. P. Turner showed his passion for building the bridge according to his plans. Turner knew the bridge would be a big deal: it would be the first transfer bridge in the western hemisphere, and the only stiff-trussed transfer bridge anywhere in the world; designing it would certainly propel his career. He had previously told the Commission he knew of a firm ready to take on the project following his plans, and in a letter to the Common Council stated he would gladly provide the city with his complete working details of the

ferry bridge so the City could better compare bids. The same letter outlined the trouble a suspension bridge would create and stated that a bridge following his plans could be built in a year, nine months if the contract included bonuses for early completion. Newspapers reported that Turner himself offered to finish the work, claiming to have "ample backing" to see the project to its end.

In a letter to the Common Council on May 23, Mayor Hugo reminded the Council that the contract had officially lapsed and that the city should resolve to eject the Duluth Canal Bridge Company from the foundation site and once again open the project to bids. The Council also received a petition from the residents of Park Point, making the same claims and requests the Mayor had. A resolution passed two days later.

Finding a company to take on the project proved no easy task. Faced with building Turner's transfer bridge, and not a suspension bridge, Roebling & Sons declined to bid, stating they could not build the bridge specified for less than $160,000. An attempt to lure back American Bridge also failed, as the company claimed the bridge could not be built for $100,000—that price had been set by the State, and Duluth could not change it. Eager as always to get the bridge built according to his plans, Turner went east, courting every bridge-building outfit he knew of: Cleveland's King Bridge Co., the Phoenix Bridge Co. of Philadelphia, McClintic-Marshal Construction Co. in New York City, and several others. Not a single eastern firm was willing to take on the project. The possibility of getting his bridge built seemed to be slipping away from Turner; certainly the good people of Park Point were equally frustrated.

In August, looking closer to home, Turner at last found a willing company. The Modern Steel Structural Co. (MSS) of Waukesha, Wisconsin, submitted a bid—the only one received—and contract negotiations followed.

But DCBC wasn't quite done. The shadow company claimed it owned C.A.P. Turner's plans as well as the foundation piers it had built under the contract. According the City Attorney Mitchell, DCBC "had given a trust deed upon all of its interest in the contract, with the city and in the work done under it, and bonds were issued secured by that trust deed." Indeed, the company had secured a $25,000 bond. The Common Council wanted the City to take legal action, but Mitchell advised that any legal proceedings against DCBC could delay contract negotiations with MSS, as it would have raised questions whether Duluth even had the right to enter into another contract. So, while in his opinion DCBC had no legal claim over the foundation piers, Mitchell suggested the city give DCBC $5,000 to settle any claims of ownership it may make over the plans or foundation piers; DCBC's attorneys held that they had a valid lien of $20,000 on the piers alone. The Common Council rejected Mitchell's proposal, deciding to wait and see if DCBC would bring any action. Sure enough, the company did place a lien on the foundation. The city paid the lien holder, Duluth's Commercial Investment Company, $3,500 to settle the matter. City records show no more correspondence with DCBC.

A FIERY MISSIVE FROM C. A. P. TURNER TO ASSISTANT ENGINEER E. R. COE IN JANUARY 1904, ALL BUT THREATENING COE TO MAKE SURE MSS STICKS TO TURNER'S PLANS. THE ANGRY LETTER CLOSES WITH A FRIENDLY POSTSCRIPT ASKING AFTER THE HEALTH OF THOMAS McGILVRAY, DULUTH'S ONCE AND FUTURE CITY ENGINEER.

Meanwhile, MSS was not pleased with the contract's financing terms, and rejected it. But MSS still wanted the job, and so resubmitted their bid but this time did not precisely follow the requirements posted in the advertisement. The Council accepted this proposal, but would have to wait until a court decided if the contract was valid in light of the previous DCBC contract.

That process involved several court proceedings and a test suit to determine the contract's legality that wound up in the Minnesota Supreme Court. On November 9 the Court upheld that Duluth was proceeding correctly under law, but that it had seen evidence MSS and Duluth had gotten together to discuss terms prior to the proposal's submission. It also held that the contract must go to the lowest bidder. So Duluth could proceed, but not under the current contract with MSS. The bid process must start once again.

The city immediately reopened the process, setting a deadline of January 23, 1904, for bids on a ferry bridge to be completed by November 1, 1904. Anticipating it would receive no other bids, the city continued its negotiations with MSS. Turner would keep his finger on the bridge's pulse: the sale of his plans to MSS included him staying on the project as consultant.

1904: THE BUILDING FINALLY BEGINS

The deadline for bids came and went with no other submissions, but a contract with MSS wasn't signed until July 20. Not that that had slowed work. During the entire time the contract was under negotiation, Turner worked with MSS to refine the bridge plans. Matters arose over the type and horsepower of the electric motors, load specifications, wind pressure, a housing for the roller-bearing trucks, even the number of rivets used per foot. It wasn't always the smoothest of processes, as Turner tenaciously fought to hold MSS to his ideas.

In January 1904 Turner noted that MSS had changed some of his plans for the ferry car, using a cheaper wood than the mahogany he had specified and leaving out the rubber tile floor his plans called for. So he wrote to assistant engineer E. R. Coe in Duluth's City Engineering Department urging him to "be stiff with these people" about the plans and that he was worried MSS was "trying to skin C.A.P.T. and the city." He all but scolded Coe: "Will say frankly that if under the conditions your department does not succeed in getting that car finished right you are not onto your job as far as looking after the city is concerned." Tough as he sounds, Turner's letter also expressed he felt Coe was up to the task and then asked after McGilvray in a postscript that read, "Trust this finds friend McG in better health."

Whatever McGilvray may have been suffering from, he soon recovered: on March 26 he took over Patton's position as City Engineer, allowing the man who brought the ferry bridge idea to Duluth to see the project through to its completion. Although Marcus B. Cullum had replaced Hugo as mayor in 1904, McGilvray's return may have been more than Duluth politics. Weeks before McGilvray reentered the City Engineer's office, Turner had become frustrated with Patton. In a letter dated March 10, Turner eloquently addresses trouble between them: "As a personal matter between men having full respect for the

honesty and frankness of each other I think the disquisition rag will bear a little further chewing between us to our mutual advantage and better understanding."

The letter indicates that Patton had initiated some design changes contrary to what he and Turner (and MSS) had previously agreed on, suggesting that the sway system Turner had specified wasn't sufficiently strong and needed bolstering. But Patton and his assistants had misread the specifications upon which they based their calculations, and Turner was angry about the time and expense needed to create "an exact diagram that good-naturedly explained [Patton's] erroneous method" when, with a little courtesy on Patton's part, the whole matter could have been explained in fifteen minutes. Turner then pointed out that while Patton's salary was guaranteed by his position with the city, Turner himself was "forced to accomplish results in

securing his bread and butter." Patton should be more considerate of his time, Turner implied, because Turner had to actually work to earn his money.

After receiving Patton's conciliatory reply, Turner told the City Engineer that he was "glad to see you recognize that our interests should be identical" and then praised Patton's "good judgment" in abandoning his own proposed changes and staying with Turner's plan. But once he took these small jabs, Turner turned his full focus once again to the bridge.

Meanwhile MSS worked without a contract, urging approval of the tower plans by March 11 so the company could immediately start building them. W. H. Hoyt, an engineer with the Duluth, Missabe and Northern Railway (DM&N), inspected and approved the steel for the towers and, later, the roller bearings. He expressed concern over the housing for the roller bear-

The Persistant Mr. Strauss

As Duluth struggled to find a firm to build its bridge during the summer of 1903, at least one Chicago engineer was more than willing to give it a try. The trouble was, he didn't want to build on C. A. P. Turner's plans; he wanted to build a bridge of his own design.

Joseph B. Strauss got off on the wrong foot, assuming that bidders were to submit their own ideas. His plan called for a transfer bridge whose ferry car actually rode up into the bridge's superstructure, not a suspended car as Turner's plans called for. Its design also did not allow for a 136-foot height clearance across the canal's entire width, a Corps of Engineers' requirement.

Still, he kept writing Duluth City Engineer W. B. Patton asking that his idea be considered. He insisted that his plan was "an improvement over the Turner design in cost, appearance, freedom from interference with river [sic] traffic and also in the pleasure of the ride." Each time Patton said no, Strauss wrote back ever longer letters. When told the design would not work as submitted, he suggested lengthening his bridge, which would mean destroying the existing foundations and building new ones, projects that would eliminate any cost savings over Turner's plan.

Strauss's final letter to Patton is dated November 28, 1903, but he must have implied to his fellow Chicagoans that his plan was an option approved by Duluth. Unaware that the city was already working with Modern Steel Structural, in January of 1904 Chicago contracting engineers Roemheld & Gallery asked Patton for the chance to bid on the "Strauss design."

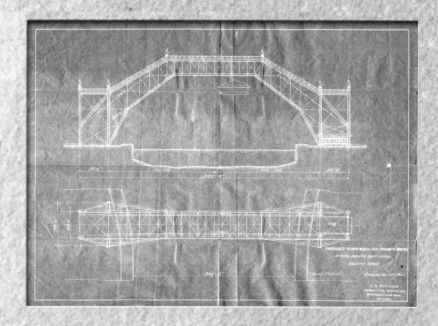

While Strauss gave up on his Duluth suspended car transfer bridge, he was apparently more convincing to the city of San Francisco: he went on to design the Golden Gate Bridge.

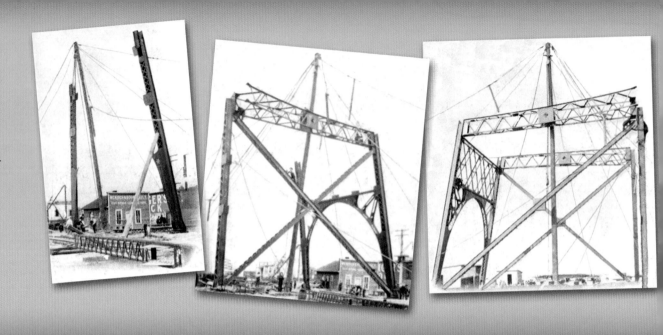

ings, seeing no protection from "blocking up with sand in the summer and snow and ice in the winter." These "roller nests" and the bearings they held were the key to the bridge's smooth operation, and time would prove that protecting them from the elements wouldn't be their only problem.

On July 20, officials from the city and MSS finally signed a contract. Two days later the first carload of steel arrived at the piers. The testing laboratories had found the metal work excellent, with all parts "fitting perfectly, without reaming or drifting." On August 1, workers had the leg of one of the towers in position. By October work was well underway, and other than a reminder from the head of the Corps of Engineers to be more careful to protect the government's piers—on October 10 builders had accidentally broken off a lamp post on the North Pier—it was progressing smoothly.

In mid November both towers stood in place, but workers had to wait for the shipping season to end before putting up the "false" wooden supports needed to bolster the towers as the truss was built piece-by-piece to connect them. MSS had, according to McGilvray's annual report, worked with the engineer's office "with the utmost courtesy, and has promptly attended to everything pertaining to the safety of the public." McGilvray even expected the company to turn the bridge over to Duluth before April 1, 1905.

1905: A NEW ERA BEGINS

In the early days of 1905, the bridge was progressing nicely. The towers and false supports were in place, and the truss was beginning to take shape, with metal work reaching from both towers toward the center. McGilvray brought up a matter previously overlooked: small stations to keep passengers warm and dry while waiting their turn to cross. Railroad engineer James H. Marcy wrote McGilvray offering to build the structures at his own cost if he were given the land and a license to operate a "cigar, stationery, and confectionary store" in each of the buildings for five

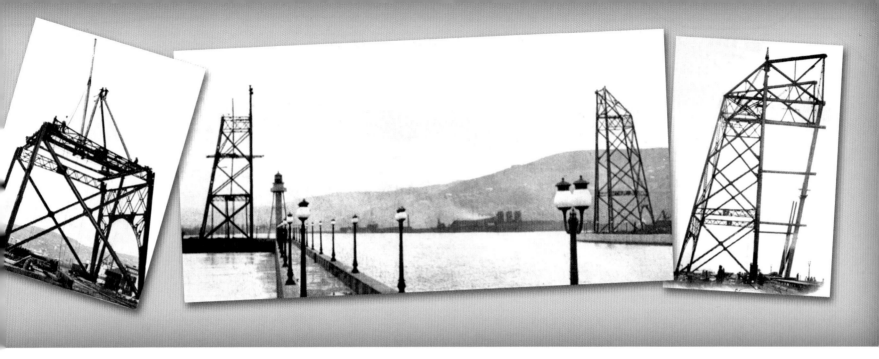

years; after that, the city could extend the license or purchase the buildings from Marcy and lease the buildings to another party. For these small structures, McGilvray turned to prominent Duluth architects German & Lignell. Major Charles L. Potter of the Corps of Engineers, Gaillard's replacement, approved the plans, which called for concrete block structures capped with ornamental red roofs estimated to cost $1,450 each.

By February the bridge was near completion, and later that month McGilvray invited two hundred people to witness the ferry car's first crossing. He included local dignitaries to take the ferry's first ride: Mayor Cullum; Common Council President Roland D. Haven; aldermen Thomas F. Trevillion, Benjamin K. Walker, and Lucien A. Barnes; A. B. Wolvin; Judge W. A. Cant; J. P. Johnson; Colonel Hubert Evra; attorney Frank Crassweller; W. A. Culkin; Chief of Police Chauncy H. Troyer; police captain Frederick E. Resche; Cameron Hewitt; D. G. Cash; C. C. Cokefair; J. B. Darling; C. A. Coleman; J. L. Owens; former City

Engineer Patton; City Attorney Bert Fesler; County Surveyor W. H. Wadsworth; Chief Engineer Herman L. Dresser and William Hoyt of the DM&N; John H. Dwight and W. S. Bishop of the First National Bank; Clyde Iron Works manager C. A. Lester; and members of McGilvray's staff, including Axel Wilson, E. R. Coe, Charles Drew, and J. Neff.

Representatives of MSS also got on board for the first crossing, including treasurer J. K. Lowry, foreman D. M. Carr, and electrical engineer Charles Adrian, as well as the structural steel workers, the men who actually built the bridge: F. Schmidtz, E. Foucoult, B. Keenan, H. Larson, J. Schrod, E. Knight, and Gus Rakowsky.

At 4:30 in the afternoon of February 23, 1905, these men entered the car at the south tower and prepared to cross. The bridge was not yet fully complete—some of the false wooden work still stood against the south tower where it had once been needed to support the bridge before the main truss was

complete. The newspaper fancied that the ferry car would "glide gracefully out over the canal and the hopes which the residents of Park Point have held for years will be realized."

To ensure safety, men were posted at the top of the bridge so they could identify any problems with the trucks in time to warn of an impending accident. McGilvray himself controlled the car, which began rolling without so much as a hiccup. One of the workmen posted atop the bridge decided to have a little fun with the crowd, striking at the false staging work with a wooden plank and shouting for Adrian to shut off the power. Afraid that "heavy objects were about to crash to the deck," many of those invited on board sought protection under the car's awnings. After a good laugh—and reassurance from Lowry that a joke had been played, nothing more—the ferry car moved ahead. Riders felt "only a slight vibration" while the car moved northward. As it reached the north end of the canal with "a gentle motion, an almost imperceptible contact against the air cushion in the approach, it stopped and locked automatically."

The entire trip lasted one minute and fifteen seconds, but it had been over fifteen years in the making. The ferry car then returned to the other side without any passengers disembarking to complete their trip across the canal.

There were no women aboard the first trip—a sign of the times. It wasn't until March 5 that the ferry car first transferred a woman across the canal. Mrs. Emil Borth of 1624 East Seventh Street, who had carefully watched the bridge's construction, became determined to be the first person across. So she approached workers and asked for a ride, and they obliged her, telling the newspaper that, "she was alone in the car and thoroughly enjoyed the little thrill of being part of so tremendous and important an enterprise." The paper went on to claim that, since the ferry's inaugural run didn't actually deliver anyone across the canal, Mrs. Borth was not just the first woman to cross the canal in the ferry car, but technically the first person period to cross via the aerial bridge. The story did not mention that bridge workers already used it regularly and an operator was on board during all crossings.

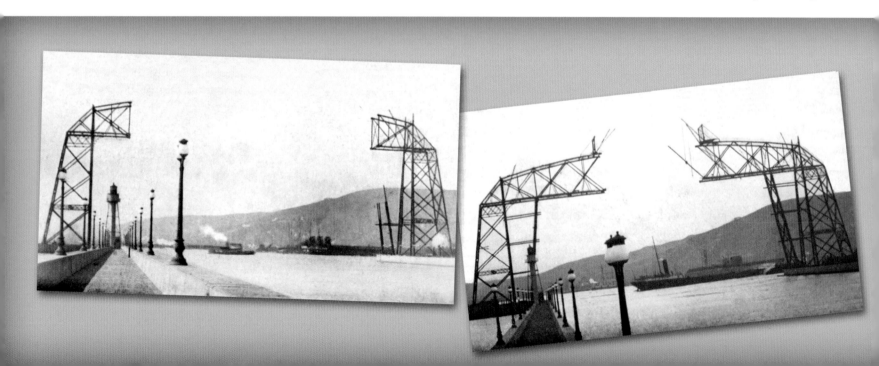

Encouraged by the test, the *Duluth News-Tribune* estimated the city would take control of the bridge by March 20, when work on the ferry car was scheduled to be complete. That proved a little too hopeful, as five days after the test MSS wrote to McGilvray requesting an extension: weather had created extremely dangerous conditions, causing unforeseen delays. MSS needed until April 1 before opening the bridge to public use and, consequently, until at least May 1 before Duluth could receive the bridge. McGilvray passed the request on to the Common Council, which extended the deadline to May 1.

On March 4 the last of the wooden false work on the south tower came down: outside of "a number of small jobs, which are unimportant, but which require time for their completion," the bridge was ready. Those tasks included painting the structure: two coats of olive green they had hoped to have on in time to honor St. Patrick's Day (alas, work was delayed until March 20). Workers painted the lower chord first because the upper chord could be painted once the bridge was in operation.

The ferry car also required many finishing touches, but these would not stand in the way of the bridge's opening "on or before All Fool's Day," as the paper reported, adding that those who would summer on Park Point that year would not need the ferry to move their belongings over the canal.

As a final safety measure, MSS decided to see if the bridge could carry the load C. A. P. Turner had specified. On Friday, March 24, after several test runs with just people aboard, workmen loaded the ferry car with sixty-five tons of steel rails, reels of phone wire, cable, a steam boiler, and heavy timber, "greater than any load that the bridge is likely to be called on to carry, at least until street cars are taken across." Even under all that weight, the bridge operated smoothly. MSS prepared to open the bridge to the public the following Monday.

An estimated crowd of over five thousand showed up on Sunday, many hoping to ride the ferry. They found disappointment instead: MSS officials did not want to open the bridge on a Sunday because of the potential crowd size; they didn't want

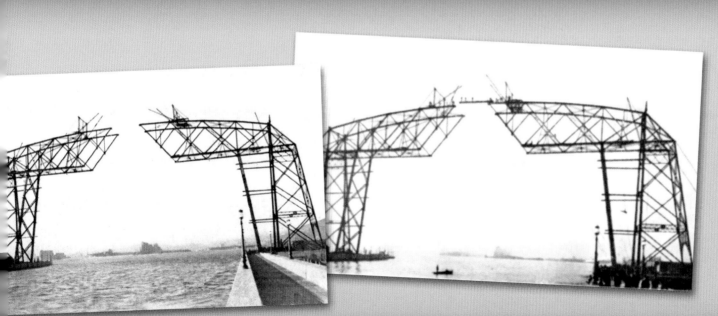

DULUTH'S AERIAL TRANSFER BRIDGE UNDER CONSTRUCTION. THE NEAR RIGHT PHOTO WAS TAKEN JUST BEFORE THE TWO HALVES WERE FIRST JOINED. NOTE THE CONSTRUCTION WORKERS ATOP THE UNSECURED BEAM, THE CROWD GATHERED TO WATCH, AND THE ROWBOAT POISED BELOW IN CASE SOMEONE FELL.

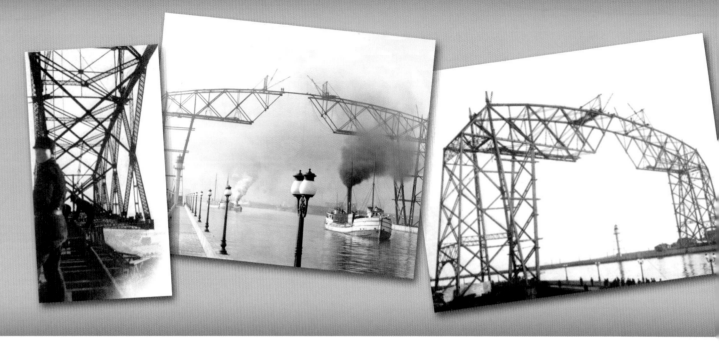

any minor problems in the operation to cause "unfavorable comment" and perhaps even raise fears among "many by whom the new bridge is viewed with distrust." A good thing, it turned out: that day the power cables feeding the electric motors broke.

Wishing to avoid yet another delay, electricians worked to reconnect the cable, and shortly before 6 P.M. on Monday, March 27, with forty people aboard and Gus Rakowsky of MSS at the controls, "the ferry car commenced regular trips." That very evening it was making runs every five or ten minutes. The next day the *Duluth News-Tribune* announced the opening with flair: "Aerial Car Crosses in Teeth of Howling Gale," it announced, reporting that the bridge operated "without a hitch" despite gale-force winds.

The *Duluth News-Tribune*'s reporter stayed with the bridge all evening, and his account paints a vivid picture of the bridge's first day of public operation. Early trips contained an average of twenty to thirty passengers, but by the end of the evening folks were crossing in twos or threes. Throughout the evening the winds picked up, and by 9 P.M. it had "the force of a hurricane." The wind "shrieked through the trusses," and in the squall the canal was "a most disagreeable and dismal place."

The reporter then joined Rakowsky for a trip across the canal in the thick of the storm, the car operating so smoothly its start was "hardly perceptible." Nearly halfway across the canal the ferry's almost silent operation was shattered by the sound of broken glass: the wind had broken two windows on the windward side. Once the ferry reached the other side, Rakowsky inspected it for further damage and nailed the empty window frames back in place. As the reporter left, Rakowsky made a prediction: "The ferry boat isn't doing much business tonight. We are going to cut off her patronage as easy as falling off a log, and Duluth is the only place that can boast of such an [*sic*] equipment."

At the City Dock, about two blocks north of the canal, people unaware that the bridge was open to operation were still

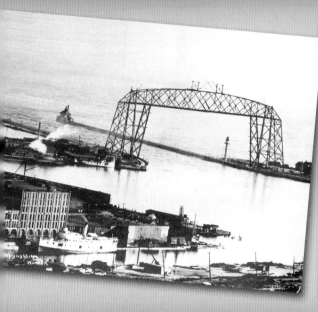

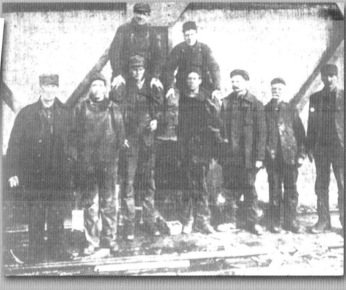

crossing on the steam ferry *Annie L. Smith*. On his way home the reporter encountered a young couple awaiting the steam ferry. The man said he intended to take the boat as "it makes better street car connections, tonight, anyway." His companion was more of a romantic, saying, "I don't know whether I will go across the bridge. There is more poetry in crossing in a boat. 'Rocked in the cradle of the deep,' don't you know."

The *Annie L. Smith's* deckhand predicted no decline in ferry patronage, at least not until Duluth took full control of the bridge. "There will be lots of people [to] travel on the *Annie L. Smith*, more than ever now," he said. "They will know that the time is short when they can get a free ride on an ocean greyhound such as this."

The very night the bridge opened the Common Council gathered to figure out who would operate it once MSS had fulfilled its obligation to run the bridge through its first "shakedown" month. One alderman called for bids from "competent electricians" to operate the bridge; another alderman countered that it would be foolish to take control of the bridge from the City. (While the City did advertise for bids, the idea was later rejected, and the bridge has never been operated by an independent contractor. It was a wise decision, as Park Pointers had complained for years about the inconsistent service provided by ferry contractors, and subletting the operation could involve a lot of city time spent on policing the bridge operation.) The aldermen also ordered an arc light placed at the foot of both approaches to the bridge and considered German & Lignell's plans for waiting rooms. While Common Council records show no reason why, the waiting rooms were never built.

Two days later Major Potter from the Corps of Engineers provided the city with a list of regulations for operating the bridge—since it stood on federal property under the Corps' jurisdiction, it was up to the Corps to say when it could and could not operate. Safety was obviously a major concern, and ship

Major Potter's Rules

Since the Duluth Aerial Transfer Bridge operated over the government canal, it fell under the U.S. Army Corps of Engineers' jurisdiction, which empowered Major Charles L. Potter to lay down the rules regarding its operation. Here's what he came up with in 1905:

Aerial Transfer Bridge Operating Regulations

Lights.

The car shall carry at night two red lights, in a vertical line, one over the other, not less than six feet apart, and located over the center of the car, at a height such that the lower light will be twenty-six feet above the water, and of such character as to be as visible all around the horizon for a distance of at least one mile.

Gong or Bell.

There shall be maintained on the car a loud sounding gong or bell, under control of the operator, such as can be heard distinctly at the distance of half a mile. A stroke of one gong shall be given one-half minute before starting from either side of the canal, and two strokes just before starting. When the car is in motion during thick weather, three strokes will be given as frequently as every fifteen seconds. At any time the car should come to a stop over the channel from failure of the motor or other cause, the gong shall be sounded continuously until the car shall be clear of the waterway. In case the signal lights for any reason be extinguished, the operator will use the gong signals prescribed for thick weather, until they are again relighted.

Right of Way.

The car shall be run so as to give clear channel to vessels and shall always keep out of their way. No special signals shall be required of vessels on account of this aerial ferry, but it is advised that when approaching the ferry in thick weather the whistle be sounded more frequently than one minute apart as prescribed by the existing rules of navigation, so that the car operator can more correctly locate the vessel. Vessels are not expected to turn out for the car except in case the car shall be detained over the channel by accident. The car shall not start on a trip across the channel when an approaching vessel, which is moving at a moderate speed is within 500 feet of the car's course. In case the vessel is believed by the operator to have a speed of eight miles an hour, or greater, this distance should be increased to 600 feet or more, so as to make ample allowance for safety. On the other hand in case of a tug towing a raft at the usual very slow speed, the interval may be less than 500 feet. The car shall in no case attempt to pass between two vessels of a tow.

Major Potter's regulations also included a rule that allowed him to change the rules if the need arose.

traffic would always have the right of way (see "Major Potter's Rules," left).

While the bridge operated smoothly in the teeth of a gale during its first day, the second day found the car taking rather bumpy rides: a cable slipped, and the source of the problem could not be located that day, so it was left on the south side of the pier for an overhaul. The next day J. K. Lowry of MSS said the drums that the cables ran on were not operating smoothly—but the company had anticipated just such an issue. The problem was that the cogs on the pinion and drums that drove the cables did not properly meet, causing the drum to wobble and, eventually, the cable to release. After some machining to the cogs and tightening of the cable, the bridge was back running by the following Sunday.

April saw more delays, and horses were temporarily barred as workers paved the bridge's approaches. Atop the car's cabins, workers installed the two red range lights called for in the operating regulations. General Electric installed an electric brake; speed had previously been controlled by reversing the engines. To keep in step with government operating regulations, Mc-Gilvray ordered a bell to announce the ferry car's movement. The car closed to passenger service for several days as workers stretched a phone cable across the bridge to provide service to Park Point and finished painting the car, according to the paper, in a "very handsome red birch finish." By May 1 it would be running flawlessly.

The *Duluth Evening Herald* described another maintenance operation on April 7 under the banner headline "NERVE WRACK-ING FEAT BY BRIDGEMEN." To gain access to the upper truss, which needed some additional riveting work, two of MSS's steel workers used the bridge's cables as an elevator to propel themselves to the truss. They did not want to climb ladders while weighed down with heavy bags full of rivets.

The next day the paper described how the men, with the bags of tools and rivets slung over their necks, climbed to the roof of the ferry car and, just as the car started across the canal, grabbed onto the cable, which "snatched them aloft at a terrible speed." Fifteen seconds later they came to the tricky part: getting off while the cable kept moving; they only had a fraction of a second to release from the cable and swing themselves onto the truss or they would be dragged through the pulley and either crushed or thrown 135 feet into the canal below. That method of conveyance was "not likely to become popular with the traveling public," the reporter joked. At the company's request, the names of the daredevil bridge workers were withheld lest they encourage such "fool-hardiness."

April 7 also saw what was likely the first boat to pass beneath the bridge entering the canal from the lakeward side. The *Bon Ami*, a 108-foot wood steamer, had set out for Port Wing and Herbster, fishing towns along the Wisconsin South Shore. The ice forced her back to Duluth, and she entered the harbor's safety through the canal, and therefore under the bridge. Not until April 20 did the *E. N. Saunders* come in off the lake to become the first vessel to navigate from Sault Ste. Marie to Duluth and enter through the canal, under the bridge.

On April 8, a bright, sunny Sunday—and the first weekend day the bridge was open to the public—the city wanted to find out if the bridge could operate to capacity. Assistant Engineer Coe wished to see if it could carry fifty thousand people in a single day. The newspaper wondered if there were "enough people in Duluth to test the carrying capacity." The car had been averaging about two hundred people a trip during busy weekday

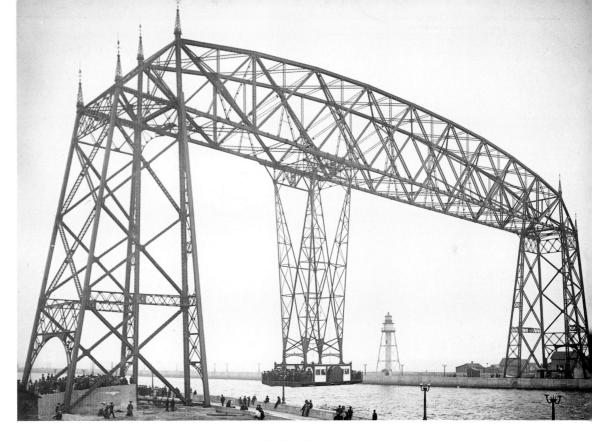

hours, the paper said, adding that "five hundred people on a trip is no crowd for that car."

The paper was right. In fact, one trip at 3:30 P.M. that Sunday took 814 passengers—an estimated fifty-five tons of human cargo. The engineers counted 32,595 people boarding the car in one twelve hour and twenty minute span, thanks in part to beautiful weather and an average trip time of just seventy seconds. So many people ventured across the canal that day that during its peak period, between 3 and 4 P.M., Lake Avenue was clogged with people from the canal north to Superior Street—half on their way to the bridge, half on their way back. So many people rode the ferry bridge that day the paper reported that, "the deck flooring was worn smooth."

DULUTH'S AERIAL TRANSFER BRIDGE WITH ITS GONDOLA CAR IN TRANSIT JUST AFTER OPENING IN 1905. NOTE THE PEOPLE LINED UP ON THE NORTH PIER FOUNDATION APPROACH AWAITING THEIR TURN TO CROSS.

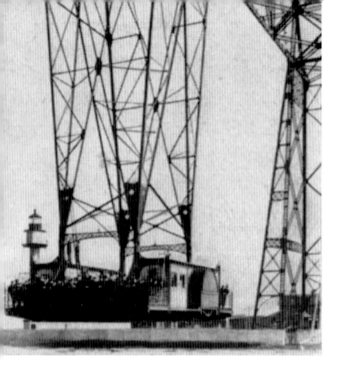

That record-setting day also saw the first automobile to cross the canal—which, subsequently, also became the first car to motor on Park Point. The car, an electric Studebaker-Stanhope, was owned and driven by Edward J. Filiatrault, who was accompanied by Dr. Thomas F. Sheridan, a local dentist. On his return trip Filiatrault handed Lowry his calling card so his accomplishment would be remembered. It also may have been a sales gimmick: Filiatrault and Emil A. Nelson owned the first car dealership in Duluth, the Mutual Electric and Auto Co.

As if to reassure the public, the newspaper mentioned that "baby cabs were sprinkled among all the loads throughout the day, many of them being in the care of mothers who had no hesitancy in boarding the ferry with the little ones." In fact, only once did anyone balk at crossing. Two young women, awaiting a trip across at the north pier, "quailed when they saw the singular car approach" and turned back toward Lake Avenue. The paper then mentioned a number of "Sunday school" children who boarded without fear. In fact, those who counted the crowds estimated that nearly a third of passengers were children. They also thought that perhaps one-fourth of Duluth's citizens crossed the canal that day.

Like the two frightened young ladies, not everyone thought of the bridge as an improvement. At least one man, describing the bridge in a postcard bearing its image, implied that he

TOP & RIGHT:
DULUTH'S AERIAL
TRANSFER BRIDGE IN
ACTION ON APRIL 8, 1905,
PERHAPS ITS BUSIEST DAY.
THE IMAGE ABOVE SHOWS
THE CAR LOADED WITH 814
PASSENGERS IN A SINGLE
TRIP DURING A DAY THAT
SAW 32,595 PEOPLE USE
THE BRIDGE TO CROSS THE
CANAL, MOST FOR THE
FIRST TIME.

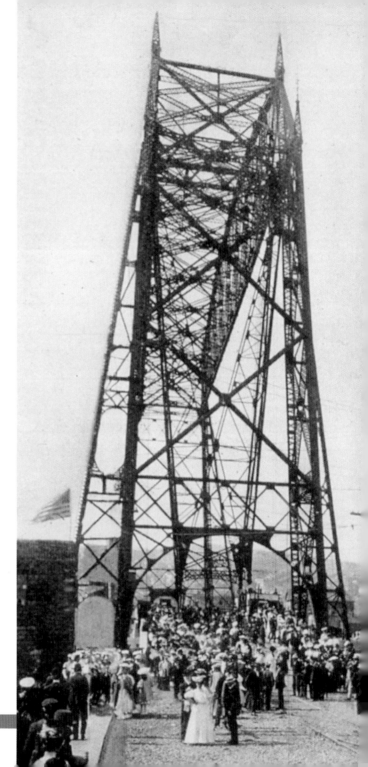

End of Regular Ferry Service, End of an Era

Ever since the canal had been dug in 1871, there had been a need to cross it. Several different temporary bridges had been used in the winter over the years, including a six-foot-wide makeshift suspension bridge sometimes referred to as the "old wire-rope bridge." When the wind blew, people crawled on their hands and knees to get across. After years of disappointing efforts on the part of the City of Duluth, Pointers took matters into their own hands, and, in 1883, villages trustees named Charles Winters both superintendent of the winter bridge and the operator of the summertime ferries.

The "rowboat and scow" ferry service remained in operation until 1897, when steam ferries—including the *May Flower*, *Estelle* (below right), and *E. T. Carrington* (below left)—took over the job. Residents accessed the ferry from the city-owned docks located bayside north of the canal at Buchanan Street and south of the canal at the Osborne Dock on Park Point.

No one expected as much of the ferrymen as did Park Point residents. Perhaps it was an effort to illustrate the need for a bridge, perhaps it was legitimate criticism, but whatever the case, Park Pointers never failed to inform city officials about poor ferry service quality.

In February 1901, residents of Park Point (along with Mayor Hugo and others) complained about an incident in which a physician, Dr. Phalen, could not get return ferry service at 2:30 A.M. after visiting a critically ill patient, Mrs. Fred Granmason, on Park Point. Regulations called for ferrymen to take special care of physicians and were to be ready at fifteen-minute intervals after 1 A.M. when they knew a doctor was south of the canal. After many attempts, neither Dr. Phalen nor Mr. Granmason could alert the ferrymen, who claimed they had been wide awake all night long. The ferrymen had violated the terms of their contract, which had been awarded to C. H. Burnham in January and included $23 a day for the use of his tug *Mayflower*. The Common Council resolved to re-advertise for bids on the ferry contract. The owner of the ferry *Estelle* won the

contract, and Park Pointers gave the tug a reprieve the following spring, petitioning the Common Council to keep the *Estelle* rather than turn to a proposed combination ferry and fire tug. The Pointers were concerned that service would be shut off whenever the tug was called to a fire.

In 1903 Park Pointers penned another petition, this time asking for a much larger and "more suitable" ferry, claiming it would be "criminal negligence to continue the present service." Despite her owner's claim that repairs would put her in "first-class condition"—and offering to do the job for $27 a day—the *Estelle* lost out to *E. T. Carrington* at $30 a day. By 1905, the *Annie L. Smith* had replaced the *Carrington* and was operating the day the ferry bridge officially went into service. After that day, the *Ellen D.* was put in service whenever the bridge was being serviced.

The *Estelle* was abandoned and dismantled in Duluth in 1906. The *E. T. Carrington* sprung a leak and sank fifteen miles from Duluth August 23, 1907.

The Great Storm of 1905 (a.k.a. the "*Mataafa* Storm")

The same year the Duluth Ship Canal was first permanently bridged, finally connecting Park Point to the rest of the community, Lake Superior saw one of its worst storms on record. Vessels navigating Lake Superior on Tuesday, November 28, 1905—two days before Thanksgiving—found themselves battling hurricane-force winds. The water on Lake Superior's western end was so high it drove through Minnesota Point at a spot known as "the barrens" hard enough to cut a channel.

That day and the next, twenty-nine ships were wrecked or suffered damage, seventeen were stranded, and at least one foundered. The human toll was also heavy; the storm took thirty-three souls, nine of them just outside Duluth's ship canal. A crowd of thousands gathered near the ship canal to watch ships attempt to ride out the storm. The *Mataafa*, hauling a load of iron and towing an equally laden barge, the *James Naysmyth*, appeared out of the squall in midafternoon, steaming hard for the canal and the safety beyond it. Her captain ordered the *Naysmyth* cut free and anchored to ride out the storm. As the *Mataafa* entered the canal, currents and wind gusts forced the ship into the north pier; conditions then carried it back into the lake before slamming it broadside against the pierhead. About 150 yards from shore, the *Mataafa* settled to the lake bottom and split in two.

Desperate sailors in both the fore and aft cabins—which were still above water—signaled for help. Members of the U.S. Life Savers stood helplessly on shore, the storm too strong to launch their lifeboats. That night thousands of Duluthians lined the shore, standing vigil as the storm pounded the wounded ship. In the wee hours of the morning, the flickering light in the pilothouse went dead. When the Life Savers finally reached the ship the next morning they found fifteen sailors—including the ship's captain—alive. Unfortunately, nine of the crew either drowned or froze to death.

The aerial bridge's ferry car had been lashed in place over the north pier during the storm. Both the bridge and car held firm, and engineer McGilvray said the structure had weathered the storm "without a tremble." Only a portion of one of the approaches was damaged.

The storm did eventually have a positive effect: the *Mataafa* sinking, and the *Madeira* going down at Gold Rock near the Split Rock River, convinced the government to build two lighthouses, one at Split Rock, the other at the eastern end of the Duluth Ship Canal's North Pier (see page 107).

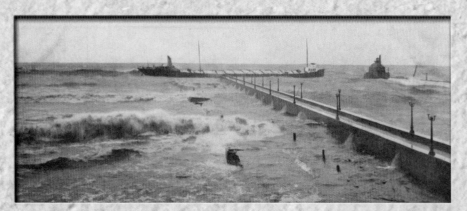

missed the adventure of crossing in a boat, writing of the bridge: "Quicker and safer, but not nearly as much fun as crossing on the old ferry."

A handful of local boys thought the bridge was much more fun. On April 28 the *Duluth News-Tribune* reported that "half a dozen boys of various ages" dodged the bridge operator, climbed on the girders below decks of the ferry car and rode the ferry clinging by their fingers just thirteen feet above the water. Alone at the controls, Adrian could do nothing to stop them. If they had lost their grip, the boys would certainly have drowned in the canal's currents.

On May 5, 1905, even though MSS still had five months left on their obligation of guaranteed flawless operation, the City officially took possession of the bridge and placed it under the jurisdiction of the Board of Public Works. While the bridge had officially opened for business, work continued throughout the summer. In June workers installed lightning arrestors—spires that rise from the corners of the bridge's north and south towers.

But soon after the City took possession, the bridge stopped operating smoothly. Several of the wheels inside the truck had broken. Inspectors discovered that the truck system that the girders holding the ferry car rode on had been engineered too rigidly. MSS was called back, under the terms of their contract, and made repeated attempts to remodel the old truck system. But it was still not operating properly in October, when Mayor Cullum wrote the Common Council that "it cannot be said . . . that their six months' trial has been entirely successful." He urged the Council to "consider these matters in their financial settlement with the Bridge Company" and, if the City Attorney advised, delay final payment to the company until they fully resolved the problem. City officials reinstated the ferry service while the bridge underwent these repairs. As the year ended, MSS was still hard at work on the problem.

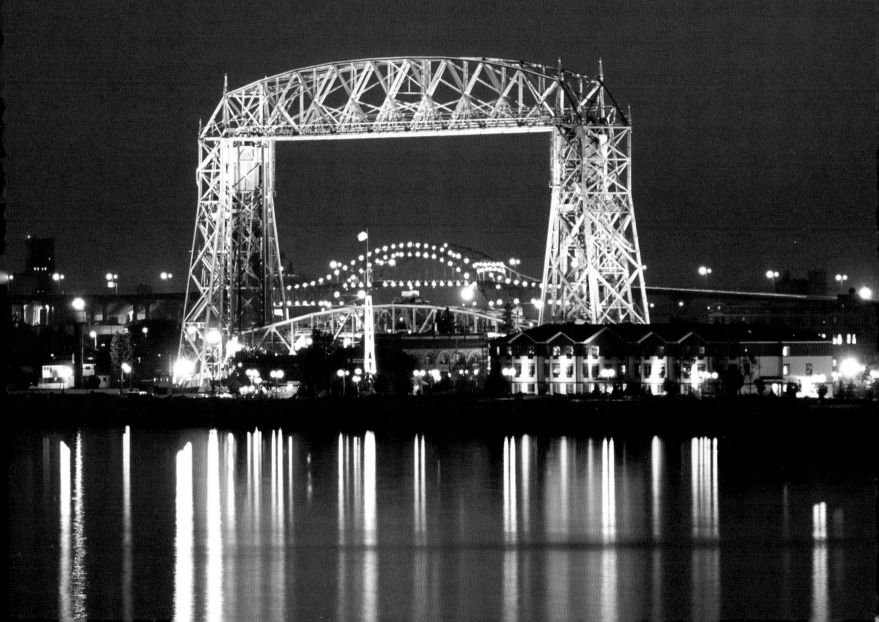

DULUTH'S AERIAL BRIDGE, SHIP CANAL, AND LIGHTHOUSES THROUGH THE LENS OF

Dennis O'Hara

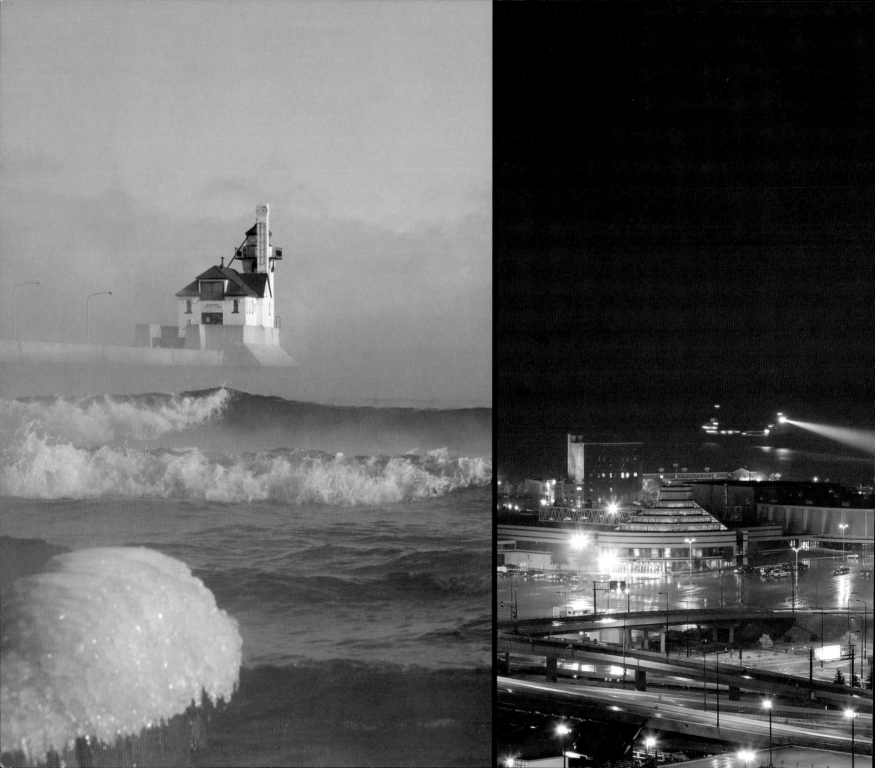

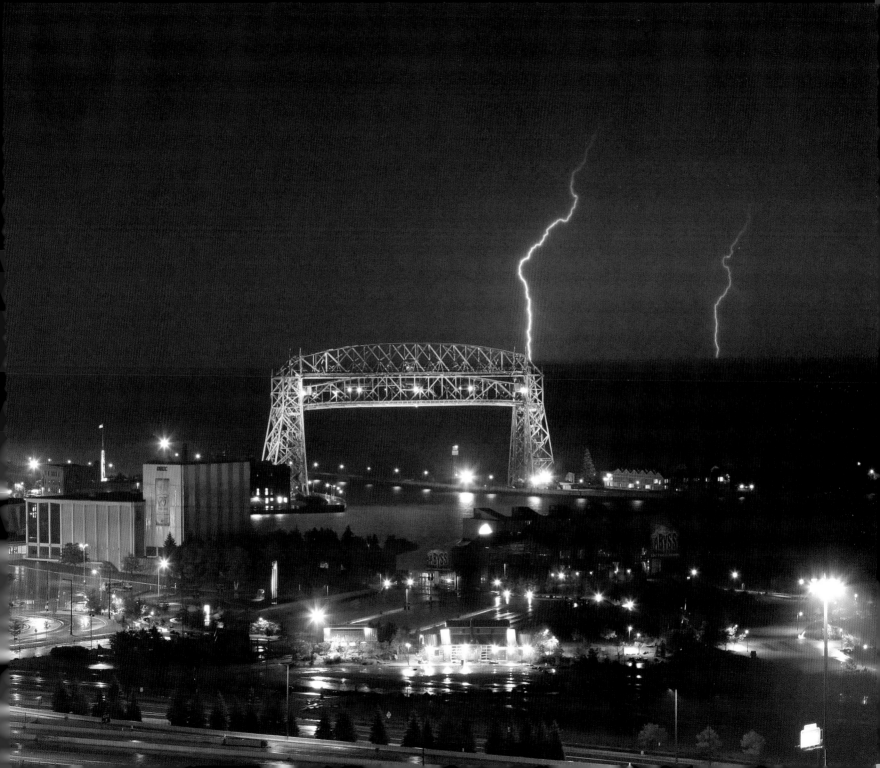

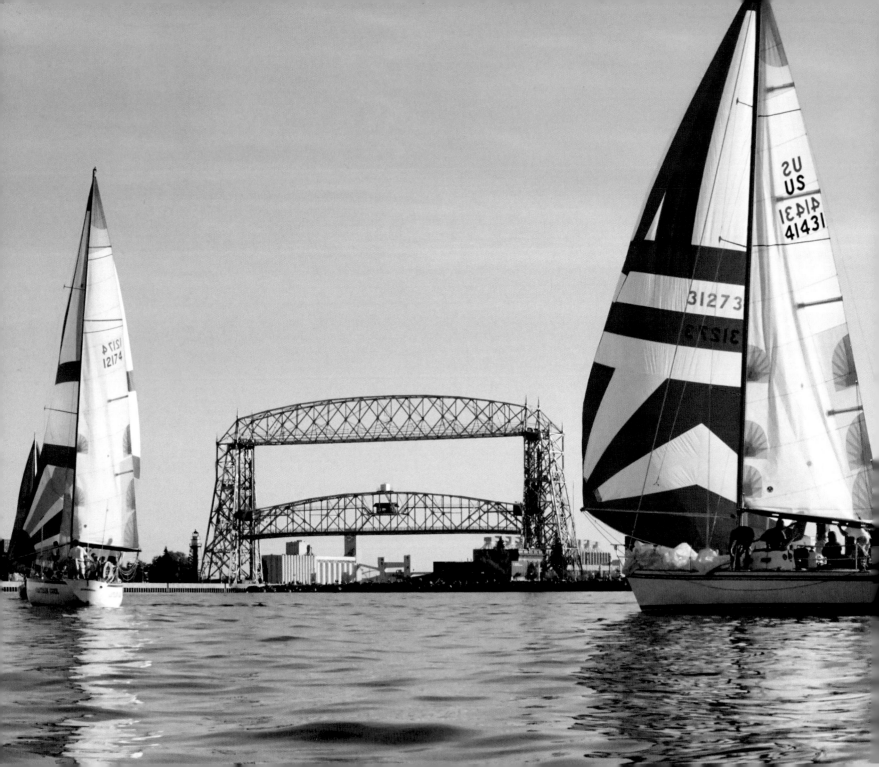

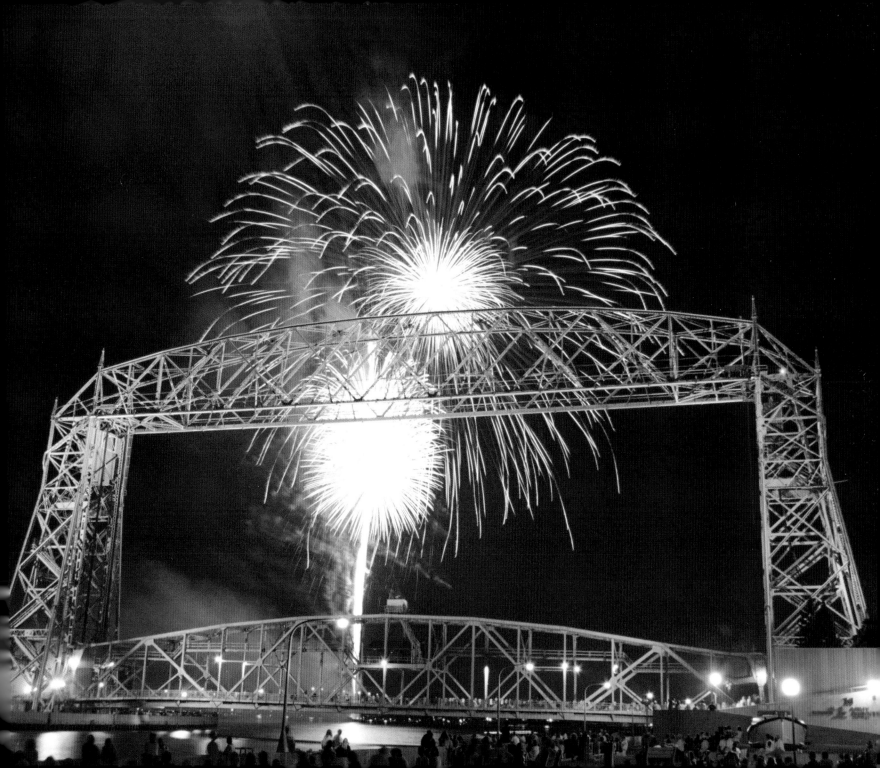

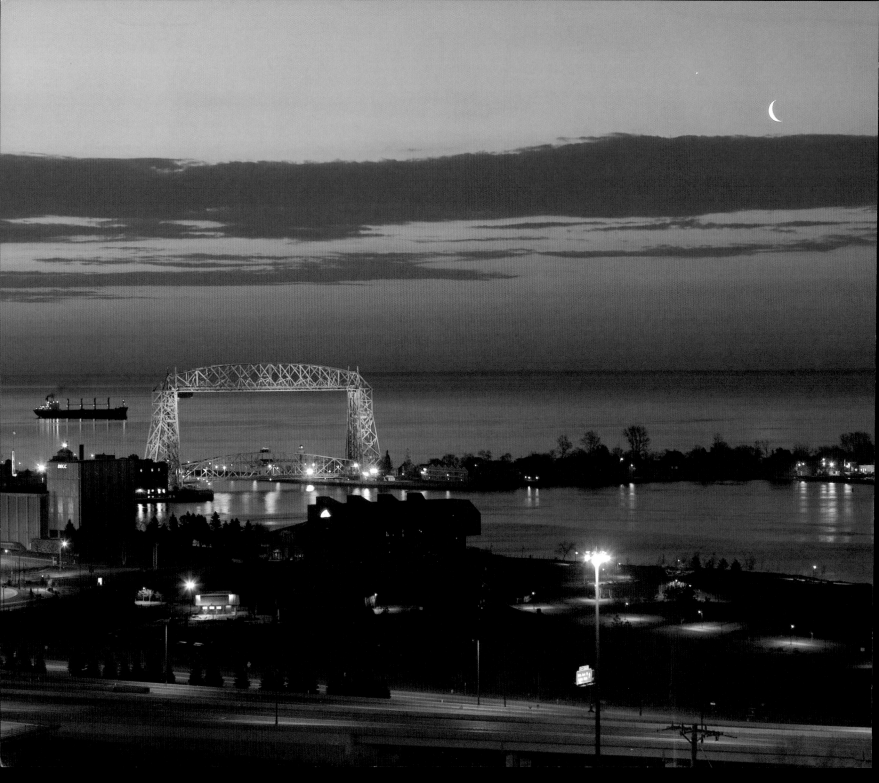

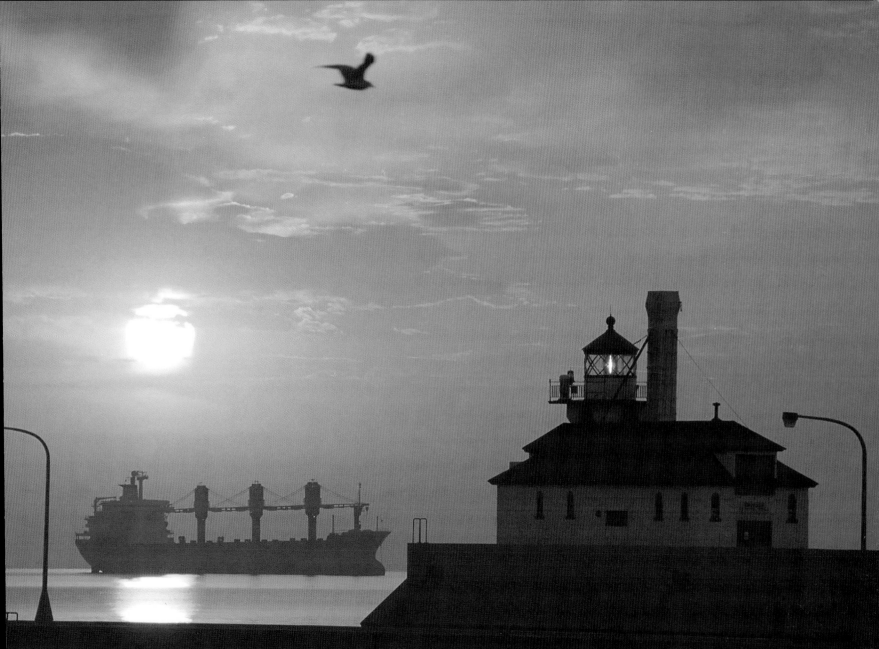

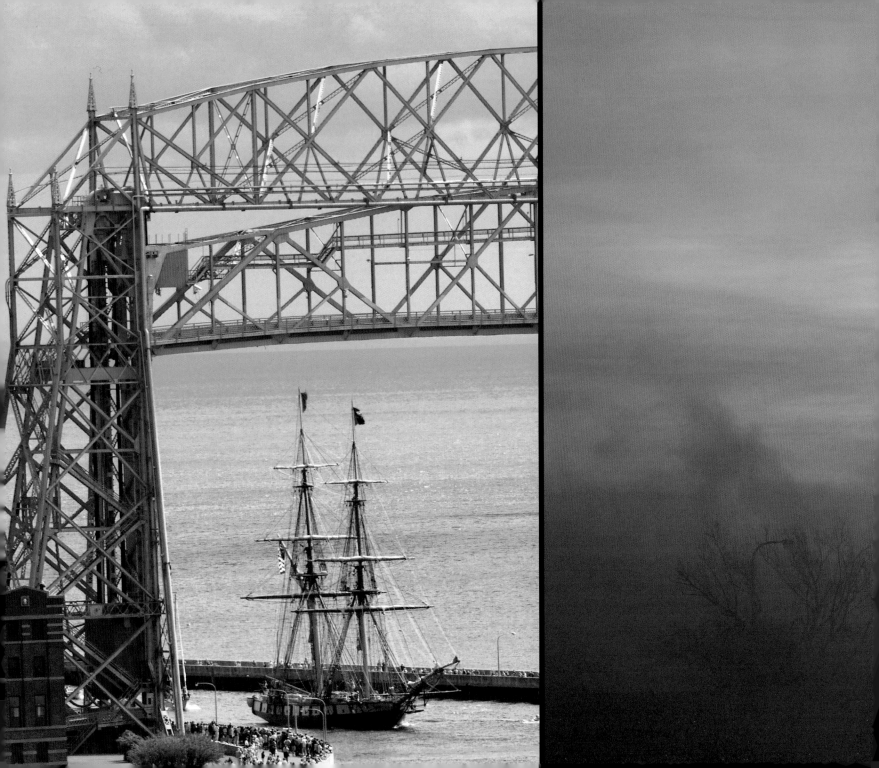

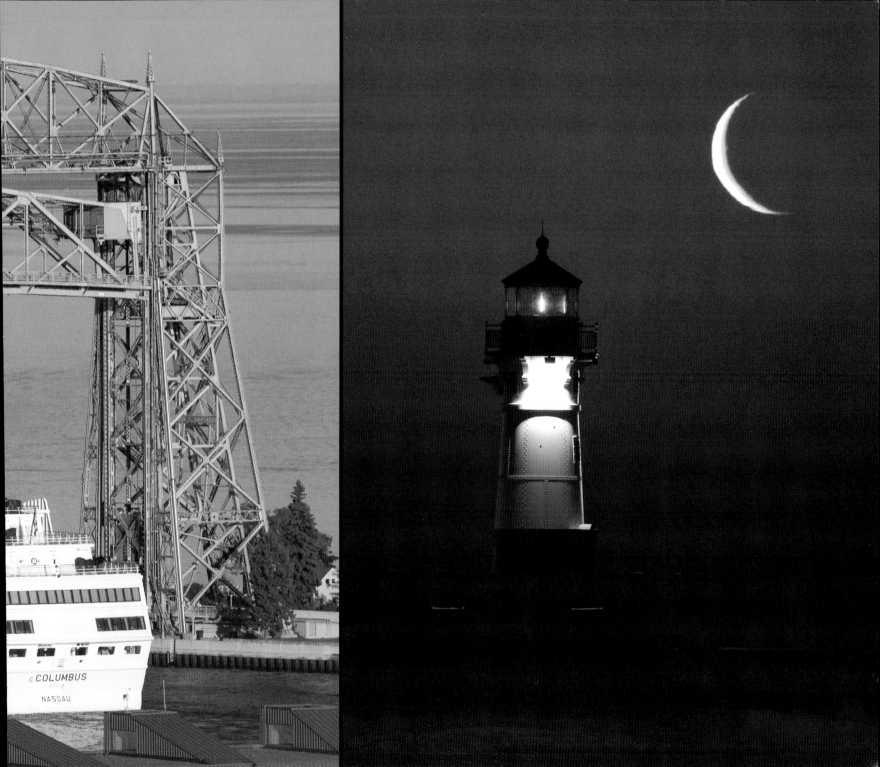

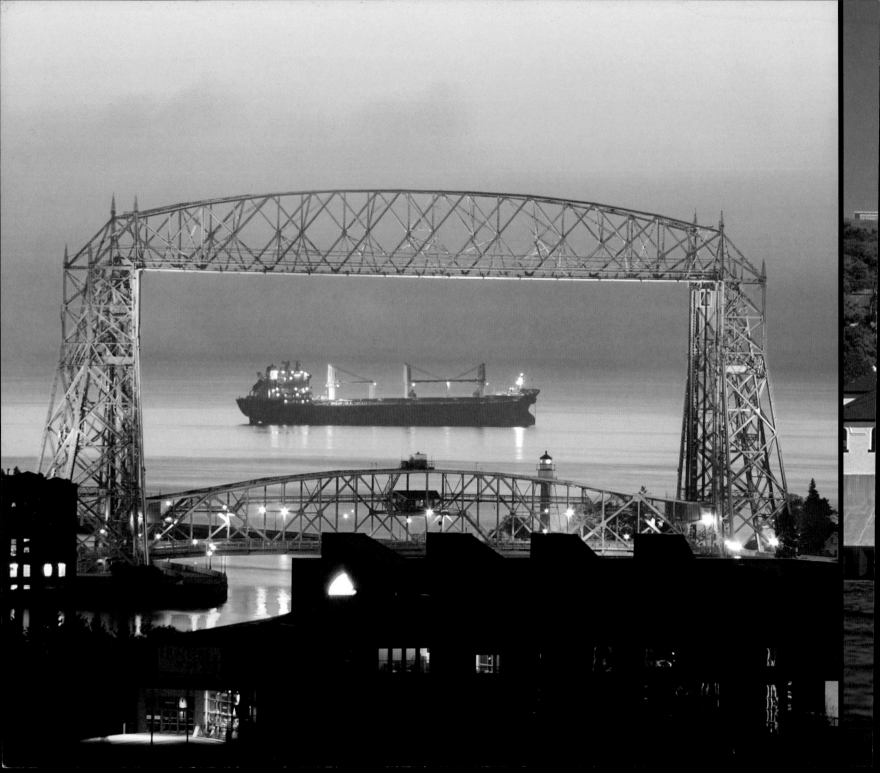

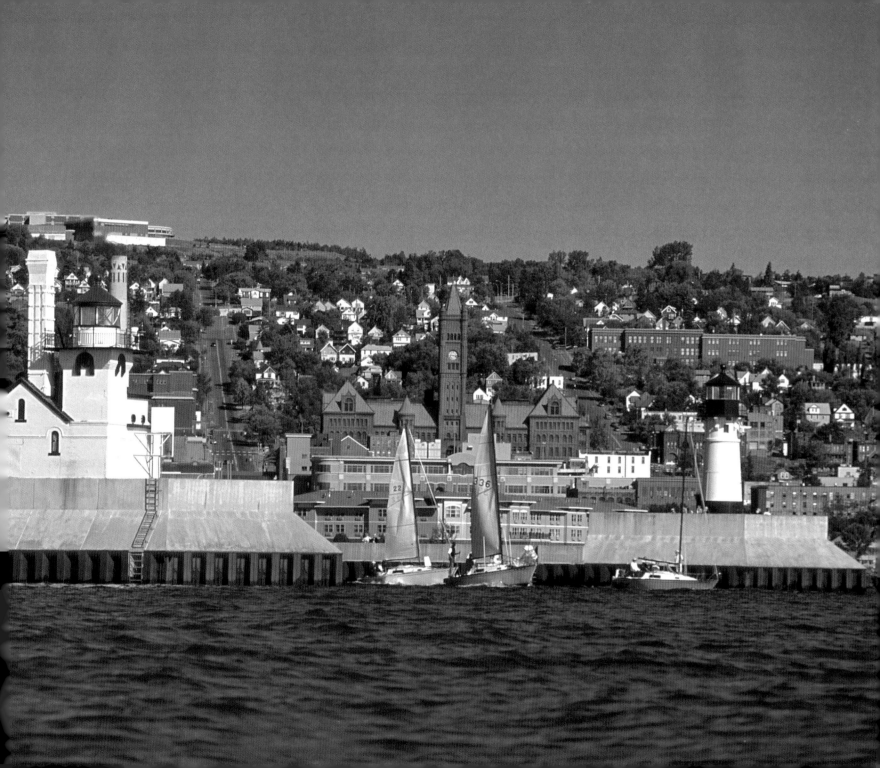

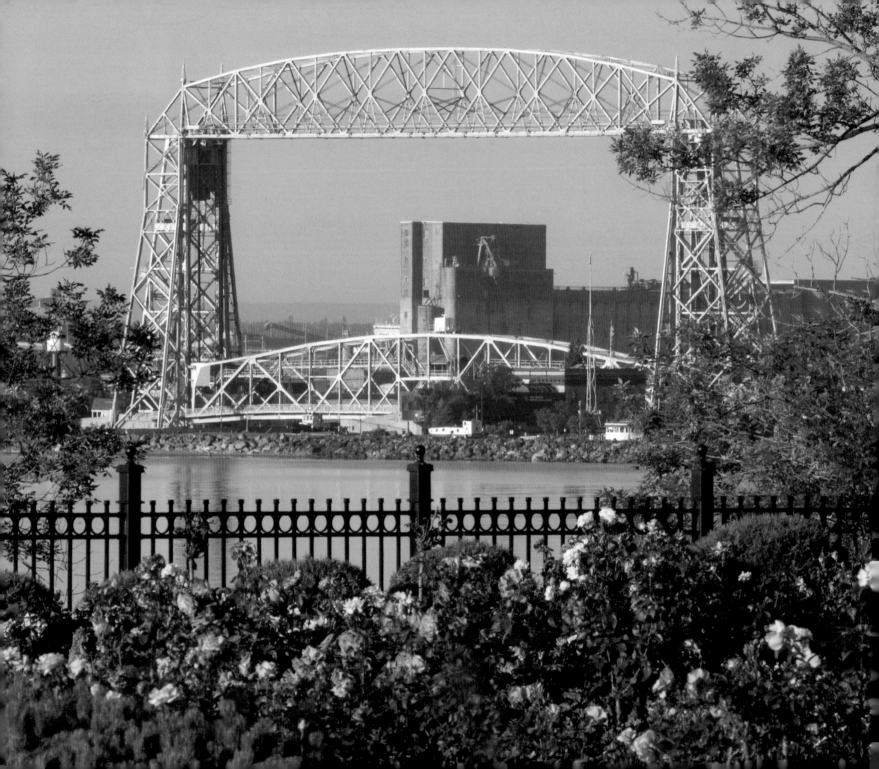

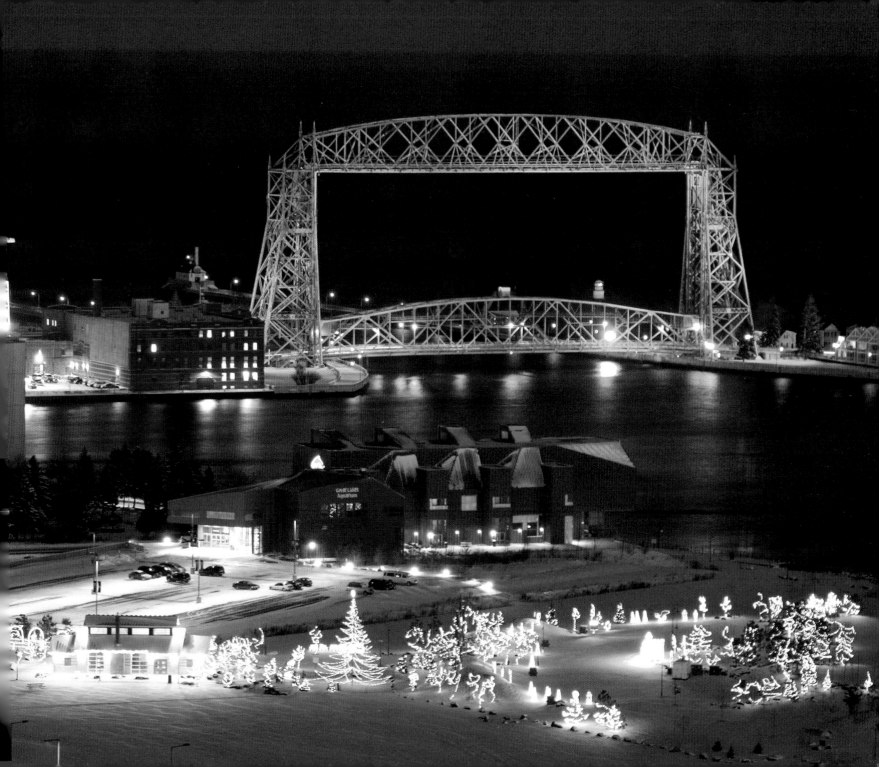

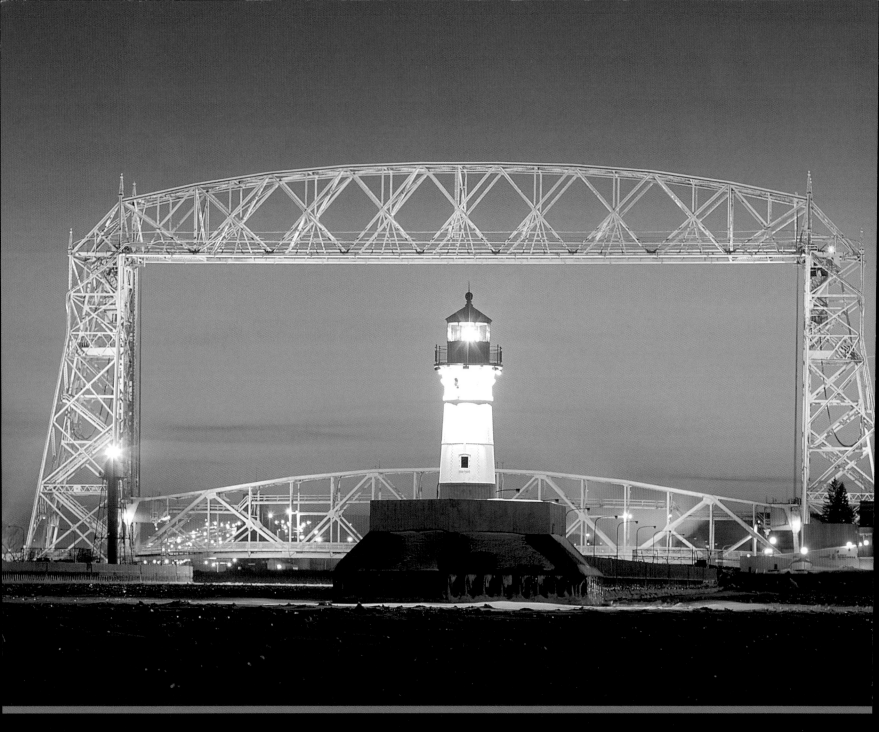

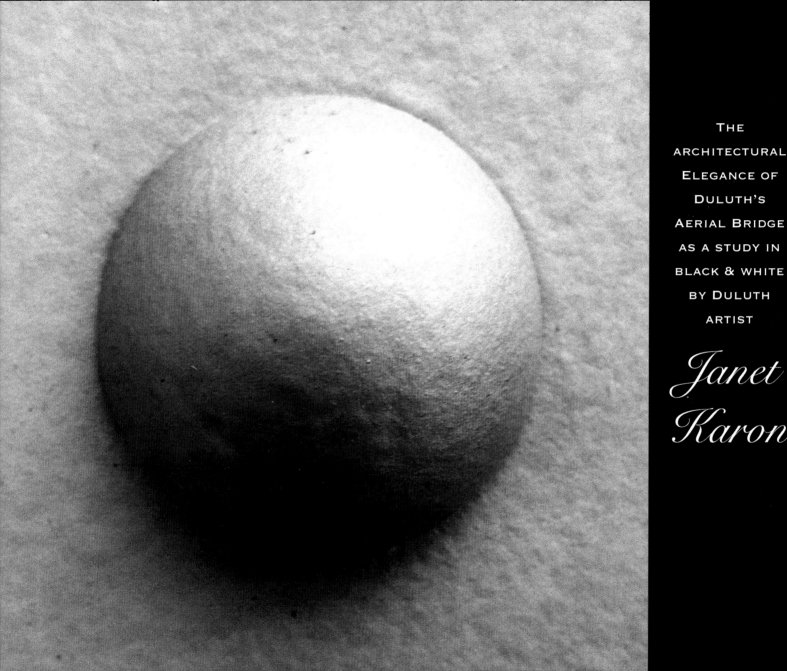

THE
ARCHITECTURAL
ELEGANCE OF
DULUTH'S
AERIAL BRIDGE
AS A STUDY IN
BLACK & WHITE
BY DULUTH
ARTIST

Janet
Karon

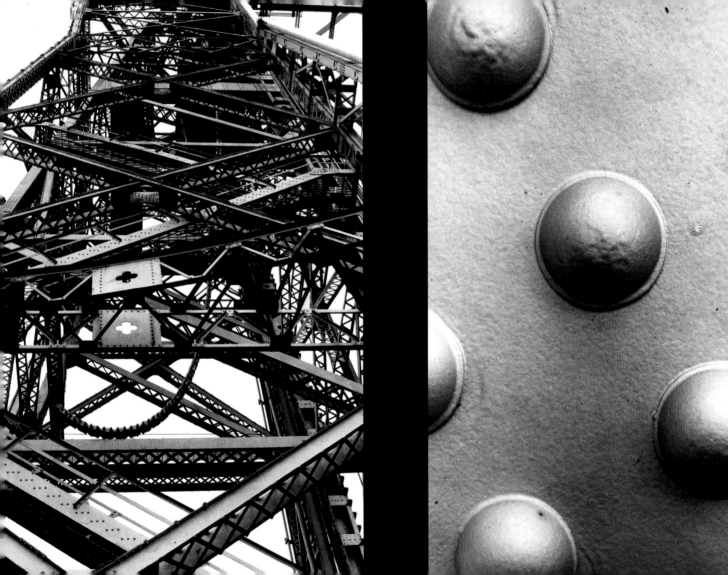

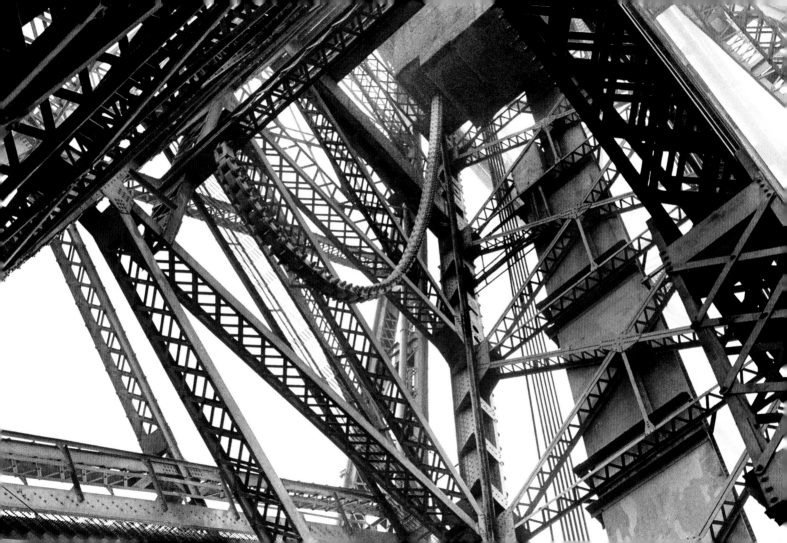

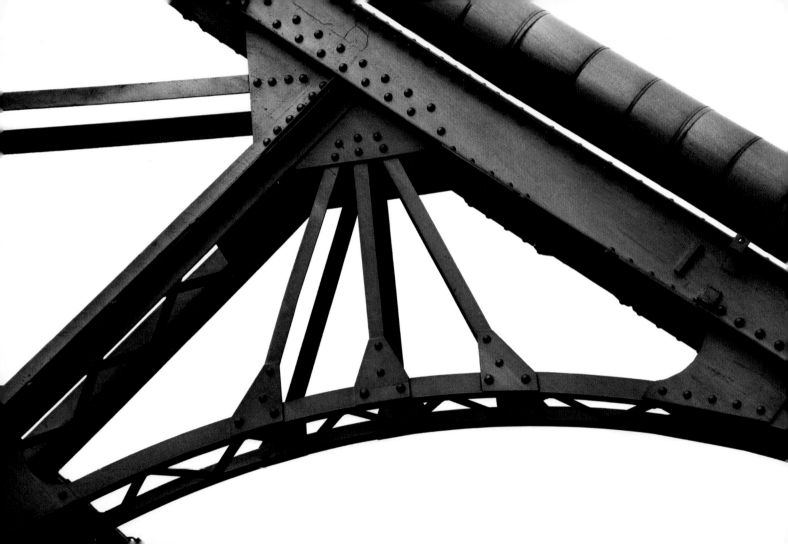

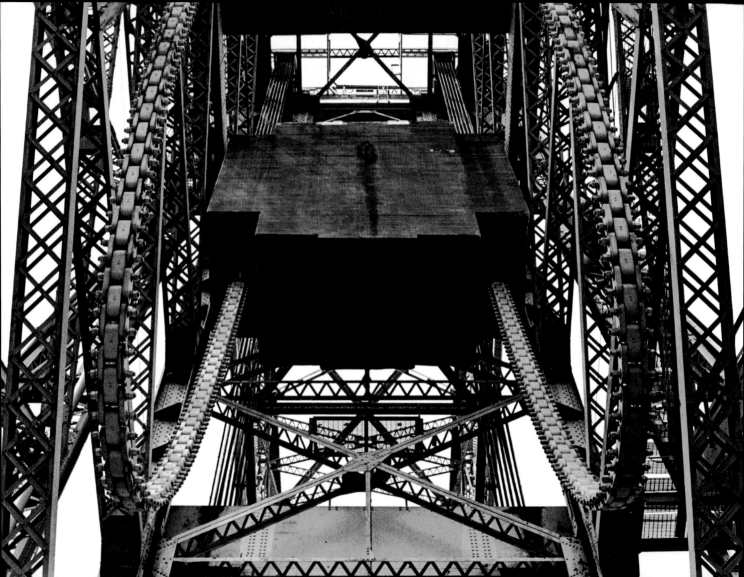

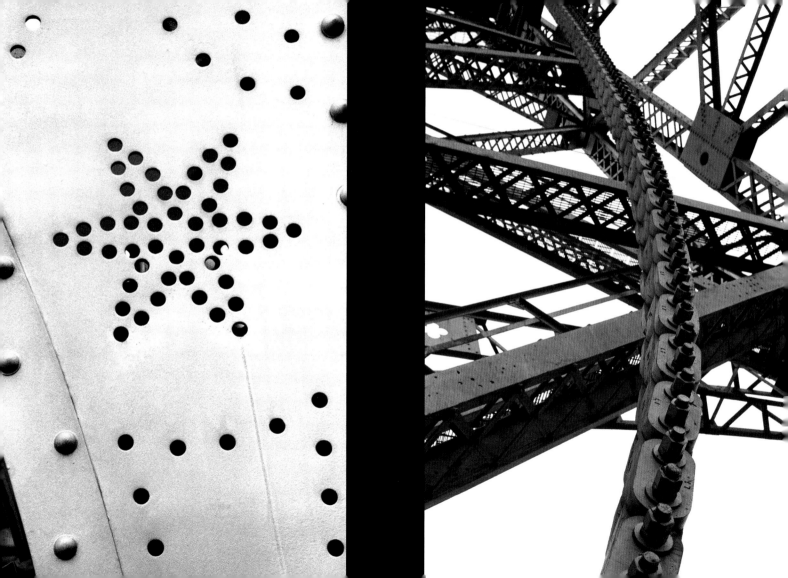

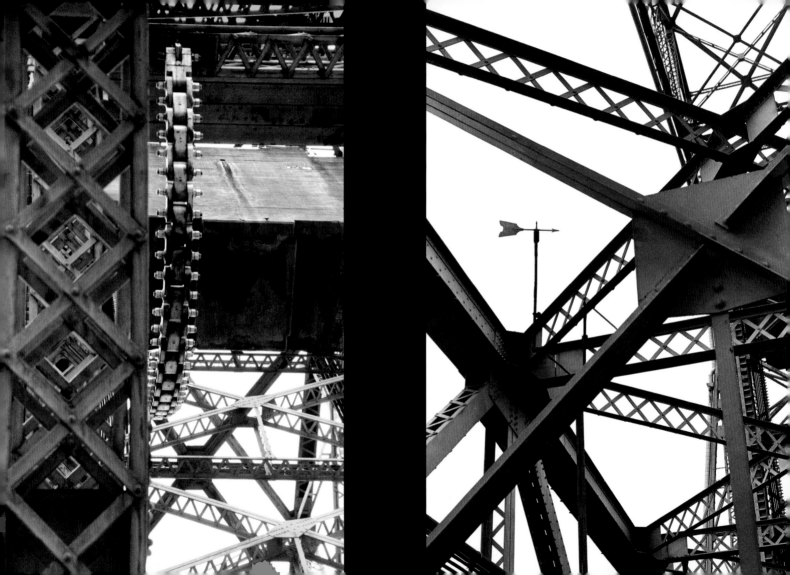

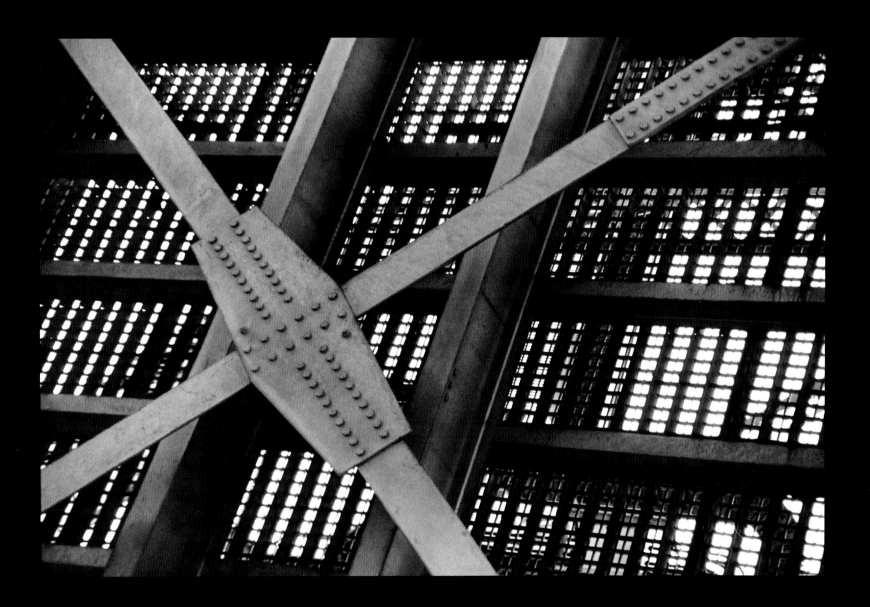

JANET KARON LIVES ON PARK POINT • HER WORK CAN BE FOUND ONLINE AT AERIALBRIDGEPHOTOS.COM

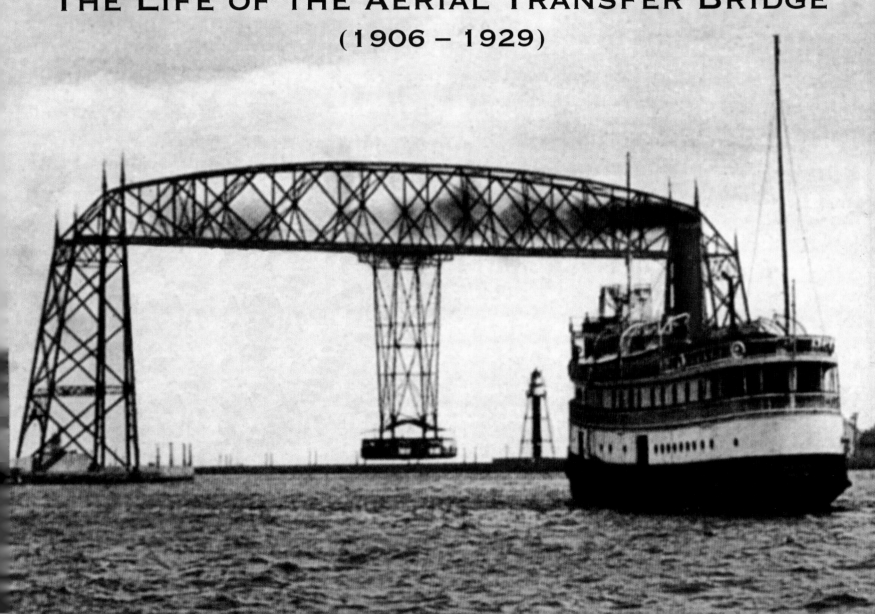

PART III:

THE LIFE OF THE AERIAL TRANSFER BRIDGE

(1906 – 1929)

BRIDGE HAS NOT MISSED A TRIP FOR ENTIRE YEAR

The Ferry Car Has Run Twelve Months Without Breakdown.

Has Safely Transported 2,500,000 Passengers and 50,000 Teams.

Since a year ago today, the aerial ferry bridge has not missed a trip across the canal on schedule time, has needed no repairs and has not cost the city a cent besides the current running expenses of the car, the wages of the operators and the cost of oil and electric power, amounting to only about $4,750.

During the time the car has moved from six to eight trips per hour, frequently attaining a speed of six miles per hour in crossing, and has carried not less than 2,500,000 passengers and 50,000 teams during the twelve months.

Though it was originally intended to run the car only four times an hour during the busy part of the day, and one trip per hour during the quiet period, the increased use of the structure has had apparently no effect on either the bridge or the running gear.

The tremendous amount of trouble and the frequent delays attendant upon the operation of the bridge during the first six months of its use is assigned by the engineering department to the fact that the Modern Structural Steel company neglected to see that the alignment of the tracks on which the car runs, was absolutely perfect, and even refused to attend to this detail when demanded by City Engineer McGilvray. Finally the city proceeded to do the aligning and charged up the cost to the company.

Though truck after truck was put out of commission and reinstalled at the expense of the constructing company before the alignment was made, how correct the engineer's diagnosis of the cause was, is proven by the practically perfect record of the bridge since the defect was remedied.

How cheaply the bridge has been operated during the past year may perhaps be realized from the fact that the cost per passenger for transportation across the canal was only one-fifth of a cent.

Since the duplicate parts of the machinery of the bridge have arrived, the engineering department is confident that no accident, except the rather impossible collision with a boat in the middle of the channel, could delay the bridge more than one trip, as a new truck could be installed in twenty minutes, and the bridge be in shape for work again. There would be no danger except perhaps, that of panic, should a boat strike the car in mid-channel, as the hanging portion of the structure is made of soft steel, and would bend so as to pass clear over a boat before breaking or dropping the car into the channel. A collision with a boat would, however, probably mean the replacing of all the suspended portion.

On several Sundays last year the record of 32,100 made on the first Sunday of operation was surpassed, and the crowds going to the White City kept the car packed to its full capacity during the rush hours. The bridge in fact made the White City a possibility, as with the old ferry transportation, the crowds which made the institution a success could not have been handled.

The question of how long the big structure will be adequate to handle the Point traffic is now being discussed. Notwithstanding the fact that traffic across the canal was quadrupled last year, in the opinion of many of those who have studied the question, the Point will attain sufficient value for railroad yards and other commercial purposes to pay a private enterprise to tunnel the canal before the construction of another bridge will be necessary. The development may, however, be more rapid than was foreseen, and no one expected that the bridge would be taxed so nearly its limit during its first real year of service, but on the other hand, the Point has reached nearly its limit as a summer resort, and the business development of the strip is bound to be slower.

However this may be, Duluth has occasion to be proud of her bridge, the record it has made, and the immense amount of the best kind of advertising and "boost" that it has given the city.

WHAT FERRY BRIDGE COSTS

Expense of Operation and Maintenance Has Exceeded Original Cost.

The expense of operating and maintaining the aerial bridge across the ship canal since it was built in 1904 to Oct. 1 of this year now aggregates more than the original cost of the structure.

At the request of a local citizen a statement showing the cost and operating expenses of the bridge has been prepared by City Auditor B. J. Campbell. It is the first tabulation of the kind which has been prepared since the bridge was erected.

For the nine years the salaries have been $32,691.69; the maintenance and repairs have amounted to $22,881.29, and the ferry service while the bridge was not running cost $26,291.36, making a total of $81,864.34. To this is added the interest of the $100,000 of 4 per cent bonds issued to pay for the bridge, bringing the total to $113,-864.34, the bond issue having run eight years, being dated 1905. The cost of building the bridge was $104,517.18, to which is added $7,182.55 for the approaches, bring the total to $111,-699.70.

In 1904 there was no salary for operators and the maintenance and repairs were only $323.19, but the ferry service bill was $10,289.60. The bridge was being built and the ferry service was continuous. This was largely true in 1905, when the cost of the ferry service was $8,099.78. The next year it was $3,403.58 and in 1907 it dropped to $72. In 1908 it was $633.50 and in 1909 reached the low mark, $68.50. Since then it has ranged from $600 to $1,560, the latter being this year's bill.

In a general way the average cost of operating the bridge has been $7,000 to $8,000 a year since the first two years.

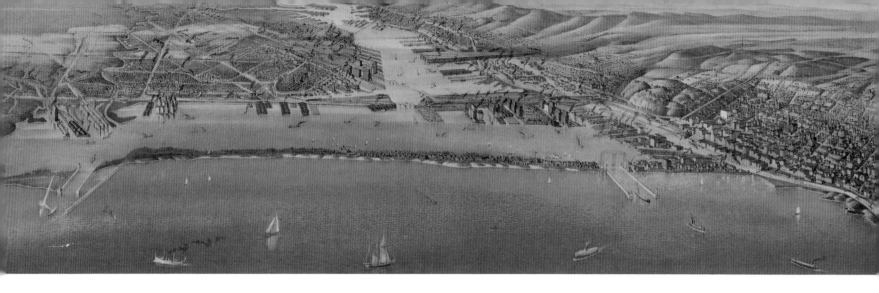

DULUTH TAKES CONTROL OF THE BRIDGE

Modern Steel Structural eventually had to replace the entire overhead works of the bridge where the trucks rolled along the rails; besides the trucks operating poorly, the rail they rolled on had not been properly aligned. With a new truck system in place in early 1906, MSS had satisfied its obligation to Duluth and the bridge, and the City took complete control of the structure.

That April the City settled up with MSS, paying the company $54,734.15—it had already paid the firm $35,000 in September 1904 to get the job started. But the total amount came to $90,000, more than $10,000 less than the contract had called for. Another $6,765.85 went directly to C. A. P. Turner. Back in April 1905, during the bridge's first month of operation, Turner had written the Common Council explaining that MSS had not met the terms of his contract with them: permitting their the use of his patents in exchange for 8 percent

of MSS's contract with the city. When the city plunked down the $35,000 down payment in September 1904, Turner had received $1,400, with a balance due of another $1,400. He never received the second payment. As far as Turner was concerned, until he got that money—and another $3,148 for other work—MSS had "forfeited its rights to the patents." And since MSS had built the bridge using patents it had no right to, the company certainly couldn't sell the bridge to the city. By April 1906, interest and other work done by Turner brought the amount to nearly $7,000. In a single resolution the Common Council first paid off Turner, satisfying MSS's contract with him, then MSS, who was now free to sell the bridge. The remaining $3,500 went to the Duluth Canal Bridge Co. in August 1905, to settle once and for all the issue of who owned the bridge's foundations.

Duluth did, along with the bridge they lead to.

In March McGilvray reported that the bridge had run perfectly since February 6, handling two hundred to three hundred teams of horses and thirty thousand people a day. He estimated the cost of operating the bridge, including the $4,000 in interest on the bond, at $10,578.31. It may not have been as big a savings from the ferry operation as anticipated, but McGilvray's spin on the numbers illustrates the bargain that was the bridge: it cost the city "one-fifth of one cent per passenger for operation, maintenance, interest, and power." He closed his report with a request for the city to install a telephone in the ferry car so its operator could call for help should the car break down in the middle of the canal. It was not granted.

Over the next year McGilvray continued to petition the city for improvements on the bridge, mostly for safety. A metal net was installed over the ferry car to protect passengers and teams

The Corps of Engineers Building and Canal Park

When the federal government took over the ship canal, it also acquired two small strips of land on either side of the waterway. They dubbed the property "Canal Park" but didn't do anything to make it very park-like. Then in 1902, with work on the new ship canal piers complete, the government decided to spend $30,000 on park improvements ("concrete walks, grass plots, and trees") and a spanking-new Neoclassical Revival office building for the Corps of Engineers, designed by Wallace Wellbanks along with architect W. T. Bray. The building would also end talks of moving the Corps' Lake Superior headquarters to Houghton or Marquette on Michigan's Upper Peninsula.

In 1971 the park received an $82,000 facelift thanks in part to Jeno's, Inc., which purchased a portion of the park to create more employee parking. The park improved its own parking, fixed drainage issues, created a circular drive to ease traffic, added additional green spaces, planted more trees, and improved the lighting to make the area more hospitable to visitors.

The park became even more of a tourist destination in 1973 with the opening of the Lake Superior Maritime Visitor Center, which later connected directly to the Corps of Engineers Building. Oddly enough the museum developed out of a need for restroom facilities. Back in the late 1960s, the bridge's "comfort stations"—bathrooms the Corps of Engineers insisted be installed in the base of the bridge's approaches in 1929—had become so decrepit that the city removed them, turning the space into storage. Soon afterward, however, desperate tourists began relieving themselves in and around the park. So the Corps of Engineers decided to build restroom facilities adjacent to the Corps building. The original plans for the project demonstrated that the height of the addition didn't complement the existing structure, so another level was added. Someone then suggested that the extra space could house an exhibit or two about Lake Superior's shipping history, which in turn sparked more ambitious ideas. By the time the building was completed in 1973, what had started as a simple bathroom addition had become the Canal Park Marine Museum.

LEFT: Workers stopped work on the Corps of Engineers building to pose for this picture in 1906.

RIGHT: A much more recent photo of the Corps building (and a very small portion of the Lake Superior Maritime Visitor Center).

The museum, designed by architects Aguar, Jrying, Whiteman & Moser to resemble a ship's bridge (see page 154), tells the history of shipping on Lake Superior through fascinating exhibits that range from actual artifacts of maritime history to recreations of sailors' quarters aboard ore boats to scale models of a variety of vessels that once sailed the lake. C. Patrick Labadie served as the museum's first curator; at this writing, Thomas Holden mans the wheel of what has been renamed the "Lake Superior Maritime Visitor Center." By the time the aerial bridge celebrated its one hundredth year in 2005, more than 12 million people had visited the museum.

"Canal Park" Before It was "Canal Park"

Today most people who live in or visit Duluth consider Canal Park the entire area between the ship canal and the Lake Avenue Bridge, which spans Interstate 35 south of Michigan Street (unfold this page to see a map). But strictly speaking, Canal Park is just the area controlled by the federal government, which owns the canal: the Corps of Engineers Building and the attached Lake Superior Maritime Visitors Center and the greenspace adjacent to the piers on both sides of the canal. The rest of the area is actually part of downtown; in fact, the area from the canal north to what is today considered downtown was at one time called "Uptown," comprising what was originally known as "Cowell's Addition" and "Industrial Addition." Outside of the canal and bridge, the area has only been a true tourist destination since roughly the late 1970s.

Before that it was for the most part highly industrialized, occupied by manufacturing concerns and warehouses. At the time the aerial bridge was built, the major businesses Uptown included the Marshall-Wells Hardware complex (once the largest hardware manufacturer in the world), the Dewitt-Seitz Company (which manufactured mattresses and later became Happy Sleeper), the A. Booth Co. (commercial fishing), Diamond Calk & Horshoe, Heimbach Lumber Company, Duluth Ice Company, Gogebic Steam Boiler Works, and Northern Shoe Co. Many smaller concerns—print shops, frame factories, woodworking and cabinet shops—also operated in the oldest part of Duluth.

Other business would come later, such as Halvorson Tree, which made nationally popular three-foot Christmas trees from the tops of Northern Spruce (chemically preserved and painted in a variety of colors), and wholesale grocers Gowan-Lenning-Brown, who built their headquarters in the shadow of the aerial bridge in 1915. (Jeno Paulucci later bought it to make Jeno's, Inc. products, and it is known today as the Paulucci Building.) The Whitney Brothers sand and gravel business opened in 1919 and closed in 1922, leaving behind the concrete ruin of its hopper off the Lake Superior shore—known affectionately today as "Uncle Harvey's Mausoleum." From 1951 to 1973, people flocked to the base of the Lake Avenue Viaduct to eat at what was considered the best restaurant in town: Joe Huie's Café. In 2006 Zenith Spring sold what was the last industrial facility in the area, now wedged between two luxury hotels and waiting for its new owner (a hotel developer) to decide what to do with it.

Many people lived in the area as well. When the aerial bridge was first built one neighborhood along the lake shore was called "Finn Town" because many poor Finnish immigrants settled here (there was a Finnish church as well); it later became home to other minority groups. There were also more than a few boarding houses and cheap residential hotels for sailors and transient workers, as well as many restaurants and lunch counters to serve the locals. Fewer and fewer people chose to live in the area over the years, and it fell into decay. By the late 1960s wrecked cars, broken appliances, and other abandoned items lay strewn along the ruins of Finn Town (where today people stroll along the Lakewalk behind luxury hotels). And what is today a parking lot surrounded by restaurants, specialty shops, and hotels—the site of homes, Webster School, and the Aerial Hotel when the bridge was built—was a scrap iron yard as recently as the mid 1970s.

Uptown could also be a rough and rowdy place, and some of the city's seedier citizens spent their free time in its many saloons and brothels—children passing through the area to get to and from Park Point were warned by parents to "stay away from the pretty ladies dressed in kimonos." In fact, the oldest structure standing in Canal Park is a tiny house at 329 Canal Park Drive (now an antique shop) built in about 1870; former owners claim it includes a hidden passage leading to a boarding house above the restaurant next door (a souvenir shop today)—if police paid a visit to the lady of the house, her guests could quietly leave in secret before she opened the door. In the 1880s housing units occupied by prostitutes were labeled "female boarding houses" on insurance maps, and they were clustered together in Duluth's own red light district: either side of the St. Croix alley south of the Heimbach Lumber Company on Railroad Street and north of Sutphin Street. This area was home to prostitutes from as early as 1883 until the late 1930s, when most of the saloons were also swept out and the ladies and barkeeps set up shop in what became known as the "Bowery," the area roughly west of Fifth Avenue West between the railroad yards and Superior Street. Legend has it that landmark Canal Park family restaurant Grandma's Saloon & Deli at 520 South Lake Avenue was a boarding house/brothel operated by a "Grandma Rosa Brochi." Rosa Brochi may have been an actual person, but the story is a marketing myth; the building was the St. Nicholas Hotel as early as 1883 and the Blanchet Hotel & Saloon from roughly 1909 to 1919; in 1930 the building was listed as vacant. There is no evidence it was ever used as a brothel, and it stood well outside the "female boarding house" district.

Improvements to Canal Park proper beginning in the 1970s, along with the extension of Interstate 35 in the early 1980s, helped change the face of that entire section of town. Many of the industries that thrived in the area for decades had begun to disappear in the 1960s, and by the late 1980s most were gone and the buildings that housed them were either demolished or in the process of being converted into retail space. Other improvements were made: with the extension of I-35, Lake Avenue South was divided into two portions connected by a half block of Railroad Street, and what was once First Avenue East (and before that, St. Croix Avenue) was renamed Canal Park Drive. Well before the work was complete Duluthians had begun to describe the entire area between the canal and the Lake Avenue bridge as "Canal Park."

Today the only remaining "old" business still operating on Canal Park is the Club Saratoga, a burlesque club that opened in the 1950s near the very corner of the lake. The city paid to relocate "the 'Toga" when highway expansion in the 1980s called for its building's demolition; officials had hoped the business would move to another part of town, but instead it set up shop right on Canal Park Drive in the heart of today's tourist district.

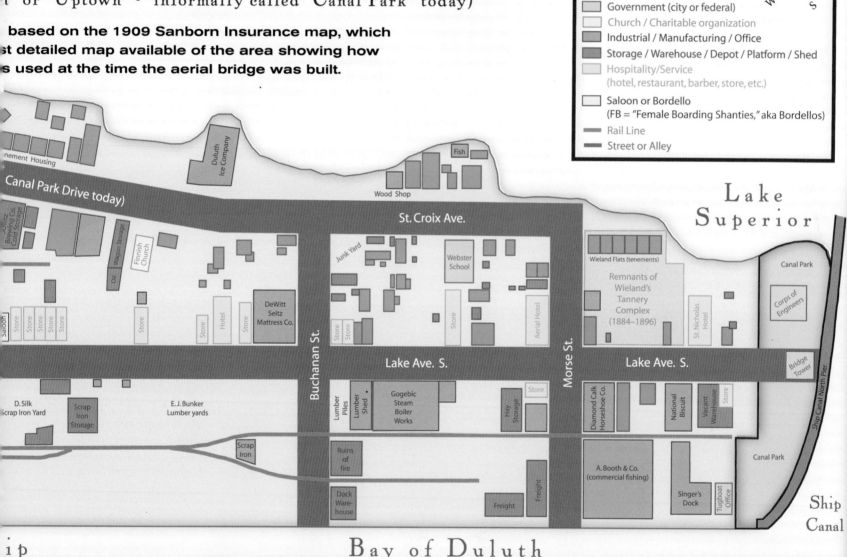

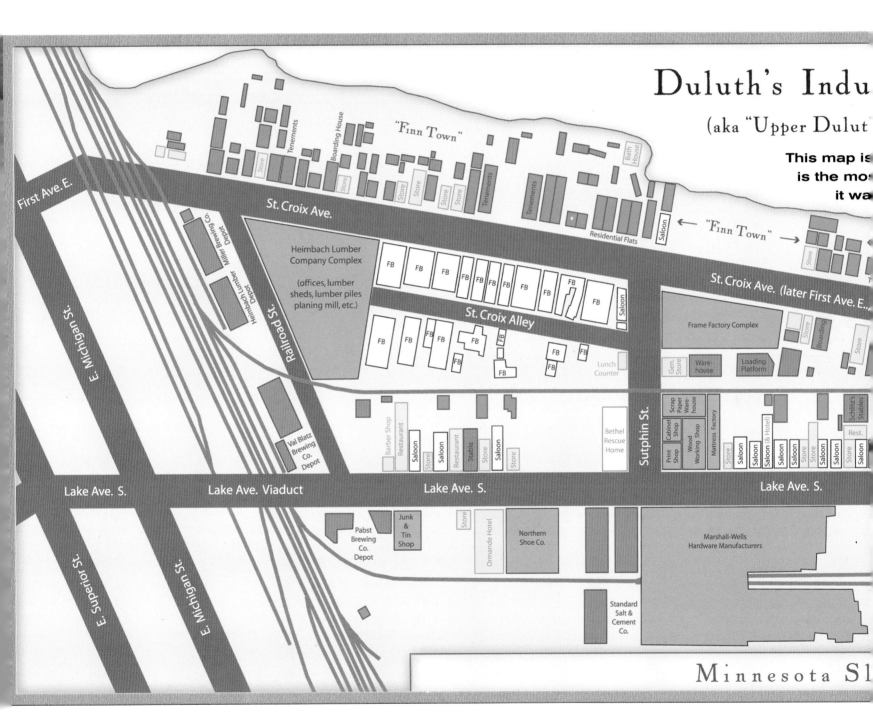

Duluth's Indu

(aka "Upper Dulut

This map is
is the mos
it wa

"Finn Town"

Boarding House

Tenements

Store

Store

Store

Store

Tenements

Tenements

Bath House

Residential Flats

Saloon

← "Finn Town" →

Store

Store

First Ave. E.

St. Croix Ave.

Miller Brewing Co. Depot

Heimbach Lumber Depot

Heimbach Lumber Company Complex

(offices, lumber sheds, lumber piles planing mill, etc.)

Railroad St.

FB FB FB FB FB FB FB FB FB FB FB

FB

Saloon

St. Croix Alley

FB FB FB FB FB

FB

FB FB

FB

FB

Lunch Counter

St. Croix Ave. (later First Ave. E...

Frame Factory Complex

Store

Boarding

Store

Gen. Store

Ware-house

Loading Platform

E. Michigan St.

Val Blatz Brewing Co. Depot

Barber Shop

Restaurant

Saloon

Store

Saloon

Restaurant

Stable

Store

Saloon

Store

Sutphin St.

Bethel Rescue Home

Scrap Paper Ware-house

Cabinet Shop

Mattress Factory

Print Shop

Wood Working Shop

Store

Saloon

Saloon

Saloon (& Hotel)

Saloon

Saloon

Store

Store

Saloon

Store

Saloon

Schitz's Stables

Rest.

Lake Ave. S.

Lake Ave. Viaduct

Lake Ave. S.

Lake Ave. S.

E. Superior St.

E. Michigan St.

Pabst Brewing Co. Depot

Junk & Tin Shop

Store

Ormande Hotel

Northern Shoe Co.

Marshall-Wells Hardware Manufacturers

Standard Salt & Cement Co.

Minnesota Sl

from falling icicles (see the photo on page 107) and McGilvray requested a hand-railed gangway on the lower chord of the truss and a covered stairway to access the truss—he wanted to stop the "dangerous acrobatic feats" required of bridge workers to maintain the structure. At his request the Common Council sought bids for a rowboat for the purpose of "saving human lives and otherwise." They also allowed him to purchase duplicate parts—such as wheels, hangers, and cable—to have on hand in case of failure. The Common Council records for 1906–1907 show that the Council granted each of the engineer's requests save one: he had again asked for a telephone, and the Council took no action.

In February 1907 the *Duluth Evening Herald* reaffirmed McGilvray's report to the city, reporting that the ferry had not missed a trip in a year, having safely moved 50,000 teams and 2,500,000 passengers making six to eight passes an hour. Already people were guessing as to how long the bridge's capacity could keep up with increasing demand to cross the canal, and some speculated that it was only a matter of time before a private enterprise tunneled the canal in order to reach the point by rail and exploit its industrial potential. Turning Park Point into an industrial center would render the ferry bridge obsolete.

Of course the tunnel and the industrialization of Park Point never occurred, but that didn't mean the bridge didn't get busier. As its use increased, so did the population and activity on Park Point; both the city and the community south of the canal did their best to keep up. An example of this occurred

in November 1907, when the Common Council asked the Duluth Street Railway Company and the Park Point Street Railway Company—which operated as wholly separate entities—to allow riders to use transfers when getting off one streetcar line to cross on the aerial bridge so they wouldn't have to pay an additional five-cent fare to use the streetcar on the other side. Few of Park Point's residents worked south of the canal, and Alderman Joseph Hartel argued it wasn't fair to have them pay twenty cents a day to commute to work when most of the city's citizens paid nothing. Meanwhile heating systems were added to the ferry car to keep passengers warm in winter weather. In his 1907 report, McGilvray once again asked for a phone as well as two more electric motors because in cases where one motor had shorted out, the other motor strained to propel the ferry car.

It wasn't all work and no play for McGilvray during this crucial time in the bridge's life. The engineer enjoyed an active life and was the skipper of his curling team—and a pretty good one at that. In 1903 the *Duluth News-Tribune* ran a caricature of McGilvray dressed in plaids, donning an oversized tam-o'-shanter cap, and ready to launch a curling stone; beneath the drawing was a limerick:

> *Here's Thomas McGilvray, you see.*
> *As a skip he's a winner, B-gee!*
> *When he starts in to curl*
> *The game goes with a whirl.*
> *His opponents are all up a tree.*

McGilvray was also a good friend of John A. Johnson, who became Minnesota's governor in 1905. In June of his first year in office, Johnson appointed McGilvray to his staff as an aide de camp and bestowed upon him the rank of Colonel (his friends would later use the title as a nickname). The new title came as a surprise to McGilvray, who knew nothing of it until he had returned from a fishing trip with his wife, Roselda, whom he called "Rosie." Mrs. McGilvray was also active in Duluth social circles, frequently making the newspaper's society page for hosting events such as a gathering at their East Second Street home to play 500, a card game much like euchre. As a member of the governor's staff, in 1908 McGilvray traveled to the Shiloh Civil War battlefield in southwestern Tennessee for the dedication of a monument to the Minnesota soldiers who died in the famous battle. On his return, McGilvray sported a button that read "John A. Johnson, Our Next President" and spoke of how everywhere the governor had gone, "people turned out by the thousands to greet him."

Not that McGilvray's duties to the government stopped him from remaining passionate about his job: When the Duluth Commercial Club—a predecessor to today's Chamber of Commerce—called the condition of Duluth's streets "deplorable" in 1908, the Engineer from Aberdeen charged the organization with slander and spat back that its report contained "mischievous and either grossly superficial or wholly biased statements." While his confirmation as City Engineer in 1897 had come with some dissent, after the bridge went up, strongly Democratic Duluth loved him. At the end of Mayor Cullum's term in 1908, newly elected Republican Mayor R. D. Haven tried to appoint another engineer to McGilvray's job, but the overwhelmingly Democratic Common Council "refused to affirm the mayor's appointment," the newspaper reported. Just two years later, Cullum defeated Haven to take his job back (Duluth mayors held two-year terms at the time) and McGilvray's position was no longer in question.

With the bridge operating apparently perfectly by 1907, its history became one of maintenance and incidents surrounding it and the canal it crossed. In November 1908 another great storm hit the western tip of Lake Superior, causing lake waters to roll so high bridge operations had to be suspended for the first time since the *Mataafa* Storm: the paper reported that "the car cannot cross the canal without being struck by waves." Considering that the bridge rested fifteen feet above the canal's waters, waves had to have been at least that high. Water easily crested over the canal's piers; a few old-timers said it was the highest they'd seen since the construction of the "ditch"—higher than the *Mataafa* Storm. After a couple of rather rough crossings, the bridge operator phoned the Board of Public Works, saying that the bridge could be damaged; certainly its electric motors, mounted beneath the car, would short out because of the water. Councilors must have finally heeded McGilvray's request for a telephone.

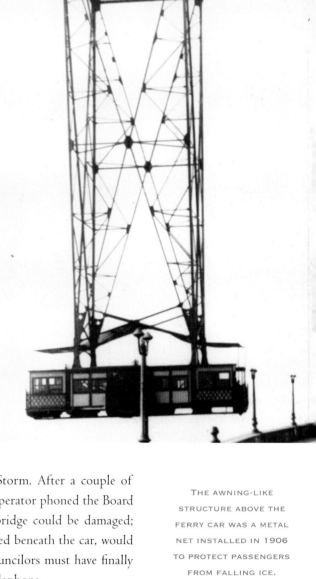

THE AWNING-LIKE STRUCTURE ABOVE THE FERRY CAR WAS A METAL NET INSTALLED IN 1906 TO PROTECT PASSENGERS FROM FALLING ICE.

White City

On the last day of June 1906, Oatka Park opened on Park Point between Thirty-Ninth and Fortieth Streets. Reports claim ten to fifteen thousand people enjoyed the park on its first day even though the park had little more to offer at the time than a public dance pavilion.

Soon after, the park became White City, an amusement park operated by the Duluth Amusement Company. In 1907 the *Duluth Evening Herald* credited the aerial transfer bridge with the park's existence; the old ferry system could never have carried as many people as crowded into White City on weekends. On more than one Sunday in 1906, crowds using the aerial bridge to reach White City surpassed the record of 32,595 set the very first Sunday the bridge opened to the public.

Rides were added, including the "Mystic River" boat ride, a miniature railroad (operators claimed it had the smallest steam locomotive in the United States), and the "Fun Factory," where ticket payers lost themselves wandering on twisted paths and "[ran] up against all kinds of funny and startling adventures."

Other attractions included an automated baseball game, a Ferris wheel, a water slide, free acrobats and burlesque performers, sitting rooms (for the ladies), cafés and restaurants, bathhouses, swimming lessons, and vaudeville acts. The park also featured a corral of deer, and at one time its owners commissioned the construction of a $7,500 gasoline-propelled airship to be named *Duluth No. 1*, although it was never built.

After a brief name change to "Joyland" in 1908, the park shut down in 1909. Part of the property on which it stood became the home of Maggie McGillis—in fact, a portion of McGillis's home, at 4010 Minnesota Avenue, is made from White City's old band shell.

The paper noted that the car had been tied up "on the Duluth side." Of course, both sides of the canal were in Duluth, but the report illustrates how even eighteen years after Park Point returned as part of Duluth, the two communities had not finished melding together in the minds of their citizens. Not all Park Pointers took the event in stride. The Board had difficulties arranging for a temporary ferry to make crossings. Eventually the tug *Pacific* was called on to act as ferry, but before that had been arranged the Board of Public Works had received an earful from angry Park Pointers. Many used their telephones to let the Board know their disgruntled state. The paper reported about one particularly angry Park Pointer who scoffed at the idea that the bridge would be unsafe in the gale and "yelled over the phone that the Board ought to get a couple of four-year-old children to run the ferry if they were afraid to do it themselves." The Board retorted that the caller would certainly get the job himself if he were to apply. The newspaper also mentioned that a woman called the paper to report that the aerial bridge's car had been "swept away and that it was riding the waves out in the middle of the lake." She was mistaken.

Temporary ferry service such as that provided by the *Pacific* was employed every twelve to eighteen months when bridge operators overhauled the structure. In the bridge's first few years, its arguably relaxed schedule allowed operators twenty minutes between trips to perform any maintenance, and with redundant equipment at hand, broken parts could be quickly swapped out and repaired at another time rather than shut the bridge down to repair the parts in place.

THE TRANSFER BRIDGE IN MID LIFE

By 1910 the ferry made seventy-five round trips a day during operating hours, and the time between trips no longer allowed on-the-fly maintenance. Starting that year, overhauls were made annually and lasted ten days.

Except for the time when his colleague William Patton filled the role from 1900–1904, Thomas McGilvray had served as Duluth's City Engineer since 1897. But at the end of 1912, he stepped away from public office. He may have been uncomfortable with a big change to Duluth's government: the shift from an alderman-based Common Council to a commissioner-based City Council. Commissioners represented the city departments: Finance, Public Works, Public Safety, Public Utilities; the mayor acted as the Public Affairs Commissioner. (The city switched to its present Mayor/City Council form of government in 1956.) Perhaps McGilvray didn't like the idea of answering to an elected public works commissioner. At his retirement reception McGilvray's fellow city engineers presented him with a Masonic emblem, and the paper reported McGilvray delivered a "neat speech." In 1913 he rejoined Patton at his Duluth Engineering Company, where he would work until 1917 before going into private practice. McGilvray unsuccessfully ran for County Surveyor in 1918. His loss may have been due to a little bad press a few months before the election. In May, he and two companions were charged for drunkenness and disorderly conduct, and the Temperance movement was in full swing; Prohibition would go into effect the next year. The newspaper account of his arrest did not elaborate on the events surrounding it.

An incident in 1913 displayed just how disruptive a bridge closing could be—especially an unexpected one. At about 1 P.M. on September 4, as the ferry car approached the north pier with a load of passengers—no teams or automobiles were aboard—a frayed cable snapped, and the car ground to a halt. The car had not reached the end of its journey, so passengers had to descend by ladder. Captain E. D. Peck of the Corps of Engineers immediately provided the use of a government launch to ferry passengers until the city could secure the services of a steam launch.

The North Pier Lighthouse

The great storm of 1905 proved a point the Lake Carrier's Association had been making for years: since the canal was only three hundred feet wide, the South Pier Light wasn't sufficient for mariners to guide their craft at night or in foggy weather, even with the help of the Rear Range Light. Too far south and a ship would run into the pier; too far north and it would beach on the rocky shore. The LCA made repeated pleas to the Lighthouse Board to build a light, but were turned down time after time. Frustration led the organization to place a temporary light at the end of the North Pier in 1908.

A year later, the Lighthouse Board called the Duluth Harbor "one of the worst and most dangerous on the whole chain of [Great] Lakes." The report—along with the evidence from 1905's *Mataafa* Storm (see page 68)—bolstered the LCA's argument and Congress appropriated $4,000 to build a lighthouse.

Building began in late 1909 and finished after the opening of the 1910 shipping season. An iron tower enclosed by steel plates, the North Pier Light stands thirty-seven feet tall, measures ten-and-a-half feet in diameter at its base, and tapers to a diameter of eight feet at the top. An octagonal cast-iron lantern holds a Fifth Order Fresnel lens made in Paris in 1881, originally illuminated by a 210-candlepower incandescent electric lamp. In clear conditions the light can be seen eleven miles away. Keepers first displayed it the night of April 7, 1910. Its white light was later replaced with a more navigationally appropriate red light (so that, along with the South Breakwater Light's green lamp, skippers can more easily identify the canal's entrance).

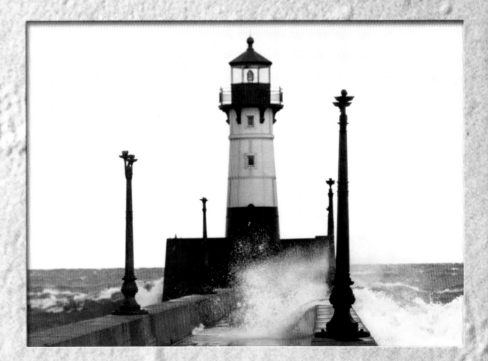

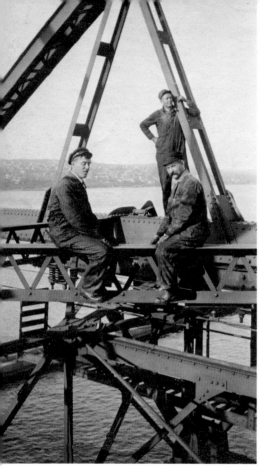

The *Plowboy* eventually took over the job, but its cargo was limited to people. Dozens of wagons, teams, and autos were stranded on Minnesota Point until workers could complete repairs, which took two weeks as the city decided it might as well put the bridge through its annual maintenance at the same time.

Another great storm stopped bridge operation on April 28, 1914. Incoming boats were forced to turn back and ride out the storm on the open lake—the waters were too rough to navigate the canal. The newspaper reported that hundreds of people armed with "cameras and Kodaks" headed to the canal to watch and take photos of the storm, but most were forced to seek shelter in the Corps of Engineers' building and the moored aerial bridge ferry car. Twenty-five Park Point residents spent the night in the ferry car; others were forced to find rooms in hotels.

At least one man didn't think conditions on the canal posed that great a danger. Twenty-four-year-old laborer Sivo "Stans" Sanden, a resident of the Torvilla Hotel a few blocks north of the canal, bet a companion one dollar that he could walk the North Pier from end to end. Setting out from beneath the aerial bridge, Sanden darted from one light post to the next, hiding behind the posts as the waves crested and running to the next before another breached the canal. About halfway through his adventure, bridge operators saw Sanden hesitate long enough to throw off his timing. When the next wave hit, it swept him over the pier and into the canal's roiling waters. He may have hit his head along the way: witnesses said he made no

attempt to swim to safety. Police and members of the life-saving station arrived quickly, having been notified by bridge operators using the ferry car's telephone. None of the would-be rescuers could locate his body.

By the summer of 1917 city officials were once again wondering how long the bridge could keep up with demand. Mayor C. R. Magney and Finance Commissioner Phillip G. Phillips of the City Council reminded citizens that the bridge's estimated life was twenty years, and that it would reach that mark in just six years. They dismissed the idea of replacing the bridge with a larger structure of the same kind; a recent carnival on Minnesota Point forced the bridge to transport thirty-two thousand spectators, which it did with some difficulty, proving that a ferry bridge could never handle the expected traffic in the years ahead. Only a tunnel would both handle the estimated traffic needs and be allowed by the Corps of Engineers, which controlled the canal, and a tunnel would take about the same amount of time to build. Despite the clamor Phillips and Magney created, the tunnel idea died.

The next year marked the first tragedy to occur on the bridge, the accidental death of Duluth pioneer and bridge operator Thomas White. On December 19, 1918, White—substituting for vacationing bridge supervisor Leonard Green—climbed to the top of the bridge to perform maintenance, mostly oiling the trucks and pulleys. No one witnessed how the accident occurred, but as the ferry car left the South Pier and headed across, White was somehow pulled into a pulley, crushing his chest. Some passengers waiting to board heard White scream, but the sound of the ferry in motion prevented the operator from immediately hearing his cries. It took a firefighter and two bridge operators quite some time to free White from the bridgeworks and lower him down by ropes, and he died just minutes after reaching the hospital.

While maintaining the bridge had proved deadly to White, not a single accident involving the ferry bridge resulted in the death of a passenger. In her book, *This is Duluth*, Dora May McDonald noted only two accidents, both involving the approaches to the ferry car. In one, a driver of a team carrying beer drove his horses right off the approach and into the canal; a 1956 article in the *Duluth News-Tribune* claimed it had been a laundry team, not a brewery team, and added that the horses drowned (if it was indeed a brewery team, it likely belonged to Van Blatz Brewery of Milwaukee, which operated a distribution warehouse on Park Point). In the other incident, DM&N Chief Engineer H. L. Dresser drove his car off the approach. McDonald reported that James Ten Eyck, the Duluth Boat Club's legendary rowing coach, happened to be waiting for the ferry when the accident occurred; he removed his pants and dove into the canal, bringing Dresser to safety. Still another tale combines these two accounts into one event, with Dresser's car forcing the team overboard before following in his car. None of these accounts included a date, however, and searches in newspaper archives for contemporary accounts have turned up nothing.

Another unverified tale turns potential tragedy into humor. The story goes that a young betrothed couple began arguing as they crossed the canal in the ferry car. The disagreement caused the woman great anxiety. Distraught, when she descended the ferry car she immediately ran to the edge of the pier and, in a dramatic effort to end her own life, threw herself into the canal. Her rash act was supposedly foiled by her enormous hoop skirt: when she landed in the canal, instead of sinking to the bottom,

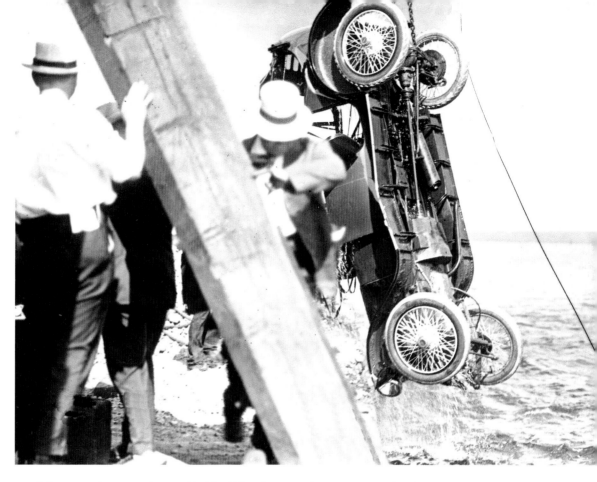

she popped up and bobbed like a buoy until rescuers arrived and plucked her to safety.

Not every event surrounding the bridge involved maintenance or potential tragedy. On March 18, 1918, pilot Wilber Larrabee became the first person to pilot an airplane beneath the aerial bridge (others would follow, see "Barnstorming the Bridge" on page 134). Larrabee, of Minneapolis, was in town to perform a "revue" of acrobat flying, with the dive beneath the bridge his headline maneuver. Unfortunately, a follow-up article on Larrabee did not provide any details of the stunt and only reported that it had been accomplished.

AN AUTOMOBILE BEING PULLED OUT OF THE SHIP CANAL. ITS DRIVER COULD WELL HAVE BEEN DM&N CHIEF ENGINEER H. L. DRESSER, WHO ONCE DROVE HIS CAR OFF THE BRIDGE APPROACH AND INTO THE CANAL; HE WAS SAVED BY DULUTH BOAT CLUB ROWING COACH JAMES TEN EYCK.

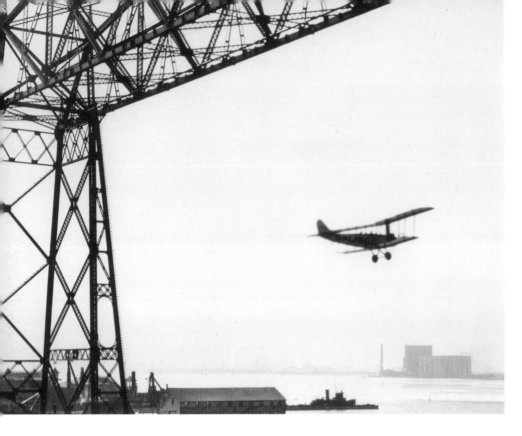

1920S: THE BEGINNING OF THE END

Throughout its life span, the Duluth Aerial Transfer Bridge never had an accident with a vessel navigating the canal—not that there hadn't been many close calls. Operators liked to say that sometimes the car came so close to a vessel, there would certainly have been a collision "if the boat had been covered with one more coat of paint." Hyperbole aside, the closest recorded call came November 8, 1921, when the outbound steamer *Joshua Rhodes* came within fifteen feet of the car. With about fifty passengers aboard—plus a full load of cars, trucks, and coal wagons—trouble with the trucks stopped the ferry car about two-fifths of its way south across the canal as the *Rhodes* approached. Its operators leaped into action: one rang the emergency signal on the bell—five loud clangs, the

Duluth Evening Herald reported—while another climbed atop the ferry car and waved his arms, trying to get the *Rhodes'* captain's attention. A nearby tug blew its whistle and waited nearby in case it was needed to help push the *Rhodes* away from the ferry car. Luckily, officers on the *Rhodes* were paying attention and were able to steer the ore boat just in time to allow it to pass safely.

A winter storm in February 1922 illustrates just how important the bridge was to Park Point's residents. A blizzard had buried the city, turning it into "a labyrinth of tunnels and narrow snow-banked lanes," according to the *Duluth News-Tribune*. The Point had been hit hard, with snowbanks as high as trolley cars. To make matters worse, a cable had snapped on the aerial bridge, cutting Park Point off completely. The town's fire chief, John Randall, worried that a fire on the Point would quickly become a tragedy. "I don't know what we can do for Park Point," he told the newspaper. "Unless a snow-shoe volunteer fire-fighting, snow-bucket brigade is organized, people must be extra careful to avoid any possible fires." Bridge boss Leonard Green explained that the gale had fouled one of the cables, which became caught up in the bridge's hangers. The problem would take only eight hours to fix, but no work could be done until the weather abated. When the weather cleared and the bridge was repaired, one of its first duties was to transport a National Guard tank to Park Point to help clear snow.

Snowstorms weren't the only problem facing Park Pointers. With more and more people using the ferry bridge, especially in summer, they were often delayed to and from work. To alleviate the problem, in June 1922 Mayor Samuel Frisbee Snively and Public Works Commissioner James A. "Bert" Ferrell introduced an ordinance to the City Council granting bridge privileges to Park Point residents: they would have precedence over other passengers queuing up for a ride "every other time it crosses from the north to the south side of the ship canal between 5:30 and

7 P.M., from June 1 until Oct. 1." The measure passed, but not without some effort by Washburn, Bailey & Mitchell, the law firm hired to represent Park Point residents.

After the measure had been introduced, City Attorney J. B. Richards gave his opinion: the ordinance violates the state constitution and discriminates against those Duluthians who did not live on Park Point. A. M. C. Washburn, on behalf of Park Point, argued the ordinance was both valid and justified in the entire city's interest both from a "traffic view and from the viewpoint of public health, safety, and morals." He added that the measure would stand up to any legal argument against it and if an arrangement with the Duluth Boat Club could be worked out, there should be no problem whatsoever.

But after both attorneys gave their opinions, the Council did not move to take any action, which infuriated Washburn. "Does the mere filing of the city attorney's opinion automatically dispose of the ordinance?" he objected. "If it does, this council certainly is unique as a legislative body. It strikes me as a cheap way of getting out of learning the constitutionality of such a measure."

Two commissioners took exception to Washburn's remarks. Finance Commissioner Leonidas Merritt said that while he sympathized with Park Pointers, he told them he would vote for the ordinance only if the city attorney approved of it—he would not expose the city to endless lawsuits. Public Utilities Commissioner Phillips, under whose jurisdiction the bridge operated, was incensed. "Don't make any more trouble for me," he told Snively and Ferrell. "I think that you who are so anxious for this ordinance ought to take over the care of the bridge, I am not going to vote for any kind of ordinance that is going to exclude any taxpayer from the use of the bridge."

The Aerial Bridge as Icon

It has been called "Duluth's Eiffel Tower," and, like that tower's role in Paris, today the bridge's role as Duluth's icon is taken for granted. Countless businesses use its image in some part of their logos, and one of the local radio stations even calls itself "The Bridge" for short. Mayor Don Ness helped bolster his political career by organizing his "Bridge Syndicate," which encouraged young people to get involved in the community. There is no end to the puns too many headline writers have been unable to resist. Canal Park plays host to a cottage industry centered on the bridge. You can find the bridge on just about anything that can be held down long enough to be printed on: coffee mugs, beach towels, t-shirts, etc. Canal Park candy shops even sell chocolate shaped like the bridge (and ore boats too). Hardly a book published about Duluth—whether about the bridge or not—makes it to stores without the bridge on its cover.

It's been that way since the bridge first went up over the canal back in 1905. Because it was the first of its kind in the United States, the ferry bridge had a national reputation (as does its lifting successor today). During its early years, images of the bridge were painted on fine china pitchers, vases, serving plates, lace plates, salt-and-pepper cellars, and cup-and-saucer sets. It was printed on postcards and letterheads; stamped or embossed on metal napkin rings, penholders, letter openers, spoons, and cigar boxes; and engraved on silver spoons and gold lockets. One of the first books to sport an image of the bridge was *The Duke of Duluth*, a 1926 novel by Thomas Hall Shastid, M.D., available at the Duluth Public Library.

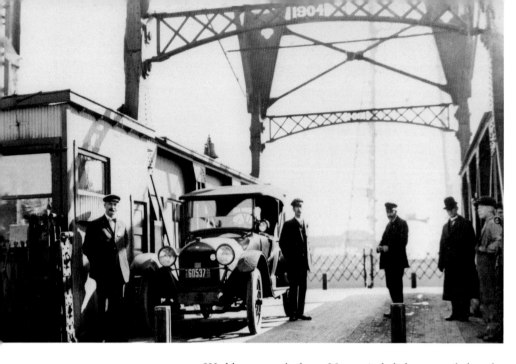

Washburn wasn't done. He reminded the council that the city attorney's ruling was "not infallible" and that "Mr. Richards…was for their guidance, not their master." The ordinance passed, with Merritt and Phillips casting the only "nay" votes.

The next year saw the passing of one of the engineers who helped create the bridge. William Patton, who stood in for McGilvray during Mayor T. W. Hugo's 1900–1904 administration, died on November 30 at age sixty-three. Besides being instrumental in the aerial bridge's construction and the president of the Duluth Engineering Company, Patton had been a very active Mason. He was one of four charter members of the King Solomon Temple of England—the other three were former presidents Teddy Roosevelt and William Howard Taft and General Thomas J. Shryock, a lumberman and one-time treasurer of Maryland. Patton was a past master of Duluth's Palestine Lodge No. 79 and in 1910 the grand master of the Minnesota Grand Lodge. At his death he was considered "one of the leading Masons in the world."

The bridge Patton helped build was also nearing the end of its life. Even with privileges in place for Park Point residents, the bridge simply could not keep up with the needs of the city—on either side of the canal. In 1901, when the transfer bridge idea was still an idea, just shy of 53,000 people lived in town and only one of them, B. E. Baker, owned an automobile (a single cylinder Oldsmobile runabout, although J. R. Zweifel also claimed his Locomobile steamer got there first). In 1925, the population was closing in on 100,000 and 17,340 automobiles and 2,600 trucks drove Duluth's streets. The bridge had in part created the growth that was rendering it obsolete: with a convenient mode of conveyance across the canal, Park Point and the entire southern portion of Minnesota Point had opened to more full-time residents and businesses, and it continued its role as "Duluth's Playground." With more and more of the people living, working, and playing on the Point—and getting to and from the isthmus on automobiles—soon there wouldn't be enough hours in the day for the bridge to move everyone who needed to use it.

And as it neared the end of its estimated life, city officials began to join Park Pointers in expressing their concern. In May 1925 Public Utilities Commissioner Phillips asked the City Council to take the responsibility of maintaining the bridge out of his hands. The meeting was not focused on the bridge, but on parks improvements, something very dear to Mayor S. F. Snively, who donated his own time and money to build Seven Bridges Road and complete Skyline Parkway. Phillips objected to Snively's idea that gravel used to help build a link between the Fond du Lac Road and Jay Cooke State Park be paid for with bond money. "I don't like that," Phillips told the Mayor. "What are we going to do in the future when we are faced with real bond issues, if we load ourselves down with bonds now?"

Snively replied, "Always afraid of the future…."

"I have a right to be," Phillips retorted. "What are we going to do in the future when the aerial bridge is declared unsafe? What will you do, if you are mayor a few years from now, and I ask you and the rest of the council to take responsibility for the bridge?"

No one replied. When asked by a reporter if the bridge was in any immediate danger, he simply replied that, "It is over twenty years old and can't be expected to last forever," before explaining that the future he was concerned with included an expense of $4,000,000 to replace the bridge with a tunnel.

Not everything about the bridge's final years involved lawyers and City Council decisions. In July 1926 J. C. Craig sought to thrill Duluthians by diving from atop the bridge, 186 feet into the canal below. Craig's jump, sanctioned by Mayor Snively and other city officials, was intended to break the record of 133 feet set by Steve Brodie when he launched himself off the Brooklyn Bridge. Craig considered Brodie a "piker," a derogatory term in vogue at the time meaning cheapskate or a person who does things in a small way. The thirty-three-year-old Craig fancied himself no piker; indeed, the paper reported he'd been "making eyes at death so long he has earned the nickname of 'Daredevil.'" Craig announced he would not only leap from the top of the bridge, but also blindfold himself and walk across the beam backward and forward until he was ready to jump.

Craig did beat Brodie's record, but not by as much as he'd hoped. High winds made it impossible for him to reach the very top of the bridge, and he had to jump from a beam on the lower edge of the span, reducing the jump to 140 feet. But as promised he put on the blindfold, walked forward and backward, hung from his toes, and basically "frolicked about" as the newspaper reported. After his successful jump, he ended up chilled to the bone (he called the canal's waters "the coldest current in the world") and battered—but his body was not as bruised as his

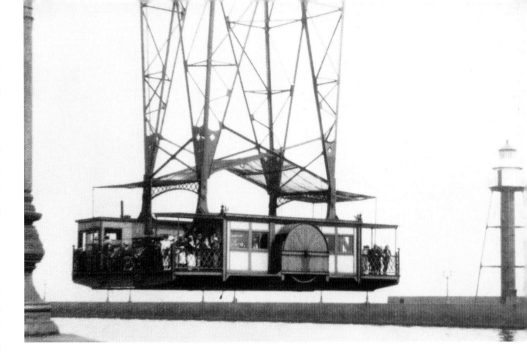

ego. Despite drawing a crowd of about ten thousand onlookers, passing the hat brought him only $65.

While the Aerial Transfer Bridge was largely known for the traffic jams it caused during its final few years, it also continued to serve Duluth as a tourist attraction and provided many memories. One man even claims to have been born on the bridge's ferry car. In 2005 Richard Sundberg told a local reporter that his parents, Albert and Rose, were caught in a stalled ferry car during the stormy night of September 6, 1927, while rushing to the hospital from their home on Park Point. Sundberg couldn't wait to get to the other side and came into the world "right there on the bucket of the bridge." But the newspapers failed to report any such birth on the bridge at the time, and some lifelong Park Pointers—those with "sand in their blood"—also have no recollection of the event. Maggie McGillis, born on the Point in 1922, said she heard no such tale growing up, but knew Sundberg to be "always kind of a smarty. He may have made this up."

THE GONDOLA CAR—
A.K.A. "THE BUCKET OF
THE BRIDGE"—IN MID
TRANSPORT, LOADED WITH
PASSENGERS. ONE MAN
CLAIMS TO HAVE BEEN
BORN IN THE GONDOLA
CAR, AND A WOMAN
NAMED "AERIAL" WAS
SUPPOSEDLY CONCEIVED
DURING A CROSSING.

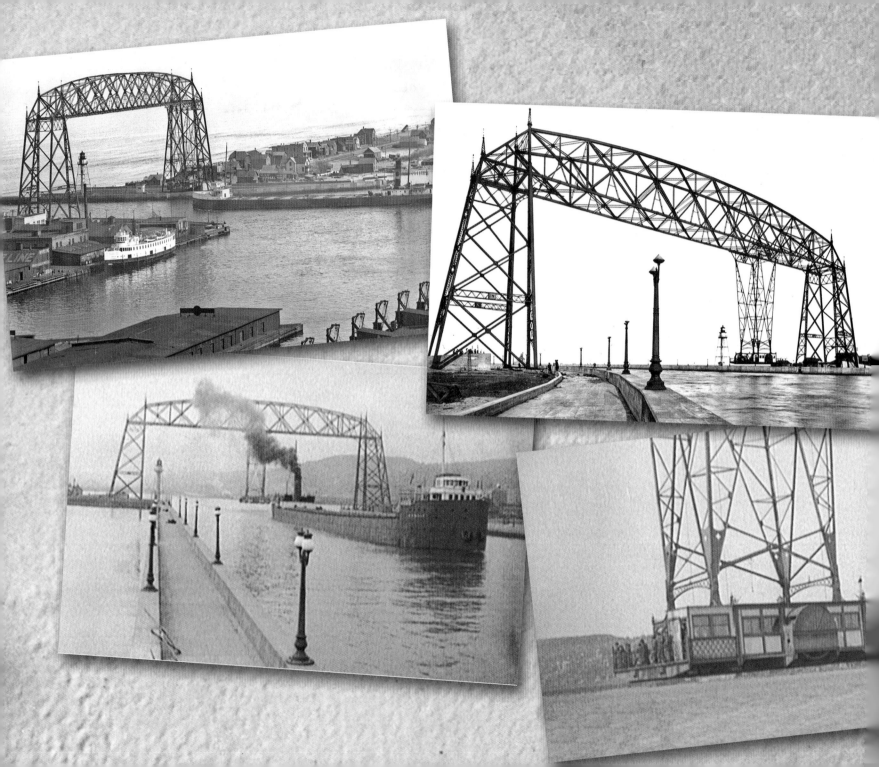

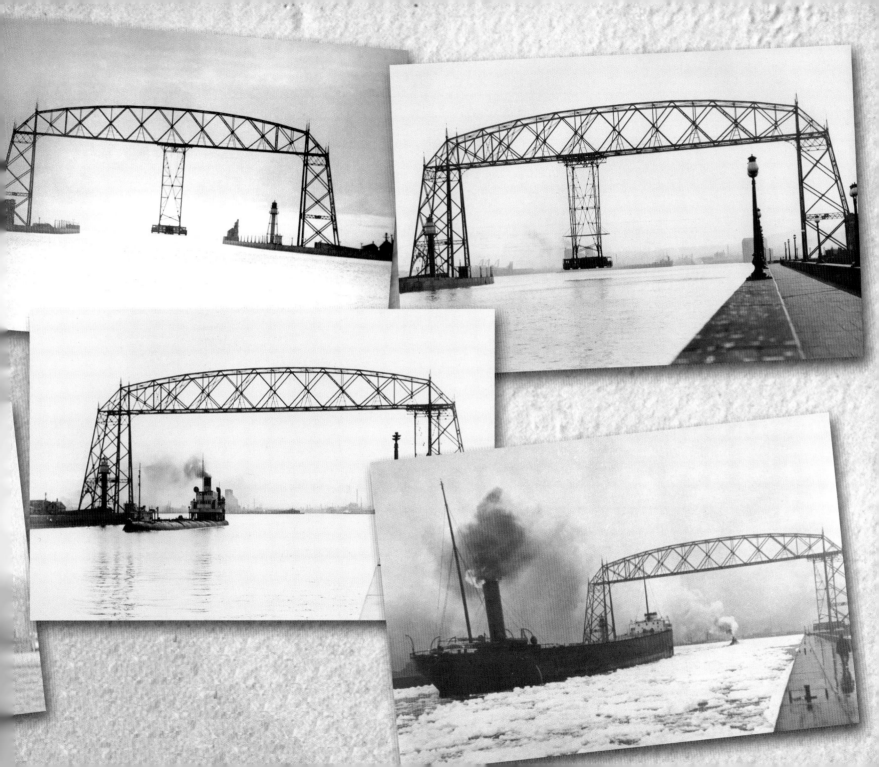

Another likely apocryphal tale is of a woman who was not born on the bridge, but conceived there. Her parents named her "Aerial," the tale goes. Of course, there is no record of such an event ever taking place on the bridge. When you consider that the ferry took about a minute to cross and was usually quite crowded and always had an operator on board, her parents would have pulled off a remarkable feat (although her father may not have wished to brag too loudly).

Despite its role as Duluth's icon, the aerial bridge was fast becoming—like daredevil Craig—nothing more than a novelty. Operating beyond its projected lifespan, the bridge was serving more as a tourist attraction than a practical way of crossing the canal. The next few years would see a movement toward the building of a replacement bridge, but just as building the first aerial bridge was fraught with obstacles, it would be a bumpy ride before anyone crossed the canal on a new bridge.

AN OLD IDEA RETURNS

The residents of Park Point had never held their tongues when it came to matters of crossing the canal, but by 1927 they were ready to put their money where their mouths were. On January 27, representatives of the Park Point Community Club—an organization that acted in many ways as the community's own form of government—approached the City Council with a well-planned and well-presented proposal. After showing the inad-

equacy and rising cost of operating the ferry bridge, they proposed an idea that had already been proven successful all over the world: a vertical lift bridge, very much like the one John Alexander Low Waddell had submitted to the 1891 contest. (In 1894 Waddell's plans for a bridge in Duluth became the first modern vertical lift bridge in the United States, Chicago's South Halstead Street bridge; see page 32.) A lift bridge would allow continuous foot and vehicle traffic except when raised to allow vessel passage. The group had also hired the Kansas City firm of Harrington, Howard & Ash to draw up the plans presented to the councilors. Founded in 1914, HH&A was well respected in the field of bridge design. Before 1928 they had about three dozen vertical lift bridges to their credit and, in 1931, would design the lift bridge at Stillwater, Minnesota. The firm's principal partner, John L. Harrington, was a gifted civil engineer who had earlier been partnered with Waddell.

The firm's drawings called for a twenty-four-foot-wide roadway with two streetcar tracks and pedestrian sidewalks on either side. Harrington explained that the vertical lift was a well-known concept, so it required no cutting-edge engineering or materials. The new bridge could also incorporate much of the existing structure, saving both costs and time. As did the original aerial bridge, it fit the site well since land for the long approaches required by a traditional bridge simply did not exist. Tunneling was far too costly, and a lifting roadway would give

far quicker crossings than the old ferry car. Perhaps most importantly, the new bridge would be no more a potential hindrance to shipping than the present one.

Park Point resident Samuel Clark Dick spoke on behalf of the club, arguing the necessity of a new bridge, which the club believed could be built with minimal disruption at a reasonable cost. The group estimated the cost at $550,000 and the Park Pointers, in a gesture of civic unselfishness, offered to pay one third of the cost—$180,000—through special assessments on their properties. As proof of its sincerity, the group provided a petition signed by 235 Park Point property owners representing 39 percent of the owners and 49 percent of the taxed property on the Point. Dick reportedly traveled to New York City to obtain the signature of Julius Barnes, the largest land owner on the Point; at the time, Barnes, who financed the Duluth Boat Club, was serving as the president of the United States Chamber of Commerce, headquartered in New York. The Council recognized a good thing when it saw one. Council member Herbert Tischer moved to refer the petition for the construction of "a steel lift bridge" to the city assessor to look into property ownership matters. Acting at its regular meetings in February, the Council passed the necessary resolutions to get the project moving.

Building the new bridge forced the city to jump through some of the same hoops it had navigated with the original bridge's construction. The city could not issue bonds for its

two thirds of the cost ($370,000) without the sanction of the Minnesota State Legislature, and even then a special election would be needed to secure the approval of the city's voters for the special bond issue. The bridge's towers, new or old, still stood on Federal land—so Congress (both the House and Senate), the Corps of Engineers, the U.S. Army, and the Department of War all needed to sign off regarding land use. The Corps also administered the ship canal and had deeply protective feelings about possible impediments to passage through it. The Lake Carriers Association represented the interests of the shipping industry and, in the real world of politics and commerce, their approval was also necessary. Finally, of course, the city needed a contractor to actually build it.

There would be other distractions as well, such as former Park Point resident Walter R. Mathew's idea to replace the ferry with a suspension bridge. But there were two major problems with Mr. Mathew's idea: its estimated cost would far exceed that of the lift bridge, and the northern approach would have to begin at Superior Street, creating other traffic issues. It was quickly dismissed.

The city really didn't have the time to entertain alternative ideas. It had to act fast: municipal elections were scheduled for April 5, 1927, and bonds to fund the bridge could only be issued by amendment to the city charter, which had to be approved by the voters. Notice of a charter amendment had to be

SAMUEL CLARK DICK OF THE PARK POINT COMMUNITY CLUB. DICK LED THE CHARGE TO CONVINCE DULUTH TO REPLACE THE TRANSFER BRIDGE. THE EFFORT INCLUDED A PETITION DRIVE, AND DICK WENT AS FAR AS TO TRAVEL TO NEW YORK CITY TO GET THE SIGNATURE OF JULIUS BARNES, BENEFACTOR OF THE DULUTH BOAT CLUB (SEE PAGE 54), WHO OWNED MORE PROPERTY ON PARK POINT THAN ANY OTHER PERSON AT THE TIME.

made public at least thirty days before an election, so on February 28 the Council told the City Clerk to get it done. Permission from the state arrived only a few days later. During the first week of March the State Legislature enacted its permission for Duluth to proceed. It was a largely *pro forma* action and passed unanimously with Governor Theodore Christiansen signing it on March 5.

An editorial in the *Duluth Evening Herald* on March 19, 1927, titled "The Aerial Bridge Acts Up" may have helped the bond issue's chances. The editor observed that twice already in 1927 cables on the ferry bridge had broken, stopping bridge service and forcing Park Pointers to "make a perilous boat trip across the canal through a floating field of broken ice." It went on: "At its best, the aerial bridge, interesting though it may be to tourists as a novelty, is utterly inadequate, and is costing the city a great deal of money through the delay in traffic it steadily causes. At its worst the aerial bridge is nearing the end of its usefulness, and before long it will be dangerous."

The editorial may not have been needed. Duluthians voiced relatively little controversy over the issue of a new bridge and approved the bonding by a vote of 16,433 to 9,326—nearly 64 percent approval. The next day the *Duluth News-Tribune* editorialized that "the old, picturesque aerial bridge which has about outlived its usefulness, will be replaced. This was a worthy proposal and the people of the city showed very good judgment in supporting it. The people living on the Point made a most generous offer…and the new bridge will benefit the entire city."

PURSUING APPROVAL

The next step involved getting the approval of the Lake Carriers Association, whose annual meeting was scheduled for April 21 in Cleveland, Ohio. Duluth sent City Attorney John Richards, armed with statements of support from several Duluth civic organizations, to argue its cause. John Harrington and Ernest Howard, the two consulting engineers who had designed the new bridge, accompanied Richards to explain how the bridge would work and how it would not interrupt ship traffic, the LCA's main concern. Harrington showed, with detailed photos and charts, the operation and structure of the proposed bridge and assured his audience that no impediments to shipping would result. The LCA gave the project their blessing the same day.

Still, none of the legislation nor the LCA's acceptance mattered one bit without the Corps of Engineers' approval. The City met with Major R. W. Crawford, the District Engineer in Duluth and the man in charge of the canal, and laid out its plan to him. Crawford found few problems with Duluth's proposal and forwarded it to Major Edgar Jadwin, the chief Army engineer in Washington. Jadwin and his staff seemed to have little objection and provided a lengthy set of rules and procedures for operating the new bridge. They also concluded that an act of Congress would be necessary before they could permit the work to begin; there was no avoiding the Army's chain of command.

So in December 1927 Minnesota's representatives in Washington introduced bills in their respective bodies of Congress. Congressman William L. Carss of Duluth introduced the House bill on December 5 and Senator Henrik Shipstead brought the same legislation to the Senate on the 15th.

In June some Duluthians started uttering disparaging words. Twenty-five Park Point property owners who had refused to sign the Community Club's petition brought a suit against the City; even if the majority of their neighbors were for it, they did not

wish to be assessed a fee for the bridge, which would come to about $52 per lot. Some of the land owners—whom the paper referred to as the "Park Point Insurgents"— owned multiple lots, and their share in the assessment was over $2,000. The suit alleged that the assessments violated the city charter and that they would exceed any benefit derived by them; the bridge ought to be entirely paid for out of general tax revenues since it benefited all Duluthians, it argued. The case dragged out until October 1928, when former Duluth Mayor C. R. Magney, now a district court judge, heard the case; Magney was not concerned with the necessity of a new bridge or its design, only whether city officials had violated the charter; he decided they had not.

When Congress reconvened in January 1928, it moved on the bills introduced by Carss and Shipstead back in December. Bills legalizing local projects are usually not controversial, particularly when no federal money is involved, and the House and Senate passed them in mid-January 1928. President Calvin Coolidge dutifully signed the legislation on February 16 and it went to the Secretary of War Dwight F. Davis for the Army's approval, the last the City needed. Permission from Davis arrived on April 16. Only two obstacles remained: finding a company to build the bridge and the money to pay them.

By August 20 Duluth had put in place provisions to begin selling bonds. Bearing 4 1/2 percent interest, the bonds would be sold in $1,000 denominations and mature in 1943, investors being paid their principle and interest "in the gold coin of the United States of America." While on the surface the bonds amounted to $370,000, the bridge's true cost to the city—principal, interest, and a State-required cushion—would come to slightly over $530,000. Combined with the Park Point special assessment of $180,000, the grand total of the bridge's conversion cost came to about $710,000.

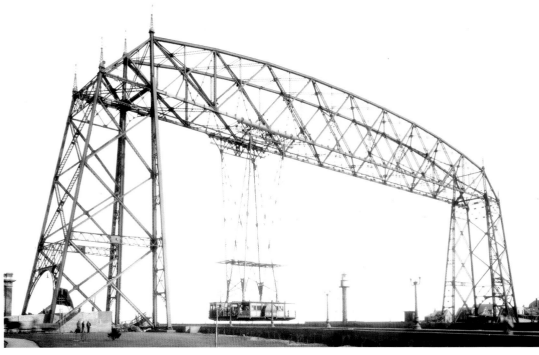

But there was one more idea still on the table, and it could greatly affect the conversion's cost. The City Council asked its special Bridge Committee to examine the idea of making the bridge substantial enough to carry freight trains, which in turn would revive the long-held idea that the bay side of Minnesota Point could be turned into miles of valuable dockage, industrializing the Point. The committee found that the additional costs and time to alter the plans at that stage were not only unfeasible, but would also delay construction. The report also indicated that a bigger bridge could have sunk the entire project. Park Point's own bridge committee made vigorous objections to the alterations. If the plans were altered for heavy rail, city officials feared that Park Pointers would withdraw their offer to pay for one third of the costs. Without the Park Pointers' support, the idea died.

With the bond drive underway and the heavy rail idea settled, on September 17 the Council authorized advertisement

for bids to construct "a steel lift type bridge across the United States ship canal at an estimated cost of $549,000 in accordance with the plans and specifications on file in the office of the city engineer." The city received two proposals by the deadline, but when city officials opened them on October 20, they were shocked. The American Bridge Company, C. A. P. Turner's old employer, bid $683,807 while Peppard and Fulton of St. Paul, builders of Ashland's 1916 ore dock, bid $692,420.50. The *Duluth News-Tribune* sadly reported that the bids were $130,000 too high and the City would have to call for new bids, dashing the original plan of constructing the bridge starting in late 1928 and opening in 1929.

Commissioner Phillips summarized the problem in a report to the Council. The original specifications called for construction after the close of the 1928 shipping season and winter work simply cost more; steel erection was more dangerous in cold weather and pouring concrete in the cold required special precautions. The issue of crossing the canal during construction also played a part: a temporary bridge had been proposed, and building it would add to the cost. These issues, Phillips explained, not only drove up the cost but also deterred some contractors from bidding at all. They would have to re-advertise for bids to do the work over the summer without a temporary bridge and revive the old ferry service for the duration of the construction work (see "Crossing During the Conversion" page 128).

C. A. P. TURNER RETURNS

Meanwhile in Minneapolis, C. A. P. Turner had kept a watchful eye on the development of a replacement for the bridge. After all, the aerial bridge helped put Turner on the map as the architect of the first stiff-trussed aerial transfer bridge ever built and he had argued passionately for its proper construction. Turner was not about to keep his ideas about the conversion to himself. He came to Duluth in early November 1928 at the invitation of Public Utilities Commissioner Chris Evans, a fan of Turner's who was critical of Harrington's plans. Turner met with city officials, offering alternative plans that would cut costs by nearly $200,000 and expressing his willingness to work with the Kansas City engineers. The essence of his idea was that the bridge's overhead span did not need to be raised in order to accommodate the lifting roadway to the extent that HH&A had proposed. The old bridge could basically be jacked up about six feet by raising the pier foundations beneath the north and south towers; this, he maintained, would save significant money. Harrington and his associates argued that jacking up the bridge was not only unfeasible, but would not comply with federal requirements. Still, HH&A said they would certainly welcome Turner's input—probably because they knew the government and the Lake Carriers Association would not approve of Turner's idea. Rather than ruffle feathers, Harrington and company were likely just playing nice and showing some respect to the famous engineer. But it didn't help things go more smoothly.

By the time the City Council met on January 14, 1929, to consider its options, things had gotten rather muddled. The Council was split over Harrington's and Turner's plans, a new round of bids had been advertised and construction firms were preparing their proposals, and the Corps' district engineer had objections to certain details.

The *Duluth News-Tribune* reported that the meeting, during which Commissioner Evans introduced a resolution to abandon Harrington's plans for Turner's, had broken down into "a heated debate between [commissioners] Evans and Phillips, in which every member of the council and Mr. Turner took part." Even City Attorney John Richards had his say, stating that he feared changing to Turner's plan would invalidate the City's agreement with Park Point residents, and then the City would have to come up with another $180,000 on its own (apparently he ignored Turner's claims that the alternate plans would cut costs by more than that amount). Before Evans could request a vote on his resolution, Phillips, who had long championed Harrington's plans, quickly moved to adjourn. Before the adjournment vote could be taken, Evans moved to vote on his resolution. City Clerk Austin Davenport was at a loss until Mayor Snively, also a proponent of Harrington's plan, reminded him that the first issue before the council was the motion to adjourn. The vote was 3–2 in favor to adjourn; Evans had been silenced. "BRIDGE DEBATE STIRS COUNCIL," the *Duluth Evening Herald* headline announced in capital letters.

Evans came to the next meeting, on January 28, with a different approach. In order to put Turner's plan on the table, Harrington's would have to come off. So Evans took up the very argument Phillips had used against Turner's plan at the previous meeting, turned it around, and aimed it at Harrington's plans: the alterations made by HH&A in order to get more affordable bids, Evans claimed, invalidated the petition granted for the bridge's construction. After the city attorney advised commissioners on the issue, Evans introduced a lengthy proposal requiring still further changes to the Harrington plan. His strategy may have been to convolute the entire process and throw the project back to the approval process, which would provide him and Turner an opportunity to submit a more complete set of plans—Turner's idea had also been criticized in the *Duluth News-Tribune* as "not definite enough to bid on." Whatever the reason, it didn't work. His fellow commissioners voted the idea down 3–2, with Public Safety Commissioner James E. Foubister his only ally on the council.

Prior to the city council's next meeting on February 18, the construction bids arrived and were opened by the engineering advisory committee set up to review them: Duluth & Iron Range Railway (D&IR) assistant engineer Oliver H. Dickerson, county highway engineer Sheldon B. Shepard, DM&N chief engineer H. L. Dresser, and Duluth City Engineer John Wilson. Because the work would take place in summer and a temporary bridge

DULUTH FINANCE COMMISSIONER PHILLIP J. PHILLIPS (IN A BLURRED 1918 PHOTO), WHO, ALONG WITH MAYOR SNIVELY AND FINANCE COMMISSIONER W. S. MCCORMICK, CHAMPIONED A LIFT BRIDGE DESIGN BY JOHN HARRINGTON OF HARRINGTON, HOWARD & ASH. THEY WOULD STRUGGLE WITH PUBLIC UTILITIES COMMISSIONER CHRISTOPHER EVANS AND HIS ALLY PUBLIC SAFETY COMMISSIONER JAMES E. FOUBISTER, WHO TOGETHER FOUGHT FOR A PLAN DRAWN UP BY C. A. P. TURNER, THE MAN WHO DESIGNED THE ORIGINAL AERIAL TRANSFER BRIDGE.

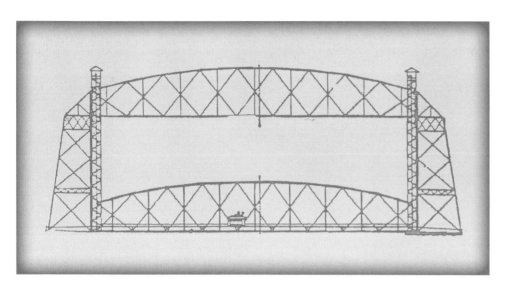

C. A. P. Turner's
crude 1928 sketch of
his idea for converting
the aerial transfer
bridge into a lift
bridge. Turner failed
to provide details as
to how the concept
would work, and his
idea to "jack up" the
old bridge with new,
taller foundations
would never have been
approved by the U. S.
Corps of Engineers,
who control the canal
piers on which the
bridge's foundations
rest. Still, Turner's
ideas created quite
a stir in Duluth City
Council chambers.

was not included, the bids were much lower without compromising any of the Harrington plan. Five bids had been submitted this time around: $520,000 from George Lounsberry and Sons (the only Duluth bidder and a Turner supporter), $508,372 from Pepper & Fulton, $475,571.69 from Wisconsin Bridge & Iron, and $449,600.00, the lowest bid, from the Kansas City Bridge Company (no record of the other losing bid could be found). The engineering advisory committee met all morning, went through all bids in detail, and concluded that any problems with the low bid were minor and solvable. The committee unanimously recommended awarding the contract to the Kansas City Bridge Company (KCBC).

That afternoon, in anticipation of the bridge contract being approved in that day's city council meeting, an editorial in the *Duluth News-Tribune* said of the matter, "Everything seems lovely with this project, except, of course, the usual bushwhacking which Duluth does not seem able to avoid in its major project. Members of the city council who favor another engineer have set up the customary bedevilment, but that is of little consequence." The piece concluded that, "Minnesota Point and the

community are assured of a fine bridge that will be sightly, safe and practical and that will be built at a reasonable cost."

Only one obstacle remained: Engineer P. C. Bullard of the Corps of Engineers had problems with the final design, and since the bridge rested on government property Bullard's approval was necessary. The newspaper had said that it considered the problems "greatly exaggerated in publication"; it should have known, having run a headline the previous day announcing that "Bridge Plans Fail to Meet U.S. Approval." Major Bullard had three concerns, which were addressed at the city council meeting. He wanted two "comfort stations," built at either end of the bridge—bathrooms for those waiting for the bridge and for spectators watching it lift. He also thought the lifting system needed additional cables to provide more redundancy and therefore more safety. Both of these demands were considered small modifications and quickly agreed to by Harrington, Howard, and Ash.

The third issue was more serious. Bullard objected to the composition of the new roadway because, in his judgment, it was not fireproof and thus a potential danger to navigation. A concrete roadway was suggested. John Harrington responded for his firm by observing that few movable bridges used concrete roads in order to save both weight and cost. The road as designed would consist of creosote-treated planks thickly surfaced with asphalt. The planking would be laid between steel channels and on top of galvanized steel sheeting and would be more than sufficiently protected from either fire or deterioration. Bullard accepted this point and the roadway's plans remained unchanged.

Although Harrington assured commissioners that he would send a report explaining as much to the government within the week, Commissioner Evans jumped on the roadway concern and the "bedeviling issue of little consequence" again reared its head.

Citing the lack of a fireproof roadway as well as a lack of provisions in the Harrington plan to carry water and power lines over the bridge, he again called for the city to reconsider C. A. P. Turner's incomplete and likely unacceptable plans.

When the discussion turned into an argument, Mayor Snively moved for another sudden adjournment because Commissioner Phillips, the Harrington plan's biggest proponent and the best man to counter Evans, was absent. Only four members of the council were in attendance: Snively and Finance Commissioner W. S. McCormick, both for the Harrington plan, and Turner backers Evans and Foubister. Phillips' absence meant a 2–2 vote, with Snively and McCormick in favor of adjournment while Evans and Foubister wanted to further champion Turner's plan. With the vote hopelessly deadlocked and the meeting still in session, Snively and McCormick simply walked out.

If City Clerk Austin Davenport had been befuddled at the last meeting, it was nothing compared to the quandary he now faced. No one knew what to do, and spectators began asking each other, "Is it over?" Foubister stayed in his seat until the spectators had cleared the room, remaining even longer than Evans. Davenport merely waited out Foubister, gathering up his records and returning to his office after the commissioner finally left. The next day the headlines roared "COUNCIL BREAKS UP IN BABBLE: Aerial Bridge Problem Disrupts Meeting."

In the end, just as the *Duluth News-Tribune* had predicted, C. A. P. Turner's plans indeed had little consequence on the project, but they had made for some entertaining political displays. They had also given Turner his say in the matter of what would become of his beloved aerial transfer bridge. But what about Thomas McGilvray, who first came up with the idea to bridge the canal with an aerial ferry and saw it through its construction and first years of operation? If he had anything to say about the

new bridge, it never made the papers. Throughout the effort to push the bridge conversion through to its completion, McGilvray had been quietly working for St. Louis County overseeing the construction of drainage ditches. He publicly held his tongue until a year before his death (see page 145).

During the following week Harrington met with Bullard and convinced the government engineer that the road span would indeed be fireproof. With the final obstacle out of the way, the City Council met on February 25 and finally and officially awarded the construction contract to KCBC on an expected 3–2 vote, Phillips, McCormick, and Snively voting in favor and Evans and Foubister against. The next day the *Duluth News-Tribune* applauded the council as performing "a good act Monday when it voted to award the contract for the proposed new bridge over the canal to Park Point, without further talk, wrangling, or discussion." Later that week the paper announced that work on the bridge would begin before April 1. Word of the famous span's imminent demise spread fast: by March 10 a film crew from Fox Studios had arrived to take footage of the Duluth Aerial Transfer Bridge before it passed into history.

CLIPPINGS OF *DULUTH NEWS-TRIBUNE* STORIES FOLLOWING THE HEATED CITY COUNCIL DEBATES BROUGHT ABOUT BY C. A. P. TURNER'S DISRUPTIVE RETURN TO DULUTH TO PUSH HIS OWN PLAN TO CONVERT HIS AERIAL TRANSFER BRIDGE INTO A LIFT BRIDGE.

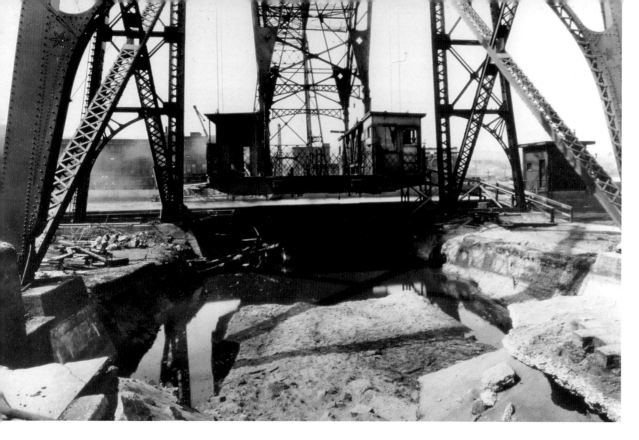

on June 19. The dynamos in the electric motors burned out, possibly due to a lightning strike days earlier. Once again the Corps of Engineers came to the rescue, using a twenty-five-foot motorboat to ferry passengers across. Repairs were made, but the motors only needed to work eleven more days.

On the morning of July 1, 1929, the aerial transfer bridge crossed the canal for the last time. The *Duluth News-Tribune* heralded the event with a banner headline, "Noted Aerial Bridge Passes into History":

> With its battered old warning bell tolling, the whistle of the Park Point street car bleating mournful accompaniment and ships tooting, the ferry car of the famous Duluth aerial bridge made the last trip of its career of twenty-four years at 8:45 A.M. today, with city officials, pioneers and a crowd of interested citizens as passengers.

Tears stood in the eyes of James Murray, veteran bridge car operator, selected to pilot it on its last voyage, as he started it back to the mainland from Park Point. After bringing it to its final stop he removed the control lever and stepped slowly from the operator's cab to the main platform. "It was a good old car and I hate to see her go," he said to the other veteran operators who were all on hand to make the last trip.

THE FERRY BRIDGE'S FINAL CROSSING

Work on the bridge did indeed begin before April 1. On Monday, March 25, KCBC went to work under the direction of chief engineer O. A. Zimmerman and superintendent of construction Thomas Weathers. The company's first task was to excavate the old foundations and lay new ones strong enough to carry the extra weight of the new bridge. This involved tearing up the approaches, so when the work began, car and wagon service on the bridge ended. Foot traffic continued until July, and to accommodate pedestrians, a "gangplank" ramp was constructed to access the ferry car from the street.

As if to put an exclamation point on the idea that the bridge's practical life was over, it suffered another breakdown

BEFORE THE TRANSFER BRIDGE STOPPED DAILY SERVICE WORKERS BEGAN EXCAVATING THE OLD FOUNDATIONS IN ORDER TO CREATE MORE SUBSTANTIAL FOUNDATIONS FOR THE NEW, HEAVIER BRIDGE. TROLLEY AND CAR SERVICE ENDED; PASSENGER SERVICE CONTINUED UNTIL JULY 1, 1929.

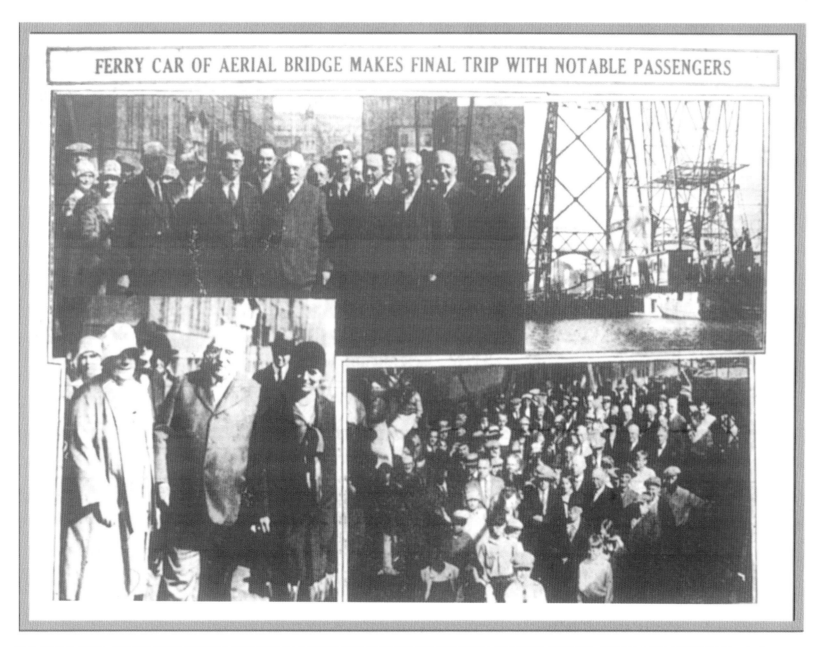

FERRY CAR OF AERIAL BRIDGE MAKES FINAL TRIP WITH NOTABLE PASSENGERS

THE JULY 2, 1929, *DULUTH NEWS-TRIBUNE* FEATURED THIS PHOTO SPREAD OF THE DULUTH AERIAL TRANSFER BRIDGE'S GONDOLA CAR'S LAST TRIP ACROSS THE CANAL.
THE "NOTABLE PASSENGERS" MENTIONED IN THE HEADLINE DID NOT INCLUDE C A. P. TURNER OR THOMAS MCGILVRAY, THE MEN CONSIDERED THE "FATHERS" OF THE BRIDGE.

Crossing During the Conversion

While the aerial bridge was undergoing conversion from a transfer bridge to a lift bridge, people still needed to get across the canal. Officials first considered a temporary bridge but quickly dismissed the idea as too costly. In April 1929, the Council ordered repairs to the dock at the west foot of Buchanan Street so that ferry service could be run from there to the government dock at Ninth Street on the bay side of Park Point. Duluth's Marine Iron and Shipbuilding Company won the contract to provide ferry service during daylight hours with their tugboat *Fashion* and a scow to haul vehicles. The city-owned steamer *Ellen D.*, sometimes called "The City's Navy," would carry passengers from the Morse Street dock. Emergency vehicles, vehicles carrying food and supplies for delivery, and vehicles owned by Park Point residents were granted priority use of the *Fashion*; all other vehicles were prohibited from using the ferry service for the duration of the bridge conversion and bridge superintendent Leonard Green was empowered to issue permits to drivers according to these priorities.

The *Ellen D.* was in poor condition, so during the summer special appropriations were made for repairs. Finally, in November, the U.S. steamboat inspector declared her unseaworthy and Marine Iron received additional money to spruce up the *Fashion* to carry passengers. Just before Christmas 1929, the council decided that the *Ellen D.*, now "in a badly leaking condition and in need of immediate disposal to prevent sinking," should be sold. Marine Iron offered $250 and the City said good riddance. By the time the new lift bridge was in operation, the temporary ferry service had proved more costly and troublesome than anticipated.

LEFT:
THE *ELLEN D.*

RIGHT:
THE *FASHION*

Murray had pulled the lever to start the car's final journey after Commissioner Chris Evans, who had been instrumental in bringing about the bridge's conversion, gave the brief command, "Let's go." The car passed from the North Pier to the South, paused while the steamer *Charles L. Hutchinson* navigated the canal as the last craft to pass under the ferry bridge, and then returned to the North Pier. Immediately upon the last passenger's departure, workers from KCBC climbed aboard and started dismantling the ferry car, work expected to take several weeks. No account could be located as to what happened to the car or its amenities. One of the benches was rumored to have been taken home by a Park Point resident; today one is on display at the Lake Superior Maritime Visitor Center and another at the St. Louis County Historical Society, which also keeps a broken operator's handle donated in 2005 by Jack Hicken, son of ferry bridge operator John Hicken.

Murray had been joined on the final trip by fellow operators William Maynard, Urban Nehring, Frank Lampert, and Leonard Green, the first and only superintendent of the aerial transfer bridge. Other dignitaries aboard included Duluth pioneers Richard Thompson, J. D. Campbell, and Henry Van Brunt, who were part of the first test trip in February 1905; city officials Mayor Snively, commissioners Evans and Phillips, and police chief E. H. Barber; Mrs. E. H. Borth, who was the first woman to cross in the ferry bridge back in 1905; and Ann Murray, who reportedly rode the ferry bridge more times than any other person outside of an operator. Many others not named by the newspaper also took the final trip. No reports indicate that either of the bridge's "fathers," C. A. P. Turner and Thomas McGilvray, took part in the aerial transfer bridge's final crossing of the canal.

PART IV:

THE AERIAL LIFT BRIDGE'S FIRST 75 YEARS

(1930 – 2005)

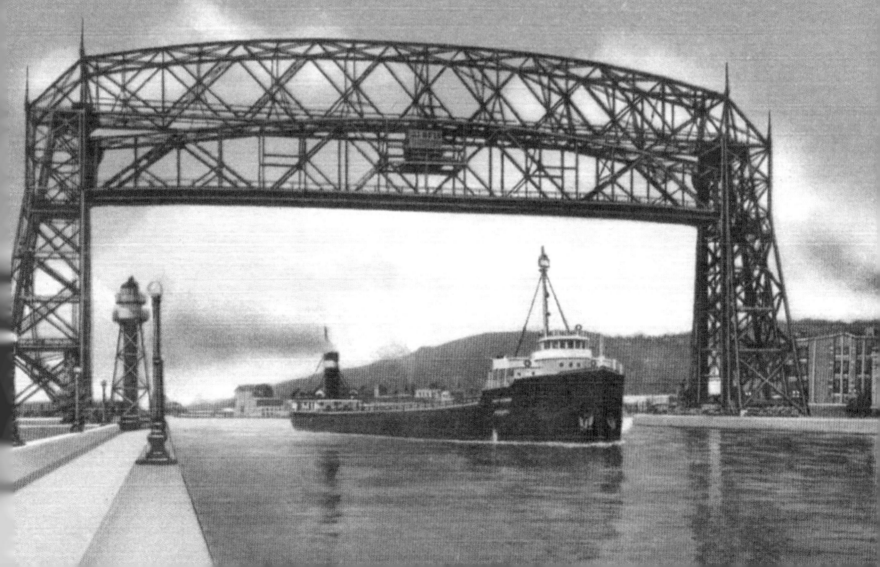

—Good for—

BANQUET and DANCE

DEDICATING

Aerial Lift Bridge

Banquet 7 P. M.

Dance 9 to 12

Park Point School

Community Club

75c Each

50c Each

A TICKET TO A BANQUET AND DANCE HELD AT THE PARK POINT COMMUNITY CLUB IN 1930 TO DEDICATE DULUTH'S AERIAL LIFT BRIDGE.

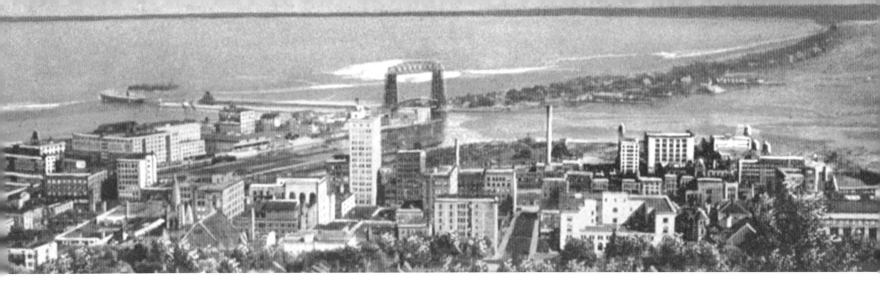

COMPLETING THE CONVERSION

By August 10, 1929, the aerial bridge had been stripped of its gondola and the girders that suspended it from the bridge's upper truss. Workers then set about the task of preparing the bridge structure for its most dramatic change: extending it 41 feet higher so that, with the roadway span raised, the bridge allowed a clearance of 135 feet for passing vessels. Workers with the KCBC put up "false work," wooden scaffolding to bolster the bridge during construction, when its span would be separated from the old north and south towers. They also erected another set of taller towers *within the framework* of the old bridge; the raised span would rest atop the new towers, which would also carry the massive pulleys and counterweights that allowed the bridge's deck to raise and lower.

A crowd estimated at five thousand gathered near the bridge on the morning of Saturday, October 19, to watch as workers armed with acetylene torches cut straps and rivets, freeing the bridge's entire overhead truss—all 410 tons of it. They then began to slowly raise it into its new position, winching it into place by 10:30 A.M. The crowd was never bored. A seaplane pilot flew his plane under the bridge as the span was being raised, and at least one steel worker mugged it up for the crowd, at one point standing on his head atop the bridge's tallest point, kicking his feet in the air. Even a film crew was on hand to capture the moment.

With the top span in place and the steel work on the new towers complete, the largest unfinished job was the lower span, the roadway that would lift out of the way to allow marine traffic through the canal. Its framework was built in sections between the towers at roughly the height of the old bridge. Workers slung sections of trestle under the overhead truss by cables or cantilevered them from the new towers. By November 7, workers had the first unit in place, reaching toward the middle from the

CONVERTING DULUTH'S AERIAL TRANSFER BRIDGE...

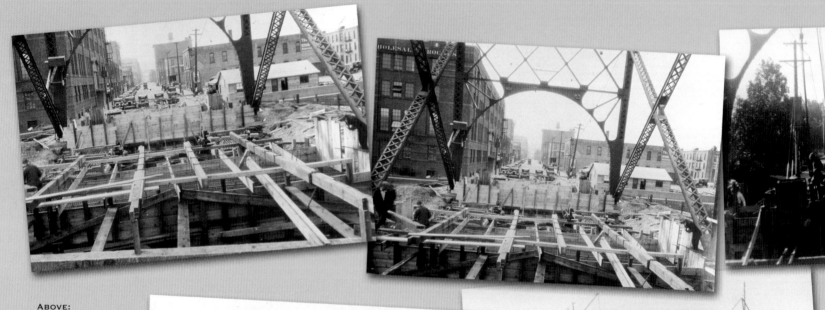

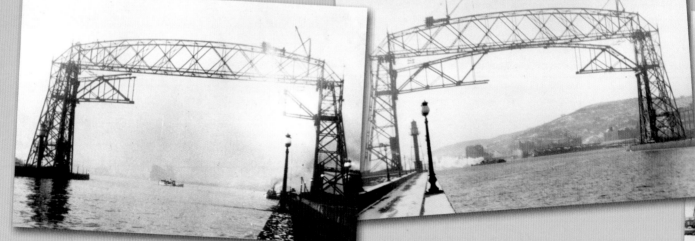

ABOVE:
THE FIRST THREE
IMAGES AT THE TOP OF
THIS SPREAD (FROM LEFT)
SHOW THE CONSTRUCTION
OF THE NEW BRIDGE
TOWER FOUNDATIONS,
WHICH HAD TO BE MADE
LARGER IN ORDER TO
HANDLE THE ADDITIONAL
LOAD OF THE NEW
TOWERS, LIFT SPAN,
COUNTERWEIGHTS, AND
OPERATING MACHINERY
AND HOUSING.

...INTO DULUTH'S AERIAL LIFT BRIDGE

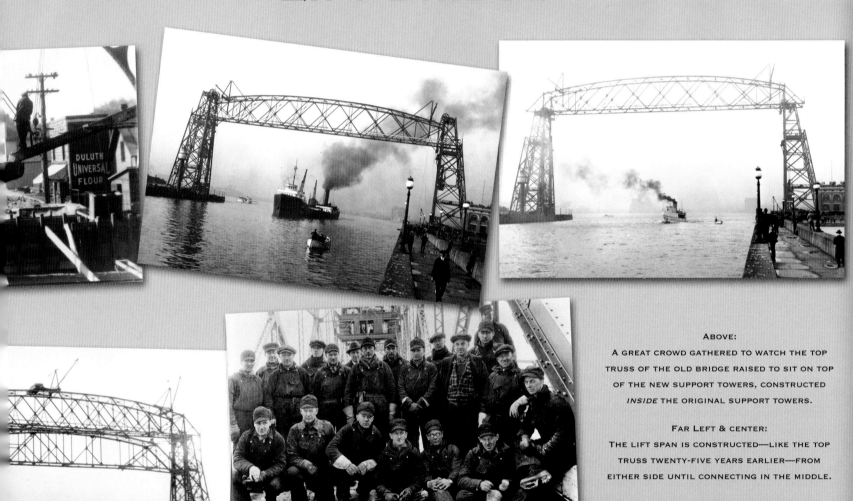

ABOVE:
A GREAT CROWD GATHERED TO WATCH THE TOP TRUSS OF THE OLD BRIDGE RAISED TO SIT ON TOP OF THE NEW SUPPORT TOWERS, CONSTRUCTED *INSIDE* THE ORIGINAL SUPPORT TOWERS.

FAR LEFT & CENTER:
THE LIFT SPAN IS CONSTRUCTED—LIKE THE TOP TRUSS TWENTY-FIVE YEARS EARLIER—FROM EITHER SIDE UNTIL CONNECTING IN THE MIDDLE.

NEAR LEFT:
THE MEN OF THE KANSAS CITY BRIDGE COMPANY, WHO CONVERTED THE BRIDGE ACCORDING TO PLANS DRAWN UP BY MOVING BRIDGE SPECIALISTS HARRINGTON, HOWARD & ASH—ALSO OF KANSAS CITY.

Barnstorming the Bridge

When Wilber Larrabee first piloted his biplane under the aerial bridge in 1918, photographer Hugh McKenzie captured the moment on film (see page 111). Others would follow Larrabee, but few would leave a record of the event—and that has caused legends to brew.

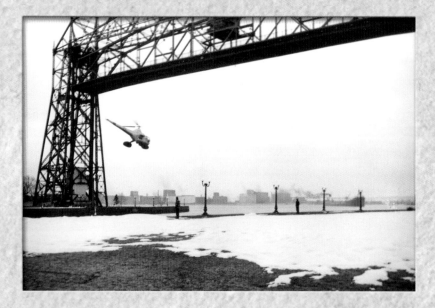

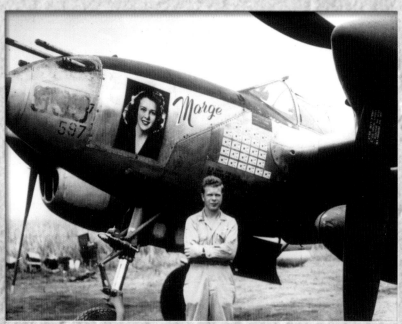

William Magie did it in 1924, at least that's what his wife Lucille told a reporter in 2005. Magie was a mail pilot who flew a WACO biplane. When he landed after threading the bridge, police were waiting for him—but they didn't arrest him. It was all just a prank, he explained. His story could well have been a prank: he told it to his future wife a year after it supposedly happened. He may have wanted to impress the future Mrs. Magie.

Local historian Glen Maxham does have proof of someone flying through the transfer bridge: film footage given him by David Hartley. Shot from the plane's cockpit, the film shows the bridge coming closer and closer until the plane passes through and flies beyond. Hartley's father knew a character named "Dusty Rhodes," a sometimes-bootlegger "notorious for doing things like that." Rhodes was likely the film's pilot—if that was his real name.

If the pilot of the next recorded barnstorming incident was trying to impress anyone, he forgot to leave a calling card. That flight occurred on October 19, 1929—the very day workers freed the bridge's truss and raised it forty-two feet for its conversion. Newspapers reported that a seaplane, entertaining the crowd watching the slow work, began "circling and dipping close to the top of the bridge, and even flying under it while the span was slowly moving upward." But no one took a picture, and no one took credit.

A helicopter passed through once, as shown in an image at left from the Lake Superior Maritime Collection. Unfortunately, the photo includes no notation, so the date and pilot are lost to history. The helicopter appears to be a Sikorsky H-5, first made in 1945, so the fly-through would have to have occurred after that date.

Many people think World War II Ace and local hero Richard A. Bong barnstormed the bridge. Bong, a native of Poplar, Wisconsin, shot down forty Japanese planes while flying his beloved P-38, nicknamed "Marge" for his wife (see photo at left). In 2006 John Hoff told a reporter he witnessed Bong take his P-38 through the bridge in 1944. Hoff was eleven years old at the time, visiting his father's office in the Alworth Building. He swears he saw a P-38 fly in low from the east between the canal's piers and emerge west of the bridge. Unfortunately, no one else saw it. Roy Mahlberg of Duluth told the newspaper he remembers the *Duluth News-Tribune*'s headlines the next day and a photo of Bong's P-38 flying under the bridge. But no newspaper account of Bong flying his plane through the bridge exists—nor any photos. Bong certainly was capable: he once flew a loop-the-loop under and over the Golden Gate Bridge.

Maybe Hoff did see a P-38 pass under the bridge, but Bong likely wasn't at the stick. It may have been Jack Daniel Brown, a Duluthian and Army Air Corps pilot. Brown's descendants recalled that in either 1943 or 1944 (which would fit Hoff's story), he and another pilot were ordered to transport two P-38s from Texas to Novia Scotia. Along the way, Brown decided to say hi to some relatives in an unconventional manner. First he buzzed the Park Point home of his brother, lift bridge operator Bob Brown, close enough so his family could see his face; then he and the other pilot approached the bridge from the bay side, barnstormed beneath it, and headed to the east coast of Canada. Of course, no one took a picture....

south tower. Work progressed from the north tower a week later. Before the month's end, workers set the framework's last piece in place and began permanently fixing it to the new lifting machinery. Not once did construction hamper canal traffic.

The construction proceeded slowly. KCBC had promised an operational bridge by the end of 1929, but it wasn't until January 6, 1930, that the lower span was lowered into place at street level for the first time, ready for its nine-hundred-ton roadway's installation. The company asked for and received a contract extension, with the bridge's final touches now due on March 15. Bridge use, however, started at 8 A.M. on January 12, 1930, the first moment cars traveled over the span, which was limited to one lane as workers paved the other. No one recorded who drove the first automobile across the bridge. The first streetcar over the canal began its journey at 5:28 A.M. on March 12. About a week's worth of minor details still had to be worked through, and the bridge still needed a coat of paint. Otherwise it was complete. To celebrate the bridge's opening, the Community Club held a banquet at the Park Point School and a dance at the Park Point Community Clubhouse at Lafayette Square; admission was seventy-five cents for the food and fifty cents to dance.

REGULAR OPERATIONS BEGIN

Like its predecessor, the Duluth Aerial Lift Bridge stood as a marvel of engineering, especially considering that the new bridge was built without completely destroying the old. The original bridge's head span, raised forty-one feet, now provided little more than wind bracing: the new towers carried the moveable road span and massive counterweights. In its new life the head span was adapted to carry electric conduits and gas and water mains across the ship canal. The power to raise and lower the roadway span came from four electric motors, each of ninety-five horsepower, located in the upper level of the two-story operators

house positioned above the road span. Any two of the motors could power a lift. The power came from storage batteries located beneath the South Pier approaches, kept charged by city electricity accessed by both a direct line and by tapping into trolley cables that ran along the top of the lift span (two generators stood by for emergencies). The same room housed a gasoline engine that could move the lift span should electricity completely fail. In the operators house's lower room, operators controlled the bridge and a host of safety devices positioned at various points on the bridge and its approaches—mechanical and electric interlocks, traffic gates, bells, signal lights, pneumatic horns, and both telephone and radio

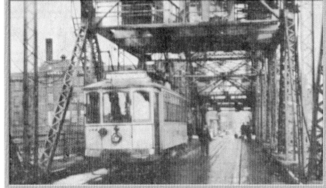

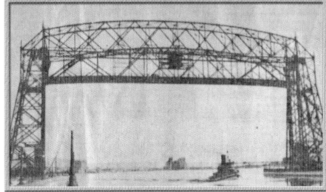

TOP: THE FIRST CARS TO CROSS THE LIFT BRIDGE, JANUARY 12, 1930; MIDDLE: THE FIRST TROLLEY CAR TO CROSS THE LIFT BRIDGE, MARCH 12, 1930; BOTTOM: THE USS *ESSAYONS*, THE FIRST VESSEL TO PASS UNDER THE LIFT BRIDGE, MARCH 29, 1930.

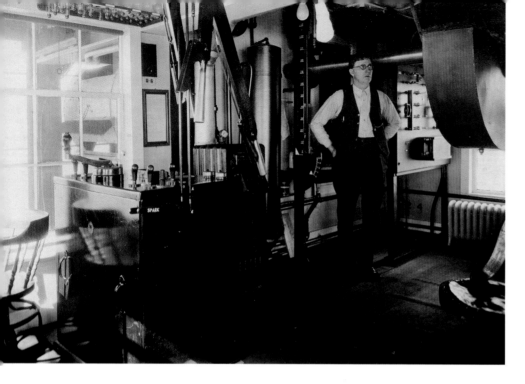

communication—to insure safe movement by land and water. With the engines directly above them, lifting and lowering the bridge was loud work for the operators.

The bridge's most intriguing engineering aspect was how the lift span and its counterweights worked. The 900-ton span was balanced by two 450-ton concrete weights, one on each end of the bridge. The span and its counterweights were connected by twelve 1 7/8-inch cables that ran over four sheaves—wheels twelve feet in diameter and weighing 14 tons each—one at each top corner of the structure. As the span went up the counterweights came down. The cables, in turn, were so heavy that they too had to be balanced. This was accomplished by attaching chains to each of the two concrete counterweights; they resemble extremely large bicycle chains measuring 81 feet long and weighing approximately 259 pounds per foot. The bridge was so well balanced that when the first paint job was applied—tinted

"Essex" green, a dark green similar to forest—the counterweights had to be adjusted to compensate for the weight of the paint. (See the appendix for diagrams of how the bridge works.)

Numerous inspections and test lifts continued until March 29, 1930, when the Corps of Engineers tug USS *Essayons* passed outbound to officially test the bridge's readiness, becoming the first vessel to pass beneath the completed bridge. The first big carrier to pass beneath the bridge, the *F. E. Taplin*, did so on April 24. Near the end of April the City Council adopted an extensive set of rules for the bridge's operation that covered right of way, loitering, warning signals, special consideration for emergency vehicles, how close a car could come to the bridge when it was raised, and others mostly to do with safe operation. Pedestrian rides were strictly forbidden, and violating any of the rules was a misdemeanor punishable by a fine of up to $100 or eighty-five days in jail. A few days later the KCBC notified the City Council that they considered their job complete. A contingency of city officials including the mayor, all five city council commissioners, the city attorney, and the city engineer followed up their bi-weekly meeting with an inspection of the bridge. It took nearly a month to work out some minor issues based on requests of the War Department, but on June 5, 1930, Duluth took possession of its aerial lift bridge.

Unlike the myriad troubles the aerial transfer bridge experienced its first year, the months after the new bridge began operation seemed relatively problem free. Operators noticed some cable fraying, which they easily corrected. The emergency gasoline engine was used once, but this was traced to an operator's mistake. But Bridge Superintendant Leonard Green found plenty wrong with the bridge: the back-up engines were too slow for emergencies, four hundred rivets were missing, the shifting gear was impractical and did not allow for quick shifting, the operators house's windows weren't weather-tight, the height indica-

tor was falling apart, the main shaft's coupling was loose, and the oilless bearing sheaves and working cables screamed from a lack of grease, which leaked from the counterweight sheaves. He made his complaints known to the City Council, which decided to withhold $27,500 it still owed KCBC to address these issues and to cover the financial responsibility for changes requested by the War Department that the builders had not completed.

Harrington, Howard & Ash quickly came to the KCBC's defense, claiming that most of Green's issues were unfounded. Not a single rivet was missing, let alone four hundred, and the fact that the height indicator had "fallen to pieces" was an issue of maintenance, and therefore the City's fault. They did admit that keeping the sheaves greased remained a problem, and recommended that the city simply hire someone to clean and replace the grease "as often as necessary." This proved impractical. Eventually Chicago's Viscosity Oil Company came up with an exceptionally heavy grease that did the job.

The reason Green thought the emergency gearing was too slow, the company said, was that it "was never intended for general operation but only when the span might be covered with ice, increasing the load to be lifted." It had a different gear ratio to handle the larger load, and therefore worked more slowly. But more important than Green's complaints was that Major Bullard of the Engineers agreed with them—and wanted a faster emergency gear if the bridge was to sit over his canal. In December Bullard, upon witnessing the bridge raise faster than he had seen before, told city commissioners that if all the operators were trained to handle the bridge like that, he would drop his request for alterations. The newspaper joked that the bridge operators were being sent to "school to study gear shifting."

Each issue was either addressed or eventually settled. In October W. A. Anderson & Co. put the final touches on the bridge: a fresh deep Essex green paint job over the bridge's old towers.

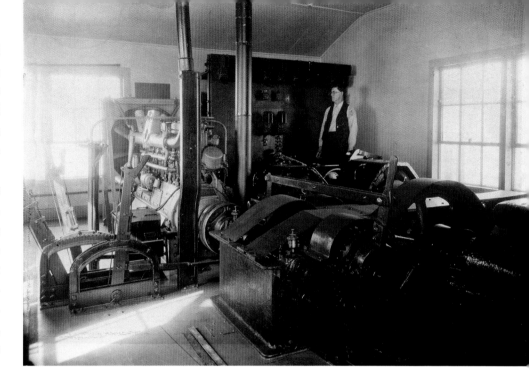

he reached the end of the span, he continued to drive straight off the bridge and, luckily, onto the pier below. Neither he nor his son were injured, but the car was totaled. Safety measures were later added, including gates at either approach to prevent cars from reaching the bridge. When preparing for a lift, warning bells go off and the entry gates close; once all cars have cleared the bridge, a set of departure gates closes behind them. Only after all four gates are closed does an electric relay allow power to the operating handle, ensuring that the bridge would no longer lift with a car on its deck.

The bridge operators could perhaps understand how Mr. Odenthal didn't hear the bell: they

BRIDGE OPERATOR (AND, LATER, SUPERVISOR) DON BOWAN GREASES ONE OF THE LIFT BRIDGE'S MASSIVE SHEAVES; WHEN THE BRIDGE FIRST OPENED, ITS SHEAVES HAD TO BE ALMOST CONSTANTLY GREASED; EVENTUALLY, BRIDGE OPERATORS FOUND AN EXCEPTIONALLY HEAVY GREASE THAT WAS UP TO THE JOB.

THE 1930S: 42,775 LIFTS

With its conversion complete, the story of the Aerial Lift Bridge—as with the Aerial Transfer Bridge or any man-made structure—became one of maintenance and incidents. The first such event occurred in May 1930. As W. J. Odenthal of Killdeer, North Dakota, and his son were driving north across the bridge in the brand-new car he had just purchased, the bridge began rising to allow a freighter to pass. Mr. Odenthal hadn't noticed the stop signs and warning bells telling him to stay off the bridge; while pointing out the sites to his son he had managed to drive past the gate before it dropped. When

knew firsthand how the canal could play tricks with sound. Less than two weeks earlier, all six bridge operators—employees of the KCBC and the former transfer bridge operators they were training—failed to hear the whistle of the steamer *L. M. Bowers* requesting a lift. The *Bowers'* captain leaned on the whistle, and it was screaming as he split the piers and entered the canal, all the while trying to reverse course to avoid hitting the bridge. Fortunately, an operator happened to look lakeward in time to quickly raise the bridge and avoid a potential tragedy.

The problem was wind. Depending on conditions and direction, the wind sometimes prevented sound off the lake

Casualties of the Canal

Storms have long attracted sightseers to the canal to watch the waves pound the piers; photographers embrace such days. But the canal, always a potentially dangerous place, is particularly dangerous during a storm. Sivo "Stans" Sanden discovered that firsthand in 1914 (see page 110). Since the 1929 bridge conversion, the canal's waters have proven deadly at least twice.

In July 1934 the canal claimed the life of seven-year-old Richard White, who lived nearby at 216 South First Avenue East with his parents, one of Duluth's few African American families at the time. They initially feared he had run away. Police and neighbors searched for seven hours, and the next day the Coast Guard dragged the lake. A day later four children, two boys and two girls aged four to six, came forward and confessed that one of them had tripped White, who fell from the north pier into the canal. The children did not call for help. While recounting the event, one boy pointed to the other and said, "He did it." The other replied, "Yes, but you told me to." No charges were ever filed. White's body was never recovered.

An incident in 1944 was far less tragic, but nonetheless unfortunate. A black bear found its way to the slips behind Marshall-Wells, jumped in the bay, and swam into the canal. Three Park Point residents—E. A. Thorleson, age twenty-four; Michael Gauthier, eighteen; and Donald Parker, fourteen—set out in a small boat to rescue the bear and return it to the wild. The bear didn't appreciate their efforts. Thorleson tried to lasso the bear, but missed; the bear used the rope to claw onto the boat, where it bit its would-be rescuer and tore his pants. Thorleson and his companions abandoned ship. The Coast Guard then towed the boat to the docks, where they successfully lassoed the bear and attempted to pull it onto the pier. But the bruin wouldn't budge, and officials, deciding it was too dangerous to help, shot it to prevent further trouble.

The worst incident to hit the canal did so in 1967. On the last day of April, three of the Halverson brothers from Duluth's Chester Park neighborhood—seventeen-year-old Eric and his sixteen-year-old twin brothers Arthur and Nathan—had gone to the canal to watch massive waves pound the piers in a spring squall. The boys ventured out to the North Pier Lighthouse for a more dramatic view. Two of them made it to the lighthouse's relative safety, but a third still clung to a light pole along the pier. A huge wave hit the pier, knocking the boy into the water. His brothers ran to help, but soon met the same fate.

Coast Guardsmen Edgar Culbertson, Richard Callahan, and Ronald Prel rushed to the pier. They tied themselves together with rope, spaced twenty-five feet apart: if a wave knocked one of them into the canal, the other two could pull him back. While returning from the lighthouse a particularly big wave lifted Culbertson off the pier and into the lake. The rope didn't help. He fell with such force he nearly pulled his compatriots in behind him; Callahan's wrist snapped from the force. Culbertson drowned.

United Methodist, where the boys attended church, added a small paneled room and named it the Three Brothers Chapel. Culbertson, Callahan, and Prel all received the Coast Guard medal, the organization's highest peace-time award for heroism. Culbertson's parents accepted the medal. A plaque commemorating his bravery sits on the north pier.

TOP: THE CANAL'S WATERS ROILING DURING A STORM ON NOVEMBER 20, 1953. BELOW: THE UNFORTUNATE BEAR WHO FOUND HIS WAY INTO THE CANAL IN 1944.

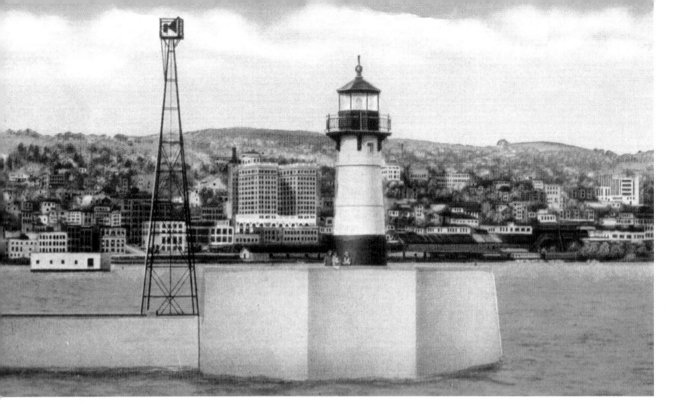

THIS LITHOGRAPHIC
POSTCARD FROM
THE 1930S SHOWS
THE EXPERIMENTAL
"MECHANICAL EAR" THAT
WAS INSTALLED ON THE
NORTH PIER IN 1932 TO
HELP BRIDGE OPERATORS
HEAR SHIPS' WHISTLES
ON WINDY DAYS. THIRTY
YEARS LATER, RADAR
WAS INSTALLED ON
THE BRIDGE.

problems; all eyes—and ears— would be on Duluth.

In May Duluth put one of the ideas to the test: the "mechanical ear." It was simple, really: a radio relaying signals picked up by a microphone. A large tower was erected on the North Pier, just west of the lighthouse. Microphones atop the tower could pick up a ship's whistle half a mile away on a stormy night. Radio signals transferred the sound back to a receiver in the operators house for monitoring. The papers greeted the innovation with the headline, "Mechanical Ear on Canal Spells Taboo to Spooners." The article played up the fact that the microphones could pick up conversation on the pier, exposing the escapades of young lovers. Operator Charles Landre poetically set the idea aside: "Young men on the pier with their sweethearts needn't worry. When the weather is nice and the moon is shining, we won't have the receiver tuned in, and besides, the microphone is too high up to catch the words plainly, anyway." (The Coast Guard also maintained a radio tower atop the South Pier from the 1920s until 1985.)

Sadly, young men on the piers were involved in far more dangerous escapades, like trying to hitch a ride on the bridge— a problem that has plagued the operators since the bridge first lifted. In 1934, seventeen-year-old Melvin Halverson, about to begin his senior year at Denfeld High School in West Duluth, grabbed the edge of a beam on the bottom of the span and

from reaching the operators house over the canal's center—a sound blind spot, if you will. Green ordered that one operator constantly scan the lakeward horizon until he found a more practical solution. By December the problem had not been fixed, but it was being addressed. On December 5 the *Duluth News-Tribune* announced that Duluth's Aerial Lift Bridge would become "the nation's experimental station during the shipping season of 1931 when city commissioners will seek development of a system to warn bridge tenders of approaching ships in a storm or fog." Various companies were invited to experiment and submit ideas for radio sets, "electronic eyes," or any other device that would report a vessel's approach. Over three hundred lift bridges were operating in the United States at the time, many located on canals and rivers with similar sound

held on as the bridge began to rise. A person can support his or her own body weight only so long, and Halverson's grip was fleeting at best. His arms gave out when he was thirty feet in the air. He fell to the pier, hit his head on the concrete, and died instantly.

The next year another near miss with a vessel prompted more safety initiatives. On June 17 the steamer *Schoonmaker* just missed striking the bridge, which had stopped seventy-five feet above the water when a circuit in the electric system had shorted out. Operators quickly started the emergency engines and lifted clear of the steamer. But they had been lucky: because of ongoing dredging in the canal, the *Schoonmaker* was traveling slower than normal. If she had been moving at normal speed a collision would have been unavoidable. Rules were changed, requiring operators to raise the bridge while the vessel was much further out, in case the bridge became disabled in any way. The change allowed more time to either fix the problem or reverse the vessel. The city also purchased an electronic failure warning system.

THE 1940s: 56,444 LIFTS

World War II dominated the bridge's life in the 1940s. Steel fueled the war effort, and iron ore came from Minnesota's iron ranges. That ore was shipped through Two Harbors and Duluth, and each ore boat loading in Duluth came and went through the ship canal. Between 1941 and 1945, the bridge lifted nearly thirty thousand times for marine traffic, averaging six hundred more lifts per year than the total average of lifts of each year from 1930 to 2005. It wouldn't see those levels again until well after the St. Lawrence Seaway opened in 1959, making Duluth-Superior an international port.

The Twin Ports war effort wasn't limited to shipping ore. Duluth and Superior became a center of shipbuilding, temporarily reviving an industry that had largely died out after World War I. Throughout World War II, the Twin Ports' eight shipyards employed over ten thousand men and women, averaging 10 ships a month while producing a fleet of 230 vessels. Zenith Dredge made 8 tankers and 13 cutters; Superior's Butler Shipyards built 13 coastal freighters, 12 frigates, and 7 cargo carriers; Globe delivered 8 frigates and 10 ocean-going tugs; Marine Iron and Shipbuilding supplied the Coast Guard with 18 cutters; and 13 plane-rearming boats and 4 sub-chasers came out of Inland Waterways. Together Scott-Graff Lumber

THIS PHOTO, TAKEN FROM ATOP THE LIFT BRIDGE, SHOWS THE USS *POUGHKEEPSIE* STEAMING THROUGH THE DULUTH SHIP CANAL IN 1943 WHILE RETURNING TO THE BUTLER SHIPYARDS IN SUPERIOR, WHERE SHE WAS BUILT. THE TWIN PORTS' EIGHT SHIPYARDS PRODUCED 230 VESSELS FOR THE ALLIED WAR EFFORT DURING WORLD WAR II.

WORKERS POSE ALONGSIDE MASSIVE TIMBER RIGGING USED TO HOLD UP THE LIFT BRIDGE WHILE ITS GEARS WERE REPLACED AND CABLES ADJUSTED IN 1949.

Company and Industrial Construction Company built 100 landing barges. Most of the ships left the Twin Ports through the ship canal.

In 1944 the City Council looked into allowing rides for sightseers, an idea that would arise periodically throughout the bridge's life. Commissioner of Public Works Francis C. Daugherty thought it was a swell idea, because a fee for rides could help pay the bridge's operating costs, which consumed $24,000 annually in salaries, power, and maintenance, along with other occasional major expenditures, such as when the bridge's gears were replaced in 1949. But the ride idea was deemed too risky, as it exposed the city to potential liability lawsuits.

Cover Bridge

On June 14, 1947, the Lift Bridge graced the cover of America's most popular publication: *The Saturday Evening Post*. The painting was executed by John Atherton. The issue included no article on the bridge or Duluth, but Atherton did say he was quite impressed by the town, particularly for its "excellent facilities for sledding."

The image at immediate right is of the Duluth Public Library's original copy of the magazine, a little worse for wear at sixty years old.

The photo of the two unidentified men holding an oversized replica of the cover was taken from about the same spot from which Atherton's painting was composed.

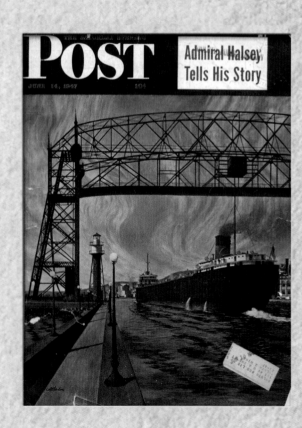

Sadly, 1944 also witnessed the passing of the aerial bridge's first and longest-serving superintendent, Leonard Green, who died of a stroke. Frank Lampert, who had worked as a bridge operator since before the lift conversion, delayed his own retirement an took over as interim superintendent before Al Hass officially took over in 1948.

THE 1950S: 46,736 LIFTS

The Aerial Lift Bridge's life in the 1950s started with a scare. Tragedy was narrowly avoided in December 1951, when sixteen-year-old Minneapolis resident Beverly Brenner ignored warnings and stayed on the bridge's sidewalk until after it began to raise. As the bridge moved upward, she panicked. Luckily the bridge was only eight feet above the pavement when she jumped. She suffered head injuries and an ambulance took her to St. Mary's Hospital for tests.

That incident aside, the bridge's life in the 1950s was marked by maintenance. In 1951 its motors were provided with fresh batteries. The new 153-cell unit installed in April filled the bridge's entire "basement" beneath the South Pier approach. The new battery was safer and consumed less electricity to charge. It was also stronger, easily providing the two hundred horsepower the engines needed to raise the lift span in normal conditions as well as the four hundred horsepower it sometimes required in high winds and icy conditions.

The winter of 1952 – 1953 witnessed major improvements. From mid December 1952 until the end of February the bridge did not raise as bridge boss Al Hass and his nine-man crew gave the bridge the "twice-over"—they never took chances on potential malfunctions. The bridge's bearings were replaced, one of the gates got a new motor, and the bridge's entire surface was repainted.

In an article about the maintenance, the *Duluth News-Tribune* asked Hass what he thought of New York's new lift bridge over the Harlem River, which could raise 110 feet in ninety seconds "as gently as eggs in a basket," according to its boasting engineers. "Well," Hass told reporters, "we don't carry much in the way of eggs, but our bridge goes up 120 feet in fifty-five seconds, and smooth, too."

THE BATTERY ROOM BENEATH THE LIFT BRIDGE'S SOUTH PIER APPROACH IN 1952, JUST AFTER A NEW 153-CELL UNIT WAS INSTALLED. THE BRIDGE NOW RUNS ON POWER SUPPLIED DIRECTLY FROM THE CITY, AND THE ROOM CONTAINS LOCKERS, A TABLE, AND A COUCH AND IS USED BY BRIDGE OPERATORS AS A BREAK ROOM AND OFFICE.

two draw spans, and the Interstate Bridge was a pivoting swing bridge). So beginning in the 1954 shipping season, captains of incoming vessels had to learn to blow a new signal to request a bridge raising, one unique to Duluth's aerial bridge: long, short, long, short (see page 187).

The bridge underwent a major improvement in 1955, when workers replaced its worn road deck with "special steel fabricated surfacing." The change was considered "an improvement badly needed" by county engineer George Deibler; the old deck still carried trolley tracks, even though Duluth's street car system had shut down fifteen years earlier. Duluth and St. Louis County shared the $68,000 cost, and the work went relatively quickly, beginning in early February and completed on March 15. Later that summer a paint job started in 1952 was finally finished. After years of problems with the original contractor, bridge operator Hartley Ness, with the approval of the painter's union, took on the task himself.

That same year saw the passing of the original aerial transport bridge's architect. C. A. P. Turner died in January in Columbus, Ohio, at eighty-six years of age. Besides the many other bridges and buildings he designed, Turner also became famous among engineers for developing a reinforced concrete flat-slab support system, often called the "mushroom cap" column system. His passing went unnoted in Duluth.

Two years later Turner was followed to the grave by the man who had first envisioned a ferry bridge over the Duluth ship canal. Thomas McGilvray died at his Third Street home

WORKERS IN 1955 POSITIONING "SPECIAL STEEL FABRICATED SURFACING" ON THE BRIDGE, REPLACING THE ORIGINAL 1929 ROADWAY, WHICH STILL CARRIED TROLLEY TRACKS EVEN THOUGH TROLLEYS HAD NOT OPERATED IN DULUTH SINCE 1949.

Over the winter of 1953–1954, on the Lake Carrier Association's recommendation, Duluth officials altered the method vessels used to signal the bridge to raise. Since 1930, incoming vessels signaled bridge operators with three long toots. While navigating in fog, ships traditionally gave three short blasts on the horn. But too often ship captains leaned on their horns too long in the fog, and often bridge operators thought they had been signaled and unnecessarily raised the bridge, wasting time and money and delaying traffic over the canal. And depending on the direction of the wind, signals from boats calling for the aerial bridge to raise often reached the harbor's other mechanical bridges (the Arrowhead Bridge opened with

on November 25, 1957. The Scottish engineer had lived ninety-seven years and his health had declined rapidly in his last year. In 1933 McGilvray had returned to his old post as Duluth's City Engineer and served until he finally retired in 1941 at seventy-two years old.

A year before McGilvray's death, a reporter had sat with him alongside the canal, watching ships pass and the bridge raise and lower. As the old engineer discussed both his transfer bridge and "that up-and-down gadget" that replaced it, his voice still rolled with a Scottish burr even after living in the U.S. for over seventy-five years. "It's been a good bridge," he told the reporter, "But some day it will have to go. Every bridge runs itself out of business." He was referring to the fact that bridges eventually become obsolete due to changes in use: either the bridge is no longer required or can no longer handle the loads, whether it be increased traffic or increased weight.

"I knew that when I built the aerial bridge," he said. "So I can't say I'm sorry to see it reaching the end of its usefulness.

I'm pleased that it served as long as it has but you can't allow sentiment to stand in the way of progress."

The newspaper's headline was a bit dramatic: "Says Its Builder: City's Famed Bridge Doomed." Perhaps McGilvray thought the impending completion of the St. Lawrence Seaway would do in the bridge's usefulness; ocean-going vessels calling on the port of Duluth in the future may be too tall to pass under the bridge. Of course, the seaway did open up, and it changed many things, not the least of which was more traffic through the canal, which required the bridge to lift more often. But so far it hasn't rendered the bridge obsolete. While it had long been possible for ocean-going vessels to reach Duluth, the limitations of the earlier canal system restricted passage to only smaller vessels no longer than 250 feet—the size limit in the Welland Canal. But when the modern seaway opened in 1959, improvements to the canals and locks allowed salties up to 730 feet long to reach all ports on the Great Lakes. Duluth-Superior Harbor became the world's most-inland seaport.

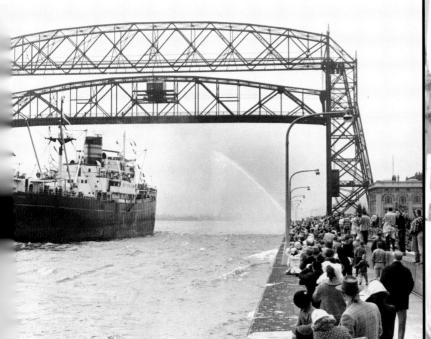

The Saga of the Neptune Statue

When Duluth became an international port it was a big deal—for the entire state. Minnesota commemorated the event by constructing a large gold-colored statue of Neptune, Roman god of the seas, and displaying it at the State Fair. Standing twenty-six feet tall on a concrete base, the statue depicted Neptune brandishing his trident in his right hand as he cradles a ship in his left—a replica of the freighter *Ramon de Larrinaga,* the first ocean-going vessel of the modern era to pass through the Duluth ship canal and under the aerial bridge.

After the Fair ended, its board donated the statue to Duluth. It was installed on the canal's North Pier and heralded by Mayor E. Clifford Mork as a "tremendous tourist attraction." Many Duluthians thought the

statue just plain ugly. For those charged with maintaining it, the statue was a headache.

Neither stone nor metal, the statue was made of fiberglass and a "weatherproof plastic component." Soon the statue was pock-marked with scars from rocks tossed up by the lakes waves and misbehaving children. Workers constantly patched and repainted the statue, costing the city about $300 a year to maintain it (close to $2,000 in 2008, adjusting for inflation).

In 1963 those maintenance woes were solved in a matter of seconds. While taking the statue off its pedestal to perform major repairs, workers using torches to free the structure from its internal supporting pipes accidentally set the statue ablaze. It took just a few minutes to turn it to ashes. The material inside the fiberglass outer shell turned out to be nothing more than papier-mâché.

The aerial bridge lifted for a big saltie for the first time at 1:15 P.M. on May 4, 1959, as it got out of the way for the 475-foot, 10,000-ton freighter *Ramon de Larrinaga* out of Liverpool, England. A crowd of about 3,500 had shown up to witness the event on a blustery day marked by high waves crashing into the rocky shore and piers. Cars blew their horns and fire trucks sprayed a salute over the passing vessel, taking the place of fire tugs that usually herald a grand marine arrival (the canal was too narrow).

The *de Larrinaga* had actually made it to Duluth by 9 A.M. that morning, but Captain Joseph Meade held up entering the canal to wait for dignitaries to gather. He was eventually greeted by Mayor E. Clifford Mork, who presented him with a key to the city and an aerial photograph of the Duluth-Superior Harbor. It was a rather odd ceremony. Chief Good Sounding Sky, an Ojibwe from Sawyer, Wisconsin, stood by dressed in full ceremonial regalia; what his presence was meant to represent was never clear. Also on hand was Greysolon Sieur du Lhut XI, Duke of the Duluth Duchy, who presented Meade with a ducal degree, naming him "Ambassador Extraordinary [*sic*] of Duluth." In real life, the duke was J. Palmer Harbison, district manager of the Equitable Life Assurance Society, his honorary title temporarily bestowed upon him by the civic organization Ambassadors of Duluth. Other dignitaries on hand included representatives of the company that owned the ship; Robert B. Morris, executive secretary of the Duluth Chamber of Commerce; and C. B. Green of Peavey, at whose elevator the ship would dock and take on 2,000 tons of oats before moving on to the Cargill elevator to load 4,545 tons of barley.

Duluth could now receive much larger ocean-going vessels, and just a few years later the additional international traffic had the bridge lifting in frequency not seen since World War II.

THE 1960S: 52,471 LIFTS

As the St. Lawrence Seaway opened a new age for the Duluth-Superior Harbor, the bridge took a big step forward as well. The so-called mechanical ear sound relay system that had helped bridge operators hear boat signals since 1932 was replaced with a very modern way of seeing through fog and other bad weather: radar. In April 1960 the City Council approved the purchase of a Raytheon Model 1500 Radar Radio Positioning Unit at the cost of $4,325. Installed in June, the bridge operators considered it a welcome addition. The radar unit had a range of thirty-two miles, but the bridge operators set it to sweep between a half mile and ten miles out. Now, instead of waiting to hear a horn blast or using binoculars to scan for arrivals, the bridge operators would be alerted to a ship's approach by a blip on a screen, long before her skipper would even need to blow a signal.

Another change on the bridge in 1960 came from the common-sense mind of Bridge Supervisor Al Hass. Each of the bridge's 153 batteries lasted about nine years. Hass replaced the tap water in each battery's cell with distilled water, nearly tripling their life span.

In May 1964 the bridge got a new voice. The four trumpet-shaped brass horns that had greeted ships since 1930 had been "wired, soldered, bolted and patched so many times they were no longer repairable," according to bridge supervisor Bob Brown. By 1960, the *Duluth News-Tribune* estimated, the horns had sounded nearly 500,000 times. The new horns—two sets of them—were also used on diesel locomotives; one faced lakeward and the other toward the bay. Federal law required that they blow a tone loud enough to be heard for at least four miles, but Brown said he could hear them sixteen miles away. He

TOP LEFT:
THE LIFT BRIDGE'S
MODEL 1500 RADAR
RADIO POSITIONING
UNIT, INSTALLED IN
APRIL 1960.

TOP RIGHT:
THE RADAR
SCREEN INSIDE
THE LIFT BRIDGE'S
OPERATORS HOUSE.

further explained that each horn was actually three horns tuned to separate frequencies "like a pipe organ" so that together they create vibrations that result in a much louder signal than if each sounded separately. "Musicians would call it a diminished fifth," Brown explained.

Along with the horns came a set of synchronized lights that flashed in time with the horns. This provided another tool for the skipper of an incoming vessel: start a stopwatch when he first sees the light, stop it when he hears the horn, and then multiply the elapsed time by one thousand to get how many feet he was from the bridge. Along with radar and radio telephones, the bridge was getting safer all the time for both the ships that passed beneath it and those who used it to cross the canal.

The 1960s also saw an effort to make the bridge much more of a tourist attraction than it already was—and had been since 1905. Officials resurrected the idea that their predecessors had twice dismissed as unsafe: public rides on the bridge as it raised and lowered from June to Labor Day. In August 1965 Charles

Cox and Dean Carlos of Higgins Industrial Supply Company installed chain-link fencing along the bridge's lakeward sidewalk to create a safe enclosure for riders; the bridge operators called it the "Monkey Cage." Later that month the bridge became a slow and careful carnival ride, and anyone over five years old could enjoy it for twenty-five cents.

"The bridge operators hated it," current Lift Bridge Supervisor Ryan Beamer said in 2007. It made extra work for them, and also created safety concerns that had nothing to do with the bridge's practical operation. Supervisor Don Bowen validated Beamer's words back in 1967: "This passenger thing really has been nerve-wracking," he told a local reporter. "Now, instead of stopping people, when the bells ring, it's like a dinner bell. People just come running aboard."

Those safety concerns became all too real the day one woman panicked. As the bridge began to rise, she opened the gate and ran toward the North Pier. Fortunately operator Richard Lyons was keeping an eye on his passengers and quickly shifted the bridge into reverse. But the bridge lost its race with the fleeing woman. When she reached the end of the bridge deck, it was still twenty feet in the air. She jumped and landed on the pier, but not without sustaining serious injuries. If Lyons had not stopped and reversed the bridge, she very well may have died. Despite the bridge operators' dislike of the rides, they continued until 1973.

In 1966 the city's Project Duluth Committee took steps to ensure that the bridge would be a night time attraction as well. They intended, chairman John Grinden explained, to illuminate the bridge after sundown with floodlights. "The Aerial Lift Bridge is the symbol of Duluth," Grinden said, probably not the first and certainly not the last to make that observation. "We want to do everything possible to promote it to dramatize Duluth to tourists." The committee hoped lighting the bridge would help make it as recognizable a symbol of Duluth as the

ABOVE:
"CANAL PARK" AS SEEN
FROM ATOP THE LIFT
BRIDGE IN THE 1960S,
WHEN DULUTH STARTED
TAKING MORE PRIDE IN THE
AREA, BEGINNING WITH
LIGHTING THE BRIDGE.

FACING PAGE, LEFT:
AN "AERIAL BRIDGE
CLUB" MEMBERSHIP CARD,
FOR THOSE WHO GAVE TO
THE LIGHTING FUND DRIVE.

FACING PAGE, RIGHT:
NEW LIGHTS BATHE THE
BRIDGE IN JANUARY, 1967
(THOSE "SCRATCHES" ARE
SNOWFLAKES CAPTURED
BY THE CAMERA'S SLOW
EXPOSURE TIME).

chitects estimated the cost at $21,000. A company named Infranor of North America won the contract.

The costs spurred the creation of another organization: the Aerial Bridge Club, chaired by Jack Arnold, public affairs director for WDSM-TV, along with former University of Minnesota football great Billy Bye, Annabelle Gallagher, and Rena Pearson. Membership was obtained by donating one dollar or more to the lighting fund, and each member's card entitled its holder to one free bridge ride. Northland Sign donated a thermometer-style sign that marked the fund drive's progress and posted it at Lake Avenue and Superior Street.

Eiffel Tower was for Paris or St. Louis's Gateway of the West Arch. The group also wanted to make the Canal Park district more attractive to visitors. Remember, at that time the only thing considered "Canal Park" was the Corps of Engineers Building, the landscaped area surrounding it, and the green space along the South Pier; the entire area south of Michigan Street to the canal was not exactly tourist friendly (see "Canal Park before it became 'Canal Park,'" page 105.)

The original plan called for fourteen floodlights installed at either end of the bridge and directed so they would light up the bridge but not the road deck—keeping out of the eyes of motorists. Everyone seemed to love the idea. Soon it had the approval of the City, the Corps of Engineers, the Lake Carrier's Association, and the Coast Guard. The architectural firm of Bean, Gilmore & Hill designed the lighting scheme using the same type of lighting that illuminated Egypt's Sphinx and the Palace of Versailles in France, 1,000-watt mercury vapor lamps and luminaries, twelve of them mounted on eight poles. The ar-

By early September the group had collected $2,300, and nearly double that by the fifteenth of September. At that time Arnold and Bye suggested that names of each person who donated should go on a scroll to be encased in glass and permanently affixed to the bridge. That spurred a few more donations, and by early November the group had $14,000 in its coffers with donations still rolling in. On Friday, November 11, they had brought in all $21,000 from 10,000 donors.

A bigger ceremony surrounded the first lighting of the bridge than had greeted the Lift Bridge's opening in 1930. On November 17 a crowd of thousands joined Bridge Club officials and city dignitaries to watch as state representative John A. Blatnik—who called the lights "a magnificent symbol of the rebirth of our area"—threw the switch to turn on the lights. They flickered for a moment, then flashed and grew stronger, bathing the bridge in what the newspaper called a "radiant, silver-blue light." When the lights reached full power, the University of Minnesota Duluth marching band broke into "Hey, Look Me

AERIAL BRIDGE CLUB

must be signed
HAS SHOWN PRIDE & PARTICIPATION IN OUR CITY BY
CONTRIBUTING TO THE INSTALLATION OF THE AERIAL
BRIDGE LIGHTING. THIS CARD ENTITLES THE BEARER
TO RIDE THE AERIAL BRIDGE. _George D. Johnson_
 mayor

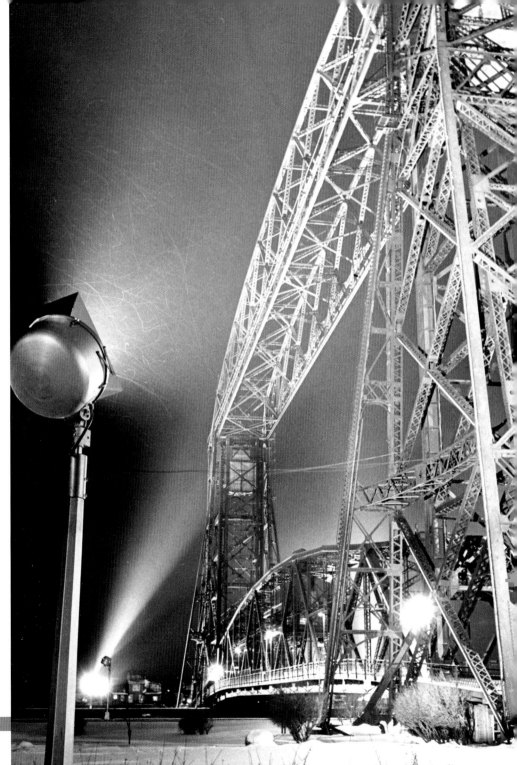

Over." After that, the crowd joined the College of St. Scholastica's choir in a rendition of "God Bless America."

Few public efforts in Duluth go uncriticized, and so it was with the illumination; detractors said that while the new lighting did make the bridge visible at night, it did "little to make the span more attractive." Perhaps Essex green was not as popular a color in the 1960s as it had been in 1930. The Project Duluth Committee had an idea: money brought in from bridge rides could not only pay for the new lights, it could cover the cost of a shiny new paint job. Committee chair John Grinden told newspapers he eventually wanted the bridge painted "aluminum" so that it would better reflect the light and therefore "stand out more," becoming even more of a tourist draw.

With the bridge still unpainted as the 1960s closed, complaints of its condition got louder. A letter to the editor in the _Duluth News-Tribune_ on October 10, 1969, called the bridge's condition "deplorable" and the bridge itself an "eyesore." Paint was peeling and rust was clearly visible. The writer wanted to know why the money coming in from bridge rides wasn't used to maintain the bridge. His concern would be addressed the next year.

ABOVE:
A CLOSE-UP OF THE BRIDGE WEARING ITS OLD "ESSEX GREEN" PAINT, WHICH WAS PEELING AND SHOWING RUST IN 1969 WHEN THE *DULUTH NEWS-TRIBUNE* CALLED THE BRIDGE'S CONDITION "DEPLORABLE" AND THE BRIDGE ITSELF AN "EYESORE." THE NEXT YEAR SAW THE START OF A PROJECT TO PAINT THE BRIDGE "ALUMINUM." THE SILVER PAINT WAS CHOSEN TO BETTER REFLECT THE LIGHTS INSTALLED IN 1966 TO ILLUMINATE THE BRIDGE AND MAKE IT A TOURIST ATTRACTION EVEN AT NIGHT.

LEFT:
(FROM LEFT) BRIDGE PAINTERS JAMES RUSSEL, RALPH RUIZ, AND THOMAS SHERMAN HAM IT UP ATOP THE AERIAL LIFT BRIDGE IN A PHOTO PROBABLY TAKEN BY JOHN PARENT, THE FOURTH MEMBER OF THEIR CREW (AND ONLY OTHER PERSON LIKELY TO BE UP ON THE NORTH PIER BRIDGE TOWER WITH THEM).

FACING PAGE:
THE EXCURSION BOAT *FLAME* WHICH, ALONG WITH THE EXCURSION BOAT *FLAMINGO*, ACCOUNTED FOR 35 PERCENT OF ALL BRIDGE LIFTS IN 1970, PROMPTING COMPLAINTS FROM PARK POINT RESIDENTS AND THE FIRST OF MANY ATTEMPTS TO ESTABLISH LIFTING RESTRICTIONS. LIFT BRIDGE SUPERVISOR BOB BROWN SIDED WITH THE POINTERS: ALL THOSE LIFTS WERE PREMATURELY WEARING OUT THE BRIDGE'S BATTERIES.

In 1970 the city got serious about painting the bridge. After a false start—the city had grossly underestimated costs—the job was divided into three phases, as Duluth only had enough money for the first phase, surface preparation and spot painting. The other phases, an intermediate coat and a final coat, would have to be spread over a number of years. The job was eventually finished in 1975, and the once-green bridge became silvery aluminum. Painting the bridge was part of a program that included upgrading the batteries and installing a new emergency engine to replace the back-up gasoline engines. Bridge Supervisor Bob Brown, who had replaced Al Hass in 1968, explained that the batteries had worn down prematurely due to overuse of the bridge by pleasure craft.

Brown reported that in July 1970, 1,588 vessels passed under the bridge. "Of that number," Brown said, "552 passages were for the excursion boats *Flame* and *Flamingo*, which constituted 35 percent of all traffic. Sailboats and other small craft made up another 404 passages or 25 percent of the lifts. The only reason the batteries had lasted as long as they had was because of Al Hass switching to distilled water ten years earlier. On top of the additional boat traffic, the bridge experienced increased automobile traffic, with 119,000 vehicles crossing the bridge that June alone.

Besides the new batteries and back-up engine, canal traffic had to be limited to extend the bridge's life, Brown argued. One possible solution would be to limit lifts by establishing "bridge hours"—a limit on the hours the bridge would raise for anything but "essential marine traffic." The Coast Guard agreed with him. It sent a notice to mariners that the Guard "will support owners of drawbridges who refuse to open their bridges for vessels capable of sailing beneath the structure." The same would apply to the lift bridge. Boat owners were encouraged to

take down antennas, fishing rigs, false smoke stacks, or anything else that could be easily removed to lower a craft's height to clear the road span's bottom. Not only were the pleasure boats wearing out the bridge and causing unnecessary delays, they were delaying larger vessels that needed the canal.

Two years later the problem remained. The Park Point Community Club took up the cause, telling the newspaper that the bridge was being "abused." Residents were sick of unnecessarily being "bridged," a popular Duluth term for being stuck in traffic waiting for the bridge to raise and lower. Many Park Pointers were still thrilled by the sight of a thousand-foot ore boat passing under the bridge, but few cared much for other craft. They had long ago learned to ride out the wait by keeping a book in the car to read, and Park Pointers always have an excuse if late: "I got bridged" is enough for any other Duluthian to understand the delay.

By 1972, Brown's argument hadn't changed much. In 1971 the bridge lifted 5,873 times, 1,700 for the *Flame* and *Flamingo*—

both of which, according to Brown, sported "needlessly long radio antennas and false smokestacks." At an estimated cost to the city of $23 per lift, those two vessels alone placed a burden of $39,000 on Duluth taxpayers.

Despite the hullabaloo, officials never put "bridge hours" into place. Not that the perception of excursion boats making the bridge raise unnecessarily ever changed. Tom Mackay, longtime Park Point resident and captain of the Vista Fleet, told reporters in 2005 that "People have cussed at me from their cars. I've had people threaten to fire a shot across my bow the next time I cause a delay."

(The Park Point Community Club made another effort to establish "bridge hours" in the mid-1990s. With the Coast Guard's consent, the bridge raised and lowered just once every half hour. But after a year the Coast Guard considered the experiment a failure, and the bridge returned to lifting on an as-needed basis.)

In 1973 the bridge received its highest honor, a spot in the National Register of Historic Places, "primarily for its engineering qualities," the Minnesota Historical Society reported. The bridge was one of the few non-buildings in the register at the time, joining what the newspaper called "an elite group of engineering marvels of American history."

The bridge's life in the second half of the 1970s was marked by many changes at the helm. Bob Brown, bridge supervisor since 1968, retired in 1974. Harold Bilsey, on the job since 1946, took his place. But Bilsey took charge for just two years before passing the baton to another member of the class of '46, Richard Lyons, in 1976. Lyons' tenure at the top also lasted only two years before he retired. In 1978 Don Bowen, who began on the bridge in 1957, took over for Lyons. Bowen would hold the position for four years. (See the appendix for more on all of the bridge supervisors.)

THE 1980s:
59,986 LIFTS

In 1982 a nineteen-year-old man made the same mistake Melvin Halverson made in 1934: he tried to hang from the bridge as it raised. Frank Weber and his friend, Tom Hanna, both of Grand Rapids, Minnesota, were visiting the canal on a Sunday afternoon in September with their girlfriends. Weber, who Hanna described as "adventurous," thought he could easily accomplish the feat. The bridge was lifting for a small sailboat, and Weber thought it would only raise about twenty feet and not stay up for long. He was wrong. As Weber began his ascent, he called for Hanna to join him as both girls urged them not to. Hanna didn't see his friend lose his grip, but when Weber began to fall Hanna rushed beneath him. "I just ran there to break his fall," Hanna told the *Duluth News-Tribune*. Weber landed hard on Hanna, breaking his friend's leg in the process. Hanna's efforts were for naught; Weber died at the scene. A nursing supervisor at St. Luke's Hospital said the young man "had so many injures that we are not sure which ones he died from."

That same year supervisor Don Bowen handed the controls to Steve Douville, already on the bridge for ten years.

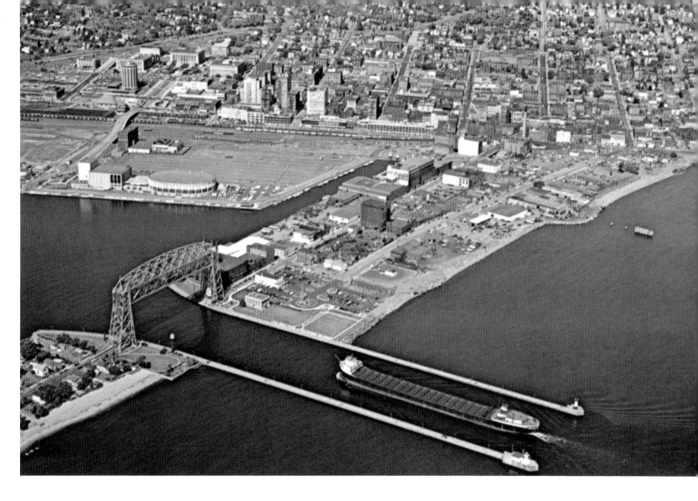

Douville would guide the bridge until its one hundredth anniversary in 2005.

In January 1985 city councilor Arno Kahn made an effort to bring back the bridge rides. Duluth Public Information Director Jerry Sabick saw the potential of big trouble with the rides: pedestrians crossing Lake Avenue to get on the bridge could cause traffic delays or accidents, human cargo would put unnecessary stress on the bridge operators, loading and unloading riders could delay a vessel's passage or back up road traffic, and, of course, a number of safety issues came to mind. Sabick

AN AERIAL VIEW OF THE BRIDGE, CANAL, AND THE AREA KNOWN INFORMALLY AS CANAL PARK IN THE LATE 1970s, JUST BEFORE THE EXPANSION OF INTERSTATE-35 THROUGH DULUTH ACCELERATED THE AREA'S SHIFT FROM AN INDUSTRIAL ZONE TO A TOURIST MECCA.

The 1985 Pier Improvements

The bridge's mid-1980s renovation coincided with a renovation of the ship canal it crossed. The piers, nearly one hundred years old, had concrete problems: the canal had in some spots been scoured by currents to fifty-five feet deep, more than thirty feet deeper than it was in 1900; its water was eroding the submerged concrete monoliths and threatened to undermine the wooden cribbing and pilings they sat on.

So the Corps of Engineers decided to create new piers over the existing ones. Sheets of steel piling were driven along the piers' sides, past the cribbing, and down beyond the wooden pilings supporting the cribbing. The pilings were not placed tight against the old concrete pier walls, creating a gap that was filled with rock, adding another layer of protection. When that work was complete, builders poured a new concrete cap across the piers' tops that also widened the walkway from twelve feet to twenty-nine feet. Work on the project, which began in July 1985 and carried over to 1987, cost the U.S. $10 million.

Unfortunately, the canal's renovation took some history with it. The tile water-level markers D. D. Gaillard had insisted on in 1902 (see page 38) would be lost forever behind the new piles. Fortunately workers removed the tiles before the driving began. The photos on this page were taken just before the tiles were removed, and show the eroded condition of the 1902 piers. The tiles themselves look to have held up pretty well, except for those missing from the United States Corps of Engineers seal at top right. According to Thom Holden, curator of the Lake Superior Maritime Visitor Center the tiles were saved and placed in storage. He is hoping to find someplace to put the tiles back together so the public can enjoy them, but concerns over potential vandalism have made that difficult.

also doubted that fees paid by riders could cover the cost of four attendants, building a cage that held fifty people, equipping the bridge with added cameras for safety, and the necessary liability insurance. In the end a warning by the state killed the project: the bridge was about to undergo a $4.6 million renovation, and if it was going to be used to give tourists rides, the state probably wouldn't help pay for the project, because it would in part be liable if an accident occurred on the bridge it financed.

The project began in the spring of 1986 and called for

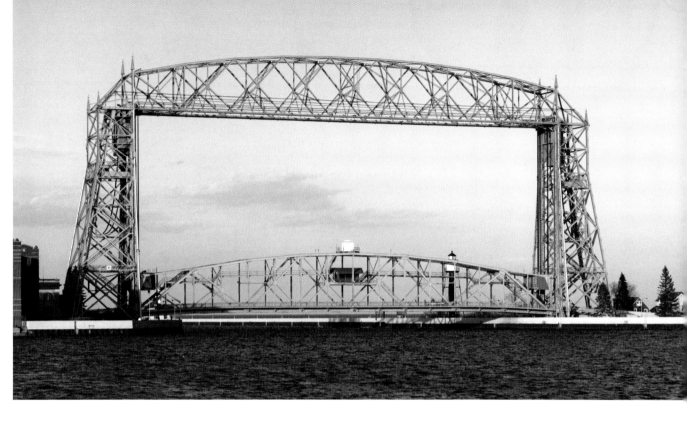

a refitting of the bridge's mechanics. Cars had become heavier over the years and traffic increased dramatically, thereby increasing the load—and stress—on the bridge. To reduce structural stress, the operating machinery, housed in the operators house's top level at the span's center, would move to each end of the lift span, with machinery houses to contain them—so a new operators house was needed as well. The old battery system of powering the bridge would finally be retired, replaced by standard electricity. The old rivets would go, nuts and bolts in their place. The approaches would be rebuilt; the 1 7/8-inch counterweight cables would be replaced with new cables. Finally, the bridge would receive a fresh coat of paint. Johnson Brothers of Litchfield, Minnesota, took on the project as its general contractor.

A computer system for controlling the bridge's speed was also added to its arsenal of instruments. "The bridge computer system was a real challenge," Douville recalled in 2008. "Its ability to control two separate machinery spaces roughly a city block apart was amazing. Raising, lowering, starting, stopping, acceleration, and deceleration at various speeds and under various load conditions was truly too good to be true— the malfunctions ranged from the mysterious to the serious." As Douville suggests, along with added convenience, it created a few problems. A $1,000 card in the computer frequently acted up, and at least once it shut the bridge down when the span was fifteen feet from fully raised. Whenever the problem occurred, operators were forced to raise the bridge manually,

ONE OF THE FIRST PHOTOS OF THE "NEW" LIFT BRIDGE, TAKEN IN 1986 JUST AFTER ITS RENOVATION WAS COMPLETE. NOTE THAT THE OPERATORS HOUSE IS NOW JUST ONE STORY, AS THE BRIDGE'S MOTORS HAVE BEEN MOVED TO NEW HOUSINGS ATOP EITHER END OF THE LIFT SPAN.

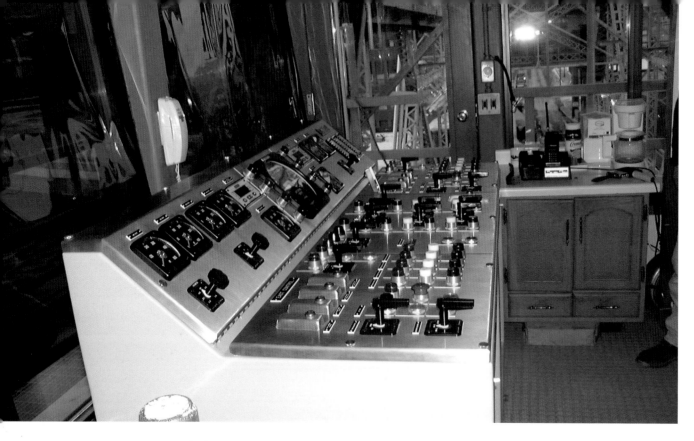

ABOVE:
THE BRIDGE'S CONTROL
PANEL, WHICH REPLACED
THE PANEL ADDED DURING
ITS 1986 RENOVATION.
THE 1986 SYSTEM—
PARTIALLY COMPUTER-
CONTROLLED—PROVED TO
BE BOTH A CONVENIENCE
AND A NUISANCE.

FACING PAGE:
A 1985 DRAWING
OF CANAL PARK BY
ARCHITECTURAL HISTORIAN
JEFFREY HESS.

which took about eighteen minutes—nearly ten times the rate under regular power. The computer malfunctioned half a dozen times in 1989, but when you consider that the bridge lifted 6,390 times that year, the problem was relatively minor.

During the bridge's renovation, workers removed the floodlights installed in the 1960s. In 1987 the Duluth Rotary Club donated $25,000 to pay for new lights, thirty-two high-pressure sodium floodlights that bathed the bridge in a golden glow. Bridge operators lit the new lamps for the first time on July 4, 1987, following the city's annual fireworks show over the harbor.

Throughout the decade, Canal Park underwent a renaissance. The 1980s saw other major changes in Duluth, not the least of which was extending Interstate 35—which had previously terminated at Mesaba Avenue—around downtown through a series of tunnels all the way to Twenty-Sixth Avenue East. The highway extension in turn created the Lakewalk and Lakeplace Park and added a rose garden to Leif Erickson Park. The short stretch of Minnesota Point north of the Corps of Engineers building to Michigan Street changed as well. The Lake Avenue viaduct came down and Lake Avenue crossed the highway (which replaced most of the railroad tracks) following the path of First Avenue East, which long before had been known as St. Croix Avenue. What had been Lake Avenue north of the old viaduct—the stretch that lead to the bridge—was renamed Canal Park Drive. Industrial complexes and warehouses were replaced by or converted into restaurants, shops, and hotels. Endion Station, originally located at 15th Avenue East and South Street, was moved to the area to save it from destruction due to highway construction. Groups organized to promote the city as a tourist destination dubbed the entire area north of the ship canal and south of the new highway the "Canal Park District" (or, when including the Duluth Entertainment and Convention Center and Lake Superior Aquarium, the "Downtown Waterfront"). Soon just about everyone referred to the entire area as Canal Park.

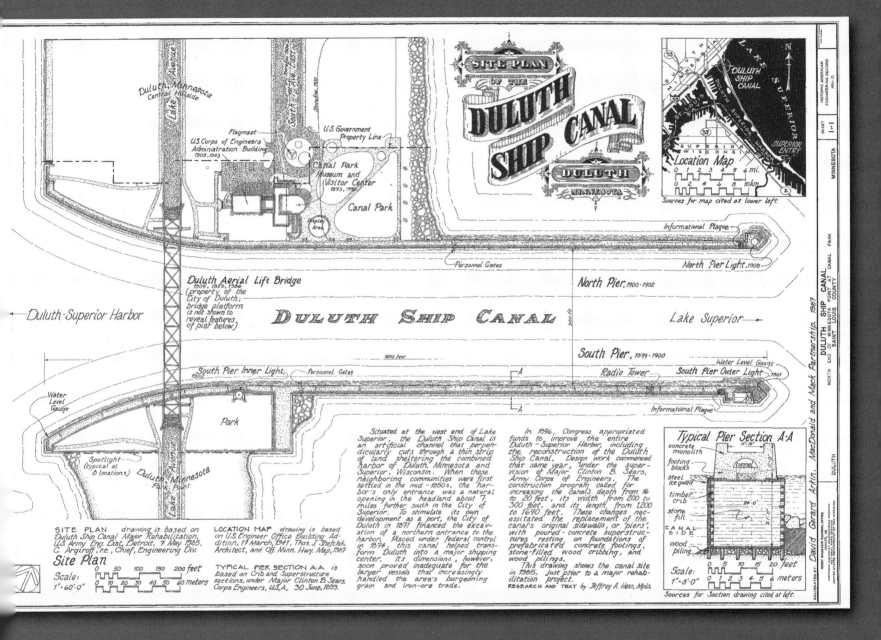

CANAL PARK SITE PLAN

THE 1990S: 53,856 LIFTS

As the 1990s began tragedy hit the bridge again in what is arguably the most notorious event in the bridge's history. At 11:30 A.M. on a beautiful Sunday in June 1990, as the bridge prepared to lift to allow the *Vista King* to pass under it, fifty-year-old Barbara Ann Paplior got on despite the warning lights flashing and bells sounding. She may have been disoriented; her family later said she suffered from manic-depressive disorder and had experienced a psychotic episode just two days earlier. She was almost halfway across when she realized the bridge was rising—and she panicked. Witnesses told the news media that she screamed, "Help me! Somebody help me, please!" If she would have stayed on the sidewalk and not moved, she could have safely rode up and back down on the bridge, but she apparently didn't know that. She ran back toward the north approach and, when the

bridge was thirty to forty feet above the ground, she leaned over and attempted to jump. But she became caught in a V of the bridge's metalwork, facing west with her legs sticking out toward the lake. As the lift span continued upward, it carried Paplior toward the stationary north tower; dismembered by the rising bridge, she died instantly. Witnesses described the event as gruesome. The bridge's operators were unaware of the mishap until after it had happened and witnesses called 911.

Later that summer the Park Point Community Club revived its efforts to reduce the number of times the bridge lifted. The club made its request to the Coast Guard because the issue essentially came down to navigating the canal, which necessitated bridge lifts. A raised bridge could back up traffic for "thirty blocks," the community argued. In just one July day that summer the bridge rose sixty-five times. The group wanted raising restricted to just once every half hour, with exceptions for commercial boats, government boats, and vessels in distress. Once again, the attempt failed; the Coast Guard cited "paramount rights of navigation" for the denial. City officials made another attempt in 1998, but it fell victim to the same fate.

One has to wonder what the Coast Guard—and the Corps of Engineers, city, and bridge operators, for that matter—thought of an event that took place on the bridge in 1994. Twin Cities–based choreographer Marylee Hardenbergh wanted to stage "Bridge Dancing." More than a dance piece, it would be performance art: a twenty-three-minute extravaganza with dancers on the lift span, in-line skaters atop the piers carrying vividly colored flags, and kayakers in the canal below all synchronized for an audience standing on the North Pier listening to music composed for the event. Hardenbergh managed to cut through all the red tape required, and the show went on. She even got the Coast Guard enthusiastic enough about the project to join in by including two of its boats in the performance.

The Saga of Duluth's Foghorn

Duluthians have either loved or hated the fog signal since it was first used in 1885 (see page 19). In 1915 the steam-powered twin whistles installed in 1901 were replaced by locomotive whistles, which in turn were replaced in 1923 by electrically powered twin Type F diaphone horns whose deep "Bee-Oh" tone could be heard for twenty miles. Almost immediately Duluthians complained. The horn was much too loud and rattled windows; in the hillside neighborhood, the horn disrupted conversation and woke the sleeping.

In 1968 the Coast Guard retired the horn, replacing it with a much quieter single-tone horn. While some Duluthians rejoiced, others dearly missed the old horn's deep toot and felt the City had lost part of its very identity. They called the new signal a "peanut whistle."

Those folks included John Ringsred and his son Eric. The Ringsreds started a non-profit organization called TOOT (ReTurn Our Old Tone) and worked for years to bring the old signal back. They purchased another antique diaphone, renovated it, and installed it in the south breakwater light. With $5,000 paid annually from the City, TOOT maintained the horn. The Coast Guard granted the City an operating permit, which TOOT leased from the City. The aerial bridge operators prepared the horn each spring, but the Coast Guard operated it.

TOOT fired up the signal for the first time in over twenty years in June 1995. The old window-rattling horn was back—to the dismay of many hillsiders. That night (and early morning) Duluthians barraged Mayor Gary Doty with calls to his home; he ordered it shut down for the night.

For the next few years Duluthians remained relatively silent on the issue. Then in late 2002 the City Council, besieged by letters both for and against the horn, attempted to come up with a compromise on its operational hours. The first idea was to limit the horn's use to between 7 A.M. and 11 P.M., but Doty vetoed the resolution; while he too enjoyed the horn, he wanted to respect those whose lives it disrupted.

But in the spring of 2003, as bridge operators prepared the horn for the new shipping season, TOOT was nowhere to be found. Their lease to operate the foghorn had expired. Eric Ringsred then sent the City a letter stating the group planned to dismantle the horn because of the operating hours dispute—in the meantime, he disabled the horn. This put the City in violation of its Coast Guard permit to operate the horn. Eventually a compromise was struck, restricting the horn's use to between 9 A.M. and 9 P.M. and only when conditions merited its use; the Coast Guard would otherwise use its smaller whistle.

The issue didn't go away for long. In April 2005 Dr. Ringsred was angry again. The City, he claimed, had failed to pay TOOT its annual $5,000 for "renting" the horn. Mayor Herb Bergson's administration retorted that TOOT had not sent the City a bill; in fact, the City had received no communication from the group for two years. Meanwhile, the City took over basic maintenance. Bridge supervisor Steve Douville explained that the City had spent $500 in parts

that very April to prepare the horn for another season. Without any help from TOOT, the horn remained in operation.

Later that fall the Coast Guard asked the City to stop using the old horn: it interfered with fog detection equipment and using both the old horn and the Coast Guard's whistle confused mariners. The City hoped to keep the old horn working and blast it once a day and on special occasions. But the Coast Guard also removed cables carrying the three-phase electricity the horn required for power; all of the pier's federal equipment functioned with single-phase power.

It would cost $15,000 to restore the cables, and TOOT felt it had already spent enough money. On September 26, 2006, members of TOOT dismantled the horn for the last

time. Reactions posted on the *Duluth News Tribune's* online message board both praised the move and displayed dismay at loss of the old tone.

The Coast Guard's "peanut whistle" still blows in foggy conditions. While most ships have radar and GPS navigation, many smaller craft do not, and to them an audible fog signal could still mean the difference between safety and peril.

Calling the bridge the show's "star" the *Duluth News-Tribune's* art critic Dominic Papatola praised the event as an "elegant, ingenious blend of aesthetics and engineering, of form and function, of fancy and reality" and an "inspired spectacle of color and motion." Over one thousand people showed up to watch the event, which proved popular enough that Hardenbergh and her dancers came back in August 1996 and gave an encore performance.

As the decade—and indeed, the century—came to a close and the bridge moved closer to its one hundredth year, the bridge again required major work. Earlier in the decade it had experienced two major breakdowns. The first, in 1993, unexpectedly closed the bridge for several days. The motors that raise the lift span fell out of synch. The bridge is normally level throughout the lifting and lowering process. The safety system was designed so that when one end of the span was six inches above the other, the bridge would stop. But the system failed, throwing the span out of skew. According to Douville,

"the bridge was out of level (from north to south end) by several feet. Anything over 3 feet is serious. My calculations put the span out of level at somewhere between 5 1/2 and 6 feet—enough to scrape the machinery room roof against the tower, shearing off rivet heads." It took Douville and his crew six hours to correct problem. In 1995 bridge operators discovered that one of the pulleys had slipped out of its housing, and realigning took nearly a month.

Three years later Duluth hired local firm LHB Engineers and Architects and New York's Hardesty and Hanover—which has specialized in moving bridges for more than one hundred years—to inspect every inch of the bridge. LHB couldn't have teamed up with a more appropriate company: Hardesty and Hanover evolved from a company established by John Alexander Low Waddell, the man who in 1892 first came up with the idea of a lift bridge in a contest to find a way of crossing the Duluth Ship Canal (the bridge, the first of its kind, was built in Chicago a year later and survives to this day as the South Halstead Street

Bridge; see page 32). During their inspection, Hardesty and Hanover discovered a 1/16-inch crack in the southwest sheave's axle shaft, caused by the extra weight added to the bridge during the 1986 renovation. Each sheave axle is 16 inches around and weighs 5,000 pounds, hefty enough to support the combined weight of the span, counterweights, and cables—half a million pounds for each axle. The shaft was repaired, but it wouldn't be the only fix the bridge required.

Other issues discovered by Hardesty and Hanover would result in another overhaul that would carry on into the next century and call for replacing nearly every moving part of the bridge. Early in 1999 plans for an ambitious renovation had been set. The project would take over a year and cost $5.6 million, but engineers expected that, except for repainting and normal maintenance, the bridge would require no work for the next thirty years. And the city received a lot of help to pay for the project, with federal transportation grants taking care of 80 percent of the costs and the state kicking in the remaining 20

percent. The work was so extensive the bridge didn't raise for four months from mid December 1999 to March 2000; during that time anything taller than sixteen feet had to enter and leave the Duluth-Superior Harbor through the Superior Entry. One lane was kept open to allow auto and foot traffic to and from Park Point during the renovation.

Engineers prepared an extensive repair and maintenance list that included repaving the approaches, outfitting the machinery rooms with new motors and control panels (and a new control panel in the operators house as well), installing new guard rails along the pedestrian walkways, strengthening the cable anchorage supports at the counterweights and lifting boxes, replacing pins in the balance chains, rebalancing the counterweights, installing new operating cables (increased from 1 7/8 inch diameter to 2 inch), replacing all four sheaves and axle shafts as well as the pulleys that the cables run on, and reinforcing the structural steel along portions of the bridge atop each tower. The bridge's lower portion—exposed to road salt during the winters—would be

TOP LEFT:
WORKERS REPLACE
THE PINS OF THE LINKS
IN ONE OF THE BRIDGE'S
COUNTERWEIGHT
BALANCE CHAINS.

TOP RIGHT:
A CRANE LOWERS ONE
OF THE TOP TRUSS'S
CROSS BEAMS BACK
INTO PLACE.

repainted. Finally, the air horn atop the north machinery room would be removed and reinstalled atop the operators house.

The ever-malfunctioning computer-controlled operating system installed in 1985 would also be replaced, but not with another computer system. The new controls operate much more simply; after all, as Duluth Public Works Director Richard "Dick" Larson explained to reporters in 1999, "there are only two things this bridge needs to be told to do: go up and go down." The old control system was simply more complicated than necessary, explained LHB vice president Joe Litmann.

Work on the project began in October 1999 when a crew from Lunda Construction of Black River Falls, Wisconsin—the project's general contractor—started moving parts, cranes, and other heavy equipment to a staging area at the foot of the bridge off the North Pier. One crane set up in front of the Corps of Engineers Building, the other alongside the South Pier. For work atop the bridge in the cold of winter, plywood "houses" were built and rigged with heat and bathroom facilities. (In case you were wondering, bridge operators use a bathroom located in the "office" below the South Pier approach.)

One big change during the renovation was that workers replaced the air horn with a quieter horn at the Coast Guard's request. Folks didn't like it, especially Susan Mattis Turnham and Connie Bloom, who started a petition drive calling for the old horn's return. To Turnham, the old horn's sound was the voice of the bridge, and the new horn had taken away its identity. Bloom thought the new horn sounded "like a car horn," hardly befitting of the bridge's majesty. Even the Coast Guard, who requested the quieter horn, complained that the new tooter wasn't loud enough for boats to hear a mile away, as required. Mayor Gary Doty agreed with Turnham, Bloom, and the Coast Guard—or at the very least, under public pressure he recognized an easy fix when he saw it. In May 2000 he ordered the old horn's return. Luckily, bridge supervisor Steve Douville had saved the old horn, anticipating just such a scenario.

THE 21ST CENTURY: 45,872 LIFTS (AND COUNTING)

With work on the bridge's most complete overhaul and renovation finished in late 2000, the bridge entered the twenty-first century in the best shape it had been in since 1930. The next year the bridge marked a milestone when Paula Hanela joined the crew on March 5, 2001, as the first female bridge operator in the structure's history.

As 2005 approached, the city had done little to prepare for the span's one hundred year anniversary. It wasn't until January 2005 that the Aerial Lift Bridge Centennial Committee was created and Mayor Herb Bergson declared 2005 "The Year of the Lift Bridge." To some, the committee's name and Bergson's proclamation suggested that the city had gotten off on the wrong foot; after all, it was the one hundredth anniversary of the Duluth Aerial Bridge; the Duluth Aerial Lift Bridge was only turning seventy-five.

Semantics aside, the committee had little time to pull something together. With the theme "Get Bridged" the committee held a logo design contest which was won, appropriately enough, by Dick Green, grandson of original bridge boss Leonard Green. The celebrations kicked off with an event at the St. Louis County Arts & Heritage Center, with guests ranging from Jack Hicken (son of transfer bridge operator John Hicken) to retiring bridge supervisor Steve Douville.

LEFT:
THE CREW FROM
LUNDA CONSTRUCTION
OF BLACK RIVER FALLS,
WISCONSIN, THE FIRM
THAT CONTRACTED THE
1999–2000 RENOVATION.

TOP:
THE "GET BRIDGED"
LOGO USED IN
CONNECTION WITH
EVENTS CELEBRATING
THE AERIAL BRIDGE'S
FIRST ONE HUNDRED
YEARS. IT WAS
DESIGNED BY DICK
GREEN, GRANDSON OF
THE BRIDGE'S FIRST
SUPERVISOR,
LEONARD GREEN.

THE BRIDGE
SCULPTURE SPONSORED
BY THE *DULUTH NEWS
TRIBUNE*, REFLECTING
THE BRIDGE'S 100
YEARS USING HEADLINES
FROM 1905 TO 2005.

The committee teamed up with Duluth's Greater Downtown Council to place decorated bridge statues at various locations throughout the city, an idea inspired by the Charles Shulz "Peanuts" statues that graced St. Paul in the 1990s. Individuals or organizations could sponsor a bridge sculpture and decorate it with a theme of their choosing. The *Duluth News Tribune*, for example, decorated its bridge with headlines from the newspaper of major events that occurred during the bridge's first one hundred years.

Many local artists got into the act by creating souvenir products such as shirts, mugs, blankets, jewelry, glass etchings, and posters either in the shape of the bridge or featuring images of the bridge. Ken Newhams' *Duluth Shipping News* produced a DVD on the bridge, and Dinehery Fence made steel-fabricated replicas of the bridge. Four songs about the aerial bridge were composed, and of course the Park Point Community Club got involved. They gathered three hundred recipes and published them in a book titled *Get Bridged*.

Local artist Gary Lundstrom—whose Great Lake Design specializes in creating memorabilia featuring landmark images of western Lake Superior, including the aerial bridge—threw himself into the event. Besides creating an entire line of bridge centennial commemoratives, Lundstrom organized the centennial kick-off at the Depot in combination with two bridge history exhibits he designed and created. He also asked the Duluth community to come forward with bridge-related stories, photos, and any older bridge memorabilia they had on their mantles or in their attics. People came forth with all sorts of items bearing images of the bridge, some of the transfer bridge, some the lift. Silver spoons, fine china (pitchers, vases, serving plates, lace plates, cups and saucers), bottle openers, Zippo lighters, antique postcards (one made of brass), salt and pepper cellars, metal items (napkin rings, pen holders, letter openers, spoons, a cigar box), a gold locket, and even a pocket watch with an engraving of the lift bridge presented to Samuel Clark Dick by the residents of Park Point. Dick had been president of the Park Point Community Club in the 1920s and worked almost obsessively on the petition to convert the transfer bridge (see page 119).

Lundstrom photographed the memorabilia and put the images together with the historic photos he had gathered in a handsome volume with a brushed metal cover called "The Aerial Bridge History Album." He only made five copies and donated one each to the Northeast Minnesota Historical Center, the St. Louis County Historical Society, the Duluth Public Library, and the Lake Superior Maritime Visitor Center. The fifth is in his possession. (Lundstrom continues to gather personal stories and images associated with the bridge; contact him through www.greatlakesgiftsandgallery.com.)

For the real bridge buffs, retired historian and Park Point resident Jerry Sandvick donned a conductor's uniform much like

those worn by the transfer bridge operators from 1905 to 1929 and provided free "Bridge Tours," explaining how the mechanics of the bridge work and showing which parts of the bridge are "new" and which remain from the original construction.

Throughout the entire year *Duluth News Tribune* columnist Chuck Frederick kept track of all the activity surrounding the bridge's centennial and chased down some great stories about Duluthians and their personal connections to the bridge. His stories were gathered in a special edition commemorative magazine-like book titled *Spanning a Century*, copies of which can be found at the Duluth Public Library.

In August festivities wrapped up with a celebration at Bayfront Park featuring music from the past one hundred years and an art fair that stretched from the bridge north to the Dewitt-Seitz building. By that point the committee volunteers had become frustrated with the efforts of Mayor Bergson's administration. Some of the volunteers had invested not only time, but a good deal of money gearing up to celebrate the life of the city's icon. Many felt that the City had done little to help promote the bridge's anniversary, and it had gone the summer relatively unnoticed by the public at large. So few people showed up at the August celebration that some of the volunteers said they felt as though their efforts had turned into little more than throwing themselves a party.

But the most significant event of the bridge's centennial year wasn't a celebration but a symbolic leap toward the future. Supervisor Steve Douville—on the bridge since April 1972 and the boss beginning May 1982—handed the reins to Ryan Beamer,

who first raised the bridge in 1998. Douville's last lift occurred on his final day of work, March 31, when he raised the bridge for an unscheduled "maintenance lift." But that symbolic event was delayed as it took Douville longer to reach the bridge operators house than anticipated: the outgoing bridge supervisor got bridged.

With a recently renovated bridge and a solid crew of operators, Beamer looks forward to an uneventful future for the bridge because, as he says, "If the bridge is working correctly and we're doing our job right, no one notices." For most people who live in Duluth, it's hard to imagine the idea that Duluth's Aerial Bridge could ever go unnoticed. But certainly Beamer and his crew feel the same way as most Duluthians and those who visit Canal Park every year: despite its practical purpose, the bridge always has been and always will be more than just a way of crossing the canal.

SOME OF THE OPERATORS ON DUTY IN 2005, THE DULUTH AERIAL LIFT BRIDGE'S ONE HUNDRETH YEAR.

FROM TOP: RICHARD SHAUL, SOON-TO-RETIRE BRIDGE SUPERVISOR STEVE DOUVILLE, DOUG SLOSSON, GEORGE FLAIM, PAULA HANELA, AND SCOTT HILL.

NOT PICTURED: DAVE CERYES, JIM WALL, PAUL THOMAS, AND RYAN BEAMER, WHO REPLACED DOUVILLE AS SUPERVISOR.

Appendix

A. Aerial Bridge Operators 1905 – 2008

As of this publication forty-nine persons—forty-eight men and one woman—have officially held the title of Aerial Lift Bridge Operator.

Bridge Supervisors

Name	Years Worked	Total Years on Bridge	Years as Supervisor	Notes
Leonard Green	1908 – 1944	36	1908 – 1944	
Frank Lampert	1921 – 1944	24	1944 – 1946	*Interim, not official*
Alfred Hass	1930 – 1967	37	1946 – 1968	
Robert Brown	1941 – 1974	33	1968 – 1974	
Harold Bilsey	1946 – 1976	30	1974 – 1976	
Richard "Dick" Lyons	1946 – 1977	31	1976 – 1978	
Don Bowen	1957 – 1982	25	1978 – 1982	
Steve Douville	1972 – 2005	33	1982 – 2005	
Ryan Beamer	1998 –	on the job	2005 –	

Bridge Operators

Name	Years Worked	Total Years on Bridge	Notes
Thomas White	1905 – 1918	13	*killed on bridge*
John Hicken	1905 – 1928	23	
William Maynard	1916 – 18, 1932 – 45	15	
James Murray	1924 – 1941	17	*"Special Police" 1931 – 41*
Urban Nehring	1928 – 1942	14	
Charles Landre	1930 – 1955	25	
Armas Vanhala	1931 – 1955	25	
Doug Creighton	1940 – 1942	2	
Hartley Ness	1942 – 1970	28	
Art Gressner	1942 – 1972	30	
Milt Anderson	1945 – 1970	25	
Cliff Lanthier	1946 – 1966	20	
Jim Milne	1955 – 1956	1	

Continued…

NAME	YEARS WORKED	TOTAL YEARS ON BRIDGE	NOTES
Clarence Cohler	1956 – 1977	21	
Dennis Peterson	1967	4 months	
Alva Eastman	1967 – 1984	17	
Don Berryhill	1968 – 1970	2	*Suffered heart attack on duty; died enroute to the hospital*
Ernie Shelton	1970 – 1976	6	
Chuck Anderson	1970 – 1973	3	
Mike Vuksich	1970 – 1981	11	
Gaylord Korhonen	1973 – 2003	29	
Roger Braff	1974 – 1988	14	
George Priley	1976 – 1989	13	
Jim Wall	1976 – 2007	29	
Al Kennedy	1977 – 1998	21	*Kennedy recorded the warning message that plays before each bridge lift; ironically, he lost his voice before he retire*
Leo Stepanek	1979 – 1996	17	
Thom Reistad	1981 – 1986	5	
Don Olson	1982 – 2001	19	
Bob Wilcox	1984 – 2000	16	
Darrel Moe	1986 – 1987	1	
Doug Slosson	1987	on the job	
Mike Geist	1989 – 1998	9	
Paul Thomas	1990	on the job	
George Flaim	1996	on the job	
Dick Shaul	1998	on the job	
Paula Hanela	2001	on the job	*First woman to work as an aerial bridge operator*
Scott Hill	2001	on the job	
Dave Ceryes	2003	on the job	
Dale Mitchell	2005	on the job	
Tim Cain	2007	on the job	

The Duluth Aerial Transfer Bridge operated very much like a streetcar trolley, and indeed ran on streetcar motors. Duluthians lucky enough to have ridden on the bridge remember that it rode very smoothly and wasn't too loud—you didn't have to shout to have a conversation during a crossing. And like a streetcar, operators used a removable handle at the "front" of the ferry car to set the bridge in motion; for the return trip, the handle was moved to the other end of the car, now moving in the opposite direction.

Only a handful of people operated the ferry bridge, including long-time bridge boss Leonard Green (see next page). Thomas White started in 1905 and in 1918 became the only operator to die on the bridge (see page 110). John Hicken also started on the bridge that first year and stayed on the job until his death from pneumonia in 1928, just a year before the bridge was converted to lift. That year a newspaper article on Hicken estimated that he had traveled 120,000 miles—300 feet at a time—and had taken on 25 million passengers before 1923. But Hicken wasn't worried about stats. "What's a couple million people between friends," he joked with the reporter. He was looking forward to working on the lift bridge except for one thing: his workday would go by without the companionship of his passengers.

William Maynard worked the bridge from 1916 to 1918, then returned in 1932 to operate the lift bridge for another thirteen years. James Murray began as an operator in 1924; when the span converted to lifting he worked as "Special Police" for the bridge. Urban Nehring joined the crew just a year

before the conversion and stayed on until 1942.

Frank Lampert, who lived two houses south of the bridge on Park Point, began as operator in 1924. Unofficial records show that he retired in 1944, but newspaper articles indicate he took over as interim bridge supervisor upon Green's death in 1944 and stayed on until Al Hass took the helm in 1946. In 2005 eighty-six-year-old Howard Boyton of Park Point told a reporter that when he controlled the old ferry car, Lampert also acted as an arbitrary gatekeeper: "Lampert would stop you, and if he knew you didn't belong uptown, you didn't get there. You didn't get to go. You stayed right there. That was the end of your trip."

By the way, that's Aerial Bridge Supervisor Leonard Green (left) and operator John Hicken pictured atop one of the south pier tower's lightning arrestor spires.

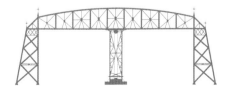

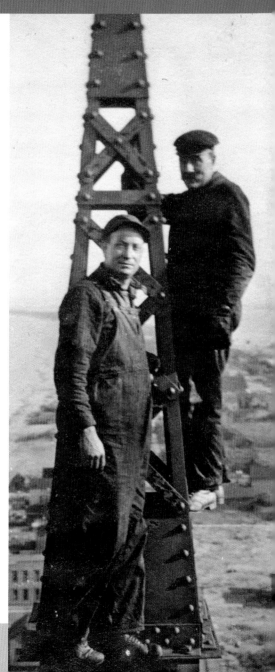

The very first "Bridge Superintendent," **Leonard Green** (pictured at right) saw the transfer bridge through all but the first three years of its life, then stewarded the aerial lift bridge for the first fourteen years of its life. A lifelong Duluthian, Green had worked the big lake as a sailor for years, working his way from fireman to marine engineer. He crewed on several tugs in the Duluth-Superior Harbor, including various fishing boats operated by the A. Booth fisheries, the *Corona* and the steamer *Bon Ami*, the first vessel to pass under the Duluth Aerial Transfer Bridge from the lakeward side in 1905. Before coming aboard the bridge, he worked as a stationary engineer for Duluth's grand Spalding Hotel.

In 1943 Green told the press he considered operating the bridge "the perfect job for an ex-sailor…. It's a good job, and I like it." Sixty-two years later, his daughter Dorothy Hubert emphasized that point, telling reporters, "The bridge and the harbor were his life. Even when he was home, he was very aware of what was going on in the harbor." He may have loved the ferry bridge, but he also recognized when it was becoming obsolete. He told the paper that as the ferry bridge neared the end of its life, lines of waiting vehicles stretched for blocks, and many drivers cursed him for the delay. "The present bridge certainly is an improvement over the other one," he said.

Green treated his crew like family. In 2005 Hubert told the *Duluth News Tribune* that the crew often got together socially, sometimes getting their families together as well. "They'd all get their wives and go out for a big picnic once a year," she said. "That was always fun. He worked well with his men. He thought a lot of them." Besides Dorothy, Green and his wife Helen raised three other children in their home in Duluth's East Hillside neighborhood. Green lived his entire life in Duluth and never retired. He died of a stroke in 1944.

Frank Lampert temporarily took over supervisor duties until 1946, when **Al Hass** became only the second man in fifty years to officially hold the title "Bridge Superintendent." Unlike Green, an old sailor, Hass had a much less likely start for a bridge operator: his first job was in a lumber camp, far from any marine activity.

Born in Triumph, Minnesota (near Albert Lea), in 1902, Hass and his family moved to Tenstrike (northeast of Bemidji) in 1911 where he eventually went to work in the logging camp. He moved to Duluth in 1926 (his wife's doctor suggested the move to relieve her hay fever suffering) and sold vacuum cleaners as he studied for an electrician's license, which he parlayed into a job with Commercial Electric.

By 1929 he was working on the bridge's electric components during its conversion from a transfer bridge to a lift bridge. When he finished his work for Commercial Electric, he went to work on the bridge as one of its operators. He had already impressed Leonard Green with his work on the bridge conversion, so Green only had one question for him at his interview: "Are

you used to heights?" After Hass explained that his work previously required him to climb telephone poles, he got the job.

As bridge boss, Hass's problem-solving abilities came in handy. He extended the life of the bridge's batteries (see page 147), worked on ways of protecting the radar antenna from falling ice, and tried to devise a way to prevent people from attempting to cling to the bottom of the bridge and "hitch a ride," a problem that has plagued operators since the bridge's 1929 conversion. During his tenure on the bridge, the operators house was warmed by a coal-fired stove, and operators had to carry the coal in bags slung over their shoulders, a two-story climb. (None of the operators appreciated this aspect of the job, and some turned it into a bit of a game, making sure to leave just a single chunk of coal for the next operator on duty simply to avoid making another trip to the bin and back.) It was also on his watch that the bridge operators' ritual lunchtime cribbage matches came to a halt. "Someone complained to the city fathers and we had to quit," he explained.

Hass and his first wife Edith raised two children in Duluth before her death in 1963; he later remarried and became the step-parent of his wife Lorraine's three children. Hass died in 1993, twenty-five years after retiring in 1968. His thirty-seven years on the bridge was the longest any one person worked on the span.

Two years after **Robert O. Brown** took the reins from Hass in 1968, he told reporters that as a kid growing up in Duluth's West End he wished that someday he could work on the bridge—he rode the transfer bridge often as a youngster. After high school he served as a Merchant Marine and later worked for Clyde Iron before taking a job with Commercial Electric along with his predecessor, Al Hass. He worked with Hass on wiring the bridge's electrical system during the 1929 conversion; while Hass got an operator's gig out of the job, Brown had to take a job with Marshall-Wells and wait eleven years

before another bridge operator position opened up. It took another twenty-seven year before he became the Bridge Supervisor. (Over the years, "Superintendent" was changed to "Chief Bridge Operator" and ultimately "Bridge Supervisor.")

Along with operating the bridge, Brown was known around Duluth for his knowledge of maritime history. Over the years he became the bridge's unofficial spokesman. When Park Pointers voiced their frustration over the number of lifts the bridge made, it was Brown who met with them and explained the reasoning behind the lifting frequency. He also gave lectures on the bridge and its history to community groups. His love of history made him a key player in the development of the Lake Superior Marine Museum. "He was among the first to volunteer to gather artifacts and put up displays," remembered museum curator C. Patrick Labadie in 1983. "I can't begin to remember the number of times I consulted Bob for information about ships or the waterfront."

Besides his roles as bridge boss and ambassador, Brown and his wife Vivian raised three sons and two daughters in their Park Point home, just two blocks south of the bridge. In 2005 his daughter Charlotte told the *Duluth News Tribune*, "We lived and breathed that bridge." Brown and his wife retired to Phoenix in 1974, where he died ten years later. Upon his retirement he told the paper, "Never in my life have I had to drag my feet to go to work...it has been a wonderful career."

If seniority had anything to do with it, it was a close call to pick Brown's successor, but **Harold Bilsey** did have a right to claim an edge, even if it was only fifteen days' worth. Bilsey lifted the bridge for the first time on September 16, 1946;

TOP:
AL HASS

BOTTOM:
BOB BROWN

Richard Lyons, October 1 of the same year. Bilsey took over from Brown, but Lyons took his turn as well, and both would serve as Bridge Supervisor for just two years, the shortest tenure of any of the bridge's supervisors. In the end, Lyons put in twenty-three months and fifteen days more that his work companion of over thirty years.

Both men were lifelong Duluthians. Bilsey grew up in West Duluth and graduated from Denfeld High School in 1931. His father owned Bilsey Grocery in West Duluth, but when he died in 1925, Bilsey and his stepbrothers and mother were left to run the store; young Harold learned how to cut meat. In World War II he signed on with the Navy and served two years aboard the USS *Iowa*. He returned to Duluth with a taste for the sea, and after a brief stint with Coolerator took a job that allowed him to stay in close contact with ships and ore boats. The skills he learned in his father's grocery never left him; even after he took the job as bridge operator, Bilsey moonlighted as a butcher. Bilsey and his wife Clara raised two daughters in Duluth. After he retired in 1976 they moved to Apple Valley, Minnesota, to be closer to their daughter Barbara and her children. He died in 2003.

Lyons was also a Denfeld grad who signed on with the bridge after serving in World War II, but he was an Army man. His sons remember that he had stories upon stories about the bridge, many of them punctuated by Lyon's well-developed sense of humor. He often gave bridge tours to classes of schoolchildren, and used to tell of one particularly serious teacher he had some fun with. When asked what an inbound freighter was carrying, he told her "post holes." The teacher made sure each of her charges listened seriously.

"How will the post holes be used?" she asked. "They wrap sheet metal around them and make heating ducts," he replied, deadpan. He also pointed out that another ship was loaded with "bladeless knives without handles." The teacher never got the joke, but Lyons and his fellow operators enjoyed a good laugh afterward.

Of course, Lyons took his job seriously as well. During a storm in 1975 (his sons believe it may have been November 10, the night the *Edmund Fitzgerald* sank), the high winds were causing the bridge to rock dramatically. Fearing for his life, the operator on duty climbed off the bridge and found shelter and a phone at the Army Reserve Center on Park Point, and then he called Lyons. Two of Lyons' sons—grown men at this point—drove him down to the bridge. They parked right on the span and climbed to the operators house. Lowell Lyons told the *Duluth News Tribune* in 2005 that the wind speed gauge in the operator's house read over one hundred miles per hour, and the canal's waters came right through the bottom of the lift span's grate-like roadway. Lowell jokes that their car "got a good wash" that night. Lyons retired in 1978. Lowell recalled how Lyons often told him, "You have to love what you do or it's just not worth it." And his dad obviously loved his job. "Dad was always so proud of it," Lowell said. "He took pride in how well it ran."

When **Don Bowen** took over as bridge supervisor after Lyons retired, he was just the sixth man to hold the title—but the fourth already in the 1970s. Unlike most of his predecessors, Bowen was not a lifelong Duluthian but a vagabond of sorts before landing his career job. He was born in the Zenith City, but grew up on the Iron Range, graduating from Cook High School. He lived in St. Paul, Chicago, California, and even Hawaii doing everything from driving truck to maintaining naval airplanes before landing back in Duluth. He took a bridge operator position in 1957.

On the bridge, Bowen earned a reputation for his ability to handle winter maintenance work in extreme cold. He said that despite its coal stove, the old steel operators house got plenty cold in the winter because of the icy winds that arrived at the bridge unabated once they cleared Spirit Mountain—or as he put it, the bridge was the wind's "first barrier since the Duluth Zoo." At least once he was called on to perform heroics beyond climbing the bridge in extreme cold to make repairs. Somehow a young girl had gotten about halfway across the lift span when it started to raise. She panicked and started to run. As the bridge raised, Bowen raced down the operators house stairs two at a time and chased after the girl. "I caught her right near the edge," he told reporters. "But the bridge was forty feet off by that time and she was going to run right off."

Bowen loved his job, but once joked with the *Duluth News Tribune* that "The trouble is, everyone in the city of Duluth is your boss. They all feel they own the bridge." He recalled how he had once received a phone call in the middle of the night from a citizen who had said he heard a boat signal at least three times to lift the bridge and the bridge hadn't responded. "Would we please raise it," Bowen recalled him asking, "'cause he was a taxpayer and didn't want his bridge busted."

A year before he retired, Bowen joked with the *Minneapolis Tribune* that "As long as I get the bridge out of the way, I don't get into trouble." While he was staying out of trouble he and his wife Marion raised three children. After leaving the bridge in 1982 he retired to Arizona, where he died in February 2006.

Bowen left the bridge in the hands of a relative rookie, as far as bridge supervisors go. He and the three supervisors before him had each been on the bridge at least twenty years before becoming boss. But in 1982 **Steve Douville** had only a decade under his belt. Like many of his fellow bridge operators, he is a lifelong Duluthian and an old Navy man. His four-year stint in the service ended in 1972, just before he went to work raising the bridge. His brother-in-law had seen an ad for the job in the newspaper, and showed it to Douville. "That's something you could do," he had said. Ten years later Douville was in charge. During his tenure the bridge's operations would go from being controlled by levers and belts to computers—and both systems had their problems.

Douville's fellow operators have long been impressed by his problem-solving abilities. Bridge operator Jim Wall once said of his boss, "If something breaks and we don't have it, he might know he has something at his house he can make work, and then he'll go quick and get it." It's a good thing, then, that Douville was at the helm during and after two of the bridge's most extensive renovations since it was converted in 1929. The refitting in 1986 caused more problems than it had solved, and Douville had to help figure out why.

Douville also witnessed a lot of mishaps, some of them tragic: a car/bus accident on the bridge as the bridge was about to lift for an incoming ship, the nineteen-year-old Grand Rapids man who died trying to hitch a ride, the woman who died in 1990 after panicking. He also encountered incidents in which the foolhardy got lucky: St. Cloud State college students trying to see how far out over the canal they could reach by "climbing" *under* the bridge's lift span, the man who climbed one of the bridge's towers and then crawled across the top span on a dare (twice!), and a Vista fleet pilot who tried to see how close his vessel could get to the bridge before it lifted

ABOVE:

DON BOWEN

(he misjudged and collided with the bridge; he lost his job and his pilot's license.) There have also been many sailboat captains who have misjudged their mast height and collided with the bridge. In case the rigging becomes entangled with the bridge, the operators have a rule for sailboat collisions: no lifting until the vessel has cleared; they don't want to lift a sailboat out of the water.

At the time of Douville's retirement in 2005, Director of Public Works Dick Larson (Douville's boss), emphasized not only Douville's knack for fixing the bridge, but his character as well. "[Steve] lives and breathes the bridge, and really cares about it," he told the *Duluth News Tribune* in 2005. "He's going to be a hard guy to replace," Wall added. "He is the bridge."

Since his retirement, Douville and his wife Patty have remained in Duluth while their children Katheryn and Kevin attend college. So far Douville's retirement been too busy for him to take the time to spend on any hobbies.

Larson may have thought the task of replacing Douville was difficult, but luckily he had another former Navy man on the bridge: **Ryan Beamer**. If you ever meet him, though, don't start by joking, "I bet your job has its ups and downs." The joke has been directed at bridge operators for years, and lazy copyeditors have relied on it as a headline grabber since at least the 1940s. But Beamer knew the joke long before he ever set foot on the bridge; prior to going to work on the span, he had served in the Navy as a submariner. Beamer spent five years as an electronics technician on the USS *Kamehameha*, a nuclear-powered ballistic missile submarine.

But unlike most past bridge bosses, Beamer is not a Duluth native. He grew up in Moose Lake, Minnesota, before joining the Navy. During shore duty in the Twin Cities Beamer met his future wife Cassi and they eventually settled in Duluth. Cassi saw the ad for operator's job in the paper: its qualifications matched Beamer's skills.

Beamer seems focused on the bridge's safe operation, and that includes the safety not only of the operators and those traversing the bridge, but too often careless or reckless tourists. In 2006 he told the *Duluth Budgeteer* that outside of maintenance work an operator's job isn't too physically demanding, but the vigilance required can be draining. "Saturdays and Sundays in the middle of summer get stressful," he said. "You don't sit down. You are constantly standing there, watching traffic, watching boats, watching pedestrians, and keeping everybody safe." He is most alarmed by parents who don't recognize the danger of the lifting span. "You see people picking up their kid to hang on the bridge as it goes up," he said. "And [they] don't realize that it moves about a foot a second." Despite several accidents over the years, including deaths in 1932 and 1982, "people attempting to hang on remains a daily occurrence in the summer months.... You have to be vigilant or people get hurt."

Besides supervising the bridge's operation, Beamer and his wife Cassi stay busy raising their four children just outside Duluth. If he wants to keep up with his old boss, he'll be working his job long after the kids graduate college: as of this writing he needs to put in another twenty-three years to catch Steve Douville.

D. WHO CONTROLS THE BRIDGE?

THE COAST GUARD?

The Coast Guard ensures the safety of vessels on the lake and in the bay, so their input in matters such as warning lights and audible signals has played a key role in the bridge's life. The Coast Guard's approval was necessary when the city allowed rides on the bridge in the 1960s and for the "Bridge Dancing" that took place in the 1990s. When Park Point residents wanted to limit the times and number of lifts the bridge made, failing to get the Coast Guard's approval killed the idea. They also maintain the lighthouses and fog signals on the piers, but they don't own the piers. The U.S. Corps of Engineers does.

THE U.S. CORPS OF ENGINEERS?

The Federal government owns the canal and the land adjacent to it and placed it under the jurisdiction of the Corps of Engineers. So the Corps operates and maintains the canal, its piers, and everything on those piers—except the lighthouses, fog signal, and the aerial bridge. But since the bridge crosses the canal and its foundations and approaches sit on the piers, the Corps has a lot to say about the bridge. Before the bridge was built, the Corps had to give its permission for the bridge to occupy the pier and operate over the canal. Ensuring that the canal always remains open for marine traffic is their responsibility, so the Corps came up with the original rules of operation for both the transfer bridge and the lift bridge—and had a lot of influence on the final design of both bridges. But neither the Corps nor the Federal government owns the bridge. The City of Duluth does.

THE CITY OF DULUTH?

Duluth needed the bridge so people could easily get to and from Minnesota Point. The Corps and the Coast Guard certainly didn't need it, and the Corps rejected many plans before the aerial bridge, fearing a bridge malfunction or accident would hinder ship traffic. Duluth planned, built, and paid for the bridges, and the operators are employees of the City. But that doesn't mean they choose when the bridge goes up and down—at least, not entirely.

The operators must follow a number of rules, including one that pretty much trumps everything: marine traffic always has the right of way.* If there's a problem on the Point and emergency vehicles need to get through, the operators can contact an incoming ship's captain and see if the vessel can slow

*And if there are two vessels—one outbound and one inbound—wishing to use the canal at the same time, the incoming vessel has the right of way. Before the 1980s, the outbound vessel had the right of way; the reasoning was that outgoing vessels in the bay had less room to maneuver. But as ships increased in size, officials determined it was easier to stop a boat that was barely under way no matter the size than to ask a thousand-foot laker with a head of steam to slow down quickly enough to let an outbound vessel go first.

down or wait, but in some cases the vessel's speed and size prevent that possibility. In the end, the operator makes the call, as a former bridge supervisor once explained to the *Duluth Budgeteer*, "We have to consider a lot of factors: the boats, the people who live on Park Point, the interests of the city, and of course, the safety of the public and the operators. Raising and lowering the bridge is always at operator discretion."

Two cases in point: In 1970, bridge operator Don Berryhill suffered a heart attack while on the job in the operators house just as a ship was approaching the canal. His fellow operator first radioed for an ambulance and then contacted the incoming ship's captain, who quickly changed course and dropped anchor. Unfortunately, the EMTs were delayed carrying Berryhill down the narrow stairs that lead from the operators house to the roadway span where their ambulance sat waiting. Sadly, he died before the ambulance reached St. Luke's Hospital. A few years earlier firefighters were delayed responding to a house fire on the Point while the bridge raised to allow a ship to pass. While the lift span was in the air, the operators—Art Gressner and Richard Lyons—heard the address broadcast on the police radio, and, unbelievably, it was Gressner's home. When the bridge could finally lower, fellow operator Richard Lyons told Gressner to rush home, but by the time he arrived the house had been destroyed.

Of course, since the operator always makes the call, and since the operator is an employee and, in many ways, an ambassador of Duluth, then yes, the city of Duluth controls the bridge.

Driven by Streetcar Motors and Pulleys

The operation of Duluth's aerial transfer bridge was surprisingly simple. The gondola car was suspended from the lower rail of the bridge's truss by a stiff-riveted steel hanger. At the top of this hanger was a "traveling pulley"—a truck holding many sets of wheels that sat in a groove along the truss. A one-inch steel cable wound through this traveling pulley and down to a large drum mounted on the side of the gondola car and back up.

Two fifty horse-power electric streetcar motors installed beneath the ferry turned the drum, making the the cables wind around it and up to the traveling pulley, setting the car in motion. Only one motor would operate at a time; the other was reserved as a back up. If the electric motors failed for any reason, operators could use a hand gear to move the car safely to shore and out of the way of oncoming vessels.

Duluth's Aerial transfer Bridge • 1905 – 1929

(POSITIONS OF CABLES, PULLEY, AND DRUM SLIGHTLY EXAGGERATED)

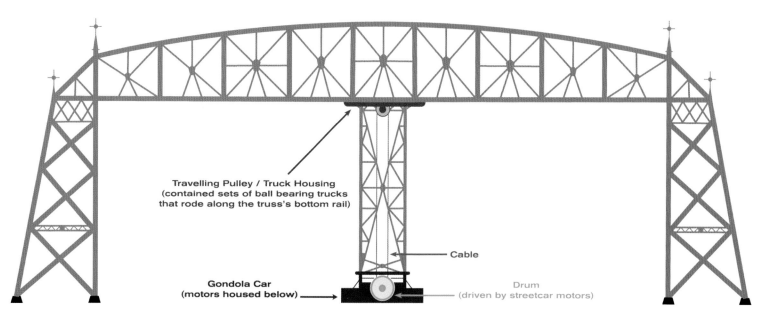

Travelling Pulley / Truck Housing
(contained sets of ball bearing trucks
that rode along the truss's bottom rail)

Cable

Gondola Car
(motors housed below)

Drum
(driven by streetcar motors)

F. HOW THE AERIAL LIFT BRIDGE WORKS

DRIVEN BY BALANCE

Duluth's lift bridge operates on the simple principle of balance. The one-thousand-ton bridge is connected to two five-hundred-ton counterweights, one on each end, via twenty-four 2-inch wire ropes (cables) which are draped over enormous twelve-foot-diameter sheave wheels (pulleys).* The cables themselves weigh about five pounds a foot, and there are forty-eight of them in total, twelve on each corner of the bridge. Just as the counterweights counterbalance the bridge, something needs to counterbalance the cables; however, because the length of the cables on the bridge side of the sheave wheels decreases and increases as the bridge raises and lowers, the amount of weight required to counterbalance the cables also decreases and increases. That's where two giant chains come in: the chains each weigh 252 pounds a foot** and are connected on one end to the bottom of the counterweights and on the other end to the steel non-moving towers of the bridge. As the bridge raises and the counterweights descend, an increasing amount of the chains' length, and therefore an increasing amount of the chains' weight, hangs from the steel towers rather than from the counterweights. So as the length and weight of cable on the bridge side of the sheave wheels decreases, the length and weight of chain supported by the counterweight also decreases, maintaining the balance that is so critical to proper operation.

Four 125-horsepower Westinghouse Induction motors are used to move the bridge. Only two motors are needed to actually move the bridge; one at each end. The other two are back-ups. The motors are attached to winching drums (two at each end) that wind the bridge up or down on eight 1 1/4-inch wire ropes (two per winching drum).

THE PROCESS

With today's technology, most of the communication between the bridge and vessels is done via marine radio. A merchant will usually give a "security call" when they are about one hour out from Duluth piers, or about fifteen minutes from leaving the dock, informing all concerned traffic of their intentions. (Small craft just show up and ask for a lift.) When the vessel is about one and a half miles from the bridge inbound or just starting its turn to lineup with the bridge outbound, the captain calls the bridge and requests the bridge to lift. The goal of the bridge operator is have a twelve-minute lift, or to block vehicle traffic for no more than twelve minutes. The operator, based on experience, will raise the bridge according to the vessel's speed, or the need for safety. The vessel always has the right of way and the captain can direct the bridge to open if he or she feels it necessary.

* Installed in 2000, the 2-inch cables replaced 1 7/8-inch cables last replaced in 1985.

**The twenty-four cables on one end of the bridge weigh 5 pounds per foot each, coming to 120 pounds per foot all together; once you take into account that the cables are over twice as long as the chains, the weights balance out nicely.

DULUTH'S AERIAL LIFT BRIDGE • 1930 – 1985

(POSITIONS OF CABLES, SHEAVES, AND ANCHOR POINTS SLIGHTLY EXAGGERATED)

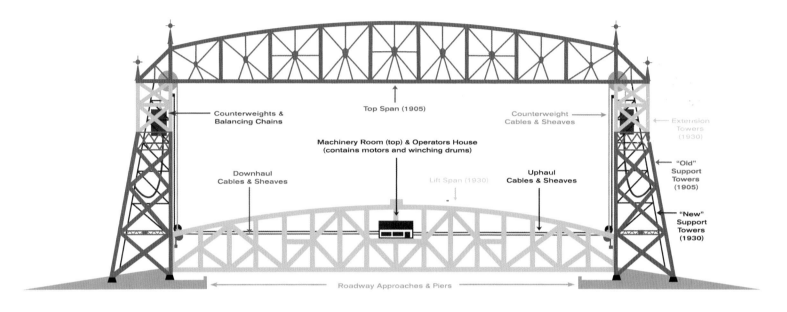

Counterweights & Balancing Chains

Top Span (1905)

Counterweight Cables & Sheaves

Extension Towers (1930)

Machinery Room (top) & Operators House (contains motors and winching drums)

Downhaul Cables & Sheaves

Lift Span (1930)

Uphaul Cables & Sheaves

"Old" Support Towers (1905)

"New" Support Towers (1930)

Roadway Approaches & Piers

When the operator starts the lifting process, he or she first sets in motion a sequence of events that must occur before the bridge actually moves.

First, a recorded message is played, informing tourists and pedestrians that a lift is going to be made.

After the message completes, the traffic lights cycle to yellow and then to red, gongs start sounding, and the "Warning: Restricted Area" lights on both ends of the bridge start to flash.

When the traffic lights turn red, an interlock releases and allows the operator to lower traffic gates. (Usually oncoming traffic gates go down first, allowing traffic to clear the bridge before the off-going gates are lowered). When all traffic gates are down,

another interlock releases and gives a blue light on the control console which indicates that the bridge can now be raised.

Before the "raise" button is pushed, another operator steps outside on the catwalk and visually checks both sidewalks and the roadway to be clear of all persons and vehicles. When the bridge is clear, the operator checking the sidewalks give a "thumbs-up" to the operator running the bridge. The operator will then check the security cameras and press the "raise" button.

As the bridge starts up, the operator will monitor the cameras to ensure nobody runs up and gets on the bridge or is hanging on underneath. Once the bridge is too high for that to happen the operator relaxes a bit and monitors the lift.

DULUTH'S AERIAL LIFT BRIDGE • 1986 – PRESENT

(POSITIONS OF CABLES, SHEAVES, AND ANCHOR POINTS SLIGHTLY EXAGGERATED)

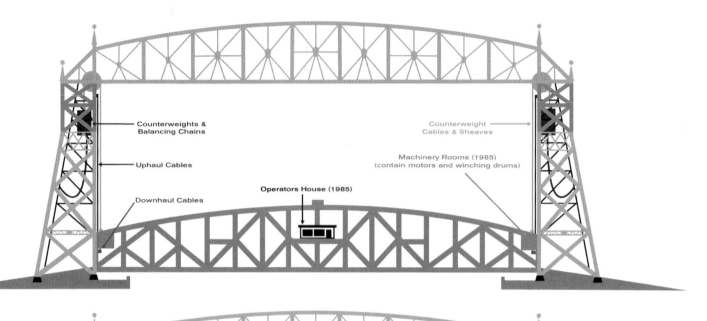

Counterweights &
Balancing Chains

Counterweight
Cables & Sheaves

Uphaul Cables

Machinery Rooms (1985)
(contain motors and winching drums)

Operators House (1985)

Downhaul Cables

Lifting & Lowering

Motors located in the machinery rooms drive winching drums, which wind
(and unwind) the cables. The uphaul cables raise the bridge's lift span
(roadway), which in turn lowers the counterweights and chains to keep
the bridge in balance. The downhaul cables do just the opposite,
lowering the lift span, which raises the counterweights and chains.
The bridge must be in proper balance at all times.

G. BRIDGE LIFTS 1930 – 2005

YEAR	JAN	FEB	MAR	APR	MAY	JUN	JUL	AUG	SEPT	OCT	NOV	DEC	TOTAL
1930	0	0	0	0	876	826	844	902	825	585	407	56	5,321
1931	0	6	16	465	633	741	889	798	554	469	248	37	4,856
1932	0	0	0	201	213	316	393	462	416	371	343	49	2,764
1933	0	0	0	96	429	380	495	621	594	622	479	178	3,894
1934	0	0	0	100	694	600	651	646	524	448	325	38	4,026
1935	0	0	0	71	519	554	586	542	470	464	328	36	3,570
1936	0	0	0	0	556	662	797	752	793	770	612	101	5,043
1937	0	0	0	342	852	887	946	856	782	639	322	27	5,653
1938	0	0	0	121	324	426	532	632	545	405	304	20	3,309
1939	0	0	0	8	455	512	690	711	687	636	589	51	4,339
													42,775
1940	0	0	0	94	734	714	797	870	835	939	536	32	5,551
1941	0	0	0	488	875	762	951	915	712	723	721	145	6,292
1942	0	0	43	464	741	754	883	868	743	754	719	95	6,064
1943	0	0	12	181	653	670	834	815	810	743	799	132	5,649
1944	0	10	13	508	763	756	805	798	764	890	522	63	5,892
1945	38	4	37	547	768	720	770	859	761	926	557	48	6,035
1946	0	0	0	141	486	660	705	709	750	723	632	52	4,858
1947	0	6	0	312	708	668	785	758	683	736	620	86	5,362
1948	0	0	4	451	606	656	807	884	704	626	669	175	5,582
1949	0	0	70	669	638	644	806	765	631	401	398	137	5,159
													56,444
1950	0	2	0	11	632	634	785	776	718	869	691	101	5,219
1951	0	0	0	464	773	713	801	762	680	703	587	96	5,579
1952	0	0	3	438	640	384	586	839	792	762	674	76	5,194
1953	0	0	24	501	667	642	754	829	760	735	494	37	5,443
1954	0	0	4	162	604	563	743	726	566	588	247	39	4,242
1955	0	0	4	219	528	600	691	770	602	705	505	55	4,679
1956	0	0	2	407	724	720	417	516	557	552	529	154	4,578
1957	0	0	0	240	621	912	717	739	612	561	278	50	4,730
1958	0	0	2	45	262	845	618	599	518	414	189	56	3,548
1959	0	0	0	125	563	709	621	352	250	267	448	189	3,524
													46,736
1960	0	0	2	195	567	639	867	900	612	397	244	39	4,462
1961	0	0	0	90	469	784	803	861	624	361	222	54	4,268
1962	0	0	0	99	390	577	580	946	711	507	566	156	4,532
1963	0	0	0	94	830	951	1,211	1,388	761	616	332	63	6,246
1964	0	2	1	323	618	779	1,069	951	628	447	365	60	5,243
1965	0	0	0	152	571	816	960	1,090	690	499	319	56	5,153
1966	0	0	6	374	613	832	1,051	1,014	657	451	311	78	5,387
1967	12	0	1	244	615	758	1,098	1,089	651	442	338	103	5,351
1968	4	0	14	370	577	742	1,115	1,151	1027	461	341	126	5,928
1969	8	0	7	191	567	823	1,134	1,266	730	517	479	179	5,901
													52,471

Continued…

YEAR	JAN	FEB	MAR	APR	MAY	JUN	JUL	AUG	SEPT	OCT	NOV	DEC	TOTAL
1970	13	0	7	265	538	858	1230	1,272	756	495	473	193	6,100
1971	34	2	6	192	602	810	1,133	1,196	784	505	430	179	5,873
1972	52	10	0	94	422	875	1,190	1,168	740	473	492	247	5,763
1973	74	17	14	372	648	1,082	1,213	1,206	822	592	466	285	6,791
1974	65	2	0	205	629	1,025	1,202	1,127	744	541	394	294	6,228
1975	93	48	64	203	651	873	1,339	1,122	793	458	297	200	6,141
1976	57	43	35	229	628	919	1,269	1,215	761	467	300	192	6,115
1977	3	2	1	165	654	1,047	1,290	1,283	713	519	293	222	6,192
1978	49	7	13	251	786	1,057	1,399	1,324	782	814	812	289	7,583
1979	30	10	10	107	580	926	1,261	1,271	1053	652	467	242	6,609
													63,395
1980	13	2	16	340	697	997	1,359	1,200	675	443	319	194	6,255
1981	17	2	29	279	632	1,210	1,099	1,184	775	435	339	159	6,160
1982	6	2	15	152	510	953	1,243	1,186	560	327	282	101	5,337
1983	4	0	17	238	490	888	1,199	1,279	689	414	270	141	5,629
1984	13	25	12	142	588	865	1,178	1,157	1019	413	357	227	5,996
1985	30	4	2	121	478	820	1,377	1,200	650	455	460	211	5,808
1986	103	0	67	278	640	1,013	1,202	1,217	684	503	281	179	6,167
1987	29	26	147	362	627	1,111	1,011	1,255	751	391	229	209	6,148
1988	21	3	40	259	606	1,045	1,389	1,124	741	398	268	202	6,096
1989	21	4	53	253	594	1,022	1,407	1,352	936	358	218	172	6,390
													59,986
1990	19	7	51	179	548	960	1,021	641	505	321	264	198	4,714
1991	0	5	49	179	493	847	1,165	1,173	640	365	208	142	5,266
1992	16	0	60	214	580	846	1,081	1,099	716	357	187	91	5,247
1993	19	8	35	168	525	789	1,032	1,149	761	269	202	177	5,134
1994	41	6	24	160	592	992	1,085	1,120	763	311	229	219	5,542
1995	41	6	73	203	545	883	1,133	1,060	786	344	213	158	5,445
1996	33	16	37	126	529	989	1,108	1,275	857	399	193	157	5,719
1997	27	10	64	175	432	937	1,063	1,160	863	412	308	263	5,714
1998	41	4	50	263	650	862	1,135	1,113	869	375	216	216	5,794
1999	22	0	59	209	535	800	998	1,028	784	390	296	160	5,281
													53,856
2000	0	0	27	283	626	914	1,140	1,139	852	401	233	194	5,809
2001	35	2	55	226	523	899	1,043	1,233	795	343	221	241	5,616
2002	32	1	30	240	540	829	1,133	1,109	834	423	250	196	5,617
2003	44	10	42	65	546	887	1,142	1,181	815	426	167	190	5,515
2004	61	0	79	212	403	823	1,160	1,164	832	433	225	162	5,554
2005	76	0	62	188	473	783	1,237	1,213	877	429	210	186	5,734
													3,3845
1930-2005	JAN	FEB	MAR	APR	MAY	JUN	JUL	AUG	SEP	OCT	NOV	DEC	TOTAL
Total	1,296	314	1,610	17,600	44,894	60,767	74,253	74,922	54,706	39,375	29,358	10,413	**78,5171**
Average	17	4	21	232	591	800	977	986	720	518	386	137	**5,397**

H. Harbor Horn Signals

In case of power or radio failure, there is still a time-tested way for vessels to communicate with each other and the bridge: horn signals.

ONE PROLONGED BLAST AT LEAST EVERY TWO MINUTES:
"Vessel moving in reduced visibility—*Pay attention!*"

TWO PROLONGED BLASTS AT LEAST EVERY TWO MINUTES:
"Vessel stopped, but not anchored, in reduced visibility—*Pay attention!*"

THREE PROLONGED BLASTS AT LEAST EVERY TWO MINUTES:
"Vessel anchored in reduced visibility—*Pay attention!*"

ONE LONG BLAST FOLLOWED BY TWO SHORT BLASTS:
Captain's Salute: "Ahoy there!" (This is the most often heard signal in the Duluth-Superior Harbor.*)

THREE LONG BLASTS FOLLOWED BY TWO SHORT BLASTS:
Ship's Salute: "Ahoy there!" (A more formal salute than the Captain's salute, rarely used.)

FIVE (OR MORE) SHORT BLASTS:
"Danger!"

ONE LONG BLAST, ONE SHORT BLAST, ANOTHER LONG BLAST, ANOTHER SHORT BLAST:
Used by vessels calling to the Duluth Aerial Lift Bridge: "Please raise the bridge!"*
(The bridge acknowledges the call using the same signal; the signal is not required if radio communication has been successful.)

Nearly everywhere else in the U.S., three long blasts are used to signal a request for a moveable bridge to open for a vessel. But the Duluth-Superior Harbor once had several moving bridges, and the signal could often be heard by operators on all of them, causing unnecessary stoppage of non-marine traffic. Also, since three prolonged blasts also indicate a vessel anchored in reduced visibility and the Duluth-Superior Harbor is often enveloped in fog, this added greater confusion. Now that there is only one other moveable bridge in the harbor (the railroad drawbridge at Grassy Point), vessels approaching the canal often use the Captain's Salute, which is returned by the bridge, just as a courtesy "hello" or "goodbye" to those within earshot.

I. IMAGE CREDITS

J. REFERENCES

BOOKS, PERIODICALS, INTERVIEWS, VIDEOS, & WEB SITES

Beamer, Ryan (supervisor, Duluth Aerial Lift Bridge). In-person interview with the author. Duluth, Minnesota. December 5, 2007.

Beck, Bell and Labadie, C. Patrick. *Pride of the Inland Seas: An Illustrated History of the Port of Duluth-Superior.* Afton, Minn: Afton Historical Society Press, 2004.

"Bessemer & Lake Erie Railroad Co." (brief history), Great Lakes Transportation, http://www.gltx.com/ (accessed April 3, 2003).

Beyond the Bridge. VHS. WDSE-TV. Duluth, Minnesota: WDSE-TV, 1991.

Bishop, Hugh E. "Life Span: The Aerial Bridge Crosses Its First Century." *Lake Superior Magazine.* Duluth, Minn.: June-July 2005, pp. 17–26.

——. "The Lights of the West." *Lake Superior Magazine.* Duluth, Minn.: Aug.-Sep. 2004, pp. 18-23.

Boller, Alfred P. "Report of Alfred P. Boller, Consulting Engineer, on Bridging the Canal." *Report of Board of Public Works, 1887–1891.* Duluth, Minn.: 1891, pp. 97–103.

——. "Report of Alfred P. Boller, Consulting Engineer, on Tunnelling [sic] the Ship Canal." *Report of Board of Public Works, for the Year Ending Feb. 28, 1891.* Duluth, Minn.: 1891, pp. 54–62.

——. "Report of Alfred P. Boller, Consulting Engineer, on Ship Canal Bridge." *Report of Board of Public Works, for the Year Ending Feb. 28, 1892.* Duluth, Minn.: 1892, pp. 6–9.

"Building the Great Government Ship Canal at Duluth." *Minneapolis Journal.* July 7, 1900.

Bullard, P. C. "Duluth Ship Canal." U.S. Engineers Office, Duluth, Minn.: 1932.

"C.A.P. Turner Collection." Northwest Architectural Archives, http://special.liv.umn.edu/manuscripts/architect.html/ (accessed April 11, 2007).

City of Duluth Communications Office, "Mayor Proclaims 'Year of the Lift Bridge.'" News release, Feb. 23, 2005.

"Competitive Designs for a Drawbridge Over the Duluth Ship Canal, Duluth, Minn." *Engineering News.* Oct. 27, 1892, pp. 390–391.

Cooley, Jerome Eugene. *Recollections of Early Days in Duluth.* Duluth, Minn.: Published by the Author, 1925.

"Coping With Erosion and High Water on Minnesota Point in Duluth," Minnesota Sea Grant, http://www.seagrant.umn.edu/coastal_communities/erosion_mnpoint (accessed Dec. 13, 2007).

Dierckins, tony. *Zenith: A Postcard Perspective of Historic Duluth.* Duluth, Minn.: X-communication, 2006.

Douville, Steve (retired supervisor, Duluth Aerial Lift Bridge). In-person interview with the author. Duluth, Minnesota. December 6, 2007 and February 7, 2008.

"Duluth's Aerial Bridges Fact Sheet." U.S. Army Corps of Engineers. Duluth, Minn.: undated.

"Duluth Aerial Bridge Ferry." *Popular Mechanics.* Jan. 1905.

"Duluth Aerial Lift Bridge," Emporis Buildings, http://www.emporis.com/en/wm/bu/?id=duluthaerialliftbridge-duluth-mn-usa (accessed Jul. 26, 2007).

"Duluth's Aerial Lift Bridges," U.S. Army Corps of Engineers, http://www.duluthshippingnews.com/aerialliftbridge.htm (accessed June 19, 2002).

"Duluth's Most Famous Landmark." *The Duluthian* Duluth, Minn.: Jul. 1973, pp. 10-13.

"Electric Steel Elevator," Emporis Buildings, http://www.emporis.com/en/wm/bu/?id=electricsteelelevator-minneapolis-mn-usa (accessed Jul. 26, 2007).

Elkins, S.B. "Response to Senate Resolution of April 12, 1892, Relative to the Proceedings of the Board of Officers Convened to Consider the Construction of a Bridge in Duluth." Reprinted in the *Annual Report of Board of Public Works.* Duluth, Minn.: 1891, pp. 97–103. April 18, 1892.

——. "Response to Senate Resolution of April 12, 1892, Relative to the Proceedings of the Board of Officers Convened to Consider the Construction of a Bridge in Duluth." Reprinted in the *Annual Report of Board of Public Works.* Duluth, Minn.: 1892, pp 82-97. Feb. 29, 1892.

——. "Duluth Harbor, Minnesota." House of Representatives, 52nd Congress, 2nd Session, Ex. Doc. No. 122. Washington, D.C.: December 9, 1892.

Ensign, J. D. *History of Duluth Harbor.* Duluth News Tribune. Duluth, Minn.: 1898.

"Famous Aerial Bridge Passes." *The Duluthian.* Duluth, Minn.: Oct. 1929, pp. 7-9.

Frederick, Chuck. *Spanning A Century: Aerial Lift Bridge Commemorative Edition 1905 – 2005*. Duluth News Tribune. Duluth, Minn.: 2005.

Gihring, Tim. "Getting Bridged." *Minnesota Monthly* March 2004, p. unk.

"Great Lakes Fleet, Inc." (brief history), Great Lakes Transportation, http://www.gltx. com/ (accessed April 3, 2003).

Historical Collections of the Great Lakes. Great Lakes Vessels Online Index. University Libraries, Bowling Green State University, ul.bgsu.edu (accessed Feb. 18, 21, and 22, 2005, June 12, 2007).

"The History of American Steamship Company." American Steamship Company, http://www.americansteamship. com/index.html#welcome (accessed April 3, 2003).

"The History of Duluth, Missabe & Iron Range Railway Co.," Great Lakes Transportation, http://www.gltx.dmir/history.htm (accessed April 3, 2003).

"The History of United States Steel Corporation," United States Steel Corporation, http:// www.uss.com/corp/about.htm (accessed April 3, 2003).

Holden, Thomas R. (Curator, Duluth Superior Marine Museum). In-person interview with the author. Duluth, Minnesota. February 7, 2007.

— —. "Duluth Aerial Lift Bridge." Duluth Shipping News, http//:www. duluthshippingnews.com/aerialliftbridge.ht. (accessed June 19, 2002).

Honebrink, Chelsea. "Thom Holden: Captain of the Maritime Museum." *Budgeteer News* Feb. 3 2008, pp. 3-4.

Homstad, Gary. "The Aerial Lift Bridge: Duluth's Most Famous Landmark Continues to Improve." *Lake Superior/Port Cities Magazine*. Duluth, Minn.: July–August 1986, pp. 66–70.

Hyde, Charles K. *The Northern Lights*. Detroit: Wayne State University Press, 1995.

"International Market Square," Emporis Buildings, http://www.emporis.com/en/wm/bu/ ?id=internationalmarketsquare-minneapolis-mn-usa (accessed Jul. 26, 2007).

Johnson, Ron D. "Swallowed By Superior." *Minnesota Motorist*. August 1976, pp. 5-7.

"Journey to Nowhere: Duluth's Aerial Bridge Lives in an Up-and-Down World." *The Duluthian*. Duluth, Minn.: March–April 1968, pp. 10–12.

Knowlton, Ralph. "Duluth-Superior Harbor, 1856-1956." Duluth: Corps of Engineers, U S Army, 1956.

Labadie, C. Patrick. "Duluth's Ship Canal." *The Duluthian*. Duluth, Minn.: Sept. – Oct. 1985, pp. 38–41.

Lydecker, Ryck and Lawrence J. Sommer, eds. *Duluth: Sketches of the Past, a Bicentennial Collection*. Duluth, Minn.: American Revolution Bicentennial Commission, 1976.

Lyons, Larry (son of Duluth Aerial Lift Bridge supervisor Richard Lyons). In-person interview with the author. January 9, 2007.

Lundstrom, Gary. *The Aerial Bridge History Album*. Duluth, Minn.: Great Lake Design, 2005.

"A Million-Dollar Blaze." *The New York Times*. New York Times archives. query.nytimes.com (accessed Dec. 27, 2007).

MacDonald, Dora Mary. *This is Duluth*. Duluth, Minn.: published by the author, 1950.

Marquis, Albert Nelson, ed. *The Book of Minnesotans*. Chicago: A.N. Marquis & Co., 1907.

McGilvray, Thomas. *Duluth Aerial Ferry Bridge*. Duluth, Minn.: City of Duluth, 1905.

"Minnesota's Lake Superior Shipwrecks: History of Minnesota's Lake Superior; History and Development of Great Lakes Water Craft." Minnesota Historical Society http://www. mnhs.org/places/nationalregister/shipwrecks/mpdf/mpdf2.ht (accessed Aug. 7 and 12, 2007.)

"Minnesota Point Timeline." *The Breeze: Newsletter of the Park Point Community Club*. November, 1990, pp. 1–3.

"New Lights Highlight Bridge." *American City and County*. Jan. 1990, p. 44.

Norman, Hollis. "Lift Bridge Turns 100" *Ripsaw*. Jan. 2005.

Patton, W. B. "The Aerial Ferry Bridge at Duluth, Minnesota." *Engineering News* Vol. 47, No. 12. Duluth, Minn.: 1902.

Perkins, Frank. "An Electrical Aerial Ferry." *Scientific American*. 10 June 1905, pp. 461-462.

Pepper, Terry. "North Pier Lighthouse; Duluth North Pierhead Lighthouses; Duluth Rear Range Light; Duluth Sound Breakwater Light; Duluth Wisconsinc Point Lighthouse; Minnesota Point Lighthouse;." Seeing the Light, http://www.terrypepper.com/lights/superior/ duluth-n-pier/duluth-n-pier.htm (accessed December 10, 12, and 17, 2007).

Petroski, Henry. *Engineers of Dreams*. New York: Vintage Books, 1995.

"Pittsburgh & Conneaut Dock Company" (brief history), Great Lakes Transportation, http://www.gltx.com/ (accessed April 3, 2003).

"Project Fact Sheet, 1999-2000 Aerial Lift Bridge Rehabilitation." *The Breeze: Newsletter of the Park Point Community Club*. October 1999, p. unk.

"Renovation of Duluth's Aerial Lift Bridge Requires Extensive Structural, Mechanical & Electrical Work," *Construction Bulletin* April 4, 1986, pp. 3-10.

R.L. Polk's & Co.'s Duluth City Directory 1922-23; 1924; 1925; 1926; 1927; 1928; 1929; 1930, Duluth, Minn.: Duluth Directory Co.

Roberts, Bruce and Ray Jones. *Western Great Lakes Lighthouses*. Guilford, Conn.: U.S.A. Globe Pequot Press, 2001.

Sanborn Fire Insurance Maps: City of Duluth. Pelham, New York: Sanborn Map Company, 1883-1941.

Sandvick, Jerry. "Celebrate the Bridge, Stage 1: Aerial Transfer Ferry Bridge." *Nor'Easter: Journal of the Lake Superior Marine Museum Association*. Vol. 30, No 1. Duluth, Minn.: 2005.

— —. "Celebrate the Bridge, Stage 2: Transfer Bridge Gets a Lift." *Nor'Easter: Journal of the Lake Superior Marine Museum Association*. Vol. 30, No 2. Duluth, Minn.: 2005.

"Ferdinand Arnodin." Structurae, www.structurae.de/persons/data/index. cfm?id=d000094 (accessed Jan. 15, 2005).

"Schwebefähre Rouen." Structurae, www.structurae.de/structures/data/index. cfm?ID=s0002350 (accessed Jan. 15 2005).

Scott, James Allen. *Duluth's Legacy. Vol. I Architecture.* City of Duluth, Duluth, Minn.: 1974.

Soetebier, Mrs. John, ed. *Park Point.* Self published by the author. Duluth, Minn.: 1983.

"Sound signals in Restricted Visibility." Department of Homeland Security U.S Coast Guard, http://www.navcen.uscg.gov/mwv/navrules/rules/Rule35.htm. (accessed April 1, 2008.)

Steel Corporation," Great Lakes Transportation, http://www.gltx.com/ (accessed April 3, 2003).

Struck, Dick. "Duluth's New Marine Museum." *The Duluthian.* Duluth, Minn.: August 1973, pp. 6-7.

United States Patent Office. "Ferdinand Joseph Arnodin, of Chateauneuf-on-the-Loire, France, and Martin Alberto De Palacio, of Bilbao, Spain: Means for Transporting Loads," patent No. 425,724, Apr. 15, 1890.

United States v. The City of Duluth, W. W. Williams, E. F. Williams, Richard G. Coburn, and H. W. Wheeler, Injunction, Circuit Court for the District of Minnesota, 9 June 1871, preserved by St. Louis County Historical Society.

Van Brunt, Walter. Duluth and St, Louis County, Minnesota: Their Story and People, Volumes 1–3. The American Historical Society. New York: 1921.

"Visitor Center is Simply a Boatwatcher's Paradise." *North Star Port* Duluth, Minn.: Fall 2003, pp. 4-5.

Walker, David A. and Hall, Stephen. *Duluth-Superior Harbor Cultural Resources Survey.* St Paul, Minn.: Dept of Army, St Paul District, Corp of Engineers, 1976.

Wilson, John. "Duluth's Aerial Lift Bridge." *The Military Engineer.* Vol. 38, No. 4. Society of American Engineers. Washington, D.C.: 1932.

Woodbridge, Dwight E. and John S. Pardee, eds. *History of Duluth and St. Louis County, Vols. 1 and 2.* C.F. Cooper & Company. Chicago, Ill.: 1910.

Young, Frank. "Duluth's Most Famous Landmark." *The Duluthian.* Duluth, Minn.: July, 1973, pp. 10–13

Vigliaturo, Robert J. Jr., and Jarry M. Keppers. *Fire and Ice: A History of the Duluth Fire Department.* Duluth: Duluth Fire Dept. Book Committee, 1993.

"Viscay Bridge." World Heritage Center Web Site. http://whc.unesco.org/en/list/1217 (accessed Jan.12, 2007).

"Zerstört im Juni 1940." Niederelbe, www.niederelbe.de/FAEHRE/f-rouen.htm (accessed Jan. 15, 2005).

NEWSPAPER ARTICLES

Duluth Budgeteer: "Bridge Dancing coming to the Aerial Lift Bridge," 8.18.1996, p. unk.; "Bridge Operator Job Has its Ups and Downs," 6.6.2004, p. unk.; "A Room at the Top: Bridge Supervisor Talks About His Job's Ups and Downs," 11.6.2006, p. unk..

Duluth Evening Herald: "The Aerial Bridge," 3.6.1905, p. 11; "Aerial Bridge Designer Dies at 97," 11.25.1957, p. unk.; "Aerial Bridge Out of Business," 9.5.1913, p. 14; "Aerial Lift Bridge to Get Lights," 6.7.1966, p. unk.; "Aerial Lift Span Job Supported," 11.8.1954, p. unk.; "Begin Work on Aerial Bridge," 9.6.1913, p. unk.; "Big Ship Draws Crowd," 5.22.1967, p. unk.; "Boredom the Watchword," 12.13.1960, p. unk.; "Bridge Has Not Missed a Trip for Entire Year," 2.2.1907, p. unk.; "Bridge in Operation," 3.28.1905, p. 7; "Bridge is Ready," 3.24.1905, p. unk.; "Bridge Operator Makes 'Fascination' a Life's Work," 4.12.1974, p. unk.; "A Bridge Night," 3.28.1905, p. 7; "Closed to Teams," 4.5.1905, p. 7; "City's Famed Bridge 'Doomed,'" 8.13.1956, p. unk.; "City Lacks Top Labor Council Told," 7.18.1955, p. unk.;

"City Officials Inspect Aerial-Lift Span," 4.29.1930, p. unk.; "Copy, Not Ghost of Former Duluth Bridge," 4.25.1930, p. 10; "Council Breaks Up in Babble," 2.19.1929, p. 3; "Crew of Aerial-Lift Span Narrowly Avoids Collision," 5.15.1930, p. unk.; "Enormous Crowd Carried By Bridge," 4.10.1905, p. 8; "Ferry Car of Aerial Bridge Makes Final Trip With Notable Passengers," 7.1.1929, p. 8; "First Boats From Lower Lakes This Year Reach Duluth," 4.21.1905, p. 10; "First Vessel Passes Under New Bridge," 3.29.1930, p. 1; "Fishing Season Opens on Lake," 4.9.1930, p. 2; "Girl, 16, Hurt in Leap Off Rising Aerial bridge," 1.19.51, p. unk."He Threatens a Fuss." 9.28.1889, p. 1; "History of Old Lighthouse on Park Point is Recalled," 11.16.1930, p. unk.; "Lift Bridge Gets New Prestige," 6.14.1973, p. 17; "Lifting Canal Span is Complete Success," 10.19.1929, p. 1; "Lift Span at Top for First Time," 3.26.1930, p. 12; "Lighting Drive Turns Up Spoon," 11.3.1966, p. unk.; "Lower False Work," 3.4.1905, p. 8; "Navigation Again Interrupted By Ice," 4.21.1905, p. unk.; "Nerve Wracking Feat by Bridgeman," 4.8.1905, p. 2; "New Regulations For Aerial-Lift Bridge Announced," 4.25.1930, p. 7; "Notable Engineering Feat Watched by Huge Crowd. . ." 10.19.1929, p. unk.; "Noted Aerial Bridge Passes Into History," 7.1.1929, p. 1; "Old Dock Not Fit to Be Used," 4.22.1913, p. 7; "Old Lighthouse is Base Line for Marine Survey," 12.16.1924, p. 9; "Oppose Train Traffic Upon Canal Bridge," 9.15.1928, p. 1; "Painting Bridge," 3.20.1905, p. 4; "Park Pointers Voice Complaints on Car, Lift Bridge Service," 5.28.1930, p. unk.; "Park Point Club Asks Boat Curb," 5.19.1972, p. unk.; "Pictures Show Evolution of Canal Bridge Since Ditch Was Dug," 4.10.1930, p. 1; "Plaque Dedicated," 4.25.1975, p. unk.; "Point Lighthouse an Historic Place," 1.20.1975, p. unk.; "Projected Tunnel: Sooy [sic] Smith's Ideas as to Work." 1.14.1891, p. 5; "Proposed Electric Signs for Aerial-Lift Span," 3.22.1930, p. unk.; "Postpone Start," 3.27.1905, p. 11; "Proposed Aerial Ferry Bridge," 10.5.1901, p. 1; "Rain Will

Stop," 4.3.1905, p. 7; "Rules for Ferry," 3.29.1905, p. 13; "Running the Aerial Bridge More than Lever-Pulling," 5.6.1970, p. unk.; "Seeing the City from Top of Remodeled Aerial Bridge," 3.19.1930, p. 1; "Scratch $30 Every Time Aerial Bridge Goes Up," 4.29.1975, p. unk.; "Steamer E.N. Saunders," 4.21.1905, p. 10; "Sunday Crowds on New Bridge Will Be Counted," 4.08.1905, p. 2; "Ten Cross Canal," 2.23.1905, p. unk.; "To Cross Canal," 2.23.1905, p. unk.; "To Follow Duluth," 4.13.1905, p. 8; "To Paint Bridge," 4.20.1905, p. 3; "Traffic Begun Over Ship Canal Without Waits," 3.12.1930, p. 1; "Transfers to Point," 11.26.1907, p. unk.; "Twenty-two Thousand Battery Gives Bridge Another 50,000 Lifts," 4.7.1951, p. unk.; "Varied Matters Before Council," 1.28.1929, p. 9; "Want to Carry 50,000 Passengers," 4.8.1905, p. 2; "Waves Hit the Bridge," 11.24.1908, p. 1+; "Will Urge Lift Span for Canal," 2.18.1929, p. 5.

Duluth Morning Call: "Opening of Canal Across Minnesota Point" 4.30.1871, p. unk.

Duluth News Tribune & Herald: "Aerial Bridge Work to Begin Next Week," 3.20.1986, p. unk.; "Bridge to Become Engineering Landmark," 9.22.1986, p. unk.; "Bridge Will Lift Three Nights Next Week for Canal Work," 11.19.1986, p. unk.; "Cost of Aerial Bridge Facelift Forces City to Revamp Plans," 12.19.1986, p. unk.; "Duluth Waterway, Lift Span Have Earned an Overhaul," [6.12.85], p. unk.; "From Wire-Rope to Basket to Today," 10.5.1966, p. unk.; "Ship Canal Work Will Close Aerial Bridge for Two Nights," 9.25.1986, p. unk.; "Work That Kept Aerial Bridge Up Is Done For Year," 6.11.1986, p. unk.

Duluth News-Tribune: "A Century of History," 10.31.1971, p. 20; "Aerial Car Soon to Resume Trips," 4.1.1905, p. 12; "Aerial Bridge Acts Up," 3.19.1927, p. 3; "Aerial Bridge a 'Go' At Last," 10.8.1901, p. unk.; "Aerial Bridge at Canal Now Closed for Repairs," 7.8.1905, p. unk.; "Aerial Bridge Contract Bids Being Rechecked," 4.15.1970, p. unk.; "Aerial Bridge Designer Broke, Goes to Work as WPA Foreman," 12.11.1938, p. unk.; "Aerial Bridge Faces Year Without Another Face-lift," 4.28.1970, p. unk.; "Aerial Bridge Funds Counted," 8.27.1966, p. unk.; "Aerial Bridge Gets New Gears," 2.24.1948, p. unk.; "Aerial Bridge Light Fund at $2,500 Mark," 9.3.1966, p. unk.; "Aerial Bridge, Ship Canal Go'Native' in Freak Picture, 7.13.1929, p. 1; "Aerial Bridge to be Illuminated Saturday," 7.3.1987, p. unk.; "Aerial Bridge to Get New Batteries," 1.28.1971, p. unk.; "Aerial Bridge to Make Final Trip on July 1," 5.14.1929, p. 1; "Aerial Bridge to Take Last Trip Monday," 6.28.1929, p. 1; "Aerial Bridge Will Lift to Sound of Old Horn," 5.13.2000, p. unk.; "Aerial Car Crosses in Teeth of Howling Gale," 3.28.1905, p. 5; "Aerial Ferry Moves. . .," 2.24.1905, p. 1 and 10; "Aerial Lift Membership Card," 9.18.1966, p. unk.; "Aerial-lift Project Spans Generations," 12.11.1999, p. unk.; "Aerial Lift Rides Urged," 8.16.1944, p. unk.; "Aerial Span to Get New Safety Aids," 6.22.1935, p. 1; "Action Appeals Levy on Bridge," 7.19.1928, p. unk.; "Again Talk of Ferry Bridge," 5.20.1903, p. unk., *NewsBank* Access date unk., *genealogybank.com*; "Alfred Hass," Obituary, 11.30.1993, p. 3D; "An Aerial Water Route Plan for Minnesota Point," 12.17.1918, p. 3; "Articles of Incorporation of Calumet Iron Mining Company," 3.17.1905, p. unk., *NewsBank* Access date unk., *genealogybank.com*; "Ask For Bids to Run Ferry," 3.28.1905, p. 5; "Eh? A Ship Canal but No 747s," 5.1.1996, p. unk.; "Bid is Opened for Ferry Bridge Across the Canal," 8.4.1908, p. 5; "Bids Opened in February," 12.1.1928, p. unk.; "Big Boats Start Season on Lakes," 4.9.1905, p. 13; "Bill Calling For New Span Passes Senate, 1.26.1928, p. unk.; "Boeing and Canal," 10.18.1889, p. unk.; "Bridge Passengers Have Close Call," 11.9.1921, p. unk.; "Bridge Service Stops," 4.29.1914, p. 1; "Bridge Cable Snaps, Park Point Isolated," 3.23.1922, p. 1; "Bridge Carriage Torn Down," 8.10.1929, p. 1; "Bridge Debate Stirs Council," 1.15.1929, p. unk.; "Bridge Expert to Submit Plan," 11.14.1928, p. unk.; "Bridge Firm Revises Plans," 1.27.1928, p. unk.; "Bridge Needs Rescue," 12.27.1995, p. unk.; "Bridge Plans Fail to Meet U.S. Approval," 2.17.1929, p. 1-2; "Bridge Plans Fireproof Says K.C. Engineer," 2.18.1929, p. 1; "Bridge Tender Calls Wind His Top Worry," 6.12.1939, p. unk.; "Bridge Up for Repair," 3.2.1997, p. 1A+; "Bridge Will Be Built This Fall," 9.10.1901, p. unk., *NewsBank* Access date unk., *genealogybank.com*; "Bridge Will Not Be Built Now," 11.23.1902, p. unk., *NewsBank* Access date unk., *genealogybank.com*; "Bumboat Completes 18-Day Stormy Voyage on Lakes," 9.8.1949, p. unk.; "Buzzing the Bridge," 7.1.2006, 1-2F; "Cable Slips and Aerial Car Stops," 5.29.1905, p. 3; "The Canal Bridge (editorial)," 2.28.1929, p. 8; "Canal; Bridge; Duluth," 11.22.1902, p. unk., *NewsBank* Access date unk., *genealogybank.com*; "Canal Park area was once Duluth's Seediest," 7.14.88, p 1E. "Canal Park Dedication Set Today." 10.31.1971, p. 20; "Can City Cash in on Aerial Bridge Action," 4.11.1992, p. unk.; "Candidates Who Solicit Your Vote Tuesday, Nov. 5, 1918," 11.2.1918, p. unk., *NewsBank* Access date unk., *genealogybank.com*; "Capt. Gaillard To Return," 5.22.1903, p. unk., *NewsBank* Access date unk., *genealogybank.com*; "Carss Presents New Canal Span Bill to Congress," 12.6.1927, p. unk.; "Charles P. Landre," Obituary, 8.16.1970, p. 3; "Chicagoan Defies Death Today in Leap From Aerial Bridge," 7.11.1926, p. 1-2; "Chicagoan Stunt Man Here for Exhibition," 7.7.1926, p. 1-2; "Children Push Missing Boy, 7, to Lake Death," 7.23.1934, p. 1; "City Accepts Aerial Bridge," 5.5.1905, p. 10; "City Council Will Study Ship Canal Traffic Problem," 3.26.1929, p. 1; "City Engineer Files His Bond," 3.26.1904, p. unk., *NewsBank* Access date unk., *genealogybank.com*; "City Engineers Prepare Data on New Lift Bridge," 2.17.1928, 13:4; "City Fathers Turn Down Canal Bridge Co.'s Claim," 7.11.1905, p. unk.; "The City Government is Ably Carried On," 9.9.1911, p. unk., *NewsBank* Access date unk., *genealogybank.com*; "City in Tabloid," 5.18.1922, p. unk., *NewsBank* Access date unk., *genealogybank.com*; "City May Lose Money if Bridge Carries Passengers. . ." 1.30.1985, p. unk.; "City Officials Inspect New Aerial Lift Span," 4.3.1930, p. 1; "City Orders Caution in Lifting Span," 6.18.1935, p. 1; "City to Mark Bridge Passing With Program," 6.18.1929, p. 1; "City to Redeck Aerial Bridge," 12.11.1953, p. unk.; "City Witholds Accepting Span," 5.13.1930, p. unk.; "Claims Aerial Bridge Will Soon Be Scrapped," 8.2.1917, p. unk.; "Claims Governor Made Big Hit," 4.16.1908, p. unk., *NewsBank* Access date unk., *genealogybank.com*; p. unk., *NewsBank* Access date unk., *genealogybank.com*; "Close Council Ballot Marks Bridge Award," 2.26.1929, p. 1; "Closer Co-operation [sic] of Council," 11.27.1929, p. 1; "Cling to

Girders of Canal Bridge," 4.29.1905, p. 2; "Coast Guard Asks City to Stop Using Old Foghorn," 9.8.2005, p. 1 and 5D; "Coast Guard Drags Lake for Missing Duluth Boy," 7.20.1934, p. 1; "Coast Guardsman Dies in Attempting Rescue," 5.1.1967, p. 1; "Coast Guard to Toot its Own Horn," 5.2.2003, p. 1-2B; "Colton Leads Tracy in Vote for Judgeship," 4.3.1929, p. 1; "Council Approves Lift Bridge Rides," 8.24.1965, p. unk.; "Contributors To Be Named On Scroll," 9.4.1966, p. unk.; "Council Engages Tug as Bridge Nears Shutdown," 4.2.1929, p. 1; "Council Grants Park Pointers. . ." 5.2.1922, p. unk.; "Council Wants Foghorn Hours Trimmed," 8.27.2002, p. unk.; "Court Joust This Week Seen as Final. . ." 10.7.1928, p. unk.; "Court Upholds Assessments For New Span," 3.17.1930, p. unk.; "Craig Makes Steve Brody. . ." 7.12.1926, p. unk.; "Crowd Sees Lift Bridge Span Lowered Into Place," 1.6.1930, p. 1; "Culebra Engineer Dying," 10.11.1913, p. unk., *NewsBank* Access date unk., *genealogybank.com*; "Cullum Silent as to Troyer," 2.3.1910, p. unk., *NewsBank* Access date unk., *genealogybank.com*; "Currents in Canal May Be Cause of Ship Mishaps," 10.7.1988, p. unk.; "Danger at the New Bridge," 3.3.1930, p. unk.; "Delays Cause Park Point Predicament," date n/a, p. unk.; "Department Slandered Charges City Engineer," 9.22.1908, p. unk., *NewsBank* Access date unk., *genealogybank.com*; "Designer of Aerial Bridge Plans for. . ." 11.2.1925, p. unk.; "Dick Lyons," Obituary, 5.16.1980, p. 1D; "Dog Loves to Live on the Edge," 3.12.1993, p. unk.; Donald Freeman Bowen Obituary, 2.5.2006, p. 7c; "Do Not Frown on Bridge Tracks," 9.21.1928, p. unk.; "Doty Vetoes Hours for Foghorn," 8.17.2002, p. 1 and 6A; "Down Goes Mr. Mac," 6.5.1897, p. unk., *NewsBank* Access date unk., *genealogybank.com*; "Drowned Man Identified," 4.29.1914, p. 3; "Duluth Bridge Plan Will Go to Davis Next," 3.15.1921, p. unk.; "Duluth Council Clears Way for Foghorn's Return," 5.28.2003, p. 1-2C; "Duluth's No. 1 Bridge to Get a Lift," 9.20.1999, p. unk.; "Duluth Reaches Port After Battling With Ice," 4.21.1905, p. 2; "Duluth Pioneer Killed on Bridge," 12.19.1918, p. 3; "Duluth's Motor Census," 11.3.1925, p. unk.; "Duluth Woman Who Took First Ride. . ." 6.29.1929, p. 1; "Engineers Formerly of Duluth are Appointed to Study Wave Actions," date n/a, p. unk.; "Engineer McGilvray in Office," 6.26.1897, p. unk., *NewsBank* Access date unk., *genealogybank. com*; "Engineers Start Second Unit of Canal Span," 11.14.1929, p. 1; "Exclusive Sketch Shows How New Duluth-Superior Span Will Appear," 1.29.1925, p. 4; "Ex-Gob Keeps Sea Contact by Supervising Lift Bridge," date Unk., 1930, p. unk.."Faults of the Aerial-Lift Span Said Exaggerated," 11.5.1930, p. unk.; "Ferry May Be Running Today," 4.2.1905, p. 16; "Figures on Big Contract," 9.9.1905, Mayor's Annual Address [re Engineering Report on Bridge], 12 March 1901; [re little progress], 10 March 2003."Files Trust Deed for $100,000," 4.16.1902, p. unk., *NewsBank* Access date unk., *genealogybank.com*; "Fire Truck Wins Clash With Lift Bridge Gate," 7.12.2004, p. unk.; "First Aerial Bridge Trestle Unit Completed," 11.7.1929, p. 1; "Fit to Be Tied, He Ties Up Canal," 12.13.1953, p. 21; "Ferry Bridge to Be Opened Today," 7.30.1905, p. unk.; "Five Thousand Duluthians Watch as Aerial Bridge Engineers Hoist Huge 450-Ton Span 42 Feet to New Supports," 10.20.1929, p. unk; "Flat-topped Tunnel: Is What Sooy [sic] Smiths are Planning for Duluth," 1.5.1891, p. 5; "Foghorn Gets a Reprieve," 5.17.2003, p. unk.; "Foghorn Here

'For Keeps,'" 7.11.1948, p. unk.; "Foghorn Ready to Blow," 4.30.2005, p. 1-2B; "Foghorn to Keep Tooting," 8.13.2002, p. 1A+; "Fortieth Anniversary of Drownings Is Sobering Reminder of Lake's Fierce Power," 4.28.2007, p. B1-2; "Floodlights Urged by 'Lady of Light,'" 8.26.1966, p. unk.; "Freighter is First Big Carrier to Enter Duluth Port in 1930," 4.24.1930, p. 3; "Gone But Not Paid for, is Aerial Bridge," 7.11.1929, p. 1; "Great Crowd Take First Ride. . ." 4.10.1905, p. 2; "Group Threatens to Silence Foghorn," 1.26.2005, p. 1-2D; "Grist From City Council Mill," 5.22.1922, p. unk.; "Harbison Heads Heart Fund Drive," 12.25.1958, p. unk.; "Harbison, Insurance Man, Appointed Duke of Duluth," 4.11.1959, p. unk.; "Harlem Bridge Not So Fast," 2.8.1953, p. unk.; "Harold L. Bilsey," Obituary, 12.13.2003, p. 7B; "Hero of Panama Dies After Long Illness," 12.6.1913, p. unk., *NewsBank* Access date unk., *genealogybank.com*; "Hey, Look Me Over, Folks!" 11.18.1966, p. unk.; "High Wind Places Bridge in Danger," 11.25.1908, p. 9; "Ho's Ho No. 3 in Duluth Sports," 2.3.1913, p. unk., *NewsBank* Access date unk., *genealogybank.com*; "Horseless Carriage Scared Horses," 7.7.1976, p. unk.; "Improvements for the Aerial Bridge," 8.23.1908, p. unk.; "Hundreds of Motorist Use Canal Span for First Time," 1.12.1930, p. unk.; "Itinerant Islands," 11.24.1895, p. unk.; "Is Killed at Aerial Bridge," 12.18.1918, p. 12; "Isolated Landmark Monument to Past," 7.21.1974, p. unk.; "James Murry," Obituary, 3.9.1942, p. 4; "John W. Hicken Veteran Bridge Operator, Dies," 11.12.1928, p. unk.; "Killed in Fall Off Aerial Span," 8.7.1934, p. unk.; "King Solomon at the Bridge," 8.5.1951, p. unk.; "Lake Breezes," 1.25.1907, p. unk., *NewsBank* Access date unk., *genealogybank.com*; "Lake Breezes," 3.18.1912, p. unk., *NewsBank* Access date unk., *genealogybank.com*; "Lake Lashed By Gale; One Dead; Loss Runs High," 4.29.1914, p. 1; "Lake Steamers Caught in Ice Off Whitefish Point," 4.11.1905, p. 7; "Lakes' Zero Point," 5.9.1954, p. unk.; "Larrabee to Try Air Stunt Today," 5.18.1919, p. 3; "Let's Light Our Bridge," 8.22.1966, p. unk.; "Lift Bridge Celebrationg Continue," 8.16.2005, p. unk.; "Lift Bridge Chief Dies," 9.17.1944, p. 1; "Lift Bridge Emergency Engine Set," 11.11.71, p. unk.; "Lift Bridge Repairs Advance," 2.26.1999, p. unk.; "Lift Bridge Radar to Locate Ships," 6.7.1960, p. unk.; "Lift Bridge Slowed Down by Bad Card in Computer," 10.5.1989, p. unk.; "Lift Bridge's Temporary Fix is a Tall Order," 11.28.1996, p. unk.; "Lighthouse Keeper," 5.11.1947, p. 5; "Lighting the Aerial Bridge Will Be a Beacon of Pride," 9.14.1966, p. unk.; "Lights May Turn Aerial Bridge to Gold at Night," 6.10.1987, p. 1A and 8A; "M'Gilvray Back From Southland," 1.17.1912, p. unk., *NewsBank* Access date unk., *genealogybank.com*; "Man Calls Bridge His Place of Birth," 8.15.2005, p. 1C; "Man Dies in Aerial Bridge Fall," 9.20.1982, p. 1A-2A; "Man Jumps Off Bridge," 4.24.1995, p. unk.; "Many Cross on Ferry at Canal," 4.19.1905, p. 2; "Many Make Use of Ferry Bridge," 4.12.1905, p. 3; "Marine News," 6.17.1935, p. 10; "May Change Aerial Ferry Bridge Plans," 6.7.1903, p. unk., *NewsBank* Access date unk., *genealogybank.com*; "May I Have Your Attention, Please," 9.11.2005, p. 1 and 6C; "The Men Who Built the Bridge," 2.26.1905, p. 7; "Missed the Boat: Remember the Hanging Car?" 7.4.1976, p. 5h-6h; "Missourian Buys Bridge Blueprints on eBay," 6.5.2005, p. unk.; "Near-Replica of Aerial Bridge in France, Says Hall," date n/a, p. unk.; "New Bridge Turned Down," 6.28.1901,

p. unk., *NewsBank* Access date unk., *genealogybank.com*; "New Canal Bridge Seen Favorable to Lake Carriers," 4.22.1927, p. 1; "New Contract Is Necessary," 9.29.1901, p. unk., *NewsBank* Access date unk., *genealogybank.com*; "New Plans for Bridge Arrive," 11.14.1928, p. unk.; "New Toots Clear Up Ship 'Fog,'" 3.9.1954, p. unk.; "Nine Defects Pointed Out in Aerial Bridge," 10.2.1930, p. unk.; "Not All Ups and Downs in Aerial Bridge Life," date n/a, pp. 17 and 22; "Now Up to Wolvin is Chairman of Committee Upon Ferry Bridge," 12.17.1900, p. unk, *NewsBank* Access date unk., *genealogybank.com*; "Object to Park Point Bridge," 6.15.1927, p. unk.; "Offers to Build Parks Along Big Ship Canal," 8.1.1905, p. 2; "Old Aerial Bridge Falters, Pointers Row Over Canal," 6.19.1929, p. 1; "One Hundred Twenty Thousand Miles Without Mishap," 8.14.1928, p. unk.; "One Killed; Loss is High in Lake Storm," 4.29.1914, p. 21; "One Remains to Sign Second Canal Bridge Contract," 3.11.1927, p. unk.; "One-Thousand Attend Memorial Rites for Halverson Boys," 5.4.1967, p. unk.; "Park Pointers Cases Are Set," 10.1.1928, p. unk.; "Park Pointers Claim Aerial Bridge 'Abused," 5.21.1972, p. unk.; "Patton Not Responsible," 8.15.1902, p. unk., *NewsBank* Access date unk., *genealogybank.com*; "Park Point Seeks Aid to Open Traffic with the Mainland," 2.23.1922, p. 5; "Passes Senate," 1.26.1928, p. unk.; "Phillips Doubts Future Safety of Aerial Bridge," 5.16.25, p. unk.; "Photographer Tells Bruin Story," 8.18.1944, p. unk.; "Plan Heated Cars for Ferry Bridge," date n/a, p. unk.; "Plans For Remodeling the Aerial Bridge Must. . ." 11.19.1928, p. unk.; "Protest Levy for New Bridge," 6.12.1928, p. unk.; "Port Board Wants the Foghorn to Blow," 8.22.2002, p. unk.; "Renovation Set to Begin on Duluth's Aerial Lift Bridge," 10.10.1999, p. 1A+; "Results of the City Election (editorial)," 4.7.1927, p. 12; "Robert O. Brown," Obituary, 6.20.1984, p. unk.; "Says Bridge Company Has Not Broken Faith," 11.20.1902, p. unk., *NewsBank* Access date unk., *genealogybank.com*; "Says Bridge is Too Costly," 5.28.1901, p. unk., *NewsBank* Access date unk., *genealogybank.com*; "Scheduled Lifts," 5.21.1972, p. unk.; "Search Continues for Three Brothers," 5.2.1967, p. unk.; "Ship Canal Ferry Now in Litigation," 4.25.1905, p. 5; "Ships Diverted; Lift Bridge part Cracked," 11.23.1996, p. unk.; "Should Another Canal Be Dug?" 4.5.1905, p. unk., *NewsBank* Access date unk., *genealogybank.com*; "Six Test Trips Made at Ferry," 3.25.1905, p. unk.; "Sounds of Controversy," 5.6.2000, p. 1A +; "Span Control Changes Urged," 5.12.1930, p. unk.; "Speedy Action on Proposal is Predicted," 12.16.1927, p. unk.; "Statue of Limitations," date n/a, p. 1-2c; "Still Another Proposal for Transcanal Transportation. . ." 2.7.1927, p. 8; "Superior Escape High Water," 4.13.1929, p. 1; "Superior Foiled," 7.29.1956, p. unk; "Tale of Daredevil Pilots Live On," 6.10.2006, p. 1-2D; Title unk., 10.31.1971, sect.2; "Talk Bridge Tomorrow," 5.22.1903, p. unk., *NewsBank* Access date unk., *genealogybank.com*; "Tall Order," 10.10.1999, p. unk.; "Tells Story of Bridge and City," 6.28.1905, p. unk., *NewsBank* Access date unk., *genealogybank.com*; "T.F. M'Gilvray is Colonel Now," 5.26.1905, p. unk., *NewsBank* Access date unk., *genealogybank.com*; "Thomas M'Gilvray Apppointed Drainage Ditch Engineer," 7.10.1918, p. unk., *NewsBank* Access date unk., *genealogybank.com*; "Tin Horn Once Guided Mariners Through Fog Here. . ." 11.18.1928, p. unk; Today's Civic Duty," 4.5.1927, p. 10; "Traffic Begun Over Ship Canal Without Waits," 3.12.1930, p. unk.; "Traffic Stops on Aerial Ferry," 3.30.1905, p. 12; "Tries to Walk Pier on a Wager and is Drowned," 4.28.1914, p. 15; "Trouble is Over with Canal Ferry," 8.2.1905, p. unk.; "Tug Breaks Ice in Harbor, Opens Navigation Here," 4.5.1929, p. 1; "Tug Fashion to Link Park Point With Mainland," 4.6.1929, p. 1; "Twin Ports to Share Welcome for Cloud Ships," 3.21.1919, p. 3; "Twenty-Five Cases Appeal Bridge Levy," 7.22.1928, p. unk.; "Two Hundred Thirty-Five Residents Would Share Cost of Bridge," 1.28.1927, p. unk.; "Unfit, Citizens Tell Council," 1.21.1927, p. unk.; "Upkeep of Lift Bridge," 10.10.1969, p. unk.; "Ups Fewer, but Winter No Downer on Bridge," date n/a, p. 1 and 10A; "Wager of $1 Costs Life; Swept to Sea," 4.29.1916, p. 2; "Will Ask No Favors of City," 8.19.1902, p. unk., *NewsBank* Access date unk., *genealogybank.com*; "William B. Patton, Well Known Engineer. . . Dies," 11.30.1923, p. 1; "Will Light Up Aerial Bridge," 7.4.1919, p. 9; "Will Mayor Let His Chiefs Go?" 2.10.1912, p. unk., *NewsBank* Access date unk., *genealogybank.com*; "Workers Atop Aerial Bridge Get Many Thrills," 7.21.1929, p. unk.; "Workmen Excavate for New Lift Bridge, 4.11.1929, p. 1; "Work on Bridge to Begin Soon," 9.26.1901, p. unk., *NewsBank* Access date unk., *genealogybank.com*; "Work on Bridge Expected to Be Started Monday," 3.21.1929, p. 1; "Work on Canal Bridge Delayed," 10.21.1928, p. 4; "Work on Canal span To Begin Before April 1," 3.8.1929, p. 1; "Work on the Bridge," 10.30.1901, p. unk., *NewsBank* Access date unk., geneaologybank.com; "Work on New Lift Bridge at Canal Starts in August," 4.11.1928, p. unk.; "Would Call for New Bids. . ." 10.24.1928, p. unk.; "W.T. Maynard," Obituary, 9.20.1945, p. 4.

Duluth Weekly Herald: "What Ferry Bridge Costs," 11.5.1913, p. 10.

Duluth Weekly Tribune: "A $1,000,000 Fire," 12.3.1886, p. 1; "Boeing and Canal," 10.18.1889, p. unk.

Minnesotian: "The Bridge Over the Ship Canal," 4.18.1872, p. 3; "The Canal Ferry," 4.27.1872, p. 3; "The Canal Injunction," 6.3.1871, p. 2; "Dredging the Canal, The Dyke, Beacon Light," 5.4.1872, p. 3; "The Duluth Ship Canal," 5.13.1871, p. unk. "Dyke Accidents," 4.20.1872, p. 3; "The Minnesota Point Canal," 9.3.1870, p. 3; "Work on the Point Canal Commenced," 9.10.1870, p. 2; "Our Ship Canal," 6.10.1871, p. 2; "Progress of Our Ship Canal," 5.6.1871, p. unk.; "The Ship Canal and the Injunction Fight," 6.17.1871, p. 2.

Superior Telegram: "The Duluth Canal and the Dike Across Superior Bay," 12.27.1980, p. unk.

CITY AND STATE GOVERNMENT REPORTS

Annual Reports of Board of Public Works, 1910. City of Duluth. pp. 168-169.

Annual Reports of City Engineer, 1900. City of Duluth. pp. 83-84; 1901, pp. 131-135; 1903, pp. 144-147, 1902, p. 147; 1904, pp. 142-146; 1905, pp. 143-147; 1906, pp. 144-165, 1907, pp. 150-167.

Annual Report of Clerk of the Board of Public Works, for the Year Ending Feb. 28, 1893. City of Duluth. p. 6.

Annual Report of Mayor, City of Duluth. [re Engineering Report on Bridge], 12 March 1901; [re little progress on bridge], 10 March 1903.

Annual Report of the Secretary of the Treasury on the State of the Finances, 1870. State of Minnesota. pp. 390-391.

Minutes of the Duluth Common Council (1888-1912) and City Council (1912-2005): 1891: Nov. 9; 1901: Feb. 4, Apr. 8, Oct. 7; 1902: May 11, June 9, Nov. 10, Nov. 17, Dec. 8; 1903: Mar. 10, Apr. 20, May 18, May 25, Aug. 17, Sept. 28, Nov. 9; 1905: Jan. 16, Feb. 27, Mar. 6, Apr. 17, Apr. 24, May 1, May 8, May 22, June 12, June 19, Aug. 28, Nov. 6, Nov. 27, Dec. 11; 1906: Mar. 12, Mar. 19, Apr. 9; 1907: Jan. 7; 1927: Jan. 24, Jan. 27, Feb. 7, Feb. 21, Feb. 28, Apr. 5, Apr. 11, Apr. 18, May 2, May 5, May 9, May 12, May 17, May 23, Nov. 22, Nov. 28, Dec. 5; 1928: Feb. 16, Mar. 12, Mar. 15, Apr. 2, Apr. 16, Apr. 23, Apr. 30, May 14, May 21, May 28, Jun. 4, Jun. 18, Jul. 2, Jul. 16, Jul. 23, Aug. 6, Aug. 20, Sep. 17, Oct. 1, Oct. 8, Oct. 17, Oct. 22, Oct. 29, Nov. 5, Nov. 13, Nov. 26, Dec. 3, Dec. 31; 1929: Jan. 7, Jan. 9, Jan. 14, Jan. 17, Jan. 28, Feb. 13, Feb. 18, Feb. 25, Mar. 4, Mar. 11, Mar. 18, Apr. 1, Apr. 8, Apr. 15, Apr. 22, Apr. May 1, May 6, May 13, May 27, Jun. 3, Jun. 17, Jun. 19, Jun. 24, Jun. 26, Jul. 1, Jul. 8, Jul. 18, Aug. 5, Aug. 19, Aug. 28, Sep. 3, Sep. 16, Sep. 18, Oct. 7, Oct. 21, Nov. 12, Nov. 18, Nov. 25, Dec. 2, Dec. 9, Dec. 16, Dec. 23; 1930: Jan. 8, Jan. 9, Jan. 13, Jan. 23, Feb. 3, Feb. 17, Mar. 31, Apr. 2, Apr. 7, Apr. 23, Apr. 28, May 5, May 7, May 12, May 19, May 28, Jun. 4, Jun. 6, Jun. 16, Jun. 18, Jun. 23, Jun. 25, Jun. 30, Jul. 7, Jul. 9, Jul. 14, Jul. 21, Jul. 23, Jul. 29, Aug. 1, Aug. 11, Aug. 13, Aug. 27, Sep. 2, Sep. 15, Sep. 17, Sep. 22, Sep. 26, Sep. 29, Sep. 30, Oct. 1, Oct. 6, Oct. 13, Oct. 20, Oct. 25, Oct. 27, Nov. 1, Nov. 3, Nov. 8, Dec. 1, Dec. 3, Dec. 15, Dec. 22; 1931: Jan. 7, Jan. 21, Feb. 9, Feb. 11, Feb. 18, Feb. 24, Mar. 9, Mar. 16, Mar. 23, Mar. 30, Apr. 6, Apr. 13, Apr. 15, Apr. 20, Apr. 27, May 4, May 11, May 13, May 18, May 25, Jun. 1, Jun. 8, Jun. 15, Jun. 24, Jun. 29, Jul. 6, Jul. 13, Jul. 20, Aug. 24, Aug. 31, Sep. 8, Sep. 21, Sep. 28, Nov. 16, Dec. 23; 1932: Feb. 23, Mar. 16, May 21, Jun. 6, Jun. 13, Jun. 20, Jul. 18, Sep. 6; 1933: Feb. 13, Feb. 20, May 31, Nov. 15; 1934: Feb. 26, Jun. 11, Jun. 18; 1935: Jan. 9, Jun. 17, Jul. 1, Jul. 15, Oct. 14, Oct. 22, Oct. 28, Dec. 12; 1936: Mar. 2, Apr. 2, May 11, Jun. 3, Jun. 8, Jul. 22; 1937: May 10, May 17, May 24, Jun. 2, Jun. 7, Jun. 9, Jun. 19, Dec. 20;

1938: Mar. 7, Apr. 13, Oct. 24; 1939: Apr. 17, May 10, Jun. 19, Aug. 31, Sep. 20, Sep. 27, Oct. 16, Nov. 20, Dec. 4; 1940: Mar. 6, Mar. 20, Mar. 25, Mar. 30, Jun. 5, Jun. 12; 1941: Jan. 27, Feb. 17, May 7, May 12, May 19, Jun. 30, Jul. 9, Aug. 18, Sep. 8, Sep. 10, Sep. 17, Sep. 22, Oct. 15, Nov. 3, Nov. 17, Nov. 19, Nov. 24, Dec. 1, Dec. 8, Dec. 15, Dec. 31; 1942: Jan. 5, Mar. 16, Mar. 23, Apr. 15, Apr. 16, Apr. 20, Apr. 27, May 17, Jun. 3, Jun. 8, Jul. 20; 1943: Jan. 27, Mar. 8, Mar. 22, Apr. 19, May 10, May 24; 1944: Jul. 5, Aug. 16, Sep. 18, Oct. 2, Oct. 18, Nov. 27, Nov. 29; 1945: Jan. 29, Feb. 13, Feb. 26, Mar. 26, Apr. 2, May 21, Jul. 9, Aug. 17, Oct. 31, Dec. 26; 1946: Jan. 16, Mar. 18, Apr. 3, May 1, May 6, Jun. 3, Jul. 10, Jul. 29, Aug. 21, Sep. 11; 1947: Jan. 17, Jan. 27, Jan. 29, Feb. 10, Feb. 17, Mar. 3, Mar. 10, Mar. 12, Mar. 17, Mar. 24, Mar. 31, Apr. 2, Apr. 23, Apr. 28, Apr. 30, Jun. 2, Jun. 18, Jun. 23, Jul. 7, Jul. 30, Aug. 6; 1948: Jan. 19, Feb. 4, Feb. 6, Mar. 31, Aug. 2, Dec. 22; 1949: Jan. 10, Apr. 25, May 16, May 18, Dec. 12, Dec. 14; 1950: Nov. 27, Dec. 6; 1951: Jan. 3, Jan. 10, Jan. 17, Feb. 14, Mar. 14, May 7, Nov. 19, Dec. 27; 1952: Feb. 4, Feb. 27, Mar. 12, Apr. 23, Apr. 28, May 7, May 19, May 28, Jun. 9, Jun. 30, Sep. 15; 1953: Mar. 2, Mar. 9, May 4, Jul. 13, Aug. 3, Aug. 5, Aug. 10, Aug. 17, Sep. 14, Sep. 23, Sep. 30, Oct. 30, Nov. 9; 1954: Feb. 24, Mar. 8, Mar. 22, Apr. 7, Apr. 14, May 12, Jun. 28, Jul. 1, Aug. 23, Sep. 27, Oct. 25, Nov. 8, Nov. 15, Nov. 22, Nov. 29; 1955: Feb. 16, Mar. 16, Mar. 21, Apr. 27, May 11, May 18, Jun. 13, Jun. 20, Jun. 27, Jul. 18, Aug. 1, Aug. 8, Sep. 7, Sep. 14; 1956: Jan. 2, Apr. 2, Apr. 16; 1958: Apr. 14, Apr. 21, Oct. 20; 1960: Mar. 28, Apr. 11; 1961: Apr. 24, May 8; 1962: Jan. 8; 1963: Jan. 11, Sep. 23; 1964: Apr. 6, Apr. 13; 1965: Apr. 12, Aug. 23, Dec. 27; 1966: Jan. 11, Jan. 23, Jan. 25, Feb. 28.

Park Point Community Club. "Petition to Common Council," [for Ferry Service] 5 May 1902; [for completing the Aerial Bridge] 10 Oct. 1902; [for finding a company other than Duluth Canal Bridge Co.] 23 May, 1903; [for "larger and more suitable ferry"] 30 March 1903.

CORRESPONDENCE

American Bridge Company to W.B. Patton [regarding request to meet with ABC engineer to go over plans], 29 March 1901; [regarding parts of ferry bridge], 18 April, 1901; [regarding Arnodin patent], 29 May 1902; to Gaillard [regarding bridge designs], 18 May, 1901; [regarding pile foundations for canal bridge], 18 June 1901; to Turner, [bid on bridge], 10 Dec. 1903.

City Engineer to Modern Steel Structural Co., [bonds and bridge plans], 31 Aug. 1903.

Cullum to Duluth President and Common Council, 31 May 1905; 12 July 1905, [advising about "final settlement" for bridge], 9 Oct. 1905.

Duluth Canal Bridge Company to City Engineer W.B. Patton, [regarding lack of metal to work on bridge], 5, Nov. 1902; 8 Nov. 1908.

——. to City Council, Proposal to Construct Bridge Across Canal, 7 Oct. 1901.

Duluth, Missabe & Northern Railway Co. to Patton, [steel work for towers], 15 March 1904; [roller bearing, plates], 23 March 1904.

Duluth Telephone Company to Cheadle, City Clerk, [asking for resolution to allow the company to set up and maintain telephone wires on bridge], 7 Apr. 1905.

Elkins, S.B. to President and Common Council [regarding "Transmitting a Letter from the Chief of Engineers, Submitting a Copy of the Report of one of the Engineers of His Investigation into the Ownership of the Ground on Which are Located the Canal, Canal Entrances, and Piers in Duluth Harbor, Minnesota."]

Ferry Bridge Commission to Contractors, [bid specifications, deadlines], 1903.

Gaillard to Mayor Hugo and Common Council, 19 July 1902; [regarding piles in canal], 3 June 1902.

Hugo to President and Common Council [LCA Okays Bridge], 21 Jan. 1901; Hugo et al to Common Council [re Ferry Problems], 4 Feb. 1901; to President and Common Council [directing Board of Public Works to Advertise for Bids to Operate a Steam Ferry] 6 March 1901; to President and Common Council, 21 July 1902; to Common Council, [regarding expiration of Duluth Canal Bridge Contract], 23 May 1903; to Common Council, [includes bridge contract with MSS], 28 Sept. 1903; [bridge bids], 28 Dec. 1903.

The King Bridge Co. to Turner, [refusing to bid], 6 July, 1903.

Marcy to McGilvray, [cigar, stationery, and confectionary store in bridge waiting rooms, [December 1904].

McClintic-Marshall Construction Co. to Turner, [refusing to bid], 8 July 1903.

McGilvray to President and Common Council, [waiting rooms at Ferry Bridge], 3 Jan. 1905; [waiting room costs], 27 March 1905; [painting the bridge], 1 May 1905; [certification of ferry bridge completion], 26 May 1905; [mechanical expert's examination/report of Ferry Bridge], 9 Oct. 1905.

Milwaukee Bridge Company to Turner, [bridge financing], 11 Nov. 1903.Mitchell to MSS [about contract terms], 9 Sept. 1903; [regarding bridge contract], 11 Sept. 1903.[regarding "piers," the city, and DCBC], 13 Aug. 1903; [regarding bridge contract and payments], [council's action on bridge contract], 7 Oct. 1903; 2 Nov. 1903; [regarding contract], [regarding payments], 11 Nov. 1903; 27 Nov. 1903; [meeting in Waukesha], 8 Dec. 1903; [changes that MSS made to bridge specs and subsequent suggestions], 28 Dec. 1903; [bridge specs], 30 Dec. 1903.

——. to Turner, [about traveling to Waukesha];23 Nov. 1903.

——. to Common Council, [Supreme Court ruling on bridge construction], 9 Nov. 1903; [regarding DCBC's claim of a $20,000 lien on bridge piers], 19 June 1905.

Modern Steel Structural Co. to Mitchell [regarding bid], 20 Jan. 1903; [bridge financing], 5 Sept. 1903 and 10 Sept. 1903; [changes to contract and financing], 19 Sept. 1903; [regarding bid], 24 Sept. 1903; [requesting meeting about bridge], 28 July 1903; [confirming meeting with city of Duluth], 8 Aug. 1903; [requesting that "piers" be settled between DCBC and the city], 10 Aug. 1903; [bridge bonds], 29 Aug. 1903; [change in contract], 26 Oct. 1903; [bridge payments], 9 Nov. 1903; [arranging a meeting], 12 Nov. 1903; [meeting],18 Nov. 1903; [bridge financing], 25 Nov. 1903; [regarding Dec. meeting], 9 Dec. 1903; [more on Dec. meeting], 10 Dec. 1903; [more about bonds, financing and bridge specifications], 19 Dec. 1903; [clarifying telegram], 23 Dec. 1903; [form of specifications], 30 Dec. 1903.

——. to Turner, [about Duluth paying MSS for bridge work], 10 Nov. 1903; [bridge financing], 25 Nov. 1903; [after meeting, more on financing], 17 Dec. 1903.

——. to Patton, [approval of tower drawings], 11 March 1904; [quality of steel], 21 March 1904; [shoe plates, castings, and roller box], 29 March 1904.

——. to President and Common Council, [payment upon bridge completion], 29 May 1905.

——. to McGilvray, [building extension requested], 27 Feb. 1905; [lightening arresters bill/"Norfolk matter"], 26 June 1905; [truck replacements for bridge], 29 June 1905; [bridge trucks explanation], 6 July 1905.

——. to Cullum, [bridge ready for final test], 27 March 1905.

——. to Board of Public Works, [bridge trucks], 6 July 1905.

——. to Nelson, Asst. Engr., [broken wheels in truck system], 16 Aug. 1905.

Modjeski to W.B. Patton [regarding inspection costs for ferry bridge], 31 Dec. 1901.

The Osborn Engineering Co. to Patton, [regarding bridge inspection], 5 Apr. 1902.

Patton to Hugo [regarding river and harbor improvements on Lake Superior], 25 Nov. 1901; to President and Common Council, [regarding transmitted bids for ferry bridge materials inspection], 7 Apr. 1902; [regarding payment for Engineering employees], 19 Oct. 1903.

Painters' Union to President and Common Council, [painting the bridge], 8 May 1905.

Phoenix Bridge Company to Turner, [refusing to bid], 3 July 1903.

Pittsburgh Testing Laboratory, LTD to Patton, [regarding bridge inspection], 6 Feb. 1902; [regarding bridge inspection], 5 Apr. 1902.

Potter to McGilvray, [protecting piers], 19 Oct. 1904.

Roemheld & Gallery to Patton [regarding Strauss design for transfer bridge] 18 Jan. 1904.

Robert W. Hunt and Co. Engineers to Patton, [regarding bridge materials inspection], 5 Apr. 1902.

Special Ferry Bridge Commission to Common Council [regarding bids for ferry bridge], 25 March 1901.

Strauss, Joseph B. to Patton, [regarding request for blue print specifications], 11 June 1903; [regarding plans for car transfer bridge] 10 July 1903; [regarding design illustrated and describe inengineering News of March 20, 1902], 13 July 1903; [regarding advantages of Strauss design for transport bridge] 29 July 1903; [regarding bids on the transfer brdge], 8 Aug. 1903; [regarding ferry bridge contract with Modern Steel Structural Co.], 21 Nov. 1903; [regarding request to include Strauss design in transfer bridge bid process]. 28 Nov. 1903.

Turner to Special ferry Bridge Commission [regarding quality of proposed bridge construction], date unk.

— —. to McGilvray, [regarding bridge parts], 28 Feb. 1904; [print of ferry car interior included/other design info], 13 May 1904.

— —. to Patton, [regarding sketch of car and drive for ferry bridge], 17 Jan. 1902;[regarding parts and plans for bridge], 28 Jan. 1902; [regarding inspection], 8 Apr. 1902; [regarding bridge construction], 19 Apr. 1902;[regarding bridge approaches], 30 June 1902; [bridge specs/structural concerns], 20 Feb. 1904; [design change/"disquisition"], 10 March 1904; ["disquisition" again], 16 March 1904.

— —. to Common Council, [regarding plans for bridge], 18 May 1903.

— —. to Mitchell, [regarding bridge contract], 10 Aug. 1903; [bridge financing], 12 Nov. 1903; regarding relations with MSS], 13 Nov. 1903; [bridge specifications], 22 Nov. 1903; [on letters from bidders], 3 Dec. 1903; [payments and negotiations], 11 Dec. 1903.

— —. to Coe, [regarding dealings with MSS], 29 Jan. 29 1904.

Whittaker to President and City Council, [waiting room stand], 20 March 1905.

K. INDEX

PEOPLE, AERIAL BRIDGE OPERATORS